JEWS *and*

PHOTOGRAPHY

in BRITAIN

EXPLORING JEWISH ARTS AND CULTURE
Robert H. Abzug, Series Editor
Director of the Schusterman Center for Jewish Studies

Jews in the realms of the arts and culture have imagined extraordinary worlds and shaped dominant cultures in ways that are only now being fully recognized and studied. The books in this series, produced by established scholars and artists, will further this revelation and make substantive contributions to both scholarly and public understandings of art, drama, literature, photography, film, dance, music, foodways, cultural studies, and other expressions of humanity as filtered through the Jewish experience, both secular and religious.

JEWS *and*

PHOTOGRAPHY

in BRITAIN

M I C H A E L B E R K O W I T Z

UNIVERSITY OF TEXAS PRESS
AUSTIN

Requests for permission to reproduce material
from this work should be sent to:
Permissions
University of Texas Press
P.O. Box 7819
Austin, TX 78713-7819
http://utpress.utexas.edu/index.php/rp-form

The paper used in this book meets the minimum requirements of
ANSI/NISO Z39.48-1992 (R1997) (Permanence of Paper). ∞

Library of Congress Cataloging-in-Publication Data

Berkowitz, Michael, author.
Jews and photography in Britain / Michael Berkowitz. — First edition.
pages cm — (Exploring Jewish arts and culture)
Includes bibliographical references and index.
ISBN 978-1-4773-0556-0 (cloth : alk. paper)
1. Photography—Great Britain—History. 2. Jews—Great Britain—History.
3. Photography—Social aspects—Great Britain—History.
I. Title. II. Series: Exploring Jewish arts and culture.
TR57.B47 2015
770.941—dc23

2015016153

to
Lesley Hyatt and Bernie Friedman
Liz and Mark Astaire
Debby, Rachel, and Stephen

and in memory (z"l) of
Marsha Goldfine (1947–2013)
Anita Friedman (1933–2013)
Paul Leeds (1940–2014)

CONTENTS

ILLUSTRATIONS

ILLUSTRATIONS

ABBREVIATIONS

AJR Association of Jewish Refugees (Britain)

BL British Library, London

BN-NN (papers of) Beaumont Newhall and Nancy Newhall at the Getty Research Institute, Los Angeles

DNB *Dictionary of National Biography*, Oxford University Press, online version (periodically updated)

FHG (Roy) Flukinger, *The Gernsheim Collection* (Austin: University of Texas Press and the Harry Ransom Center, 2010)

GEH George Eastman House Museum of Photography, archives, Rochester, New York

GRI Getty Research Institute, Los Angeles

HGC Helmut Gernsheim Collection, Harry Ransom Center, University of Texas, Austin

HGPF *Helmut Gernsheim: Pionier der Fotogeschichte/Pioneer of Photo History* (Ostfildern-Ruit: Hatje Cantz Verlag and Reiss-Engelhorn-Museen, 2004)

HGVW (Helmut) Gernsheim interview(s) with Val Williams, Oral History of British photography project, British Library, followed by tape number

HRC Harry Ransom Center, University of Texas, Austin

JC *Jewish Chronicle*

LBI Leo Baeck Institute (London, New York, Jerusalem)

NA (British) National Archives, Kew

NAL National Art Library, Victoria and Albert Museum, London

NPG National Portrait Gallery, London

RE Reiss-Engelhorn Museum, Mannheim [Helmut Gernsheim collection]

ABBREVIATIONS

RfV Refugee Voices Oral History collection, Wiener Library, London

SLA (Stefan) Lorant albums documenting his career, "The Life of Stefan Lorant," scrapbooks in three volumes, OB.31.c.7204, apparently compiled in 1995, British Library

SLT (Stefan) Lorant interview(s) with Alan Dein, Oral History of British Photography project, British Library

SPSL Society for the Protection of Science and Learning archive, Radcliffe Library, University of Oxford

TGA Tate Gallery Archive, Tate Britain, Millbank

V&A Victoria and Albert Museum, London

WIA Warburg Institute Archive, School of Advanced Study, University of London

WL Wiener Library, London

The Prince, the Professor, the Photographer— and the Jewish Question

⟶※⟵

AT 11:30 A.M., on Tuesday, March 13, 2012, I had an audience, lasting some forty-five minutes, with the Duke of Edinburgh in his library at Buckingham Palace. His wife, the Queen of England, was somewhere in the palace, but I didn't get to meet her that day. Maybe next time.

I have written occasionally for newspapers but have no press credentials. I haven't been especially concerned with the monarchy in my professional life, and would not consider myself a keen royal-watcher. It is unusual for an academic with no existing tie to either royalty or "the great and good" of British society to have an in-depth discussion with a member of the royal family. Thousands of people enjoy brief exchanges with the royals, but this was something quite different.

How and why would a historian who has not been accorded an official "honour" be invited for an audience at Buckingham Palace? It was a result of *chutzpah*, on my part, combined with Prince Philip's willingness to speak about someone he fondly remembered, the photographer known as Baron—Baron Sterling Henry Nahum—who has rarely been discussed since his death in 1956.

AT THE END OF OCTOBER 2011 I was tidying up an early version of a manuscript on Jews and photography in Britain, now materialized as this book. Its epilogue dealt with photographers to the Court of St. James. Among other topics, I recounted the controversy that arose in 2007 over the Queen's photo-shoot with Annie Leibovitz (to be revisited here in the conclusion). Commercials for a BBC-commissioned documentary made it appear that there had been a nasty spat between Leibovitz and Queen Elizabeth II. But the reality was the opposite: they got along splendidly. My larger point was that there had been a good

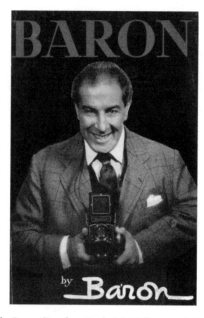

Cover of *Baron by Baron* (London: Frederick Muller, 1957). Baron assumed his
autobiography would be a big seller due to his popular television show. Baron
wrote that the Duke of Edinburgh asked: "'What on earth are you writing
a biography for? You are too young.'" Baron replied: "'I can give you ten
thousand reasons, sir, and I shall. Ten thousand quid'" (25). Baron
died before the book went to press. Private collection.

relationship between the royals and a succession of Jewish photographers, one
which seemed to reach beyond professional responsibility and cordiality. I also
wrote a few pages about Baron.

I cannot recall when I first heard of him. Possibly it was after I learned that
the photographer Snowdon (Antony Armstrong-Jones, first Earl of Snowdon, b.
1930)—who had been married to the Queen's younger sister, Princess Marga-
ret—had a partly Jewish background. The path from Snowdon led to Baron, with
whom Snowdon had apprenticed to learn photography. Baron's memoir, *Baron
by Baron* (1957) is explicit about his Jewish origins, and he details his family's
history—ranging from North Africa to the United Kingdom and beyond.
(Snowdon, by the way, writes that his Jewish side was a strong element of his
own makeup.) Although he was by no means religiously observant, there is no
mistaking that Baron was a Jew. Actor Peter Ustinov, in his foreword to Baron's
autobiography, suggests that Baron was evasive about what his Jewishness meant
to him and his career—but it is important that Baron did address it nonetheless.

Baron asserted that he was close to the royal couple, and especially friendly with Prince Philip. After the Second World War Baron founded "a little club to lighten the gloom that surrounded us all," meeting once a week above Wheeler's Oyster Bar in Soho. "I think one of the principal reasons for the success of the club was that no speeches were allowed and nobody was permitted to stand up when telling a story." A leading member of that informal society was Lieutenant Philip Mountbatten, as he then was, whom Baron met during a photo shoot at Broadlands, the home of Dickie and Edwina Mountbatten, in 1947. After finishing with the Mountbattens, Baron snapped a few informal photos of Philip. Baron used his "miniature camera," taking "little more than snapshots without much quality or significance." But "when I look back through all of the photographs I have taken officially and unofficially," he recalled, "the one which I keep on my desk, signed 'Philip, 1947,' taken so casually . . . is the one I like best of all."

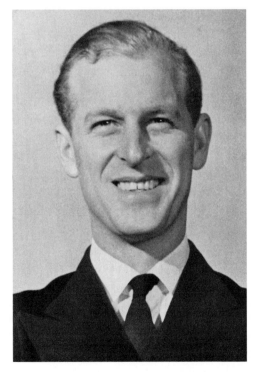

Baron, *The True Philip*. Lieutenant Philip Mountbatten (formerly Prince Philip of Greece and Denmark, soon to be Duke of Edinburgh), 1947. In *Baron by Baron* (London: Frederick Muller, 1957), opposite p. 96. Photograph by Baron, Camera Press London.

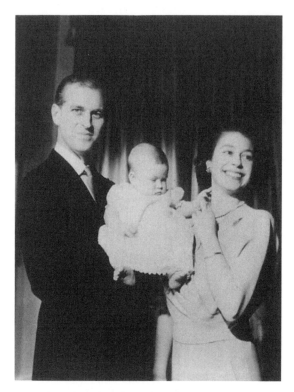

Baron, *T. R. H. The Duke and Duchess of Edinburgh and H. R. H. Prince Charles*, from late 1947 or early 1948. Reprinted as a postcard and reproduced here from Mary Dunkin and David Robson, "Royal Mail," in *Weekend FT Magazine*, Jan. 14/15, 2012, p. 20. Photograph by Baron, Camera Press London.

A few days after their meeting at the Mountbattens', Philip visited Baron's studio and had lunch with him. According to Baron, "From that time onwards we saw each other frequently. . . . He himself was interested in photography and handled a miniature camera skillfully. Rumours were flying everywhere to the effect that he was engaged to Princess Elizabeth, but his discretion was absolute and unshakable. I, who was seeing probably as much of him as any other friend he had, finally learned of the engagement when I read it in the papers." It stands to reason, then, that Philip asked Baron to shoot some of the royal wedding photography, also noteworthy because this was to be done in color.

Concerning Prince Philip's role in the Thursday Club, Baron wrote that he "was popular not because of his position but because he was a good mixer, a first-class raconteur and a witty conversationalist. For a while he was even on the

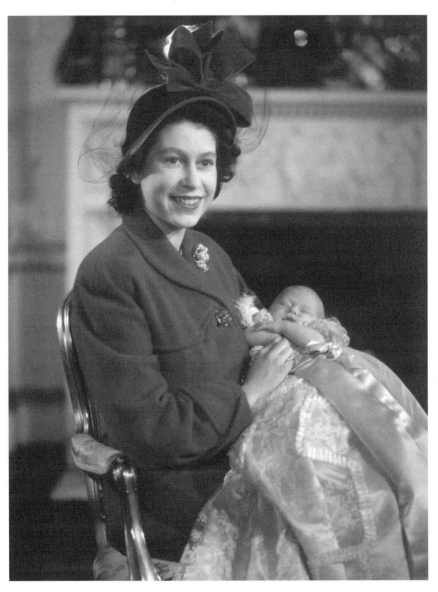

Baron, *Princess Elizabeth with Prince Charles* (1947).
Photograph by Baron, Camera Press London.

Committee of the Club, and worked hard at it." Becoming increasingly promi-
nent, Prince Philip received some "unfavourable press" for public statements.
Despite his great "charm and friendliness," Philip's "refusal to have his speeches
written for him and instead speak off the cuff" caused anxiety for some of his
handlers, according to his recent biographer, Philip Eade. Baron emphasized,
though, that Prince Philip's "development over the years has been remarkable,
and his judgment today [in 1955] lightning-keen. I can say that there is no per-
son in the world whose advice I value more. He is forthright and hypercritical,
and is sometimes frighteningly so."

Overall Baron's memoir struck me as sincere. His feelings about Prince Philip
seemed honest. Baron himself was no intellectual but was street-smart. He was
occasionally boastful but did not seem to exaggerate and certainly was no liar.
Baron actually held back, in his memoir, from saying he had arranged, according
to Eade, the "unofficial stag dinner party" for Philip. What impressed me most,
though, were his photographs. The royal couple, photographed by Baron, appear
relaxed, with cheesy grins, and truly cheerful. I was taken by Baron's work be-
cause many of his photographs were so different from those of other royal and
"society" photographers.

In the realm of gossip Baron occasionally is chastised as a bad influence on
Prince Philip for having introduced him to the wrong sorts of people. He is cast
as an outsider or shady figure. Perhaps the most pronounced reservation about
Philip—to those wishing to demean him in a typically British understated way—
is to lambast his choice of friends, "notably the photographer Baron Nahum. The
son of Italian immigrants [*sic*] from Tripoli," Baron was said to have shared with
Prince Philip an "infatuation with the beautiful Frenchwoman Yola Letellier." A
few others who visited the Thursday Club, such as Kim Philby (1912–1988),
were later embroiled in scandals. Baron was specifically charged, though, with
"introducing Philip to the first of the showgirls with whom he was rumoured to
have had an affair," Pat Kirkwood. Such accusations persisted for years.

Having read Baron's memoir and Philip Eade's reputable *Young Prince Philip:
His Turbulent Early Life*, I wondered: what did the royal couple think about
Baron, who died in 1956? I mainly wanted to know if Baron was, indeed, one of
his dearest friends and what both the Queen and Prince Philip thought of him.
Given that Baron was tainted by unsavory associations, as well as his link to
Snowdon, whom Princess Margaret had divorced in 1978, I thought it unlikely
that Buckingham Palace would have anything to say.

When I finished the manuscript, despite this reservation, I wrote to the
Queen (October 2011) and asked if she and the Duke of Edinburgh might share
their recollections of Baron with me.

PREFACE

The Queen's Senior Correspondence Officer responded: "Her Majesty was interested to know that you are writing a book about the involvement of Jews in photography in Britain and has taken careful note of your comments regarding the photographer known as Baron (Sterling Henry Nahum). I am afraid I must tell you that throughout her reign The Queen has made it a rule not to publicly comment on her personal views on such matters. I am sorry to send you a disappointing reply, but may I send my good wishes for the success of your project. You may wish, however, to write separately to The Duke of Edinburgh."

Given the delicacy of the issues with which Baron and Prince Philip had been encumbered, I was surprised. The Queen was giving her consent for me to talk to Prince Philip about Baron! Perhaps she correctly surmised that I am not a scandalmonger. What a remarkable gesture: go ahead, talk to my husband. One does not take suggestions from the Queen lightly.

I immediately wrote the duke. I heard back from his Equerry-in-Waiting, Lieutenant Commander A. J. Mundin, Royal Navy, in less than a week—with an appointment for an audience.

My meeting with Prince Philip, in his library, was surreal. It also was serious. He gave me around three-quarters of an hour of his time. Although the main topic was his relationship with Baron, the conversation sometimes turned to broader subjects. He seemed to have reacquainted himself with the Baron autobiography, which he first read when it was published.

"Why Jews and photography?" he immediately challenged me. "Aren't Jews everywhere in the arts and professions? So what?" I attempted to provide a sketch of my thesis concerning the distinctive Jewish role(s) in photography, as related to their socioeconomic circumstances. He was wary, but went on with the discussion nevertheless. He seemed to enjoy my willingness to argue.

Prince Philip immediately confirmed that Baron's account was trustworthy and they had indeed been good friends. He said, though, that he did not recall if he ever knew anything about Baron's background. The prince then made a very strong point: he took great pains not to know about someone's religion or family origins. He also said that he is introduced to a lot of people who want something of him—and in the end they aren't worth knowing. "Baron wasn't like that," he said. He was his friend. Prince Philip might have been aware that there was some "foreign" element to Baron's background but thought nothing of it. And Baron was, in fact, the photographer with whom he was closest. Prince Philip did not much enjoy having his picture taken—he scoffed at being "directed." Baron was different from the others, and that's why he invited Baron to accompany him and the Queen on their worldwide cruise after his wife's accession. Baron suffered a fatal heart attack before the voyage. Prince Philip tried to recall the name of the

photographer who did accompany them, and he speculated that this man too may have been Jewish, from Austria—possibly a refugee. He didn't remember.

I asked about his experience with one of the most famous royal photographers, Cecil Beaton (1904–1980), who was "friendly" with Baron but also disparaged him. (Beaton will surface intermittently in this book.) This was the one moment where the prince seemed to hold himself back. He said that Beaton was only close to the women. He was photographed numerous times by Beaton, but there was no friendship.

In the midst of his recollections of Baron, the Prince vigorously pointed down to the floor, perhaps indicating the lower levels of the palace, and said, "We [that is, Baron and he] played squash together, every week, right here." Baron mentioned that they were squash partners, but did not say that they played in the palace. The prince went on to recount, in detail, his version of the Thursday Club. He mentioned a number of individuals and recalled the institution with fondness. Perhaps the most fascinating moment was when he wistfully mentioned his wife's accession to the throne—which "wasn't supposed to happen . . . and everything changed." That is, King George VI, his father-in-law, had been expected to live a long life. Philip and Elizabeth were supposed to have enjoyed a relatively normal existence for years, perhaps decades. Instead, fate intervened and they were thrust into the spotlight and telescopic lenses as the Queen of England and her consort.

ACKNOWLEDGMENTS

M Y FIRST NOTE of thanks goes to Queen Elizabeth II, for her encouragement and her suggestion that I contact Prince Philip directly. The next acknowledgment is directed to another Elizabeth—royalty of a different type: Elisabeth Beck-Gernsheim, niece of Helmut and Walter Gernsheim. She and her husband, Ulrich Beck, shared their time, knowledge, and good humor with me. Elisabeth read an early draft of the book. She saved me from some errors and provided essential information. Elisabeth also attended the photography history colloquium hosted by Martin Deppner in Osnabrück in November 2013 at which some of this research was presented. She offered perceptive insights and gave me the family photos that appear here. These are among the most touching gifts I've ever received.

Through Martin Deppner's efforts I met Claude Sui, of the Reiss-Engelhorn Museum, whose insights fundamentally reshaped my earlier thoughts about Helmut Gernsheim. Claude hosted me during a visit to Mannheim, and Emma Hamilton, his intern, helped make my brief stay productive.

I'd be nowhere without the continuous assistance of my colleague Lars Fischer, who managed the complicated rights and permissions for reproductions in this book. In the course of this effort he improved the entire work tremendously, saved me from numerous mistakes, and discovered a number of more appropriate and compelling photos than the ones I had thought to incorporate.

My current PhD student, Rabbi Frank Dabba Smith, read several early drafts of chapters. Frank, himself a talented professional photographer, introduced me to Trudy Goodman and Susana Beer, who shared stories and items about their respective family's engagement with photography. Through Frank I also met Ron Collins, a photographic pioneer and winner of an Academy Award for technical achievement. At a critical stage of this work in London's British Library (BL), Jen Angel and Joanna Newman offered specific advice and support. Jen

informed me of extensive recorded interviews with Stefan Lorant and Helmut Gernsheim held there. The Gernsheim tapes led me to Val Williams, whose interviews are among the greatest but least exploited treasures in the history of photography. I wish to thank Claudia Wedepohl of the Warburg Institute archives and Colin Harris of Oxford University's Society for the Protection of Science and Learning (SPSL) archive for access to these important collections. At Bradford's National Media Museum Brian Liddy gave Frank Dabba Smith and me a great introduction to the archives. Through Daniel Wildmann of London's Leo Baeck Institute (LBI), Michael Himmel and Alexander Walther provided important material from New York's LBI.

Sander Gilman, for this subject and countless others, was a goldmine. I am especially grateful for his close reading of a late draft of the book. Shulamith Behr made a point of alerting me to the lectures of Christy Anderson (University of Toronto) at the Courtauld Institute, which concern her work on the collaboration between Helmut Gernsheim and Rudolf Wittkower. Shulamith was right: Christy's work is fabulous. I have learned a great deal from her.

When I began this project, one of my first interviewees was the photographer Dorothy Bohm. I'm still drawing on the experiences she shared. I also had the opportunity to meet Wolf Suschitzky, another émigré photographer discussed in the book. Bea Lewkowicz advised me to make use of the Refugee Voices collection at London's Wiener Library. This was indeed a fabulously informative source.

My colleagues at University College London have indulged my talking about (and showing photos) ad nauseam. One could not ask for better colleagues than Francois Guesnet, Ada Rapoport-Albert, Helen Beer, Sacha Stern, Tsila Ratner, Lily Kahn, Willem Smelik, Neill Lochery, and Mark Geller. Originally my late colleague John Klier (z"l) pressed me to pursue the subject of Jews and photography.

Among the colleagues in Europe, Israel, and the United States who deserve special mention are David de Vries, Eric Jacobson, John Efron, Simha Goldin, David Levitan, David Myers, Scott Spector, Jack Jacobs, Gail Levin, Carol Zemel, John Van Sickle, Danny Greene, Ross Forman, Nathan Abrams, Sacha Ivanov, Joel Berkowitz, Megan Loiselle, and Susan Tananbaum.

I am extremely lucky that there are brilliant and generous souls in the small circle of those specifically interested in Jews and photography. David Shneer and Lisa Silverman have produced terrific scholarship on the subject. I've furthermore taken the liberty to borrow extensively from Lisa's interpretive framework in *Becoming Austrians: Jews and Culture between the World Wars*. I found it exemplary in its examination of the significance of Jews in secular culture.

ACKNOWLEDGMENTS

I also drew liberally on a book on Anglo-Jewish history—nothing to do, though, with photography—that I found exceptional: Julie Mell's forthcoming study, *"Which is the Merchant here, and which the Jew?" On the Myth of the Medieval Jewish Moneylender*. I wish to thank Julie, expressly, for allowing me to quote from her manuscript, a stunning book in the making.

A grant from the Getty Research Institute in Los Angeles afforded me the opportunity to spend time in their wonderful archive and library. I especially wish to thank Gail Feigenbaum of the Getty. Her brief comments about the importance of Walter Gernsheim were among the greatest gems in the many responses to this work. While in Los Angeles I enjoyed the hospitality of my dear friends Bernie Friedman and Lesley Hyatt.

Research at New York's International Center of Photography, supported by the Central Research Fund of the University of London, was facilitated by Maya Benton of the Vishniac Archives, and Cynthia Young kindly shared her expertise in the collection of Robert Capa and Chim (David Seymour), for which I am most grateful.

A large share of the research was conducted at the Harry Ransom Center of the University of Texas at Austin. I received a Schusterman-Dorot Fellowship, which allowed me to work at the center for several weeks, spread out over an extended period. Thanks are due to Bob Abzug, Roy Flukinger, David Coleman, and Linda Briscoe. I also greatly appreciate the time and generosity of my Austin colleagues, John Hoberman and Seth Wolitz. For many years Seth has been an invaluable confidant and font of wisdom and humor. Being in Austin also allowed me to spend time with the Texas Goldsteins, always a treat.

When I began my work in Texas I had no idea that the late Harry Ransom himself would be central to the story. I wish to give special thanks to Thomas Staley, former director of the Ransom Center, for allowing me to see and quote from the uncatalogued material concerning the acquisition of the Gernsheim Collection at the University of Texas.

Research in the papers of Gisèle Freund, in the Special Collections of Washington State University's library, was made possible by an invitation to Pullman, Washington, to deliver the annual Holocaust Memorial Day lecture. I wish to thank Pat Main, Steve Kale, Ray Sun, and their colleagues for their exceptional hospitality.

I wish I could remember—all the people who have given me excellent tips and advice. Thanks are due to Alan Swarc, Felicity Griffiths, Sheila Lassman, and Lida Barner. I've also benefited greatly from the knowledge of Francis Hodgson. Eve Hersov shared her family *kuckers* from the Catskills, which was a great help until I was able to locate my own. Phil Sharkey, son of the boxer and photographer

Dave Sharkey, helped set the course of this book with recollections of his father, whose legacy lives on in Phil's Oxford Street studio.

Fundamental research was conducted in my hometown of Rochester, New York. On several occasions I visited the George Eastman House archive and library of the University of Rochester, including Special Collections. While my work there was mainly for other purposes, I gained a great deal of insight from Joe Struble and Rachel Stuhlman at the George Eastman House, and Nancy Martin and Martin Scott at the University of Rochester. I owe a huge debt of gratitude to Grant Romer, who helped formulate the kind of questions I would investigate for the next decade.

I would like to thank Bob Azbug, Jim Burr, David Hamrick, Sarah Rosen, and Molly Frisinger for for their dedicated and highly creative efforts at seeing this book through to publication at the University of Texas Press.

I wish to record a special debt of thanks to Liz and Mark Astaire, who are a rare combination of relatives and friends by choice. Mark generously established a dedicated fund that enabled the project's completion as the richly illustrated volume it is.

I've started with the royal family and will end with my own.

Immediately after being discharged from service in the Second World War, my father, William Berkowitz (1917–1995), was hired by Eastman Kodak Co. (Rochester, NY) in its metal shop, mainly to do structural steel construction and metal fabrication. His duties included spot-welding, operating a crane, and driving a forklift truck. He did this more or less until his retirement in 1982.

I also worked at the Kodak plant during the summers of my undergraduate years in the late 1970s. I was a melter's helper, which means that I performed a number of tasks related to the gathering of material for film emulsion and mixing it together before it was "roll coated" as the base for film. Much of this was done in darkroom and "cleanroom" conditions. In 1979, while studying as an undergraduate in London, I visited Kodak in Harrow, and wrote a paper comparing the operations of the "melting" divisions in the different national settings. (My instructor for that course, sociologist Daniel Snowman, is now one of my University of London colleagues.)

After working on a number of topics in Jewish history, I turned in 2006 to the historical study of Jews and photography, inspired by a newly discovered family connection. My long-lost cousin, Lily Titova, informed me that photography had been the occupation of a branch of my family in Lithuania and Russia. Especially through the guidance of John Klier, I started investigating the engagement of Jews in photography and began talking about what I found.

The last words of thanks go to my family: for Debby, Rachel, and Stephen, with love.

INTRODUCTION

Fancy, Fear, Suspicion

⸺✣⸺

T HE MATERIAL IN THIS BOOK was supposed to fill a footnote, perhaps a sentence or two. When I began research nearly a decade ago for an international history of the Jewish engagement with photography I assumed there was little to say about Britain. Few Jews in the country were important and their Jewishness was negligible. I was stupendously ignorant on both counts. As the work progressed I found that Jews were so vital in diverse photographic realms in Britain that the subject deserved a book all of its own. Jews were not only contributors but catalytic agents, advancing studio photography and its business practices from the time of photography's inception. They profoundly shaped what came to be known as photojournalism. They were pioneers in applying photography to the fine arts. They were at the cutting edge of collecting, curatorship, the writing of photographic criticism and history, and photography publishing. Jews were not necessarily the most revered, talented, or illustrious photographers, but they were prime movers behind nearly all things photographic in Britain until at least the 1970s.

Originally I simply wished to fill gaps and detail the activities of persons and institutions that had escaped scholarly scrutiny. I soon surmised that most of them had not been examined from the perspective of how Jewishness and attitudes toward Jews had informed their perspectives and may have boosted or blocked their careers. Beyond this I came to see that our understanding of the history of photography in Britain might be substantially enhanced if a greater sensitivity to social and cultural history, which would include consideration of not only class and gender but ethnic difference, were interwoven in the narrative. My approach may be compared to recent explorations concerning Jews and music, which have sought to comprehend the highly noticeable presence of Jews in "all branches" of music beginning in the early nineteenth century, and which include reinterpretations of the history of modern music in and of itself.[1]

The current book, centering on photography, examines, in the words of Lisa Silverman on a different topic, "the role Jewish difference played in the lives, works, and deeds of a broad range" of men and women, "from self-professed Jews to converts, from native Yiddish, Hungarian, Polish, and German speakers" to secular Britons, "regardless of their degree of Jewish self-identification."[2] Photography was one of the most open avenues for Jews in Britain to make a living as well as "to shape mainstream culture."[3] This book tries to examine the work of Jews in Britain "without making Jewish self-identification the ontological foundation of Jewish experience and Jewish history. Instead, it foregrounds Jewish difference as one of a number of analytic categories or frameworks, like gender and class, that not only intersected and overlapped, but also used each others' terms in order to articulate their power."[4] Jews in photography, no matter their degree of Jewishness, "often were integrated in Jewish social networks that proved crucial" to the success of their endeavors.[5]

With few exceptions, writers on photography have expressed little interest or even curiosity about religious origins and ethnic difference. At the time of writing I have yet to discover a single work of scholarship, beyond studies of solitary figures or couples, that treats the subject of Jews and photography in Britain historically. This book comprises, then, the first attempt to recognize and explore the association of Jews and photography in Britain in a cultural-historical context. There is no need, therefore, to ponder and pick apart the historiography. It simply does not exist.

Photography was continuously evolving from the time of its inception, yet we may generalize somewhat about its social character and business dimensions. From the 1850s to the 1950s, if one's picture was snapped for a price, there was a good chance that the person behind the camera was born a Jew.[6] This was true in Britain and most of continental Europe before 1939, with the possible exceptions of Belgium and France.[7] Compared to almost any other vocation, there was little that stood in a Jewish photographer's way. It was more or less expected that photographers, and assistants in a studio, might be Jews—or some other kind of so-called foreigner—possibly Italian, French, Spanish, or Armenian. Jews in photography often encouraged such ethnic obfuscation by adopting monikers that did not sound so, well, Jewish.[8] Indistinct or "romantic" origins, and claims of having trained in Paris or Madrid, were thought to be good for business, even if one's clientele was largely Jewish.[9] This is part of the reason scholars have minimized ethnicity and religious background as factors in the history of photography.[10]

In Britain—as in Continental Europe, North and South America, Australia, and South Africa—Jews were conspicuous in establishing and staffing photography studios, which in turn were geared to the greater, non-exclusively Jewish

population. As to be expected, they also served the needs of their own communities. Although always a minority, there was a smattering of women among them, and Jewish girls and women were especially known for their expertise in "retouching," which was integral to the trade. Many photographers, however, wished to distance themselves from retouching, which often was derided as grossly manipulative, thereby detracting from the "honesty" of a picture.[11] "Truthfulness" was the watchword of countless photographers, if not the profession overall. The critical phase of retouching, as part of the relationship between sitter and the studio, is not well reflected in the historiography, although it was noted in the training and career paths of scores, if not hundreds, of Jewish photographers.[12] Could it be that everyone's ancestors were so free of acne, warts, scars, and other imperfections? How is it that one hardly ever notices a bride with a "bump"?[13]

Jews with cameras on tripods or around their necks enticed customers to have their photos taken in public spaces such as the grounds in front of Buckingham Palace and in Trafalgar Square, and proceeded to sell them prints, postcards, albums, and buttons. Occasionally they were able to produce these goods on the spot.

Up through the interwar years, Jews photographed the recently deceased, although this was not a standard practice in Judaism. They encouraged the reproduction or enlargement of photographs of the dearly departed. Jews also helped to institutionalize the photographic commemoration of more cheerful life-cycle events, especially weddings. They helped invent the traditions of "class photos" and professional-quality "holiday snaps" in Britain.[14] Because photography was taken, without question, as a heavily Jewish field, Jews participated in government-sponsored photographic expeditions, preservation efforts, and state-building projects. Jews were also court photographers—officially and surreptitiously, in Britain and elsewhere in Europe—from the time of photography's inception.[15] They advanced film and optical technologies, as individual inventors and as employees of major companies such as Kodak and Ilford Limited, both of which were based in north London.[16]

Kodak's stake in radiography, which became vital to the company, was advanced substantially by Nahum Luboschez (1869–1925), a self-educated scientist and chief demonstrator for the firm.[17] A humorous, gentle, and self-effacing polyglot, Luboschez may have been the most important ambassador of photography of all time. Luboschez also was an excellent portraitist who took the best known photograph of none other than George Eastman (1854–1932), the founder of Eastman Kodak. As a photographer of socioeconomic conditions in Russia prior to the First World War, Luboschez was decades ahead of his time.[18]

His underappreciated photographs rival, in terms of style and content, the socially conscious work of Dorothea Lange.[19] Luboschez was a key figure in

N. E. Luboschez (Nahum Ellan Luboshez), *Self-Portrait.* Most
likely taken in Harrow, north London. Gelatin silver print.
Harry Ransom Center, University of Texas.

several networks of tremendous importance to the field, which included his
brother and his sons. Since his death in 1925, though, few have noticed Lubos-
chez except for Helmut Gernsheim, who arrived in London a dozen years later.
Luboschez's work was among the early acquisitions of Gernsheim's world-re-
nowned photography collection.[20]

Beginning in the 1930s, Jewish émigrés from Central and East Central Eu-
rope, in Britain and elsewhere, played roles immensely out of proportion to their
numbers in photojournalism, advertising, fashion photography, and sports pho-
tography. In these realms there might have been a fair amount of autonomy,
depending on the individual's career stage, and how highly she or he was re-
garded.[21] This is, perhaps, where a kind of Jewish-friendly subjectivity was most
manifested—especially on the part of editors and agency heads, such as Stefan
Lorant (1901–1997) and Bert Garai (1890–1973), who worked with numerous
Jewish and refugee photographers.[22] Lorant has been hailed as "the first major
editor of modern photojournalism,"[23] and is best remembered as the editor of
Picture Post. He will feature in chapter 2.

N. E. Luboschez, *George Eastman* (1921). Official portrait of George Eastman (1854–1932), founder of Eastman Kodak Company in Rochester, New York, who also established a manufacturing and commercial base for the company in North London. Gelatin silver print. Harry Ransom Center, University of Texas.

In 1933–1934, upon its relocation from Hamburg to London, the Warburg Institute intensively incorporated photography into its work, to an extent greater than any other scholarly institution. Photography became a leading means of connecting to scholars, universally, and disseminating the fruits of its research. The Warburg Institute is the main subject of chapter 3.

The very domains of British "photography publishing" and "photography history"—which came into existence from the 1930s to the 1950s—would have been unimaginable without their progenitors of émigré origin, namely Andor Kraszna-Krausz (1904–1989), Béla Horovitz (1898–1955), Walter Neurath (1903–1967), Hans Juda (1904–1975) and Elsbeth Juda (b. 1911),[24] and Helmut Gernsheim (1913–1995). But few who write about photography see any reason to comment on the skewed social composition of the field. The sparse attention to Jews who were central to the evolution and fortunes of photography in Britain exists in approximately inverse proportion to the extent to which these men and women affected the country's visual culture. They were so successful that almost nobody noticed.

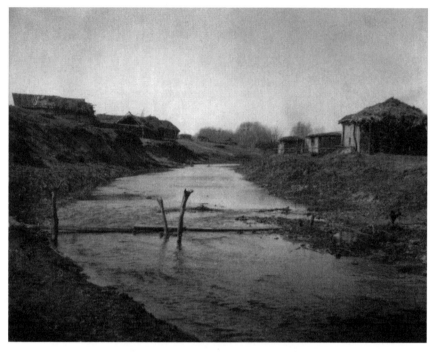

N. E. Luboschez, *Russian Famine Landscape* (ca. 1910). Gelatin silver print.
Harry Ransom Center, University of Texas.

The overarching tendency among scholars who deal with Anglo-Jewry is to examine Jews as an entity separate from gentiles, focusing on its dynamics as a people among itself, or in juxtaposition to non-Jewish society and British officialdom.[25] The thrust of this book, in contrast, is to explore a part of the Jewish world that usually did not identify strongly with traditional Judaism, or with the established Jewish community in an institutional sense. This is mainly a story of Jews who are not terribly "Jewish." But a central figure in this book, Helmut Gernsheim, had a more pronounced Jewish identity than is typically assumed. Until quite recently this has registered little interest for scholars of photography, despite Roy Flukinger's clear assertion of how antisemitism figured prominently in Gernsheim's life.[26] With encouragement from Martin Deppner,[27] Claude Sui, the head of the Gernsheim archive in the Reiss-Engelhorn Museum in Mannheim, in 2012 revealed some fascinating clues concerning Gernsheim's thoughts about the "Jewishness" of photography, as well as his own Jewish identity.[28] There is, in fact, quite a bit to say about Gernsheim's Jewish consciousness—here the subject of chapter 5. Gernsheim, in something of a huff, claimed that writing about Jews

in photography was an area he himself had staked out, and occasionally saw others who sought to comment on the subject as encroaching on his turf.[29]
My work on this book started years before I became aware of Gernsheim's interest in Jewish (hyper-)activity in photography. I found in Gernsheim's own intellectual history, however, a complement to my investigation of the field; by no means should my work be read as an extension of that of Gernsheim. But I do wish to bring attention to the richness of his mind and his excavations of

N. E. Luboschez, *Russian Girl in Famine* (ca. 1910). Gelatin silver print.
Harry Ransom Center, University of Texas.

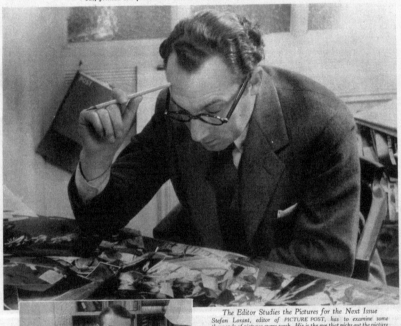

Picture Post, December 24, 1938

HOW PICTURE POST
is produced

Dozens of readers have asked us to tell them the story of the paper. How is each number of PICTURE POST planned, carried out, printed and produced ? Here then is the story—the story of ourselves.

The Editor Studies the Pictures for the Next Issue
Stefan Lorant, editor of PICTURE POST, has to examine some thousands of pictures every week. His is the eye that picks out the picture to make large; the picture for the cover; the series that will run over ten pages; the one good picture in an otherwise useless set. He is also editor of the monthly magazine "Lilliput."

THE official start of every issue is the weekly editorial conference—held as soon as the last issue has gone to press. To this conference each member of the staff brings a list of ideas. The last issue is discussed. Criticisms made by the publisher or other members of the staff are discussed. What readers have been saying in their letters is considered. Then, one by one, the members of the staff put forward ideas and suggestions, for the critical examination of the rest. One idea is too like something that has been done before. Another would be better carried out in summer—so

it is put down for later in the year. Very many which sound good will not translate into effective pictures. Occasionally someone produces one which is at once acclaimed a winner. So, after a morning's discussion, the framework of a new issue is taking shape. The editor goes off to discuss plans with the publisher. The assistant editor gets on the 'phone to contributors and cameramen. One has to leave to-night for Newcastle. One must spend the night on the Embankment. One has to photograph an operation. Another must find at once twelve pretty girls. . . . For five days each member of the

The Assistant Editor Orders the Contributions
Tom Hopkinson keeps in touch with contributors; sees that pictures and articles come in in time; is responsible for the literary side of the paper and the wording of captions.

PICTURE POST

Unattributed [Kurt Hutton], "How *Picture Post* Is Produced," *Picture Post* 59, Dec. 24, 1938, p. 64. This photo story, shot by Kurt Hutton (born Hübschmann, 1893–1960), is one of the few times when Stefan Lorant (1901–1997) portrayed himself in his central role for *Picture Post*. Kurt Hutton/Getty Images.

photography's history, which did not preclude an examination of "Jewish questions."[30] Perhaps Gernsheim's work on Jews and photography would have attained full fruition had a visiting professorship at Hebrew University materialized as he had hoped.[31]

For most of the others, however, what we can reconstruct as most "Jewish" about them is the extent to which their Jewish origins helped to determine the content, limits, and possibilities of their social and socioeconomic opportunities—and sometimes their opposition to antisemitism. This is, then, a history of people of Jewish origins, and groups and networks of Jews, dedicated to photography, within the larger worlds of which they were a part. Along with prominent individuals I wish to illuminate communities and chains of persons who tended to give each other "breaks" that often made a difference in their lives—as has been noted by David Shneer in his pathbreaking study of Jewish photographers in the Soviet Union.[32] It also is possible to see how relations between Jews, in addition to their providing a leg up for each other, comprised a vital connective tissue beneath the surface—albeit in a highly competitive professional milieu in which searing criticisms also were the norm.

In the 1970s, when Walter Benjamin's star was sharply ascending, which saw him promoted as a font of wisdom about all things photographic, Tim (Nahum) Gidal (1909–1996) and Helmut Gernsheim were befuddled. Both were photographers as well as critics and historians of photography. They did not understand the canonical status that was accorded Benjamin's two essays, "The Work of Art in the Age of Mechanical Reproduction" and his "Little History of Photography."[33] At first Gernsheim did not chime in when Gidal accused Benjamin of superficiality, saying, "So far I only read references to it and short extracts, but a fair judge should imbibe the great man's knowledge first hand"; no doubt his dubbing Benjamin a "great man" was a subtle jibe.[34]

Several weeks later Gernsheim arrived at his own opinion:

I have bought and read the little Benjamin. His *History*, even with *Little* in front[,] is a complete misnomer, but the megalomaniacal title is the most absurd part of the essay. It is very fragmentary as it is, for he only knows the work of four artists, published in monographs shortly before he penned his esthetic criticism, viz. Hill, Atget, Blossfeldt, and Sander. Though sometimes quite sound in his judgment he attempts no more than contemplative notes of the type Baudelaire penned of the Salon 1859. And like B. he combines sense with nonsense, errors and disputable statements such as "Atgets Pariser Photos sind die Vorläufer der surrealistischen Photographie." I see nothing surrealistic in Atget's documentation whatsoever,

and his extremely precise pictures seem to me to be the very antithesis to the me-
andering Busoni genius. He condemns the materialistic gendering of Renger-
Patzsch's *Neue Sachlichkeit* photos—and yet admires the Russian films of the day
to which they are the closest approach in style to still photography. Forget about
Benjamin. What he has written is not important enough to merit refuting.[35]

Compared to the oceans of print on Benjamin, there is but a trickle for Gern-
sheim. The preference for Benjamin as guru says much more about intellectual
fashions than about serious concern with photography's history. The impres-
sions Benjamin gleaned from samplings, as opposed to the deep archival re-
search and sleuthing exemplified by Gernsheim, have been embraced as sacred
texts by a number of disciplines. (Gisèle Freund's brilliant treatment of the phe-
nomenon is more historically grounded than that of Benjamin, but she is largely
ignored.[36]) But whatever Gernsheim's misgivings, he included Benjamin in a
pantheon of "Jews prominent in photography"—with the insinuation that Ben-
jamin had changed his name.[37] Gernsheim was compelled to acknowledge that
despite his faults, Benjamin triggered a surge of interest in photography, but this
most often took the form of the interrogation of the theories of Benjamin and
others, divorced from historical research.

One of Gernsheim's close friends in later life, also both a photographer and
historian of photography, Gisèle Freund (1908–2000), shot what became an
iconic photo of Benjamin—in Kodachrome. Freund had met Benjamin in the
Balearic Islands in 1932, and developed a warm friendship with him when they
were both living in Paris in 1934. Freund relates nothing, though, about his
views on photography.[38] Despite Gernsheim's placement of Benjamin in photog-
raphy's Jewish family tree, it is only recently that a scholar of Jewish Studies, Eric
Jacobson, has rigorously explored the relationship between Benjamin's thoughts
about photography and his intellectual trajectory as a Jew.[39]

The overwhelming tendency among scholars and curators has been simply to
exhibit photographs by Jewish photographers, and to use photographs of Jews
for illustrative purposes, without excavating deeper layers of the particular Jew-
ish involvement in the field. Given the plethora of material, it is not surprising
that historical museums exhibit Jewish family photos and that scholars mainly
have analyzed the photographing of Jews "as Jews," especially in interwar Eu-
rope. A great deal of this has centered on Roman Vishniac (1897–1990), who left
a gargantuan but enigmatic body of work.[40] Other photographers among the
exiles from Nazism, as well as photographs of Jews as victims of the Holocaust,
have gained scholarly and curatorial notice—in contrast to the Jewish engage-
ment with photography generally.[41]

INTRODUCTION

As a matter of course I will address Jewish contributions and analyze internal Jewish discourses. But the main objective here is to interpret the integration of Jews and Jewish matters in photography in order to gain a better understanding of photography's history and its influence on modernism in its diverse settings, applications, and meanings. The changing sense of what was considered respectable with regard to photography is especially germane in reconstructing the impact of Jews.[42] After the rise of Hitler in 1933 Britain became a particularly significant social location, as a number of photographic trends prevalent in Eastern and Central Europe were transferred to London. The latter topic is illuminated in *Second Chance* (1991) and *Arts in Exile* (2004), projects of, respectively, Werner Mosse, and Shulamith Behr and Marian Malet.[43] Although *Second Chance* was unprecedented, and *Arts in Exile* is an exemplary work, I believe that the influence of Jews on photography in Britain was far greater than suggested, especially in light of the efforts of Stefan Lorant, the brothers Walter (1909–2006) and Helmut Gernsheim, and the approach to photography assumed by Fritz Saxl (1890–1948) of the Warburg Institute upon its transplantation to London.

With the exception of the self-styled George Gilbert, to be discussed below, few historians of photography per se have said anything at all about Jewishness, other than statements about origins and outright persecution. Some astute commentators in British arts and letters have raised the issue. Colin Ford has come closest to the problem in his work on Hungarian photographers, which includes some who practiced in Britain.[44] Ford, too, is intrigued by Helmut Gernsheim's Jewishness.[45] But the Jewish identities of his subjects have proven more evasive than their apparent Hungarian core. The sum total of what has been conveyed, however interesting, does little justice to the broad and complex significance of Jewishness in photography.

One of the few direct approaches to this subject, albeit via a fictional and highly stylized vehicle, is the feature film *The Governess* (1998), written and directed by Sandra Goldbacher (b. 1960). This steamy costume drama, set in roughly mid-Victorian times, stars Minnie Driver as a vivacious Sephardic Jew, Rosina da Silva. In order to support her family in London when they fall precipitously into economic distress, Rosina attempts to pass as a non-Jew. She attains employment as a governess for an aristocratic Scottish family. The head of the household, Charles Cavendish, played by Tom Wilkinson, is an early enthusiast in photography. At that time—prior to the Kodak innovation "you press the button, we do the rest"—photography required facility in the complicated processing of glass plates. As his main vocation Cavendish styles himself an inventor intent on improving the quality of photographic images. The scientific side of the Cavendish character may have derived from biographies of William Fox

Talbot (1800–1877) and John Herschel (1792–1871), foundational figures in the history of photography in Britain, along with the French inventor Nicéphore Niépce (1765–1833). While she is affectionately and effectively tending to the children, a torrid affair unfolds between Rosina and the otherwise buttoned-up lord of the manor. The governess is as smitten, however, with Cavendish's "hobby" of photography as she is with the man himself. Rosina encourages, even teases her lover to push the boundaries of his picture-taking, toward the increasingly daring and eroti-cally charged, with herself as the subject. Rosina's combination of voracious sexual and photographic appetites may be seen as foreshadowing the efforts of Alfred Stieglitz (1864–1946),[46] arguably the most influential photographer of all time—from a reverse-gender perspective. Stieglitz was the leading exponent of elevating photography into the fine arts on its own terms, as integral to the mod-ernist project in total. Although neither traditional nor religiously observant, Stieglitz was known as a leading Jewish personality of his day,[47] and derided as "a Hoboken Jew without knowledge of, or interest in," American art and aesthetics, and "hardly equipped for the leadership of a genuine American expression."[48] This dimension of his reputation has until recently been largely ignored.[49] Espe-cially through his nude photographs of Georgia O'Keeffe and Rebecca Strand, Stieglitz wished to obliterate the taint of pornography that contributed to the perception of photography as unseemly, or as an inherently dubious form of creative expression. Goldbacher's Rosina, too, is indulging in the making of art, not pornography, although the stodgy Cavendish ultimately cannot overcome his discomfort with the governess as a pornographer and a Jew.

A critical twist of the plot is Rosina's accidental discovery of a monumental advance in photography—in the midst of a private, clandestine Passover *seder* held in her room. After clumsily spilling the salt water from the ceremony (which traditionally represents the tears of Jewish slaves in Egypt) on an under-exposed print, she observes that salt plays a role in photochemical processes. Rosina gleefully shares this insight with Cavendish, hoping to win the accep-tance and respect of her lover, with the ultimate aim of becoming his partner in the full light of society. The cad Cavendish, though, appropriates her revelation as his own, which leads to tension and conflict between him and Rosina. In the end, predictably, Rosina's Jewish identity is unmasked, and she is expelled vio-lently from the manor. The film's close shows Rosina ensconced as the proprietor of a photography studio in London's East End. She is no Stieglitz, but she seems to have achieved a fulfilling livelihood.

While the central conceit of *The Governess*, that a Jewish woman invented photography, is bunk, Goldbacher's story is, in fact, true to history to a certain

degree. The ultimate shot of *The Governess*, showing Rosina with a client, is the moment of the film that most nearly reflects an important, yet little noticed, reality. There were indeed Jewish women, and Jewish men, who owned and operated photography studios in London—and elsewhere in the world—in numbers well out of proportion to their percentage of the general population.

This fragment of social history from the mid- to late nineteenth century also serves as the main subject of an 1888 novel by Amy Levy (1861–1889), *The Romance of a Shop.*[50] The book details the exploits of a famoily of Jewish women who open a photography studio in London. In a narrative similar to the storyline of *The Governess*, they seek to overturn a family tragedy and the possibility of destitution. The Jewishness of its characters is lightly worn, yet is nevertheless recognizable, and the inside knowledge Levy displays of how a studio was run is impressive. It took almost a century for Levy to gain widespread acclaim as a novelist and poet who was particularly sensitive to the conditions and sentiments of London's Jews. Her novel *Reuben Sachs: A Sketch*, which also appeared in 1888, was reissued in 1973,[51] and major reconsiderations of her work and reputation commenced in the 1990s.[52] The scholarly attention lavished on Levy as a writer, however, has not led to more penetrating investigations of either women or Jews in photography. There has been no London equivalent of the effort of curators at the Jewish Museum in Vienna, whose work resulted in a stunning survey of women photographers in the pre-Anschluss capital, *Vienna's Shooting Girls/Jüdische Fotografinnen aus Wien* (2012).[53]

Along with the fact of the presence of Jews in photography, Goldbacher's film and Levy's novel serve to introduce some of this study's themes. Many Jews did enter the field because of economic distress. This was particularly true of those who came from Central and East Central Europe as refugees, beginning in the 1930s. Therefore the connection between Rosina reenacting the Jewish escape from bondage in the Passover service and her embarking on a career in photography is not as absurd as it may seem. But in contrast to Rosina learning the rudiments of photography during her tempestuous sojourn in Scotland, the majority of Jews who opened studios in Britain came to the country with both specialized knowledge and professional equipment. Some of the best-known firms in London, such as those of H. W. Barnett, Boris, and Perkoff's, were reestablished in London after having been founded elsewhere. Photography businesses opened by Jews were most often transplanted enterprises, rather than an endeavor starting from scratch.

The Governess is most insightful, however unknowingly, in its imagining of a Jewish character at photography's cutting edge. A repercussion of this is the possibility that one who ventures into uncharted terrain tends to be looked at with

suspicion or disdain. Perhaps most significantly: the film is one of the rare reflections on photography, as a medium, to confront its problematic relationship with respectability. This, I believe, is integral to any understanding of Jews and photography. Because photography was less than respectable, Jews were afforded entry into the field. It was not typically the vocation of an upstanding Englishman. The fact that Jews and recent émigrés became dominant in photography, from its early days, also is crucial. Although Jews did not invent photography, they were among its chief purveyors and practitioners throughout Europe from the 1840s until the Holocaust. This fact has all but disappeared from Jewish memory, and hardly ever surfaces in the vast historiography on photography.

In addition to Amy Levy's *Romance of a Shop*, Louis Golding's *Magnolia Street* (1932) is a notable Anglo-Jewish novel of a social-realist bent that features a Jewish photographer and highlights the place of photography among Jews in interwar Manchester.[54] As opposed to Levy's reserved, genteel characters, the photographer in *Magnolia Street*, Johnnie Hummel, is the novel's most unappealing figure. Golding plays off of the stereotype of the photographer taking advantage of the desire of his clients, especially women, for self-flattery and vanity.[55]

Along with reading about "prize-fighting and the merchant navy" to lend authenticity to *Magnolia Street*,[56] Golding also conducted research into photography. His depiction of Hummel's operation is worth quoting at length, as there are few (if any) such descriptions in the history of photography.

> His speciality was the commemoration of the dead. Whenever and wherever a farmer died in the counties within a radius of fifty miles from Doomington, his widow would find Johnnie Hummel at her ear, almost before the corpse had been taken off. He would talk and talk and talk. . . . If she sought to escape, he would make her feel she was guilty of gross disrespect to her dead. A week or two later her husband's image, an "Enlargement of the Trade," would hang on the parlour wall, a series of gray blurs, slipped eyesockets, thickened lips. She would be poorer by anything between ten shillings and three pounds, according to the amount of gold in the frame and the impotence into which her grief had thrown her.[57]

Sparing no reservation about the predatory essence of his vocation, Golding asserts that "[t]here was something vulture-like about Johnnie Hummel. For not only would he appear on the scene when someone was dead already. He had an uneasy instinct for finding out when a death might be hoped for in a day or two."[58] Johnnie, it was said, "would put up at the village pub until the moment to pounce was due; in the meanwhile he could pick up an honest penny with his camera, though you could never expect anything like such good results from the

direct photography of the living as from the indirect photography of the dead."[59] This recalls later American discussions of the photographer Weegee (born Usher Fellig, 1899–1968). Although Beaumont Newhall, the dean of photography historians, found his work compelling, important, even artful, it was scorned by some as violent sensationalism.[60]

In addition to prefiguring anti-Weegee criticisms, photographers like Johnnie were their society's equivalent of ambulance-chasing lawyers and insurance agents, as he "displayed his real genius at the times when the papers announced 'Five Hundred Miners Buried in a Mine near Bolton'; or, 'Terrible Tragedy in Blackburn Sunday-School Treat, Three Hundred Children in Blazing Hall'; or, 'Isle of Man Pleasure Steamer Sunk, No Survivors.' Then Johnnie got busy. Then Johnnie flew like lightning to Bolton, to Blackburn, to the Isle of Man." After a barrage of bullshit, "Johnnie reaped his golden harvest. The goods trains groaned with the crates in which he despatched" his photographs to his prey.[61] Sometimes, though, "he reaped another sort of harvest, a couple of black eyes and one or two missing teeth. But that was not often. The most furious fist fell limp in the blast of that talking. And there were times when he talked to win more delicate prizes than gold sovereigns. *He talked to win a wink here, a body there*" (emphasis added).[62]

The most beautiful girl he set eyes on, and decided to pursue as his own, was Ada Berman, from a family of "slum Jews." Golding unflinchingly portrays an order in which the dispensing of sex was an established part of the political economy of photography. "They lived in a dreadful hole called Magnolia Street. *They were not, like himself, the sort of Jew whom any right-minded person would take for an Italian.* But he did not let them see how low he thought of them. On the contrary he was very charming to them." He saw Ada "as a plum, a peach, a little red apple; a lovely bit of goods to get back to after a gruelling week among the widows and orphans among the miners; and a real economy, too. Sometimes you had to pay the women you slept with; always you had to pay the landladies" (emphasis added).[63]

While being with Johnnie meant a vast material improvement over Magnolia Street conditions, Ada's marriage in every respect was an unhappy one.[64] She reacted by fervently embracing Jewish rituals. In addition to neglecting his wife and children and subjecting them to beatings when he was around, Johnnie humiliated Ada in a most dramatic fashion. On the eve of Yom Kippur, the holiest day of high holidays and a fast, he came home "with a few slices of ham. He got a handful of plates and defiled them all by placing a little slice on each. He also brought in a pint of milk to swallow the ham with" (the laws of *kashrut* forbid having milk with meat).[65] Johnnie taunts Ada:

"Won't you have a little? No? You won't? You're fasting. Of course! It's Bank Holiday! Come and kiss me then! Come here, you little bitch, come here!"

He seized her round the waist and kissed her with his abominable mouth full on the lips.

"How's that darling? A bit hammy? . . . And now I'm off for a little rough-and-tumble with Elsie. You don't know Elsie, do you? That girl's got a mouth like a cork-screw—" and winking genially he left her.[66]

Leaving for good, Johnnie wrecked the contents of their house and "treated with especial malignance the enlarged photographs of Ada herself, posed against French chateaux, the Pyramids, Niagara Falls."[67] Of course, she had never visited such places. These were stock backgrounds in studios at the time, as derided by Walter Benjamin. Upon seeing the utter devastation of her daughter and her home, Ada's mother died a few days later.[68]

Besides the base individual motives detailed by Golding there were other reasons for seeing photographers as prone to corruption. By its very nature, the relationship between the photographer and his or her sitter was intimate. Posing the client for a long-exposure shot usually meant touching and even holding a face, shoulders, and, often, exposed skin. As recounted in the tale of Johnnie Hummel, photographers were denigrated for taking liberties with their female clients. Some believed that the camera allowed photographers to see inside of clothing and underneath dresses. Photography studios were not hard to imagine as "dens of iniquity," as were other commercial spaces associated with Jews, such as department stores in Central Europe.[69]

One humorous early twentieth-century postcard, depicting a photographer with a doughty elderly customer, has him asking: "But Madam, won't you take that cord from round your ankles?"; this strap holds her hem so tightly she can barely move. "Oh no!" she exclaims. "I know your little tricks, young man; when you look through that machine I shall be upside down."[70] Another piece of photographic humor implies that the suspicion of the photographer as "on the make" was not just a matter of paranoia. The card shows two scenes: on top is the docile wife, at home, on the phone; on the bottom is her husband, the photographer, with a woman on his lap. "Sorry I shan't be home to tea," he says. "I've got a sitter."[71]

In the photographic caricature collection of Helmut Gernsheim and the illustrations on display at the National Media Museum of Bradford, all of the photographers pictured have stereotypically dark "Jewish" features. In the words of Francis Hodgson, in the end they were just tradesmen.[72] Certainly there were many among the general public who sensed something distasteful about the photography trade in general, from the 1880s up through the 1960s, despite the huge demand for its services.

In post–Second World War Britain, an imaginary photographer was depicted on film who was even more menacing and sex-obsessed than Johnnie Hummel: the title character of Michael Powell's *Peeping Tom* (1960), which was conceived and written by Leo Marks (1920–2001). *Peeping Tom* retains a whiff of infamy as the smut that derailed Michael Powell's career,[73] despite a determined effort by Martin Scorsese and numerous critics to appreciate it as monumental.[74] One reviewer charged that the film indulged pornography; this opinion is primarily a response to Powell's 'unfortunate collaboration' with Leo Marks.[75] It was too puzzling, sexualized, and visually overpowering to be widely accepted in early 1960s Britain.[76] Despite initial reactions, the film remains a fabulous testament to the creativity of both Powell and Marks,[77] as the tide surely has turned and *Peeping Tom* is now held in lofty esteem,[78] appearing on many lists as one of the greatest films of all time.[79]

Michael Powell, a non-Jew, obviously is essential to any analysis of *Peeping Tom*.[80] A number of secularized Jewish discourses, however, had an impact on and are interwoven in the film—including Leo Marks's understanding of the Jewish relationship to photography.[81] Critic Luke Jennings pointed in this direction in 1999: "Perhaps the best key to an understanding of *Peeping Tom* is *Between Silk and Cyanide*," Leo Marks's memoir of the Second World War.[82] *Between Silk and Cyanide* is drenched in *yidishkeyt* (Jewishness), overtly and covertly. I would go so far as to say that *Peeping Tom* can be fruitfully explored as a "Jewish" and even, to a lesser extent, a "Holocaust" film.[83]

Peeping Tom is undoubtedly odd: boy meets girl, takes her picture, kills her with the end of a tripod fashioned into a bayonet. Boy meets another girl. Almost kills her. Kills himself. The film features Mark Lewis, played by Carl (or Karlheinz) Boehm,[84] a subtly "German" photographer in London who identifies himself as having been born in the house he lives in, and rents out the lower floors. He is obsessed with taking photos of women, preferably in the nude, at the moment of their murder. Lewis's horrific acts are shown as a consequence of his having been experimented upon by his "biologist" father, Professor A. N. Lewis, purportedly conducting an investigation of fear in children. A. N. Lewis's last project, we learn toward the end of the film, was the study of "scoptophilia." *Peeping Tom* is not based on any known murderer or case. The story derives from the imagination of Leo Marks, and is fueled by his desire to convey, to a general public, an appreciation of Freudian psychology, which is inextricably tied to the sense of Jews as outsiders held by both Marks and Sigmund Freud.

Apparently the original choice to play the lead character in this movie was a European-born Jew, Laurence Harvey,[85] whose career was cut short by his death from cancer at age forty-five.[86] Harvey was reputed to be "a fastidious connoisseur of antiques, food and wine. His baronial manner, cheeky wit, and upper-

class British accent gave the impression that he was of aristocratic birth. But Mr. Harvey, whose real name was Larushka Misha Skikne, was born in Joniskis, Lithuania, of Jewish parents." Harvey also was recalled for his "arrogant manner" and a personality that "could freeze ice cubes." He had been one of the world's greatest playboys, someone "who most mothers feared their daughters might marry—or be ruined by—during an afternoon in the country."[87] Michael Powell leaves no doubt that he was pleased with himself for casting Carl Boehm in the role after "losing" Harvey.[88] But no interviewer thought to ask Leo Marks about Harvey being replaced by an actor with such different looks, temperament, and lineage.

Marks's complex historicizing of photography is articulated more explicitly in *Between Silk and Cyanide*. This intimates that *Peeping Tom*'s Mark Lewis is not simply an everyman. He represents a connection between Jews and photography, as one of *Peeping Tom*'s wellsprings is the history and mid-twentieth century practice of photography as perceived by Marks. One aspect of this is the overrepresentation of Jews in the making and peddling of pornography. "Model" Pam Green, a talented actress, astute businesswoman, and art director, appears twice in *Peeping Tom* during Mark Lewis's shoots for pornography magazine publicity, and Weegee himself visited the set. In the film she teases Mark, "Come on, sonny . . . make us famous," and further requests that his photos avoid revealing her "bruises," received at the hand of her jealous fiancé. When Lewis first appears at her door she exclaims: "Well look who's here—Cecil Beaton!" It is a joke within a joke. Mark was a nobody. Beaton was one of Britain's most famous society and royal photographers, but he was seen as a phony by some of his fellow photographers, and notorious as one of the few within the photographic world who expressed antisemitic views. She also is aware that taciturn Mark is not what he seems, telling him, "You're a puzzle and a half."

Green is well known for her collaboration with former "glamour photographer" George Harrison Marks (born George Harris Marks, 1926–1997, no apparent relation to Leo), later her husband, in founding the magazine *Kamera* (1957–1968). Toward the end of *Peeping Tom*, when Mark is filming the outside of the newsagent shop above which he plans to kill Milly (Green), he specifically shoots covers of *Kamera* featuring Green. A number of publications in this genre, in the guise of one-off magazines, had innocuous titles like *Art Advertiser*, *Studio News*, and *Qt No. 62*. Harrison Marks "was a byword for the softest kind of soft pornography, a smut peddler who became a self-perpetuating legend. He was twice bankrupt, twice arrested and four times married, a vaudevillian at heart who pioneered porn in Britain and lived all his life in the same house where he was born."[89] It is not surprising that there is little investigation of a

Weegee, *Pam Green and Weegee on the Set of the Film* Peeping Tom *(director, Michael Powell), 1960.* Pam Green (1929–2010) clowning with Weegee (Arthur Fellig, 1899–1968). Pam Green, who studied art at London's Central St. Martin's, was aware of her position on photography's cutting edge. Courtesy of Yahya El-Droubie.

particular Jewish role in British pornography, given Anglo-Jewry's discomfort with less becoming "contributions" to society.

Who was Leo Marks? A boiled-down synopsis, which barely does justice to his talents, begins with his family background: His father was the founder and proprietor of the bookshop, Marks & Co., at 84 Charing Cross Road, which was the subject of the book by Helene Hanff[90] and later the film starring Anne Bancroft (1987).[91] Marks's memoir, *Between Silk and Cyanide*, details his exploits as a cryptographer for the British armed forces during the Second World War in the complex espionage and counterespionage operation based in Baker Street.[92] The first chapter, entitled "A Hard Man to Place"—the first of many double, triple, and quadruple entendres—begins:

In January 1942 I was escorted to the war by my parents in case I couldn't find it or met with an accident on the way. In one hand I clutched my railway warrant— the first prize I had ever won; in the other I held a carefully-wrapped black-market chicken. My mother, who had begun to take God seriously the day I was called up, strode protectively beside me—praying that the train would never arrive, cursing the Führer when she saw that it had and blessing the porter who found me a seat. Mother would have taken my place if she could, and might have shortened the war if she had.[93]

Marks's reminiscence is quite similar to that of photographer Robert Capa (1913–1954) before his departure to cover the invasion of Normandy. The degree to which Capa articulates his Jewishness through his relationship with his mother has likewise been underappreciated by scholars.[94] For both Marks and Capa, beginning their stories with the image of their stereotypically overprotective *yidishe mames*, doting on their baby boys well into adulthood, was a way of marking themselves as Jews. For both, it was a literary equivalent of *brit milah* (a *briss*, or circumcision). Underscoring his hypersexualization, upon his interview for service in Special Branch with the "headmaster of the code-breaking school," a Major Masters, Marks was asked about his hobbies, to which he replied: "'Incunabula and intercourse, sir.'"[95]

The characterization of Mark Lewis as "Peeping Tom" was an inside joke, one of a series of jokes, about Jews as Jews, and Jews as photographers. There was an explicit reason why Marks wished to call attention to their questionable characters. In *Between Silk and Cyanide*, in an episode central to his distinctive contribution to fortifying secret codes, Marks describes his need to enlist the efforts of photography firms. His initial, callous treatment at the hands of several photographers, whose rejection of the assignment could have meant the difference between life and death for scores of Allied agents,[96] may have helped inspire his negative, wildly exaggerated tale of "Mark Lewis."

The very title of the book reflects this: either the code would be printed, photographically, on silk—or the agents would be compelled to swallow a cyanide capsule. The photographers, though, did not want to undertake the work because they thought it would cost too much to produce, and they also were afraid that it would not turn out right. Although Marks presented this as a matter of life and death for those in the field, many of the London (Jewish) photographers he met seemed unmoved. In an interview he explained that "I knew nothing whatsoever about photography, but every single code had to be printed onto silk, and they were all different. Although they knew how to mass-produce maps on silk, this was a [different] technique. *So I became obsessed with photography,* and even

more obsessed by how to persuade photographers to work around the clock so that every agent could have a code printed on silk that was unique to him, or her. That is why Peeping Tom became a photographer" (emphasis added).[97]

A far more generous glimpse of a Jewish photographer in British popular culture is offered by Simon Blumenfeld's 1937 novel, *Phineas Kahn: Portrait of an Immigrant*. Born in a small town in the Crimea, in Russia's Pale of Settlement, Phineas emigrated, like thousands of others, to Vienna, then the East End of London, and, with millions of others, eventually to New York. He sailed to the United States with the intention of getting a foothold and then sending for his wife, Shandel. When the *Titanic* sank (1912), Shandel feared that she and her family would not survive the trans-Atlantic crossing, so she implored Phineas to return to London. As Phineas was getting aboard ship, a friend, Rubin, offered to make him "a made man," that is, to supply him with a good livelihood.

He picked up a receptacle shaped like a violin case, and placed it on the table. He opened the case and extracted a small camera and tripod and a square tin tank. He leaned confidently across the table, and like a purveyor of precious stones poised the camera under Phineas's nose.

"You see this little machine," he whispered. "It's one of the greatest inventions of the age. It takes photographs and develops them in five minutes. You can go about the streets and pleasure resorts and they'll be fighting to have their pictures taken, and it is so simple that a child can work it." He put his hand in his pocket and drew out a pile of tin types and passed them over to Phineas. "Taken with this identical camera. Good eh? . . . Good! It's marvellous!" He continued enthusiastically, without waiting for a reply. "And it's yours for ten dollars."

Rubin's enthusiasm seeped through Phineas. It seemed legitimate enough. . . . He set out on his long journey . . . returning not empty-handed but with a heaven-sent contraption that would put him on his feet once more and prevent those eight long-suffering stomachs from ever going hungry again.[98]

The camera did indeed perform as demonstrated, even if it was not, in the end, the instrument of deliverance for Phineas. After he was returned to the bosom of his family,

[l]ike a conjurer extracting rabbits from a hat, he produced the camera, the touchstone of their salvation. He photographed the family in a group, then each member individually. He photographed old Copper-beard and Miriam, and his neighbours all gratis. The first pictures bore traces of amateur handing, the figures being swathed in a greyish mist, but in a day or two he discovered the trick of precise

exposure and development. Now he was all set for his new career, but simultaneously with the perfection of the process his plates gave out and the quick-developing solution dwindled into a few weak drops at the bottom of the tank. He went around to every photographer and chemist in the district trying to replenish his apparatus, but nobody could match up the exact size and composition of the plates, or had any idea of the ingredients of the solution. To import these necessities from America would be too expensive, so after a week of fruitless endeavour Phineas reluctantly discarded his photographic career and sold the camera for the best offer—three and sixpence.[99]

Although there is no reason to assume that a work of fiction reflects a social reality, this story of Phineas and the camera is highly plausible. There were at least one hundred and fifty distinct development processes in use from the 1840s through the early decades of the twentieth century. During this period photographs were printed "using a mind-boggling array of materials, some of them highly fragile: bitumen (mineral tar), albumen (egg whites), potato starch, collodion, salt, mercury, silver, gold, platinum and even uranium."[100] Many of these represented some variant of "instant" photography. There was, in fact, at least one camera available (it appeared in 1911) whose processing matched that described by Blumenfeld: the "minute picture machine" of the American Minute Photo Company, based in the West Side of Chicago, where the city's Jewish community was then concentrated. Ads proclaimed, "The pictures are developed, toned and finished in a single developing solution."[101] Similar products were packaged as get-rich-quick schemes; among them was the "Plateless Daydark," which advised its buyers: "Do it now and start making money."[102] The New York Ferrotype Co. appeal could not have been more stark: "It means your future."[103]

After the Second World War a Jewish refugee inventor in Britain, Salman Stemmer, invented a way of taking and presenting photographs, what he termed a *kucker*. Countless people would come to take a *kucker* for granted as the way a holiday moment is preserved—through a small plastic object in which one looks at the photo. *Kucker* comes from the Yiddish expression, *gib a kuk*—"take a look."[104]

While it is difficult to reconstruct the history of these firms, many seem to have been either owned or operated by Jews and especially pitched to a Jewish clientele. In 1926, "a Jewish inventor from Siberia named Anatol Josepho (shortened from Josephowitz) opened a photo-booth concession, the Photomaton," in Times Square, which became a huge sensation. Customers "spent 25 cents each to pose and then wait the eight minutes it took to process a strip of eight small photographs."[105]

PHOTOGRAPHER. *"No Smoking here, Sir!"*
DICK TINTO. *"Oh! A thousand pardons! I was not aware that——"*
PHOTOGRAPHER (interrupting, with dignified severity). *"Please to remember, Gentlemen, that this is not a Common Hartist's Studio!"*——[N.B. Dick and his friends, who *are* Common Artists, feel shut up by this little aristocratic distinction, which had not yet occurred to them.]

George Du Maurier (1834–1896), "The Photographer's Studio,"
Punch, Oct. 6, 1860. James Jarché remarked that such illustrations
reminded him of his own father. Special Collections,
University College London.

The most important point, however, of the incident in *Phineas Kahn* is the assumption that Jews were able to make their way in photography in Britain, like elsewhere, with little or no thought of antisemitism. This was crucial in Helmut Gernsheim's turn to photography when he came to Britain as a refugee. When confronted with the immediate objective of having to make a living, especially for those who wished to be connected to the arts, photography seemed to be a better bet than almost any other vocation.

It is not surprising that another instance of recessed memory regarding Jews and photography surfaces in the work of novelist David Lodge. Near the outset of his historically faithful novel of 2004, *Author, Author*, Lodge reconstructs the relationship between Henry James and *Punch* illustrator George Du Maurier. Reminiscing about their earliest encounter, Du Maurier describes his attempts to establish himself.

"I had my sights set on *Punch*, and a salaried position on the staff. I got my foot in the door, but for a long time no further. A few initials—decorative capital letters, you know—at fifteen shillings a go. One cartoon—not very well drawn, though I have a soft spot for it now. 'The Photographer's Studio.'"

"I remember it," said Henry.

"Do you?" Du Maurier was gratified but surprised.

"I told you I followed you from the beginning," said Henry. "If I remember rightly, there's a rather overdressed, Jewish-looking photographer in his studio, and three young artists coming in through the door, smoking cigarettes, and he is telling them very pompously that they musn't."

"What a memory you have, James!" exclaimed Du Maurier, and proceeded to quote the caption, with appropriate accents: "*'Please to remember, Gentlemen, that his is not a common Hartist's Studio." Dick Tinto, and his friends, feel shut up by his little aristocratic distinction, which had not yet occurred to them.'* There was a lot of rot being talked then, of how photography would kill off the illustrator's trade, so there was some personal feeling behind it."[106]

The individuals entering the studio in the image were meant to be none other than Du Maurier himself, with the artists James McNeil Whistler and Thomas Lamont.[107] In fact, Henry James was photographed by Henry Walter Barnett (1862–1934), who "was on the staff of the leading London court photographer of the day, W. and D. Downey."[108] Barnett, whose career played out in his native Australia, England, France, and the United States, is responsible for more than five hundred pictures in London's National Portrait Gallery, and the Downey's firm—which apparently employed a number of Jews—has thousands in the collection. Barnett's parents were London-born Jews who emigrated to Australia in the late 1840s.

The aim here is not to underscore the relatively genteel antisemitism in the discourse of James and Du Maurier, but to suggest three subtexts in the memorable cartoon of 1860. First, that it was common in London, and throughout Europe, from the mid-nineteenth century until the 1950s, to assume that a photographer in a photo studio would be a Jew. Second, that the Jew often was a relatively recent immigrant, from Eastern, Central, or Western Europe, as marked by a distinct foreign accent. And third, that the Jewish photographer could easily be lampooned for his artistic pretensions. Historiographically speaking, however, we have known relatively little until now about Du Maurier's photographer and his ilk. There has been some interest in the most prominent individuals and firms but sparse investigation of the general character of those who peopled the field.

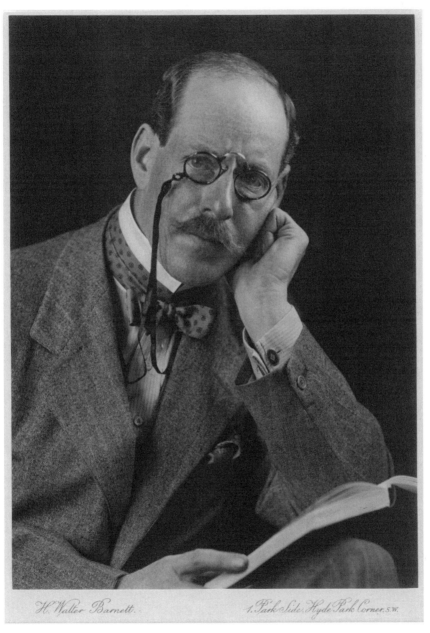

H. W. Barnett, *Self-Portrait,* ca. 1917. Harry Ransom Center,
University of Texas.

THE FIRST CHAPTER of this book explores connections between Jews and studio photography in Britain, with special reference to developments in Central and Eastern Europe as well as the United States. It argues that Jews established methods of innovative entrepreneurship in photography that came to be adopted generally. Numerous Jews—in addition to H. W. Barnett—worked for Downey's, and several ran their own firms. Barnett's career is illustrative of the interrelationships between photography and art, as Barnett used his wealth and reputation to become a player in the cultivation of public art collections in his native Australia. As is clear from the portfolios of Barnett and others, the proliferation of Jews among studio owners helped facilitate both the reality and the imagining of the transformation of Jews into Englishmen and Englishwomen. In contrast to the theme of a popular exhibition at the Jewish Museum, London, highlighting the work of "Boris" (Bennett)—who specialized in Jewish weddings[109]—the focus here is on Jews whose horizons extended beyond the Jewish community and the East End. An argument put forward concerning Jewish economic history, generally, is that Jews sometimes were "tutors" and "commercial guardians" of the "younger" nations before they matured. In commercial photography Jews may be said to comprise a "mature nation" as an ethnic community.[110]

Chapter 2 examines Jews as press photographers, as well as agents and editors. There are a number of connections between studio photography and those who became cameramen, such as James Jarché (1890–1965), the grandfather of actor David Suchet. Many of the preeminent press photographers had significant British connections, including Erich Salomon (1866–1944), Robert Capa, Zoltán Glass (1903–1982), and Alfred Eisenstaedt (1898–1995). Although Erich Salomon is remembered as a pioneer in Weimar Germany of what would later become known as photojournalism, he likewise was a signal figure in Fleet Street. There is a relationship as well between the Jewishness of the vocation and its relative receptivity to the inclusion of women. The work of Stefan Lorant and *Picture Post* has been noted but not explored in depth in the contexts of the history of photography and Jewish history in Britain. In particular, the revolutionary character of *Picture Post* has been minimized, and it has sometimes mistakenly been assumed to be an imitation of Henry Luce's *Life* magazine.

Chapter 3 details the uses and popularization of photography under the auspices of the Warburg Institute, which promised a complex and mutually beneficial relationship between photography and the study of antiquity and appreciation of the fine arts. Relocated from Hamburg to London in 1933, the Warburg was mainly dedicated to the study of classical civilization, through the Renaissance. Assuming the role of a good corporate citizen in Britain, it embraced photography as a chief means by which it could fulfill a popular, educative function.

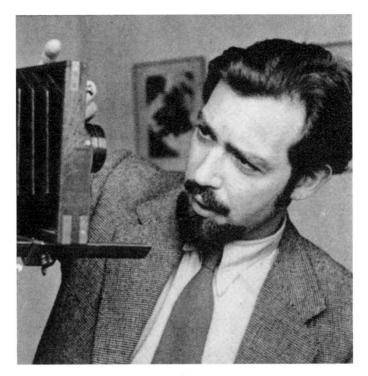

Felix Man, *Helmut Gernsheim with Camera,* 1946.
Harry Ransom Center, University of Texas.

It held four major photographic exhibitions from 1939 to 1943, and assisted in the National Buildings Record project. One of the chief photographers of the latter was Helmut Gernsheim, who was responsible for Westminster Abbey, St. Paul's Cathedral, a number of other Wren churches, and palaces.[111]

The Warburg Institute also supported the enterprise of Walter Gernsheim (older brother of Helmut), who endeavored to photograph illuminated manuscripts and prints; this body of work later came to be known as the Gernsheim Photographical Corpus of Drawings, which is a major subject of chapter 4. Although the Gernsheim Corpus is now appreciated as a seminal tool for art historical research, little scholarly notice has been taken of the fitful and complex origins of the enterprise.

The beginnings of his brother Helmut's career in Britain, before his immersion in collecting and the history of photography, will be explored in a social-historical context. Upon his escape from Germany Helmut was one of a handful in England to specialize in *color* commercial photography. After his voyage on

the *Dunera* and internment in Australia, where he conducted seminars on pho-
tography, Helmut Gernsheim became a strident critic of photographic practice
in Britain. In the midst and wake of the Second World War Helmut emerged as
a leading photo collector, and this complemented his vocation as one of its semi-
nal, outstanding historians.

Chapter 5 takes up the story of Helmut Gernsheim in 1951, when he curated
an unprecedented exhibition at the Victoria and Albert Museum for the Festival
of Britain. Gernsheim saw this as a first step toward establishing a British na-
tional museum of photography, with his own growing collection as its nucleus.
Having been turned down in England, Gernsheim explored some possibilities in
Germany and elsewhere; eventually his collection was sold to the University of
Texas in 1962. That deal would have been unimaginable without a critical Jewish
interlocutor, Lew Feldman, who is hardly ever recalled in the history of photog-
raphy. While Gernsheim was too far ahead of his time as a collector, he attained
success as an author and compiler of photography books, a specialization that he
and other Jewish émigrés helped to create.

Chapter 6 catches up with Helmut Gernsheim in the 1970s, when he began
sketching his thoughts about Jews and photography. He enjoyed close ties to the
Israeli academy, attending a memorable event at the Hebrew University. He seri-
ously entertained the possibility of teaching there. Around that time he was com-
mitted to situating his own and his family's history in the context of German
Jewry. He wrote a poem about the Holocaust in which he interweaves the destruc-
tion of the Jews and the German nation's undermining of its liberal and creative
tradition, which had given rise to revolutionary advances in photography.

It is important to recall that the émigrés who feature so prominently in this
book "emigrated as Jews, and the experience of emigration decisively shaped
them. Whether they wished it or not, Nazi racial policy imposed the category of
Jewish upon them." On the one hand, their "intellectual trajectories were shaped"
by the institutional "cultures of Great Britain" they encountered. On the other
hand "their Jewishness . . . served as a touchstone" for approaches to photogra-
phy "that have shaped trans-national European [and American] culture far be-
yond the boundaries of any particular local affiliation."[112]

The book's conclusion investigates a project that resulted in 1979 in an exhi-
bition and book, *The Great British*, by the American photographer Arnold New-
man. The choice of Newman was contentious, supposedly because he was an
American. This episode is worth a closer look, because at that moment the his-
tory of photography in Britain seems to have been substantially rewritten, side-
stepping the significance of figures such as Salomon, Lorant, and Helmut Gern-
sheim. This study ends by recalling the Queen's controversial photo session with

Annie Leibovitz in 2007, which brought back to life many of the long-buried murky associations of Jews and photography.

The serious, complex approach to photography that came to be associated with Britain has a great deal to do with secularized Jews who did not simply assimilate into the respective realms they inhabited. Some of them wished to disown or downplay their distinctive ethnic origins, support systems, and networks, but the extent to which British photography is a Jewish story is remarkable. This study builds on the notion that a cultural realm that only occasionally "addresses Jewish subject matter, created by artists and thinkers with a range of Jewish self-identifications, can also reveal much about Jewish difference."[113] Manifestations of Jewish difference, in tension and contact with the general culture and British officialdom, was tantamount to the trauma in the oyster that induces the making of a pearl. In this case the processes resulted in an ongoing explosion of creativity in nearly every dimension of photography.

Studios

Between Intimacy and Commercialism

I N BRITAIN Jews enjoyed relatively open access to livelihoods based in photography because of its novelty—it only appeared in the realm of vocations in the mid-nineteenth century. They also were given nearly free rein because of photography's marginal status, which was barely considered respectable. This is part of the reason that connections to the photography business were not especially valued or remembered even within families. The photographs themselves are treasured, but not necessarily the vocation of photography.

Along with speculation about why Jews chose photography—which appears to have been mainly because of economic incentives[1]—we may ask why Jews were readily accepted by non-Jews as their photographers. Comparisons are apparent with Jewish instrumentality in fields like the clothing/fashion industry, such as in Central Europe,[2] and the movies, especially in the United States context, which catered to individual choice and personal tastes.[3] The British public at large apparently assumed Jews could deal with, and even take leading parts in, devising how women and men wished to present themselves—as actual or aspiring members of the upper and middle classes, and as proper Englishwomen or Englishmen. Especially for those from the mass immigration around 1900—Jews, Italians, Slavs, Irish, and others—it may be significant that Jews were image-weavers in other respects, such as the creators and purveyors of film, beginning in 1897.[4] There is no evidence of outright objections to Jews as studio photographers, even though they were frequently snubbed as shady and snobby characters and became the objects of pointed humor. It also was taken for granted that Jews were comfortable with the necessary technical expertise.

By no means does the following purport to be a complete survey. The emphasis is on how Jews came to be regarded as central to the trade, and their roles in pioneering the field. Photography studios are a critical yet overlooked segment

of the economic and cultural life of Jews, and provided a setting in which non-Jews of diverse backgrounds encountered Jews (either wittingly or unwittingly) on a possibly intimate basis.

One of the early photographers whose work resides in Britain's National Portrait Gallery is one Albert Mendelssohn. Moses Mendelssohn (1729–1786), no apparent relation, had been the leading exponent of the Haskalah, or Jewish variety of the Enlightenment in Central Europe, so the name was common currency among Jews. Extant records reveal that Albert Mendelssohn was born in Hamburg in 1846, married Mathilda (born in Brussels in 1846), and had one son and two daughters. As of 1871 he made his living as an importer of photographs while residing at 44 Great Queen Street in central London. By 1881, he called himself a "manager in fine art publishers" living at 81 Palatine Road, Stoke Newington.[5] Most likely this meant that he was dealing in relatively expensive, good-quality photographic reproductions of works of art. The National Portrait Gallery holds an albumen (egg-white based) carte de visite with Mendelssohn's imprint, dating from the 1860s, of the Prussian Helmuth Karl Bernhard von Moltke (1800–1891), a field marshal and military theorist.[6]

A passing reference in a volume on nineteenth-century photography indicates that Mendelssohn had premises in Berlin and Hamburg, in addition to London.[7] We also are informed, in the brief entry concerning the better-known photographer Hayman Selig Mendelssohn, that Arthur may have been one of his relatives, although their precise connection is unknown.[8]

Hayman Selig (Seleg) Mendelssohn became a naturalized British subject. He identified his birthplace as (present-day) Suwalki, in the northwest corner of Poland, which was referred to then as "Russian Poland."[9] The town has also been called Augustow and Suvalsky. In addition, his own name, Mendelssohn, the first (Christian) name given to his son, is telling. He called his boy Montefiore, as a way to indicate allegiance to the leading Anglo-Jewish figure of the times, Sir Moses Montefiore (1784–1885). Hayman Mendelssohn did well professionally. One of the testimonials for his naturalization was provided by his children's piano instructor.[10] H. S. Mendelssohn's photographs are held in both the National Portrait Gallery and the Victoria and Albert Museum collections. His famous sitters included a prime minister, W. E. Gladstone, and a chief rabbi, Hermann Adler. Mendelssohn was employed by the Downey Studio in Newcastle before starting his own business.[11] A number of actresses were among his sitters while he worked at the firm, including Ellen Terry (1847–1928), the leading Shakespearean actress of her day, and Sarah Bernhardt.[12] Mendelssohn also produced colored prints of celebrities.[13] H. S. Mendelssohn, along with Barnett and others, was a founding member of the Professional Photographers' Association.[14] In the

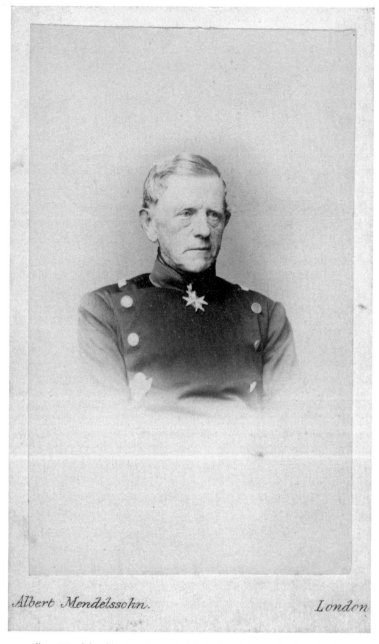

Albert Mendelssohn. *London*

Albert Mendelssohn, *Count von Moltke*. Helmuth James Graf von Moltke
(1800–1891) was a Prussian general, a German field marshal, and a revered
military strategist. Albumen carte de visite, 1860s. Image size 3½ × 2⅛ in.
(90 × 55 mm). © National Portrait Gallery, London.

mid-1880s the letterhead of his firm deemed him a "High Art Photographer to Her Majesty the Queen and Royal Family."[15]

Herman Eliaschor (Eliashov?) Mendelssohn, a business partner and possibly a relative of Hayman, was naturalized in 1886. He remained at Newcastle-upon-Tyne after Hayman relocated to London,[16] but eventually he, too, left Newcastle for Mayfair. Despite the high-born, Germanic-sounding moniker "Mendelssohn," Herman was born in Zelva, or Podzelva, in the Kovno province in the Russian Empire.[17] He was, in Jewish terms, a "Litvak." He, too, made a nice living: one of his references was from an employee of the National Provident Bank of England, Ltd., who affirmed that Herman had held an account there for five years.[18] For some time the Mendelssohns had multiple studios, a common situation of Jews in the profession. Studios owned by Jews also were known for regularly having photographers in public places, where they would compete with other photographers for prime spots and customers—sometimes using brute force in order to claim their territory or fees.[19]

As sparse as this information is, several critical contours indicating the activity of Jews and émigrés as photographers are visible. In order to be well established, it was important that one be deemed respectable. Those who wrote on behalf of the naturalization of Herman and Hayman Mendelssohn understood this and made it explicit. The flipside is that photographers, by definition, might have been assumed to be less than honorable.[20] The fact that Herman had two children, and Hayman, four, was a sign that they belonged to the middle classes. In addition, Albert Mendelssohn's photograph of von Moltke indicates that he was at or near the level of a court photographer. Tim Gidal, in one of the few serious works to date on Jews and photography, has shown that Jews had been prevalent among court photographers in Central Europe since photography's inception.[21] It is not surprising that photographers, like others in a royal entourage, might migrate from one court to another, or at least exploit the connections from such an appointment. The number of Jews who claimed to be royal or court photographers is striking. Most of these titles probably have some element of truth.

Another aspect of Albert Mendelssohn's career that was characteristic of many Jews in the trade, in addition to establishing more than one branch of his studio, was the use of his expertise to develop other lines of commerce besides photographs or cartes de visite per se. Mendelssohn's presentation of himself as an "importer of photographs" and as engaged in the "fine arts" is intriguing. A consistent feature of the involvement of Jews and photography is the connection to the fine arts of painting and sculpture, and applied arts such as architecture.

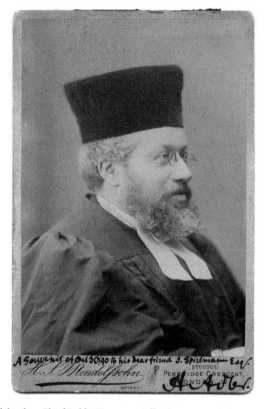

H. S. Mendelssohn, *Chief Rabbi Hermann Adler* (1839–1911). Born in Hanover,
Hermann Adler served as Chief Rabbi of the British Empire, 1891–1911. Religious
figures, of every faith and denomination, provided a large amount of business for
Jewish photographers throughout Europe. Albumen cabinet card, 1886–1889. Image
size 5¾ × 3⅞ in. (146 × 100 mm). © National Portrait Gallery, London.

In part because of Walter Benjamin's famous critique "The Work of Art in an
Age of Mechanical Reproduction,"[22] it often is forgotten that high-quality photo-
graphs of art, and even postcards, were not necessarily regarded as kitsch, but as
objects of value in themselves.[23] We also will see that it was common for Jews in
photography, and those engaged in reprographic techniques, to be the sons or
daughters of artists, and vice versa. Even in the history of postcards the line be-
tween art, photography, and various printing methods is not always clear.[24] The
fields of photographic reproduction, art, design, and printing were intricately
interwoven, such as in the enterprises of Max and Arthur Jaffe of Vienna and
New York, Max Levy Co. of Philadelphia, Levy Sons & Co. of Paris and London,

J. Salmon of London, and Raphael Tuck (1821–1900) of London.[25] Despite this, the connections of printing to photography are rarely recognized.[26] Two striking illustrations of the relationships between photography and the arts in Britain are the cases of the artist and designer Abram Games (1914–1996), whose father, originally from Latvia, was the London photographer Joseph Gamse, and Nahum Elea Luboschez, a portraitist and scientist, whose son, Serius N. Ferris Luboshez (1896–1984), became a foundational collector and expert in Chinese art.

One of the photographers active in the late nineteenth and early twentieth centuries about whom we have a great deal of information is Henry Walter Barnett.[27] He is illustrious enough to be included in Oxford's *Dictionary of National*

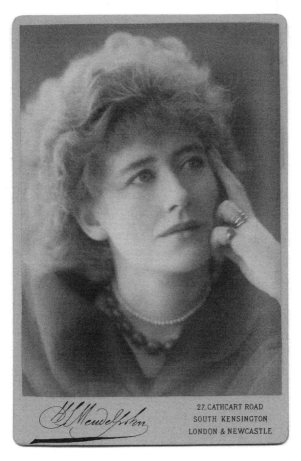

27, CATHCART ROAD
SOUTH KENSINGTON
LONDON & NEWCASTLE

H. S. Mendelssohn, *Ellen Terry*, 1883. Albumen cabinet card. Image size 5⅝ × 4 in. (142 × 102 mm). © National Portrait Gallery, London.

Biography. Barnett was born in Melbourne, Australia, on January 25, 1862. Both his parents were London Jews who emigrated to Australia in the late 1840s. Barnett's maternal grandmother was "a Strakosch of the nineteenth-century opera dynasty."[28] His mother's family traded in sugar and textiles, in addition to being active in show business, which was surely helpful to her son's photographic career. "Apart from the fluent French he learned from his mother, little is known of his schooling, but at thirteen he joined the leading photographic studio in Melbourne, Stewart & Co." Five years later Barnett went to Hobart, Tasmania, establishing his own studio before undertaking a grand tour in 1882. In his travels he found work with "photographers in San Francisco, Chicago, New York, and London, where he was on the staff of the leading court photographer of the day, W. and D. Downey."[29] Barnett was in Britain for only a portion of his career yet he is credited with five hundred fifty photographs in the National Portrait Gallery, and likely responsible for many others attributed to Downey's.

There is no doubt that Barnett was energetic, talented, and highly ambitious. Yet his career also seems to have been assisted, in significant respects, by the Jewish contacts he made and cultivated in Britain and the United States. His mother's family connections probably helped. By adopting the name Falk for the studio—whose relationship to the New York firm of Benjamin J. "Jake" Falk (1852–1925), the theatrical photographer,[30] is unclear—Barnett was adding luster to the venture he established in Australia in 1885, Sydney's "Falk Studios." The name itself might also have been more than an indicator that Barnett was a follower of Falk in a technical sense. Falk was well respected among his peers for taking "a very great interest in the welfare of the profession as a whole, and in particular," dedicating fervent effort to "the question of copyright in photographs"[31]—which remains a vexing issue. Barnett's studio "was to become the leader in its field, particularly specializing in portraits of stars of the stage." He "not only photographed celebrity visitors to Australia during the 1890s—the writers Robert Louis Stevenson (1893) and Mark Twain (1896), and the French actress Sarah Bernhardt (1891) among them—but also leading local people, including the poet Banjo Paterson (ca. 1895), and the premier of New South Wales, Sir Henry Parkes (1892), father of Australian federation."[32]

Promotional material for the firm claimed it was "the most extensive and popular photographic business in the Southern Hemisphere," apparently an accurate assessment. The setting was luxurious, "replete with comforts and furnished in such elegance and taste as have called forth encomiums from every visitor. In the Studios, the apparatus and appliances are of the highest type, and the latest inventions of photographic science are enlisted as soon as their merits are proved."[33]

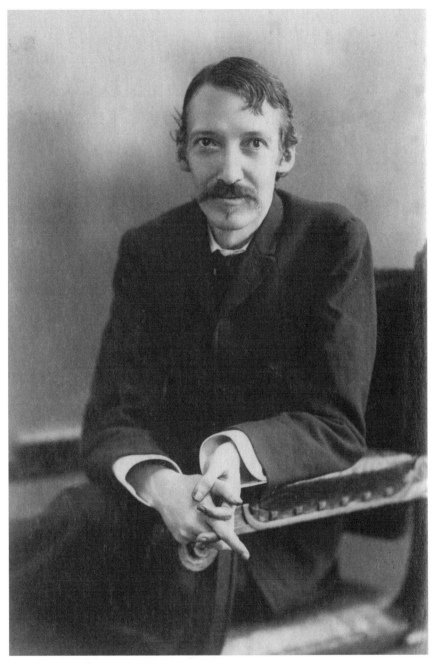

H. W. Barnett, *Robert Louis Stevenson,* 1893. In Australia and Britain Barnett encouraged the public to hang photographs in their homes of not only their own family, but personalities of the day. Postcard print. Image size 5 × 3¼ in. (126 × 81 mm). Harry Ransom Center, University of Texas.

Barnett prided himself on his up-to-the-minute expertise. He mainly employed a specific process, which may, indeed, have been originated at Falk's New York studio. "The Falk Paris Panel Portraits," apparently carbon sepia, "are the latest production of modern photography, and their delicate effects of light and shade must delight all lovers of the beautiful in art. As the Paris Panels are taken absolutely instantaneously, head-rests and all such uncomfortable appurtenances are entirely dispensed with, and the consequent freedom from stiffness and consciousness has earned them a high reputation."[34] The technique was cutting edge, while being even more comfortable for the sitter. But despite using the latest technology, and the ease of the process, it was not very expensive.[35] Like Falk, at this point in his career Barnett did not define himself, as so many did, as a society photographer.[36]

In addition to portraits, which comprised Barnett's main business, he had a substantial trade in "Falk Celebrity Portraits." This particular aspect of the firm seemed to fit well with conditions in Sydney—namely, the continuous immigration from abroad, and ongoing relocation of those already resident in Australia. Many of the new arrivals apparently started out in relatively unadorned accommodations, and Barnett was there to help. "What lends a more homelike appearance to bare walls than costly pictures or works of art? What can be more elevating than artistic surroundings?" Again, a nod was given to the common man: "It is not given to all of us to possess works from the brush of living or past masters of the palette, but you can line your walls with the famous art productions of the Falk Studios. These artistic works, equal in excellence to those of the best English and American studios, can be obtained, in a variety of styles, at prices within reach of all."[37]

One need not assume that these "celebrities" were only those from the other ends of the earth. The selection also included "the distinguished visitors and local celebrities of New South Wales." Even people who lived in the distant reaches of the continent could be served: the photos would be sent, "post free, to any part of the Australian Colonies."[38]

There was yet another side of the business: the reproduction and improvement of existing photographs. This, too, was adapted to local conditions. "Who does not know the old family album," Barnett asked, "with its pages filled with portraits in almost every stage of dingy yellowness?—a fact which has led to the reproach so often cast upon Photography, that its records are not permanent. By means of the Platinotype Process, which has received special attention at the Falk Studios, pictures absolutely permanent in character are now prepared, which rival in appearance a delicate steel engraving."[39]

It is little wonder that Barnett's business thrived. Although the publicity linked the platinotype process to Falk, there is a good chance that Barnett also had a relationship with Nahum Luboschez from Eastman Kodak, based in Harrow.[40] Around that time Luboschez had worked on, and been promoting, "Platino-Bromide Paper."[41] This would help to explain how, despite the overall appearance of luxuriousness of Barnett's business, it was geared to the broad masses and even catered to a customer base well beyond the growing city of Sydney.

The smooth operation of his studio guaranteed without its founder being ever-present, Barnett undertook an extended trip to Britain in 1896, an itinerary that included acceptance of "the medal for artistic portraiture by the Royal Photographic Society" in 1897.[42] He returned to Sydney later that year.[43] On the voyage back to Australia, while stopping over in Bombay, he met Marius Sestier, a Frenchman who "was a cameraman for the pioneering Paris-based film company, Lumière."[44] Not surprisingly, they engaged in shoptalk. Sestier had a problem with film he had recently shot in India, and so "Barnett suggested that Sestier come to Sydney with him to try his luck there, and this he did."[45] In addition to extending professional courtesy, Barnett perceived an opportunity that would lead his company in yet another direction. It was at almost the same moment that the first motion picture film, the Corbett–Fitzsimmons prizefight, was showing to packed houses in New York and elsewhere.[46] Barnett's meeting with Sestier led "to the first movie-film shot in Australia, including scenes at the Melbourne Cup horse race,[47] and, the following year, the first ever cricket footage— Prince Ranjitsinhji batting in the nets at the Sydney cricket ground."[48] Stieglitz, like Barnett, had long been smitten by horse racing,[49] and sought to capture its excitement on film, but he never moved decisively into cinema as his protégé Paul Strand did.

In Britain these films were "marketed by the Fuerst Brothers." Jules Fuerst (1864–1938), a "photographer, cameraman, and chemist," was "one of the earliest cinematographers in England to film news and topical events," including the Henry Royal Regatta in 1897, "using the Lumière machine after it was de-restricted."[50] An even more fascinating item in Fuerst's résumé is an 1899 translation of an article by Gabriel Lippman (also Lippmann) (from French to English), "Directions for Taking Photographs in Natural Colours."[51] Lippmann was awarded the Progress Medal of the Royal Photographic Society in 1897, and the Nobel Prize in Physics in 1908. The Fuerst Brothers business, until early 1895, also operated out of New York.[52]

Barnett himself was personally involved in producing at least one other film, a large-scale offering on the Battle of Hastings and the Norman invasion, which

he aspired to make "historically accurate to the smallest detail."[53] It is possible that he retained some kind of business interest in other film projects.

Yet another contact from his travels, a fellow Australian, the artist Arthur Streeton, prodded Barnett to expand his offerings in a further direction: with an art exhibition at Falk's Melbourne studio.[54] Indeed, Streeton would later be recognized as one of Australia's premier talents. This was a foretaste of the more formidable effort to influence the art scene in Australia undertaken when Barnett returned to Melbourne in 1933 with the aim of bringing Europe's prized artworks into the country's permanent collections.[55]

Barnett's relocation to London in March 1897 was treated as a significant social and cultural event. The press coverage not only lauded his photographic achievements, but described in great detail his studio space at Park Side, Hyde Park Corner, upon its grand opening, of which we have a photographic record as well.[56] *The Stage* reported that the premises would, "perhaps, prove more interesting to the ladies than the gentlemen who favour Mr. Barnett with a sitting" but were "calculated to please everyone." Barnett's carbon sepia photographs were "artistic," brimming with "force and power." "Most striking" were the head shots, mainly done "in small medallion form and simply framed in old oak. In them the features (untouched) [that is, un-retouched] stand out from the frame in a very lifelike manner, giving one an impression of the real flesh texture."[57] Visitors were impressed by the celebrity portraits, which included Sarah Bernhardt and Mark Twain. The "more artistic subjects" were said to demonstrate that Barnett had "studied art as an artist."[58] There is some irony in this last comment, because he would gain notoriety years later for severely criticizing the conventional forms of English photography, including the pictorial style that he had been praised for mastering.[59]

In 1899 Barnett was welcomed into the photo-secessionist group known as the Linked Ring,[60] within which he used the pseudonym "the Antipodean."[61] Two years later he was a founder of the Professional Photographers' Association, and by 1903 Barnett "had become the only professional to be elected to the council of the Royal Photographic Society."[62] The latter was an especially glittering prize, because all of the others in the RPS council were established scientists.[63] He continued in the vein of Falk: "Many leading musicians sat for him, including Dame Nellie Melba (1903), Paderewski (1904), Sir Thomas Beecham, and the violin virtuoso Jan Kubelík (1907). The Melba image is used on the Australian $100 note. The core of his London business was British high society, including royalty."[64] Barnett became the favored photographer of Auguste Rodin, who was reputed to have said "that Barnett was making better portraits than those of English painters."[65]

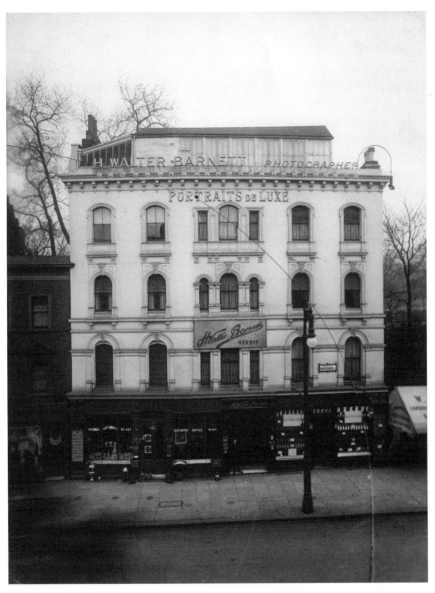

H. W. Barnett, *Barnett's Studio, London*. In this imposing building at 1 Hyde Park Corner, Barnett installed a glass roof on part of the penthouse to allow for photography by natural light. Vintage print, early 1900s. Image size 8¼ × 6⅛ in. (208 × 157 mm). Courtesy of the National Portrait Gallery, London

For years Barnett basked in rave reviews. His photographs were indeed evolving in a more sophisticated and realistic direction—a trend he helped to lead. While attaining critical acclaim, Barnett also was fortunate that his stylistic changes suited the growth of a new clientele: military men. This did not just include generals and other officers, for he developed another subspecialty: portraits of rugged British soldiers who were fighting the (second) Boer War of 1899–1902. These had a dark yet sharp quality, and were "mounted on a thick art paper, not cards." This market was said to have netted Barnett, who was already quite well-off, an infusion of "sudden wealth." It was reported that his studio was so popular that it could "hardly cope with his orders."[66] With this boost in Barnett's fortunes, he was able to assume a freer hand in his work. Although never as cutting edge as Alfred Stieglitz, he saw himself as a mover in the art world, while his criticism of his own professional cohort became increasingly strident.

The Sketch of 1903 claimed that Barnett had "revolutionized the art of photographic portraiture." With no comment about his reputation for manly images of England's fighting men, it stressed instead "his photographic studies of well-known society women," which "have about them a curious delicacy and charm . . . while retaining the likeness of the sitters to a remarkable degree."[67] This journalist was aware that photographs of actresses did not often faithfully depict the stars due to excessive retouching.[68]

The writer was struck as well by the announcement that Barnett had contracted, as a business partner, "Miss Ethel Arnold, a niece of Matthew Arnold and herself a writer of some distinction."[69] There is no record of how long Ethel Arnold's relationship with Barnett lasted. Their politics were certainly compatible: both were progressive but not radical, and they shared a special concern for women's rights and possibilities for autonomy.[70]

Barnett's acquisition of the upper echelons as his clientele was swift: "It rarely happens that a photographer, however good his work, catches the attention of the great London world so quickly as had done Mr. Barnett." The biggest catch, it seems, among his "beautiful sitters" was "the lovely Crown Princess of Roumania, undoubtedly one of the most charming and best-dressed of future Queens. Her Royal Highness, who is, of course, one of King Edward's many nieces, made quite a long stay in London during the Coronation Season. She has many friends in England, where she is still remembered affectionately under the old name of Princess Marie of Edinburgh."[71] The crown princess was known to be vivacious, engaging in torrid affairs before and during her marriage, and as generally being independent-minded. Barnett was quite friendly with her, and he photographed her on many occasions.

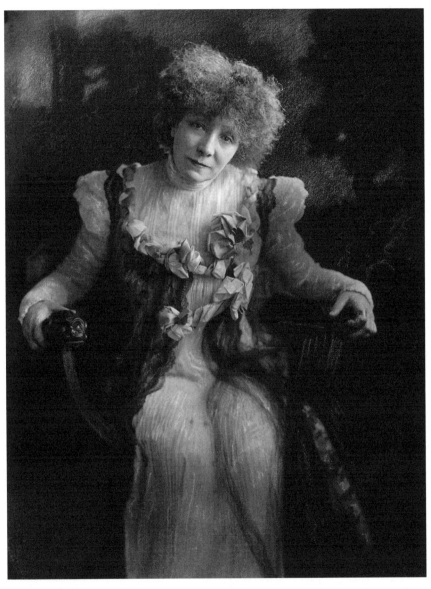

H. W. Barnett, *Sarah Bernhardt*. Bernhardt (1844–1923) was forthright about her Jewish background and arguably the most famous actress of her time. It is little wonder that Barnett, a friend, shot some extraordinary portraits of her. Modern bromide print from an original negative. 1910. Image size 17⅞ in. x 13⅝ in. (453 × 346 mm).

© National Portrait Gallery, London.

In 1905–1906 Barnett took another lengthy trip to the United States; this included a visit to Baltimore and a stay in the Midwest. His contacts were primarily men, and occasionally women, similar to himself: Jews who had become leading photographers, who were known for capturing the great and the good on film, and who were recognized personalities in arts and entertainment, all while satisfying a broad customer base. Possibly some of the invitations he received were initiated or bolstered by family connections, mainly on the Strakosch side—which is not the kind of thing that would be discussed openly or revealed in press reports. His hosts included Simon Stein in Milwaukee, Meredith Janvier (a painter, photographer, and bookseller) in Baltimore,[72] and the head of the Strauss firm in St. Louis, who had one of the most flourishing monikers of all: J. C., for Julius Cesar (1857–1924).[73] Simon Stein, born in Marienbad (d. 1922), like Barnett, "took an intense interest" in scientific advances in photographic processes, and was said to have been "instrumental in the work of perfecting the Lumière and English color plate processes . . . though he did not make color work a part of his business and never exhibited" color photographs. He was a formidable communal figure in Milwaukee, with "'an artistic soul and firm ideals,'" and his main organizational identification was as a Freemason.[74]

J. C. Strauss had a similar stature in St. Louis. "The nation's professionals were a tight-knit group that fed on social and professional interaction. These were truly the days of hospitality." The basement of Strauss's studio was known as "'the Growlery' . . . where not only photographers, but artisans, thinkers, poets, writers and patrons of the arts gathered, as if they all belonged to the same club. . . . Photographers in many instances were still aligned with artisans and thinkers . . . business was important but so was comrad[e]ship and social intercourse."[75]

While on tour Barnett showed and sold his own photographs, and also gave a number of interviews concerning photography as well as art. The fact that Barnett had photographed the royal family in various settings made a particularly strong impression. Barnett was tremendously appreciated, even a sensation, wherever he went.[76]

There were reverberations of his United States visit in Britain, however, and these reveal the increasing distance between Barnett and the English photographic establishment. Concerning the appearance of "Mr. Walter Barnett in America," the *British Journal of Photography* wrote that he was "at present the guest of J. C. Strauss of St. Louis" and exhibiting in his studio. The collection on display included "photographs of royal and titled English men and women, printed in mezzotint and on flexible mounts." Quoting another photography paper, the *Photographer*, the article emphasizes that Barnett distanced himself

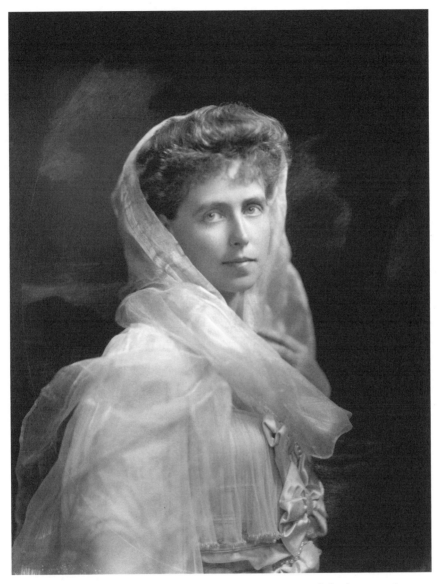

H. W. Barnett, *Crown Princess Marie of Romania,* 1902. Barnett helped to create the expectation that there be beautiful and even interesting photographs of the country's elite that revealed something of their personalities. Whole-plate glass negative, 1902.
© National Portrait Gallery, London.

from English "conventions": "He has produced something broad and daring, and yet he has faithfully portrayed the English type and character. He has given life and individuality to his sitters, which is not the accepted form of English photography."

Barnett asserted, "'Americans lead in the art. And it is because the people of America are eternally demanding something new. In England the people are conventional and cling to established rules.'" In contrast, "'Every Englishwoman wants a portrait representing her to have perfectly arched eyebrows, a Cupid's-bow-mouth, a straight nose, and a slender form, whether she possesses them or not. If a photographer is successful this is the sort of photograph he must turn out. That is why all the photographs of Englishwomen look alike.'" He continues, "In America women like to be made beautiful, yet they want independence and individuality, which gives to the photographer much liberty for bold, broad work." Barnett said that in London he had "'refused to give these namby-pamby doll-like portraits, yet I have been forced to retain to a greater or less degree conventional forms.'" Stateside, by contrast, he came to "'admire the daring and boldness of the high-class American photographers.'" In Britain it was said that "'Americans are lacking in the artistic sense, that they are purely commercial; but I cannot believe it. They must have the artistic sense, else they would not accept the characteristic work of their photographers. I look for the highest development of art in America.'"[77]

While the publicity was no doubt welcomed by Barnett, he was also being damned with faint praise. The article's conclusion insinuates that the intense interest in his show derives primarily from the fact that his subject matter comprised "a great many of leading members of the English aristocracy. 'Personages of Prominence and Title in London Society'—is their designation on the catalogue, and *the names alone are sufficient to bring a crowd of visitors* to Mr. Strauss's studio" (emphasis added).[78]

Although it may have been exaggerating slightly, there was some substance to a report about Barnett published in 1912.

An entirely new departure is being made by the distinguished photographer, Mr. H. Walter Barnett, of Hyde Park Corner, London, in as much as he has secured what is probably the most magnificent suite of rooms of London, consisting of the Louis XVI. Ballroom and Foyer, with private entrance, at the Hyde Park Hotel, Albert Gate, for the purpose of photographing ladies before and after Presentations at the Majesties' Courts. . . . Mr. Barnett, with these splendid surroundings, will be able to photograph under conditions which are equal in dignity to the

Throne room at Buckingham Palace, and instead of the "make believe" of the usual photographic studio, the magnificent real decorations of the room will form part of the pictures produced.

The system of lighting is American and is entirely novel in London, and by it results are produced which give a pictorial value which proves the rapid advance being made in the "Cinderella" of the arts.

Mr. Barnett particularly invites American ladies, among whom he has so many distinguished clients. There are no advance fees whatever, sets of proofs being submitted, no charge being made unless the portraits meet with full approval.[79]

By creating his own regal space that outdid the usual well-appointed studio, Barnett could photograph the elites in his own domain. His reputation was such that he could be discreet about his fees, like an expensive restaurant with no prices. There also is a hint that he was a ladies' man, and particularly alluring to his female clients. The admiration for "American" techniques, associated with a Jew who had imported them, would feature in English photographic discourse even into the late twentieth century, notably as a rationale for why Arnold Newman was the best choice to capture the "Great British" in 1979.

"In 1920 Barnett sold his London studio and moved to France, where gradually his interest moved from photography to art collecting." While in Dieppe he continued working in the "new, more direct style"[80] which had started with the soldiers, and was given a fillip from his experiences in the United States[81]—"of working men around the town."[82] Perhaps he had grown a bit tired of the well-born. His pictures of coachmen and other members of the working class are truly affectionate portraits. This series "tends to break most of the conventions found in his studio portraits. His locksmith, removed from the typical sentimentality of the studio, stands within a clearly definable room, bathed in the direct, curtained sunlight. . . . The final effect, however, is one of enhancement rather than distortion. For Barnett's use of light adds texture, form, and shape—the elements of substance itself—to this figural study, in a manner which is innovative, theatrical, and original."[83]

Although he was not as expressly modernist, and by no means saw himself as subversive, Barnett styled himself as akin to Alfred Stieglitz. While endeavoring to improve and promote photography, taking it to a higher level, he also wished to make a name for himself, and to permanently influence the art world, as an arbiter of taste. He especially wished to bring a better, finer, and more modern sensibility to his native Australia.[84] In 1927 he removed "his own art collection to Melbourne. From this exhibition the National Gallery of Victoria bought

H. W. Barnett, *Coachman* (ca. 1930). Harry Ransom Center,
University of Texas.

[Jacques-Émile] Blanche's *Ivory Peonies*, a gift from the artist in 1922."[85] Rather than being a tranquil stage of his career, however, Barnett's time in Australia turned out to be tempestuous. He had a falling out with the artist Tom Roberts, with whom he had had an apparently solid relationship for decades.[86] Barnett also clashed more generally with the arts establishment in Australia while its National Gallery was attempting to enhance its collection.

In 1933 Barnett left Australia to settle in France, and died in Nice early in 1934,[87] but he was not able to rest easy after his return to Europe. From France Barnett was prompted to write *A Protest against the Maladministration of the Beneficent Public Trust Known as the Felton Bequest*, which he published privately as a pamphlet in Paris. The author wished "it to be known that this Brochure [was to be] used for the enlightenment of Melbourne Citizens. It may however also be of interest to Members of the London FINE ART TRADE and Directors of British Public Picture Galleries."[88] At first glance this might seem to be a tirade against an arts establishment that was willing to courageously make some substantial investments in its future, though from a conservative perspective. But this was not the case. It seems that the lion's share of the Felton Bequest came from Alfred Felton (1831–1904), but Barnett himself may have supplemented funds for the purchase of art. Barnett stated that

the administration of the Felton Bequest ha[s] been brought to a serious crisis by the recent purchases in London of the self-portrait of Rembrandt known as the "The Welbeck Rembrandt" and acquired from the Duke of Portland for the sum of £26,000, and in the further purchase of a large canvass by R. B. Tiepolo entitled— The Banquet of Cleopatra—from a well known firm of London picture dealers for the sum of £31,000. Both of these transactions have aroused a just and far reaching feeling of indignation amongst independent and competent connoisseurs as to the value of these works for the Walls of the National Gallery of Victoria.

It is not alone the question of this vast expenditure upon two works of dubious merit that has given rise to discussion—verging close to scandal—during the past few months in London. Competent authorities have questioned the wisdom of acquiring, on the one hand, the very disreputable Rembrandt that has been exhibited—on loan—at the National Gallery London; and the additional error of purchasing a florid and none too well preserved composition by a Venetian baroque painter at a price which seems to have been determined by the glamour of the picture's former association with the Hermitage Gallery under the Czars, rather than by intrinsic merit.[89]

The next section of the brochure reprints a number of responses to the affair. It appears to reproduce all of the correspondence relevant to the controversy, whether sympathetic or not to Barnett's perspective. A letter from July 7, 1932, reads:

> Since one of the greatest possessions of the Hermitage, "The Banquet of Cleopatra," by J. B. Tiepolo, has now been purchased directly from the Soviet Government by the Melbourne Gallery and at the present moment is being publicly exhibited in London, no doubt can any longer be possibly held as to whether the Hermitage Collection is being broken up.
>
> The spoliation by the present rulers of Russia of one of the world's most wonderful collections, the result of the cumulative effort of generations, is taking place, and there is no knowing if and when the process will be arrested. We believe we are right in saying that this is something which is viewed with dismay by the vast majority of Russians, irrespective of political opinion: and we consider it our duty toward our country and towards history to put on record our most emphatic protest against that which is now taking place.

The complaint was aired by A. Goukassow, who identified himself as belonging to the Union Centrale Russe of Paris. Asserting that he was in no way acting on behalf of the Soviet Union, Barnett responded that the Tiepolo "was disposed by the Soviet authorities to make room for better works, and that, according to very high authority, the arrangement of the Hermitage Gallery is now vastly superior and more educational for the general public than during that long period of royal rule in Russia."[90]

Decades later, it appeared that Barnett's intuition and sleuthing skills had been vindicated. What was claimed to be a Rembrandt self-portrait was ascertained by most scholars to be a product of Rembrandt's workshop, or possibly done under his supervision—but likely not painted by the master himself. In the early twenty-first century, though, a revisionist version is reasserting the authenticity of the "Welbeck self-portrait." An Australian art historian makes her impassioned case on the basis of scientific but slender evidence. Included in her discussion, however, is a pointed dismissal of Barnett, whom she calls "an expatriate photographer." Barnett, it is claimed, "considered that a European collection of impressionists and post-impressionists would have been preferable to Rembrandt or Tiepelo. He criticized both acquisitions. . . . Barnett . . . was unintelligent about art history. His own expertise was limited to Japanese prints and bookplates."[91] It is true that Barnett was no art historian, but he was a fabulous

businessman. Had the museum purchased Impressionist and post-Impressionist works at that time—say, £50,000-worth—that would have been an infinitely better investment and boon to the future of their institution. The two pieces actually acquired were basically duds. The sneering put-down of Barnett is pure hindsight—after all, the chemical-analysis proof she cites could not have been part of Barnett's judgment. Even more absurd is her notion that he objected to a Rembrandt. The problem was that it was a fake. Even the gallery itself, as of 2011, is reticent to proclaim this work's authenticity. A particular irony is the fact that in the present-day National Gallery of Australia, the only "Rembrandt" is a photograph of the artist's etching, "The Admiral's Wife," which is from Stieglitz's journal, *Camera Work* (July 1903). It was purchased in 1976.[92]

Barnett's businesses were apparently sold off. He lived the end of his days in a grand manor house in France. The fact that his studio was not passed to another generation is one of the few elements of his story that make him atypical as a Jewish proprietor of such a concern. Taking the long run of Barnett's career as a template, we recognize several aspects that would distinguish Jewish photographers/entrepreneurs in Britain. The first of these is the sexualized dynamic of the profession—it consisted mainly of Jewish men taking pictures of non-Jewish women. But there was more of an allowance for women in the profession than in many others. As we saw, Barnett himself, at least briefly, had a female collaborator.

Second: it always helped to have connections to official circles. Barnett surely used his foothold from Downey's to ingratiate himself with aristocrats. But he charmed his way into the court of St. James itself, and became an intimate of many among the royals and their set. The intimacy of the photographer/sitter relationship, especially one that persisted over time, was a factor that contributed, as well, to the rise and effectiveness of Jews as press photographers, to be discussed below.

Third: Given the rapid advance of technologies, which usually meant that costs were able to be lowered for an increasingly improved product, it was sensible for a photography studio to be aggressive in expanding its offerings and clientele, as Barnett did. He served the elite but did business with a broad swath of social classes. He took pictures of the rich and famous, artists, writers, and entertainers, while also selling their pictures to those who were neither rich nor famous. He offered other types of photographic services too, such as reproductions and enlarging, to all levels of society.

Fourth: As typical of others in this group, conceived diachronically, he expressed sympathy for free expression in almost every respect, and favored a

broad, rather than narrow, concept of art and aesthetics. He followed convention to a great extent, but he also saw himself as progressive and, even more so, modern. He pushed the boundaries—while still making a good living. How could one be photographer and not be modern? It is not surprising that there are numerous connections between studio photography and motion pictures; this fact has been underappreciated by scholars and critics, but is apparent in the work of directors such as Ernst Lubitsch and Stanley Kubrick.[93]

Fifth: The image Barnett promoted of himself was that of a good local and national citizen, and subject of the monarchy and empire, but also that of an upholder of universal values. He was cosmopolitan, in the sense that he would learn, and take the best, from the quickly evolving photographic realm—even the way it was done in America. His connection to motion pictures, in this way, was typical.

Last, and perhaps most important: Barnett did not see any contradiction between being a businessman, an artist, and a promoter of a specific artistic vision. His studio was the font of his livelihood, and he deserved to make a good living. He was practicing a skilled craft, which some would call art but that also, unequivocally, had a constructive social and economic function. Like Stieglitz, he strove for photography to be respected as both dignified labor and art.

THE PHOTOGRAPHERS to be discussed next are chiefly examined with regard to how they replicated, departed from, and expanded on the practices established by Barnett. Mario von Bucovich self-published a profusely illustrated book about his own photographic practice in which he echoed Barnett's critique of excessive retouching.[94] His integration of photography in the fine arts also recalled Barnett, yet his theoretical, long-term historical perspective bears some resemblance to Walter Benjamin's thoughts about the relationships between traditional artworks and photography. Bucovich's sitters were mainly women and a number of "rich businessmen,"[95] and several of his pieces currently available are nudes. Perhaps most significantly, Bucovich turned his dyspeptic existence to his advantage by publishing photographic books about the places he had lived in and visited, including Ibiza, Paris, Berlin, Washington, and New York.[96] He was, then, at the forefront of what may be termed "photography publishing." This would emerge as a coherent segment in publishing only in the late 1930s, and then, mainly under the auspices of émigrés and Jews.

One of the most fascinating photographs of a "rich businessman" taken in a London studio was what would become the best-known portrait of George Eastman, the founder of Eastman Kodak Company, by Nahum Elea (N. E.) Lubos-

chez.[97] This was the model for the US postage stamp issued in Eastman's honor. Eastman was known for harboring a number of prejudices and conservative tendencies.[98] There was a suspicion that some kind of quota system existed, however informal, at the Kodak factory in Rochester (New York), which meant that there would never be more than a handful of Jews.[99] But Eastman made an exception for Jewish photographers and scientists whom he regarded as possessing special talents, even if he never exhibited much warmth toward them.[100] The most famous of these, Leopold Mannes and Leopold Godowsky Jr. (inventors of Kodachrome), were recruited by C. E. Kenneth Mees (1882–1960), who also was close to Luboschez, and might have been his first connection with Eastman. Mees was a photographic scientist working for Wratten and Wainwright plate manufacturers when the company was acquired by Eastman in 1912. Luboschez also photographed Mees.[101] Eastman no doubt appreciated the volume of business Luboschez generated as an inventor and roving representative for the company. One of the nameless portraits that Luboschez kept in his portfolio, and Helmut Gernsheim retained for his collection, is likely that of a traditional Jew.

After his death Luboschez was described as having hailed from a distinguished clan that counted artists and intellectuals in its circle. Choices of first names show the family as on the traditional side of Judaism while also steeped in photography. The death certificate for Elea Lubschez (or Luboschey), most likely Nahum's brother, of Kansas City, Missouri (1863–1924), identifies him as a photographer, and notes that his mother was "Fannie Berkowitz."[102] Fannie née Berkowitz Lubschez may have been related to the Jasvoin family, owners of photography studios.[103] Nahum Luboschez's father was a photographer, and his brother, Ben Jehudah (1881–1963), an architect and author on architecture, was also "an accomplished photographer"[104] and historian of motion picture film.[105] Nahum's son Ben (1898–1975) worked as a scientist for Eastman Kodak in Rochester.[106]

Born in the Russian Empire in 1869, Nahum E. Luboschez grew up in the United States, most likely in Kansas City. The family name apparently is a corruption of Leibschutz, Lipschitz, Lipsitz, and other variations. The obituary in the *British Journal of Photography* stated, "As a child he immigrated with his parents to America where he got work in photographic studios, becoming famous as a retoucher. He returned to Europe with the idea of studying art and for some years spent all his earning as a photographer on his studies in the art centres."[107] It is likely that Luboschez came to, or perhaps stayed in, Europe as a result of his family's association with anarchist politics in the United States. In 1917 Elea Luboshey (one of the many varieties of the name), identified as a photographer,

DR. C. E. KENNETH MEES

BY N. E. LUBOSCHEZ

From the Exhibition of the Royal Photographic Society

N. E. Luboschez, *Dr. C. E. Kenneth Mees.* From the Exhibition of the Royal Photographic Society, in *The Amateur Photographer and Photography,* Nov. 13, 1918. George Eastman himself was a great talent-spotter. One of his most consequential hires was Dr. C. E. K. Mees, who would lead his research laboratory in Rochester; Mees himself had a tremendous sense of those who could unleash photography's potential.
Private collection.

N. E. Luboschez, unidentified portrait. Gelatin silver print.
Harry Ransom Center, University of Texas.

was arrested for organizing a movement against the draft upon the entry of the United States into the Great War[108] and served time in Leavenworth, a US penitentiary.[109] This is not surprising, considering that the family was known to be intimate with Prince Kropotkin (1842–1921), who inspired a variety of anarchists, as well as "Tolstoy and other leaders of Russian thought."[110] One of the most reproduced portraits of Kropotkin is by Luboschez.[111] Luboschez also shot the lesser-known but significant Georgian anarchist (Prince) Varlam Cherkezov (Tcherkesoff, Cherekezishvili) (1846–1925). Cherkezov spent his later years in London. Another portrait by Luboschez which seems to have been taken around the same time as Kropotkin's is that of Luboschez's niece, Natasha, who was killed by the Bolsheviks.[112] She most likely was an anarchist. Both Kropotkin and Cherkezov were among the associates of firebrand anarchist Emma Goldman (1869–1940), who tried in 1892 to operate a combined photography and art studio in order to secure "a financial base," first in Springfield, and then Worcester, Massachusetts.[113] Overall, Luboschez's photography from Russia reveals his acute social conscience.

Subsequent to gaining "a Continental reputation as a portraitist," Luboschez joined Eastman Kodak Co. in Harrow

and for a great many years occupied a niche of his own in the Company's organization, combining the more or less official duties of an expert in photography with the activities of a roving commissioner. He was a familiar figure in the photographic circles of practically every European country, and delivered innumerable lectures before professionals and amateurs on lighting in portraiture as well as on the many processes concerned in the making of photographs. Although he was never a traveler in goods and could scarcely be imagined as transmitting orders in proper detail from a customer to the headquarters of the firm, he was nevertheless a master of salesmanship of the higher kind for he could go into a photographer's studio and, taking things as he found them, use his firm's materials in making portraits which were an education to those whom he visited. As a portrait photographer he was at once a great artist and an expert technician.[114]

The area where Luboschez may have had the greatest impact, however, was in a growing branch of photography that coincided with a medical field in which there also were a disproportionate number of Jews: radiography (also roentgenology and subsumed into radiology). Interestingly, Helmut Gernsheim would later recognize Luboschez, in this regard, as fostering another dimension of photography as art: in its role as a tool for medical diagnoses. Around 1918, Luboschez was deeply unsettled by "the wretchedly poor technical results obtained by

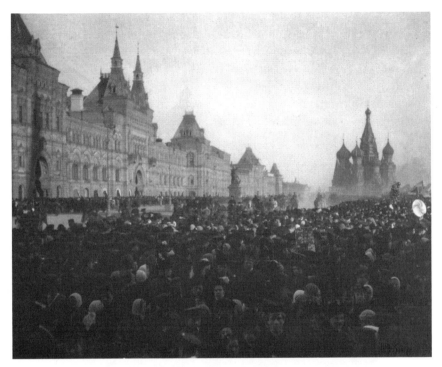

N. E. Luboschez, *Moscow Demonstration* (ca. 1910). Gelatin
silver print. Harry Ransom Center, University of Texas.

many X-ray operators," so "he set himself to develop improved methods which
would give to radiography the same degree of certainty and technical perfection
as ordinary photography. Thus he devised methods by which the exposure in
X-ray work could be definitively ascertained, originating the system of improv-
ing the results by the use of several sensitive films, as embodied commercially in
the Eastman double-coated X-ray film." He also "designed appliances for the
mechanical handling of the films and did a great deal of experimental work, in
some respects uncompleted, for making use of 'hard' X-rays in conjunction with
several intensifying screens for the purpose of greatly shortening exposures."[115]

These achievements in particular gained wide notice. In 1920 he was awarded
the Royal Photographic Society's medal "and a similar award was made at the
Northern exhibition a year later." Later he won the coveted "Progress" medal of
the Society.[116] Despite this substantial recognition, Luboschez is underappreci-
ated for the extent to which he not only improved a certain branch of photogra-
phy, but enhanced the possibilities of better health for countless people.

He was, by many accounts, one of the most popular figures in the world of professional photographers, and a favored speaker for almost any kind of photographic organization, of which there were many in Britain and throughout Europe. Although his "active mind" was legendary, he was revered as well for the "charm and generosity of his nature. He was a great soul, erratic and feverishly enthusiastic, but without a trace of the narrowness of self-regard which not infrequently goes with the artistic temperament. There are probably few great cities in Europe where his death has not been felt as the passing of a great encourager and helper."[117] There were many jokes and stories about him being lousy on the business side, but the most creative and helpful corporate representative imaginable. Luboschez was famous for going into studios, labs, and even hospitals, and showing practitioners how they could overcome problems and produce

N. E. Luboschez, *X-ray Skull* (ca. 1910). Harry Ransom Center,
University of Texas.

better results. He visited a staggering number of shops, studios, laboratories, and camera clubs, and addressed countless gatherings of all aspects of the trade dealing with photography.

The family's contribution to the arts and culture did not end with Nahum's generation. His son, Sergius N. Ferris Luboshez, trained as a lawyer and rose to rank of admiral in the US Navy. He was commissioned a captain, and served the Navy in a legal capacity as a general counsel to the office of Foreign Liquidation of the State Department. He became one of the world's more important collectors of Chinese art.[118] Among his many diverse achievements were advances in sonar technology, and he also continued the family's dedication to photography, "developing a number of inventions relating to radiation shielding and light control."[119] His brother Ben, although he did not possess his father's effervescent personality, was a brilliant research scientist at Kodak in Rochester; he accumulated numerous patents and was particularly dedicated to improving medical photography.

In contrast to the peripatetic existence of Luboschez, Bucovich, and Barnett, there were numerous photographers of Jewish origin in Britain who were decidedly more settled. Individuals and their firms put down deep roots, establishing themselves in some instances for more than a century. These long-term premises, though, tended to be strategically located, associated with well-established institutions and a steady stream of clients. The firm of Hills and Saunders, which apparently counted Jews among its founders or principal operators for most of its existence, was said to have begun in Oxford in 1851. A local history of Cornmarket, a main street in Oxford, relates that in 1851, Robert Hills "was a hairdresser and perfumer" who styled himself as "an 'artist in hair.'"[120] Hills set up a photography studio in 1856 and became partners with John Henry Saunders in 1860.[121]

In the short time the Prince of Wales (later Edward VII) was a student at Christ Church, Oxford, Hills's firm became his official photographer. Apparently the prince enjoyed having his picture taken, and found the firm accommodating, if not delightful.[122]

The prince left Oxford after a year in order to pursue his studies at Cambridge, but the prestige and formal association of Hills and Saunders as royal photographers stuck. By 1861 Hills and Saunders had moved decisively into the photography trade. Now calling himself a "photographic artist," Hills was said to employ "ten men, two women, and three boys. He also was living in the premises with his wife Annie, and children Robert, Henry, and Annie."[123] Around 1863 Hills and Saunders "opened an 'Oxford Photographic Gallery' at Eton" and "worked for the royal family at Windsor."[124]

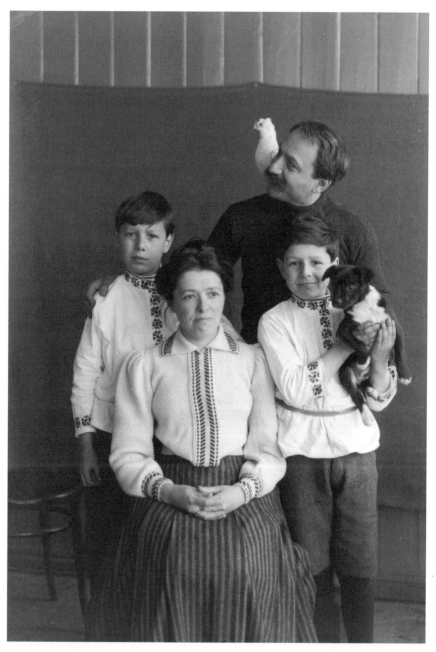

N. E. Luboschez, *Family Self-Portrait*. Digitally converted positive image made from the original negative in the George Eastman House Collection. Courtesy of George Eastman House, International Museum of Photography and Film.

If Oxford, why not Cambridge? Although British students have traditionally been forbidden from applying to both august institutions, there apparently is no law against the same business establishing itself in the major university towns. In 1869 a Hills and Saunders Cambridge studio was opened in the King's Parade. The business "grew to include studios in London, Aldershot, Rugby, Sandhurst, and York Town." Harrow also became an important base. "The range of studios show them aiming at a specific clientele—the public schoolboy (and his family) who went on to a university or a military career." "They were granted a Royal Warrant as photographers to the Queen in April 1867."[125]

It may be assumed that either Hills or Saunders, or both, were Jews. One of the novelties of their enterprise was that "chain stores" were usually thought to be more suited to the lower, as opposed to the higher end, of the market. They proved the contrary: that a "multiple" could work for the upper classes.[126] Other Jewish photographers, such as Louis and Adolph Langfier, maintained studios in Glasgow, Edinburgh, London, and Harrogate. Interestingly, Louis Saul Langfier also billed himself as "the official court photographer in London."[127] Hills and Saunders enjoyed unusual longevity, "remaining in Oxford at number sixteen Cornmarket until the 1920s."[128] They were able to buy out at least two other studios between 1868 and 1886. Their fortunes, however, were not always robust. A bankruptcy was declared for the Cambridge firm in 1892, but it apparently had been reestablished by 1895.[129] The business, for much of its existence, was not limited to photography. "From 1867 to roughly 1928, the company, in addition to advertising their services as photographers, were engaged in print-selling, publishing, picture-frame making, and the restoration of old paintings."[130] We will repeatedly see Jews creatively exploiting photography as an entré into the field of fine art.

The firm was taken over by Gillman and Soame, another Oxford photographer, in the midst of the Depression in 1931. In the late 1980s the proprietor of what had formerly been the "Hills and Saunders" located in Harrow was Richard Shymansky. Shymansky, in cooperation with "the noted Old Harrovian photographer, Patrick Lichfield, and the School's Assistant Archivist and Head of General Studies, Jim Golland," produced an *Illustrated History of Harrow School*. This accompanied an effort to archive its collection, which was not completed.

The Harrow premises of Hills and Saunders itself are no longer in operation.[131] But the company, either while under the auspices of Hills and Saunders or in its later incarnation, claimed to have invented another specialty that was particularly geared to the colleges of Oxbridge, public schools, and, later, military men: large group photos. A current advertisement, which might have been

unchanged for decades, states: "For group photography we have created a system whereby individuals' names are printed to correspond to their position within the group, regardless of the numbers involved. This unique feature enhances the value of the photograph for all concerned, not only as personal memorabilia but also invaluable for archival purposes."[132]

The firm also expresses pride in having added movies to its offerings. The company's "Cinematograph" service was "one of the earliest commercial 8m film services" and was particularly fortunate to have been "on hand to capture Roger Bannister's historic four minute mile on 6th May 1954." Gillman and Soame also claims to have introduced, in 1964, "the first commercial colour school portraiture service, followed closely by the introduction of colour processing for all school photography and university photography."[133] Around the same time, however, in 1963, Salman Stemmer, a German Jewish refugee who came to Manchester via France and Palestine, also began soliciting schools, and likewise enjoyed remarkable success.[134]

Stemmer did not have a photo studio per se—but a great deal of his work involved securing clients who otherwise would later be approached by studio-based firms. Similar to Barnett, he made technical modifications of his own which proved to be decisive. Most important, Stemmer invented a photo viewer unlike anything on the market.

He was born in Nuremberg in 1916, among the small community of Bobover Hasidim. After the Nazis rose to power he first escaped to France, and eventually made his way to Palestine during the Second World War. While working as a holiday photographer in Palestine he produced "a little viewer" which had "real glass lenses." He called this device a *kucker*, literally a "looker" or "peeper," from the Yiddish. While in Paris for a wedding, some relatives living in England suggested that he produce and market his invention in Britain. "Salman," he recalls them saying, "you bring that to England, you'll make a fortune." When arranging for his immigration, it was expressly with the aim to introduce his patented process and "open a factory."

One of his initial markets was schools, as this type of product would appeal to children and their parents. When the company was up and running, even though he did not know English, Stemmer "started taking pictures in schools." His canvassers, Jewish teenagers, solicited orders. At a school in Manchester on Marlborough Road, whose headmistress was a nun, Stemmer feared he would be shunned as a foreigner, so he pretended to be deaf and dumb and received the commission. "Years later I returned to that same school to try something else—a key ring or something. And the nun said, 'What a miracle! He can hear! He can speak!'"[135]

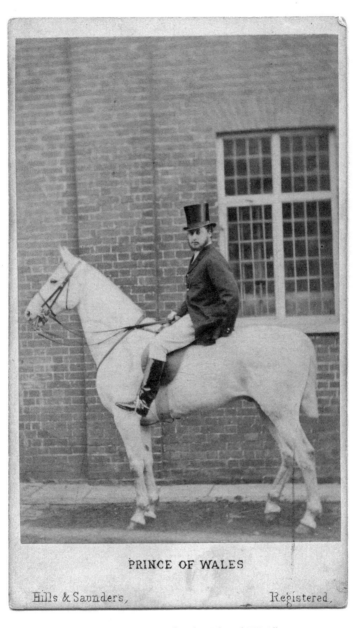

PRINCE OF WALES

Hills & Saunders, Registered.

Hills and Saunders, *Prince of Wales, Edward VII*. Albumen
carte de visite, 1866. Image size 3½ × 2¼ in. (89 × 58 mm).
© National Portrait Gallery, London.

"In Israel," Stemmer's "main income was from three holiday places, where the turnover was roughly five-hundred to six-hundred persons, weekly." He soon realized that he could apply his business in Britain to the school holiday schedule. Someone suggested that he look into the popular campgrounds, such as Butlins and Pontins. These proved to be more of a challenge than the schools.[136] After some investigation, he learned that any business with Butlin's would have to be conducted through its head office in London. He recalls that the response was an unqualified rejection. Stemmer suspected that the managers were mainly ex-servicemen. He also believed that there might have been some element of antisemitism at play. But Stemmer was undaunted. He saw the holiday camps as too fecund a possible market. He persisted in having younger people "working for me as canvassers. We walked from caravan to caravan. I took pictures in the caravans during the holiday. Fantastic! People like it! It's new!"

Adjacent to a carousel at one camp he went into the photography shop and "spoke to the woman in charge," a Mrs. Chapman. Predictably, she said that she was beholden to company instructions, which came from London. Stemmer, however, made her an attractive offer: he would take photographs for free, in order to demonstrate "how good" his product was, and how appealing it would be to their customers. Stemmer calculated that there were some five thousand people, rotating on a weekly basis. It was worth the gamble. Mrs. Chapman agreed.[137]

Stemmer returned with his equipment and some girls as helpers. He had "special machines," which he had designed himself to splice the film. A few tourists feared that Stemmer was trading in "dirty pictures." The fact that photos were to be viewed through such a device led some to suspect the worst. "'Oh, no,'" Stemmer's salesgirls responded, "'it's nice!' 'Do you want one of them?'" Stemmer took the photos and each person got a ticket. They were asked to return the next day when the photos in the *kuckers* would be ready. He had taken over three-hundred fifty pictures. Around five o'clock in the evening he returned to the shop and "asked Mrs. Chapman, 'Where can I process the pictures?' 'What do you mean? We are closing soon.' 'What do you mean you're closing? I promised the pictures for tomorrow, and I wanted to show you how easy it is to make them.'" She persuaded two of her staff to remain longer to observe the processing and cutting of the film, and the work lasted until eleven that night. The photos were all set in the viewers and made ready for the customers to collect, according to the numbered tickets.[138]

Apparently the collection of the *kuckers* went off without a hitch, and a sensation was ignited. "All around the camp people were queuing! Fighting to be photographed! Mrs. Chapman couldn't understand it. She went on the phone to

London. A miracle!" Her superiors from London came to see for themselves. Stemmer had the satisfaction of personally telling the man who had earlier rebuffed him, but found the scene "fantastic," of his earlier rejection. "So I reminded him. 'You didn't want it.' To make it short he ordered a few hundred thousand. Over the years I sold him a few millions of the viewers." The product emerged as a major source of revenue for Butlin's photo shop. But later, according to Stemmer, they sought to undercut him by manufacturing their own devices. Again, he feared that prejudice might have entered into their business decision. They were not, however, able to competently reproduce the lenses, which were critical—so in the end the firm relied on Stemmer to produce the lenses. "I made more money on lenses than I made on the viewers."[139]

Wherever the British went on holiday, Stemmer followed, especially to seaside venues like Blackpool and Rhyl. The photographic-viewing technology led him to produce a new type of key-ring with one or two pictures inside.[140] His enterprise even extended to the United States. For the hotels in New York's Catskill Mountains, which catered to a largely Jewish clientele from the 1950s to 1970s, he supplied the local photographers "with the *kucker* with the names of the hotels" imprinted on them.[141] Stemmer's invention became a mainstay of the experience of visitors to Catskill hotels in the years before these resorts experienced a precipitous decline in the 1980s. His company, Photo Plastics, also manufactured frames and photo albums in Manchester. Photo Plastics eventually was transformed into a dental supply firm by one of Stemmer's sons, who called it Mydent.[142]

Compared to, say, men such as the Mendelssohns, Barnett, Bucovich, and Luboschez, the Jewish self-consciousness and assertiveness of Stemmer was a world apart. But Stemmer had no sense that Jews had been active in the field earlier. He might not have recognized a Jewish pedigree in many of the establishment firms, such as Gillman and Soame. Yet even among those whose connection to Jewishness was tenuous there was some awareness that relations between Jews were helpful in the photography world. The extensive interviews given by photographers Ernst Flesch, Inge Ader, and Dorothy Bohm to the Association for Jewish Refugees (AJR) provide a thick description of the working environment of Jewish photographers. Unfortunately we have no equivalent for earlier generations.

Ernst Flesch, who was born in Vienna, came to Britain on the Kindertransport, an initiative conceived in the wake of what came to be known as the Night of the Shattered Glass, or Reichskristallnacht, November 9–10, 1938. The Kindertransport removed some ten thousand children and teenagers from Germany and Austria. Ernst's father would be murdered in Auschwitz in 1943. After

Kucker from the Pines Hotel, South Fallsburg,
New York. Private collection.

Photo inside the Pines Hotel *kucker*. William, Gloria, and daughter Edie: The Berkowitz's at
the Pines, early 1980s. Nobody knew the origins of the *kucker*. It remains a beloved
heirloom for thousands (of mainly non-Jews) from English holiday camps and
(mainly American Jews) from the Catskill hotels. All of the hotels of
"the borsht belt" are now defunct. Private collection.

arriving in London, Ernst spent a short time in Swiss Cottage.[143] Swiss Cottage, between St. John's Wood and West Hampstead, was a focal point for both the refugee community of the 1930s to 1950s, and for Jews engaged in photography generally—along with London's East End. Rather than being placed with a family, Flesch was sent to the Gertrude Jacobson Orphanage in Glasgow, which was mainly for poor children.[144]

At the age of fifteen, in 1943, Ernst left school and wished to commence a career in photography. Through the (Anglo-Jewish) Board of Deputies he was directed to "Boris," "a well-known Jewish photographer who had about six shops in the West End." Flesch thought that Boris "had made a huge fortune from all the American Air Force men," as "they all wanted pictures."[145] Boris is now mainly recalled as the leading wedding photographer among London's Jews, who pioneered a "Hollywood style" of elaborate wedding pictures.[146]

He "was born Boris Sochaczewska in 1900 in Poland," and said that he worked "in a photographic studio in Paris" before emigrating to London in 1922.[147] Boris had been an assistant in the Perkoff studio on the East End's Commercial Road, whose proprietors were leading figures in the Yiddish theater scene and Jewish politics.[148] Boris's first studio was at 150 Whitechapel Road, and in 1933 he moved to what would be his longtime flagship shop, at number 14. He was active in numerous Jewish causes throughout his life. After his career in photography ended in 1945, Boris became "a successful financier."[149]

Flesch recalls that he was hired by another family member of Boris's, Bernhard Bennett, who was then working mainly from an Oxford Street studio. He visited Boris's other premises, where he "picked up how to take photographs and how to retouch and that sort of thing." Flesch suspects that his success in these areas was partly due to talent he had demonstrated in drawing. He was not "taught" in any formal sense, such as an apprenticeship.[150]

He worked for "Boris" for four years, until most of the West End shops were closed down and "then Bennett went into cameras."[151] Here Boris was repeating a trend with which he might have been familiar in eastern Europe. In Lithuania a chain of photo equipment stores was founded by the Jasvoin family, who had originally made their name with studio portraiture.

Flesch recalled that Freddy Weitzman, one of Boris's younger operators in Marble Arch, established his own studio. "And there is a vague connection, very odd. Life is odd. His uncle in Vienna took some of my baby photographs. He had a studio in our district," the tenth. No doubt owing to the decimation of Vienna's Jews in the Holocaust, photographs from Weitzman's studio are now plentiful in the city's flea markets seventy-five years after the Anschluss. At their height the Weitzman family ran sixteen studios throughout the city.[152]

"Boris" photo album cover. Inscribed: "To Jean and John,
Sincerely yours, Norah & Sidney, Oct. 31. 1948."
Private collection.

Flesch was aware there were at least three generations of photographers in Weitzman's family, which now continued in Britain. Freddy "opened up on his own in Swiss Cottage," and Flesch "worked for him" from 1947 to 1956. His career was mainly as a photographer and retoucher.[153] Freddy, though, eventually chose to strike out beyond the confines of Jewish London. He reoriented his business to "posh English weddings" and, joined by Flesch, "became Mayfair Press with an address in Baker Street . . . and a postal address in Curzon Street." Flesch recalled him fondly, and remarked on his business acumen. He was "shrewd," and "went into property later."[154]

Inge Ader (née Nord), whose family was from Lübeck in the north of Germany, was born in Schwerin in 1918. As a young teenager in Hamburg she came upon a studio run by a woman and became entranced by photography. Beginning at age sixteen she sought apprenticeships to established studios—which was difficult to do in 1935, two years into Nazi rule. By that time large numbers of Jews already had fled the country, and others had had their businesses hurt or destroyed by the boycott of "non-Aryans." Most working photographers, then, were non-Jewish Germans. She discovered, by accident, a tiny studio that was run by a woman who was indifferent to the official antisemitic policy. To her pleasant surprise, Ader was taken on for an apprenticeship. In 1937 she managed to obtain an official qualification as a photographer. Upon completion of her initial training, in October 1937, she again found a sympathetic woman photographer who had advertised a position in the Labor Exchange. Although Ader was wary that her Jewishness would prevent her from being offered the position, again she was met with courtesy and accommodation. She was told it "didn't matter." After all, Ader would be employed mainly in the darkroom, developing and retouching.[155]

For some months in 1938 she worked with the established Hamburg photographer Erich Kastan (1898–1954), whose work by that time was confined to the sequestered Jewish community. Ader greatly respected Kastan. Although he was not officially a member of Hamburg's Jewish community before the Nazi seizure of power, many of his assignments came from Jewish institutions. There was, ironically, a lot of work for Kastan in 1938. The Nazis made a point of publicizing the cultural and religious activities taking place under the auspices of the government-controlled official Jewish body (Jüdische Kulturbund), so the photographing of theatrical productions and concerts was expressly encouraged, if not ordered. This was part of a Nazi smokescreen, to offer "proof" that Jews were able to exercise a reasonable degree of political and cultural autonomy.[156] Kastan was not able to get out of Germany until late December of 1938.[157] After moving to New York, he never regained the eminence he had held in pre-Nazi Hamburg, and much of his work came from the Federation of Jewish Philanthropies. He was unable to fully reconstruct his career as a specialist in advertising photography.[158] But Ader's work with Kastan, it seems, enabled her to get an important break with Karl Schenker (1880–1952). Schenker had been a "first class fashion photographer" in Berlin. But he too was compelled to relocate to London.[159]

Ader was able to leave Germany in the wake of Reichskristallnacht because her husband, Max, who dealt in sausage casings, with material imported from China, convinced the authorities that he could reestablish his business in Lon-

don.[160] Inge was authorized to come to Britain only as a domestic.[161] Due to the assistance of a few unusually sympathetic, and possibly anti-Nazi, workers who handled her shipment, it was possible for Ader to bring an excellent camera into Britain along with other equipment.

Her first position in Britain was in the studio of Schenker. Schenker's studio had been one of Bucovich's main workplaces in Berlin. There is a fair chance that Schenker and Bucovich helped each other, at different times. Ader recalls Schenker as "a very good fashion photographer, but he did other things well." His studio was "magnificent," located in Lower Regent Street and later Dover Street, in trendy Mayfair. At that time she was "the only assistant," and an older woman was serving as an apprentice. "I did everything," she remembers, with appreciation. "I learned an awful lot." Schenker "had very good connections," and this helped Ader to open her own studio in Swiss Cottage, in the spring of 1942, with Annely Bunyard. Bunyard was another émigré from Germany who was a "trained photographer" and "a very good artist." Both women took portraits. Bunyard had a number of clients from the world of theater and the arts. Ader, possibly in part due to her husband, had more connections among manufacturers, and received commissions for advertising. She had a contact who was an editor at *Vogue*, which led to other magazine offers.[162]

While their business was thriving the women attempted to offer paid work to other refugees. "I tried to employ refugees," Ader said, "but mostly they were not telling the truth when they came." They may have been less than forthcoming about their legal status or professional experience. Nevertheless, "I always liked to help them. Refugees helped me and I liked to help them. But it very often didn't work out." Relating a story that speaks volumes about the different approaches to Jewish identity in Britain, Ader reminisced that from the outset they hired "an English retoucher. After a few months I said something like 'well, you can't judge, you're not Jewish.' Then she said she is Jewish, and she was, and we didn't know. Not a refugee, English Jewish. And I never thought she was. She knew that we were, but she never said anything." Among their clients were the actors at the Laterndl [Little lantern], the refugee cabaret, and the Embassy Theatre, which also catered to new immigrants.

Ader noticed the social distance between her own small firm and those in central London: "The society photographers in Bond Street, though they were well liked by the English people, they were not our style."[163] Like Barnett and Bucovich, Ader scoffed at the "society photographers" for producing mediocre, predicable photographs. She also intimates that they were social climbers, obsequious to their clients to such an extent that the quality of their work was dubi-

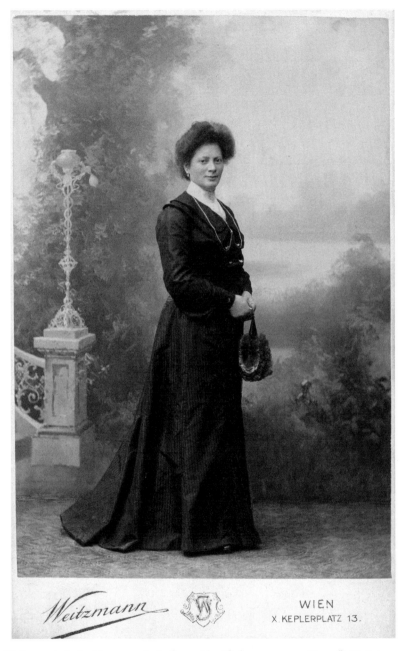

Weitzmann's studio, Vienna, portrait of an unidentified woman, 1905. Verso: "J. Weitzmann, Photographisches Atelier, X. Keplerplatz 13, früher X. Himbergerstrasse 51., rückwärts im Garten. Sie Platten bleiben für Nachbestellung aubewahrt." Along with addresses, the consumer is informed that "the plates remain so photos can be reordered." Purchased for €2 from a market stall vendor in Vienna, August 2014. Private collection.

ous. It is not known if Ader had any sense of how many of these also happened to have Jewish origins. "We took what we loved," she clarified. "Modern photography at the time, which Erich Kastan did . . . and which Karl Schenker did, but not the Bond Street style which was hazy, sepia, brown, unsharp, . . . not really what I would call good photographs, never did. But other people did."[164] Ader's depiction of "the Bond Street style" is ungenerous, if not distorted. Jewish photographers at the high end would persist and distinguish themselves for the quality and innovativeness of their work; two examples are Elsbeth Juda, chief photographer for the leading textile industry journal, *The Ambassador*, and Paul Kaye, who famously traveled to take official portraits of heads of state, including some rather distasteful dictators.

When their rent was raised substantially in 1948 or 1949, Ader and Bunyard were unable to secure another shop. Ader continued, however, to work out of her home. As for other émigré photographers, such as Alfred Carlebach, photography for newspaper and magazine advertising comprised much of her business. This coincided with the growth of the pictorial press in Britain from the late 1930s onward, which in turn was connected to the influx of Central European refugees. Interestingly, her retoucher established her own studio with another friend "between Maida Vale and Bayswater," and Ader supplied her with a great deal of work. Ader herself continued with retouching and other photographic activity until her eyesight declined.[165]

A younger contemporary of Ader and Flesch, who has had many similar experiences, is Dorothy Bohm. In the second decade of the twenty-first century, Bohm is one of Britain's most celebrated photographers.[166] Born in Königsberg, East Prussia, on June 22, 1924, she lived with her family in Klaipeda, on the western coast of Lithuania, known to Germans as Memel, where her father owned a large textiles factory. Her initial career ambition was medicine, but photography turned out to be a practical and fortuitous option. "I was very lucky," Bohm said, because Sami Silbermann, "a first cousin of my father's doctor, who had brought me into the world," emigrated to England from Königsberg "to escape the Nazis." Sami's wife, Eva, was a non-Jewish woman, whom Bohm recalls as "a wonderful lady." She had a background in art history and had been "a Bauhaus photographer." Eva actually encouraged her husband to set out for England ahead of her, with the intention of eventually following him. The Nazis demanded she denounce Sami. She refused and was murdered. Once in England, Sami "worked with refugees," perhaps as a physician, and he offered to help Bohm find her way. She was "sixteen, without family, and without money." She was "very vulnerable," and Sami assisted her immeasurably by suggesting that

she investigate photography as a career.[167] This was very similar to the advice given to Helmut Gernsheim by his brother, Walter. Photography was suggested to both as a field in which there seemed to be fewer obstacles for Jews than in other realms.

Bohm, however, already had some familiarity with the camera. Her father had bought "a Leica in its early days," but she did not enjoy being photographed herself. Bohm was not aware of what photography as a profession actually entailed. Sami "had a good friend," Germaine Kanova, "who was half Czech and half French." She operated "a wonderful studio in Baker Street." Silbermann took Bohm to visit, and she was tremendously impressed. Kanova photographed a number of different subjects, including portraits and still lifes. She made Bohm a fantastic offer—to be her assistant. Bohm was attracted to Kanova's sparkling personality and to the kind of "work she was doing. . . . I thought to myself yes, why not. But then the Blitz started," and it was impossible to remain in London. "So she moved. I was again at a loose end."

Bohm decided to enroll in "Manchester University College of Technology, which had a vocational course for photography." The officials "made a very special effort to take me in. I was only sixteen. I was supposed to be too young, but again you see how lucky I was with being granted some privileges, and I started a photography course there. This was during the war."[168] In the Manchester program she learned the technical aspects of the field, but Bohm said: "It taught me nothing about the art of photography, and I'd always been very interested in painting, reading, that sort of thing. And I did alright..I was very poor. I couldn't afford anything but I also took a job after college to earn some pocket money . . . with Kodak, and was wearing gum boots, and working with them, the chaps."[169]

She was offered a job in "the poshest part of Manchester," but it was not initially as a photographer. Bohm would be "selling cameras and optics." One of the interesting things Bohm remembers about this experience was that her employer advised her not to use her surname: Israelit. "Now this Jewish chap" professed that he was sorry, "'but I cannot call you Israelit, Miss Israelit.' Now this was a Jew in Manchester." Bohm reluctantly agreed, and suggested that they use "the other family name," Alexander.[170]

A poignant irony struck Bohm. She was among Jews, and had attained the position partly through Jewish connections. But the owner did not want her to appear to be "too Jewish." Bohm was unaware, though, that there had been a long tradition of Jewish photographers changing their names and public personas to seem less Jewish. Later "another Jewish chap" in Manchester, Samuel Cooper, offered her a job. He treated her well but "underpaid" Bohm, as was the

norm with female employees. She accumulated, however, a great deal of expertise and experience with a wide range of sitters. "During the war everybody wanted portraits to send to their sons, or daughters, in the army and so on." She learned a great deal, and overall, found the time to be "wonderful." Her employer entrusted her with a great deal of responsibility and "in the end I was running the studio."[171]

Her employment with Cooper led to another fruitful career path. While Bohm was operating his studio, Cooper was asked by the Manchester College of Technology to teach a course for returning veterans who had previously worked in photography, to reintroduce them to the field. Cooper declined the invitation, but suggested Bohm as an instructor. Even though she was not able to continue for a long period, it was an important vote of confidence in her knowledge and abilities. She also was employed as a speaker by the Ministry of Information, which consumed time and energy, but was challenging and paid decently.[172]

Bohm established Studio Alexander, a portrait studio in Manchester, in 1945, "when most seem[ed] to be closing." Her career was boosted by a prize for portraiture. Her own studio became so well established that she found time to accompany her husband on his business travel, and she began to take photographs purely on her own initiative, of "things I wanted to photograph." Among her significant contacts in this period was Abram Games. Bohm fondly recalls that "it was due to him that my first book was published." Abram "had a love–hate relationship with photography because his father was a photographer in the East End. And he helped him as a youngster. But being an artist he found that photography was usurping a lot of the graphics." Another link in Bohm's professional network was "a friend of [Lord] Snowdon's at the Design Centre," who had helped develop high-speed trains.[173]

Bohm's operation of the studio in Manchester ended in the late 1950s, around the time of the birth of her daughter, Monica.[174] Among the major achievements of her career, which is thriving as of 2013, is her co-founding of the Photographers' Gallery in London in 1971. She served as its associate director until 1986.[175]

Another contemporary of Bohm whose illustrious career extends into the 2010s is Wolf Suschitzky. Studio photography had been part of his career after he left Austria for the Netherlands, but upon entering Britain he did not continue with portrait photography as the main avenue of his livelihood. In 1948 his fellow émigré Helmut Gernsheim wrote: "In Suschitzky's hands the camera has become a most sensitive instrument for recording the expression and emotion of children and animals, and it is with photographs of these two subjects that he established his fame."[176]

Like Suschitzky and his sister, Edith (Tudor-Hart), scores of others would arrive in Britain from the late 1930s to the 40s with press photography as their main vocation; these individuals helped to fundamentally recast the way the British viewed the world. Yet even Tudor-Hart, a radical who abhorred convention, "shared a central London [portrait] studio" with "the South African–born photographer and filmmaker Vera Elkan," who photographed the International Brigade in Spain, in 1937.[177] To Tudor-Hart and Elkan, this might have been something of a bourgeois cliché—two Jewish women running a photography studio, serving a mainly non-Jewish clientele. It was nothing special. But what was then commonplace is now almost totally forgotten.

Elective Affinities in Photojournalism

❧

I N PHOTOGRAPHY's first dozen years, "large plate cameras requiring lenses of long focus and consequently a small stop"—that is, a large aperture (opening for light)—"were generally too slow for reportage work." An important step toward being able to take photographs while reporting came, Helmut Gernsheim noted, with a "small binocular camera introduced in 1853 by J. B. Dancer (1812–1887), a Manchester optician," which "revolutionized photography in the mid-Victorian era."[1] At that point in his career Gernsheim neither knew nor cared that there was something of a Jewish story in the technology behind what came to be known as photojournalism.

In refining and bringing his camera to market, Dancer, whose own origins are murky, worked closely over eight years with an instrument-maker named Abraham Abraham. (Although the double name may sound odd, it was not uncommon for Jews of his time. Abraham apparently had a relative named Moses Moses.)[2] Abraham's interest in photography extends even further back than "the first public announcements of photographic processes in 1839."[3] He was not an immigrant like the early photographers named Mendelssohn discussed previously. Abraham's father, Jacob, lived in Bath in the 1820s or 30s, and helped to found a synagogue there.

His son's company, Abraham and Dancer, was the leading producer of portable cameras, until the appearance of the Leica in 1928.[4] According to Gernsheim, "the greatest advance in this field" after Abraham and Dancer's design was represented by "fast gelatine dry plates, available in England from the late 1870s onward."[5] Jews such as Joseph Solomon of Bloomsbury and the Fuerst brothers were among those who improved dry plate technology and enhanced its commercial reach and applications. Solomon's "Wholesale American, English and French Photographic and Optical Warehouse" in Red Lion Square[6] was the

initial employer of Frederick Wratten, later of Wratten and Wainwright, the dry plate manufacturer that eventually was absorbed into Kodak, along with its manager and chief scientist, Kenneth Mees.

There apparently were no Jews involved in the development of the Leica,[7] which used 35mm film and was immediately renowned for its ability to capture images that could then be turned into sharp, large pictures. But among those selling and promoting the Leica, and the photographers considered its greatest practitioners, were an extraordinarily large share of Jews. Ilse Bing (1889–1998), of Frankfurt, Paris, and New York, was widely known as the "Queen of the Leica." Likewise Gisèle Freund (1908–2000), who was at the forefront of both color photography and the history of photography, yet is woefully underappreciated in both realms, wished to be identified with her Leica.[8] Freund also is notable as the last photographer to take a portrait, in 1939, of Virginia Woolf, "who was already very ill and would commit suicide in 1941."[9]

It is little wonder that most writing about photojournalism tends to be journalistic. Stress is usually laid on individual characters. It is, however, a devilish subject for historical investigation. As opposed to self-styled political and government bodies, religious and social organizations, and economic units, before the 1950s few believed that documentary evidence accompanying the creation and dissemination of photographs for newspapers, magazines, and exhibitions was important enough to be preserved. Correspondence relating to photography, therefore, is sometimes thought of as "business papers" or ephemera of limited value.[10] "Archive" in photography typically refers to prints, negatives, and contact sheets. When historians talk about "archives" and photographic professionals talk about "archives," they often mean something quite different. By academic standards, it is not surprising, then, that the body of historiography on photojournalism is slender, despite the fact that it is such a critical phenomenon. As opposed to the ubiquity of pictorial journals and their huge significance, there is limited academic study devoted to this field.[11]

Other factors contribute to this gap. Even in the scholarly domain, discussions of photojournalism usually are confined by national boundaries. Only in rare cases has some kind of cultural migration, or the influence of one nation upon others, been contemplated.[12] Tim Gidal argued that "German" trends weighed heavily on what emerged as long-lasting features of the field. "Modern Photojournalism," according to Gidal, "originated in Germany between 1928 and 1931"; "Berlin," Irme Schaber writes, was its "Mecca."[13] The sea change in photojournalism emanated from Germany following "the emergence of a new generation of sensitive photo-reporters," Gidal asserted, "who came mainly from an academic or intellectual background and who opened up new areas of photo

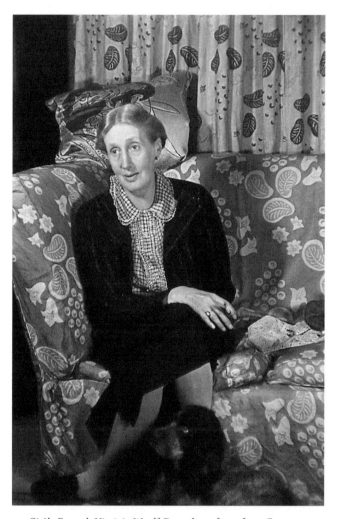

Gisèle Freund, *Virginia Woolf*. Freund, a refugee from Germany,
photographed Virginia Woolf (1882–1941) and other cultural figures
in color, in the late 1930s, long before it was fashionable. This was
most likely shot in Kodachrome. Diapositive couleur, diapositive
24 × 36 mm. 1939. © Estate Gisèle Freund/Réunion des Musées
Nationaux, Agence Photographique.

reportage as witness to their experiences and of their own time." They possessed the tools of the trade "developed a few years before: the small camera, above all the Leica and the Ermanox, and the increasingly sensitive negative material available for the picture carrier, the film. Some editors of the illustrated magazines were immediately prepared to integrate these new photo reports in their publications. Last but not least," German publishers "recognized Modern Photojournalism as a weapon in the competition for higher circulation [and] for more advertisements, and, in consequence, for higher financial returns."[14]

Gidal's stress on market forces in relation to aesthetics or a desire for authenticity has not been consistently integrated in further studies. Along with singling out Germany, Gidal also was keen to show that Jews were at the cutting edge as photojournalists in Central Europe. David Shneer has demonstrated that this extends as well to the Soviet Union.[15] Hungarians are the only ethnic group besides Jews that occasionally receives mention as playing a seminal part in the "roots" of the field.[16] The historiography of journalism, photography, and photojournalism—with the exception of Shneer and Gidal's efforts[17]—rarely confronts the "Jewishness" of the informal Zunft.[18] Gidal, himself a photographer of some renown, despite being dismissed by Felix Man as "small fry,"[19] was among the few to apply a longer-range historical perspective to photojournalism.[20] Gidal was a close friend and colleague of Helmut Gernsheim, and helped Gernsheim to see himself and other Jews as vital to the history of their own profession.

Studies of photojournalism also remain cloudy because of a tendency to downplay multiple, complex, and complementary influences on its evolution. This is especially evident in the writing about *Picture Post*.[21] One of the reasons Stefan Lorant was interested in recording a lengthy interview for the British Library in 1994 is that he was troubled by the way he and his publications were presented in the books of his successor, Tom Hopkinson.[22] Lorant also wished to acknowledge those on the business end of *Picture Post* who deserved more credit for its success, especially Sydney Jacobson and Maxwell Raison. Upon his departure from London, Jacobson wrote to Lorant: "It must have been a wrench leaving, after you had built up two such successes at *Picture Post* and *Lilliput*, but I think you did the right thing. I saw [in] Tuesday's *Telegraph* that you arrived in New York together with Madame Tabouis and Noel Coward—which one of them did you seduce? To me your going seemed the breaking of the last link with our happy three years before the war."[23] During the course of the interviews, Lorant frequently read out passages in Hopkinson's books and expressed his dismay. To a lesser extent, Lorant was unhappy with the way that photographer Felix Man, a non-Jewish photographer who fled Nazi Germany because of his leftist politics, explained editing practices in both Germany and Britain.[24] Both

Man and Gidal pressed their own versions of the history of photojournalism on Beaumont Newhall, seeing Newhall as the ultimate arbiter of the field.[25] Gernsheim certainly respected Lorant, but he tended to give Man, with whom he was friendly, the benefit of the doubt in his writings.[26]

The settling of scores usually is unproductive, but sometimes it leads to modifications of accepted beliefs and new avenues of investigation. Although Lorant was impassioned, and he glossed over some less salubrious aspects of his life, for the most part his account can be corroborated from documentary evidence, especially when one takes into account his work before his arrival in Britain. The tension and enmity between Lorant and Hopkinson is sad, because Hopkinson sincerely fought to keep his boss, Lorant, as editor of *Picture Post* in 1940.[27] "A month after I left" London, Lorant recalled, a photograph of the paper's publisher, Edward Hulton, appeared on the cover of *Psychology Magazine*, with an article entitled: "It Couldn't Be Done—but He Did It." His own name, Lorant added, "was not even mentioned."[28]

A historical approach to photojournalism is an especially striking lacuna in the case of Britain. This area is intellectually impoverished partly because of the centrality of "outsiders" in its development. Each of them departed the British scene in such a way as to make a study of their historical legacy unlikely. Some of the individuals most significant for the understanding of photojournalism in Britain disappeared rather unceremoniously. Erich Salomon, although a German subject until being made stateless by the Nazis, helped set critical trends in what came to be seen as "Fleet Street" photography. Salomon was murdered in Auschwitz.

Lorant, who did more than anyone to increase the quality, accessibility, and allure of photojournalism in London, was refused naturalization by the Home Office in the summer of 1940, and emigrated to the United States. Lorant did not adhere to any religion, but his Jewish origins played no small part in his staunchly anti-fascist political sympathies, fervent protests against Nazi antisemitism,[29] and professional networks. The fact that he was denied naturalization probably had more to do with prejudices relative to his Jewishness, however tenuous, than his "Hungarianness" or politics. Lorant, holding himself back from blaming antisemitism for his fate in Britain, thought that imagined communist connections also were at play. He was in the country for only six years, but he revolutionized photojournalism in his short tenure. Ironically, the most consequential materialization of his efforts arose in the United States. *Life* magazine was, in fact, closely modeled, from the start, on the magazine that was the forerunner to the *Picture Post*, the *Weekly Illustrated*, but this has been subdued in most of the historiography.[30] *Picture Post* did not just "inspire" *Life*: *Life* was almost the clone

of Lorant's initial UK venture.[31] Generosity toward, or even acknowledgment of, those who helped create his empire was not necessarily a strong suit of *Life*'s publisher, Henry Luce.[32]

There is no question that from the 1950s to the 1980s, Helmut Gernsheim knew more, and published more, about the history of photojournalism than anyone. (Gidal was perhaps the runner-up.) Gernsheim made a few mistakes, and not all of his assumptions were well founded. But his work is a treasure trove that has been under-utilized, with the exception of the dutiful curators of his archive at the University of Texas and the Reiss-Engelhorn Museum. Few in Britain, though, took up the cudgels for him. He had no protégé. His wife, Alison, who was his partner in writing and research, predeceased him. He held no regular university position from which he would have been able to encourage students or colleagues to follow up on the innumerable threads of photographic history he unearthed.

It did not help that on a personal level he did not usually like press photographers and their agents. In a 1950 letter to Beaumont Newhall, Gernsheim asserted that "photographers and photographic editors belong to the most uneducated class of people, and the less contact one has with them the better."[33] This could not have been more different from the assessment of Gidal, who characterized this group as a kind of intelligentsia. Certainly Gernsheim's notoriously difficult personality had something to do with his inability to keep his collection in Britain. He eventually transferred his archives (in both senses) to the United States and Germany. A wealth of insight on both Lorant and Gernsheim can be reconstructed through the extensive interviews conducted with them by Alan Dein and Val Williams, respectively, for the Oral History of British Photography project of the British Library.

In addition to the problem of preserving and locating sources, writing a history of British photojournalism is even more slippery because for a long time press photographers and photojournalists were not thought of as very important. In many cases we lack even the most basic information. For example, the mainly photographic *Last Courts of Europe* (1981), written by Jeffrey Finestone and introduced by Robert K. Massey, has no attribution of photographers or firms in its chapter on Britain.[34] When a photographer went to shoot persons or events he often was regarded as an appendage to the camera.

This attitude toward press photographers is brilliantly depicted in volume 2 of John Galsworthy's *Forsyte Saga* (1929). Tory Member of Parliament and government minister Michael Mont, who had proposed a new direction in policy, received

a request for an interview from a Press syndicate whose representative would come down to suit his convenience. . . . Michael made the appointment and prepared an elaborate exposition of his faith. The representative, however, turned out to be a camera, and a photograph entitled: "The Member for mid-Bucks expounding Foggartism to our Representative," became the only record of it. The camera was active. It took a family group in front of the porch. . . . It took Fleur [Mrs. Mont]. . . . It took the Jacobean wing. It took the Minister, with his pipe, "enjoying a Christmas rest." It took a corner of the walled garden: "In the grounds." It then had lunch. After lunch it took the whole house-party.[35]

Among the stolid Monts and their ilk no thought was given to the notion that there might be a human being involved in the process. At the end of the encounter, "[t]he camera took three photographs. Michael . . . suggested to the camera that it would miss its train."[36] To the extent that they were considered at all, it was to dismiss press photographers as some sort of "subspecies."[37]

It is crucial to the current project to note that photojournalists were derided, at least up through the early 1940s, as denizens of the gutter—lacking in respectability and morally dubious.[38] In the beginnings of press photography, according to Hannen Swaffer (1879–1962), "the press photographer was regarded as an animal almost beneath contempt. Where he had come from, nobody knew. Often he had owned a small business as a photographer somewhere in the suburbs, one he had thrown up for the high adventure of Fleet Street."[39] This quote is repeated in a few publications, and served as an epigraph for a press photography exhibition held at London's National Portrait Gallery (2007).

In the wake of the Second World War, photojournalism came to be seen as respectable, authoritative, and even dignified—but getting there was arduous. There is little acknowledgment, aside from Gidal, that its ranks had been disproportionately Jewish since the early 1920s, and that individual Jews were among those most responsible for elevating its status. Swaffer's comment in its 2007 context was meant as generic, applicable to the broad cohort of press photographers, but it originated as an introduction to the autobiography of photographer James (Jimmy) Jarché (1890–1965), *People I Have Shot*, published in 1934.[40] "In the early days," Swaffer recalled, even the "reporters would not speak to him."[41] Indeed, a large share of these "small businesses," especially those clustered on the Finchley Road, Edgeware Road, Whitechapel High Street, and Commercial Road, seem to have been in Jewish hands—even if their proprietors were not keen to advertise their actual ethnic identities.[42]

There are a few elements in the authoritative *Oxford Dictionary of National Biography* entry for Jimmy Jarché that may be termed as apocryphal, or simply

James Jarché, *Self-Portrait.* 1957. 10457116 Royal Photographic Society/National Media Museum/Science and Society Picture Library.

made up. Jimmy was, indeed, "the son of Arnold Jarché (or Jarchy; d. 1901) and his wife, Armelie Solomon," both of whom were Jewish. But they were unlikely to have been "born in France."[43] A relatively reliable website is even more fanciful, stating that Arnold was "born in Spain."[44] British Jews from Eastern Europe frequently claimed to be of Spanish or Portuguese origin, because this was (and remains) a way to claim an elevated social status. To say they were from France was a typical studio photographer's affectation, which probably was as flimsy as the Paris origins of Boris. In the case of the Jarchés this became apparent during research about the family for an episode of the BBC television series "Who Do You Think You Are," about Jimmy's grandson, actor David Suchet.[45] I was contacted by an exasperated production assistant who reported that they were unable to find any professional trace of Arnold Jarché in Paris. After all, James Jarché's "autobiography" is unequivocal: "My parents were French," he wrote in 1934. "Since photography in Paris was a paying proposition, they came over to England without a penny piece, in company with my father's brother, Serge, also a photographer, who worked for Lafayette."[46] Lafayette, a high-end studio chain most famous in Dublin, was founded by a "Lauder."[47] I suggested that there may not be any French connection, in terms of studios where Arnold said he had trained or was employed. He probably came from somewhere in Eastern Europe, perhaps Lithuania. To their shame, the BBC failed to give me credit in their boast about their exemplary sleuthing techniques, under the rubric of "Find out how we did it."[48] "So both David's great-grandparents were Russian, not French!"[49] To historians, though, this would not earn an exclamation point. Amelie was "born in Grodno" (present-day Belarus, then considered part of Lithuanian territory), and Arnold, Dunabourg (also Dinaburg, Drinsk) in Latvia, then in the Russian Empire.[50] Even though he did not hail from Lithuania proper, in Jewish terms Arnold was a Litvak, and many of his ancestors were from the west coast of Lithuania—from Memel, or Klaipeida,[51] the same place of origin as Dorothy Bohm and several others.

On much firmer historical ground, Oxford University Press's (continuously revised) *Dictionary of National Biography* (*DNB*) reports that Arnold "had a photographic studio in Rotherhithe, trading as Jarchy: the business prospered and additional premises were opened in Tower Bridge Road and in Balham. The young Jarché assisted his father and, as well as taking conventional portraits for cartes-de-visite, worked with the Rotherhithe police, photographing corpses recovered from the Thames."[52] Although this is true, it is likely that Jarché also photographed those who had died of natural deaths, which would have been part of his father's trade.

Jarché's own narrative portrait of his father is nearly identical to the du Maurier caricature referred to above. In fact, he makes explicit reference to the artist as capturing his father's likeness.

> My father started in a very small way. He went about with a camera to photograph horses, shops, houses, anything and everything. Since he was a born artist, his work invariably gave satisfaction, and orders began to flow in. As soon as he had saved enough money, he opened a business in Union Road, Rotherhithe, where we also lived. He did not need to advertise. He was himself a living advertisement, a "once-seen-never-forgotten" sort of figure. For he stood over six feet high, and his pointed beard, pale, interesting face, and shock of black wavy hair gave him the appearance of Svengali in du Maurier's *Trilby*.[53] He also affected the dress of an artist, wearing a braided black velvet coat, black and white check trousers, and loose flowing tie. With his long slender fingers he ought to have been either a surgeon or a musician.[54]

The sexualized dynamic, what one scholar has termed "the sexual charge,"[55] also played a significant role: "The girls from the factories, from Peek Frean's [biscuit/cookie company], from the Mazawattee Tea Co., and the ladies from the Star Musical Hall, Bermondsey—they all flocked to Jarché's and he gave them portraits of themselves, looking like beauties."[56]

Jarché writes, "My father also had another and very different side to his work," one with which there would be great continuity in his own profession as a press photographer. "At that time Scotland Yard had no photographic department of its own, but engaged men for the job of photographing any exhibits wanted by the police. The work consisted of photographing cheques, thought to have been forged, or footprints, or sometimes a ship which had collided with another, or a tram which had fouled the points. But as a rule the objects to be photographed were bodies taken from the river, or seamen found on the wharves with their throats slit by some irate shipmate." This supplied a steady trade, as "payment was so much per body, and on the average there were perhaps two or three a week."[57]

The picture of Jimmy Jarché as an unruly lad also is consistent with what materialized as the myth of the brusque, hard, press photographer, a "reluctant schoolboy" who "was expelled from St. Olave's Grammar School."[58] During the Great War, he made a return visit to St. Olave's and encountered the Headmaster who had disciplined him and thrown him out. "I walked into his study," Jarché writes, "wearing the uniform of a company sergeant-major of the Army Gym

Staff. He shot out his hand, but he did not remember me. 'Yet I seem to know your face,' he mused, looking at me, but failing to place me as one of his 'old boys.' 'My face was not the portion of my anatomy which came in for most of your attention, sir,' I reminded him."[59]

Jarché's father, who had a habit of over one hundred cigarettes a day,[60] died of a smoking-related disease in 1901. James was packed off to boarding school in Ramsgate, where he did not distinguish himself.[61] Upon returning home to Rotherhithe, "he joined Grange Park wrestling club and in 1909 became a world amateur wrestling middleweight champion."[62] As in the case of Dave Sharkey, prowess in boxing and wrestling were seen as attributes in some branches of photography, especially where photographers had to jostle to get their shot, or place their tripod to get a choice location for netting tourists. "By this time his mother, who had been running the photographic studios since the death of his father, decided it was time for Jarché to take gainful employment."[63]

His mother had made a conscientious effort to improve her photography and simultaneously impart it to her son.[64] Jarché asserted, "[M]y mother's work was good enough, and still is," that is, in 1934. "But she could not pretend to have my father's flair for getting on with people, and to her dismay all the three businesses slowly but steadily began to go down. She quickly made up her mind to give up the other two, and to concentrate on the one in Rotherhithe."[65] Soon afterward, though, she gave up the business entirely.[66]

Jarché's first job was "cycling around the London suburbs photographing schools inside and out" for the *Daily Telegraph*. He owed the opportunity to the strength of his father's reputation.[67] Later "his mother apprenticed him (for £30)," a hefty sum, "to a Bond Street photographer,"[68] a "famous firm" which Jarché does not identify. He found it pretentious, and thought their work "was not half as artistic as my father's."[69] "This ended abruptly when the chief operator boxed his ears for asking questions. This was unwise because Jarché, a fit wrestling champion, sent him tumbling down the stairs."[70] Jarché left, and his mother in a fury recovered the apprenticeship payment. "Thus ended," Jarché concludes, "my one and only excursion into the realms of polite photography."[71]

His Fleet Street career started in earnest with "a photograph of ragamuffins playing leapfrog in Southwark Park, sold at his mother's suggestion to the *Daily Mirror*, which paid him half a guinea." This led to a position at the World's Graphic Press,[72] which has been described as leftish, which may be true, and also as "the world's first news photo agency,"[73] which is difficult, if not impossible, to substantiate. There was at least one other such agency founded in Britain, in 1908: the Press Photographic Agency.[74] International Graphic Press Limited apparently succeeded "World's Graphic Press," which was owned by Hans Max

Albert Silver. Silver, the proprietor of the firm at the start of the Second World War, was interned as an enemy alien.[75]

The objective for photographers such as Jarché, and agencies such as Bert Garai's "Keystone," was to get as many "scoops" as possible. Similar to Jarché, Garai does not mention his Jewishness, yet his indebtedness to Jewish networks and contacts is pervasive.[76] Jarché's first scoop was "a Zeppelin illuminated by searchlights bursting into flames," which appeared on the front page of the *Daily Sketch*, where he was a staff photographer from 1912 to 1929. In addition to the *Sketch*, after his service in the First World War he also worked for the *Graphic* and the *Daily Herald* of the Odham's Press. Beginning in 1934 he shot photos for the *Weekly Illustrated*,[77] the first British magazine founded by Lorant, who had arrived in London just months earlier.[78]

Upon assuming that position, Jarché "began to be influenced by a talented group of refugee photographers from Nazi Germany," such as Felix Man and Kurt Hutton, directed by Lorant. "Lorant and his proteges had turned upside-down the notion that photography's role was merely to illustrate the text; they developed a style in which the pictures themselves told stories, and the arrangement of images and text was crucial to the meaning of the journalism."[79] As opposed to Colin Osman, who believes that Jarché's tutelage under editor Tom Hopkinson was important,[80] Colin Jacobson asserts that Jarché's evolving style was swayed more by Lorant. With Lorant giving him direction, "Jarché seems to have thrown off his tendency to photographic showmanship, resisting his urge to set up or control events and, instead, just gets on with it."[81] This might well have been, as Jacobson says, the high point of his career. Jarché's dedication to "[m]y brother press photographers past, present, and to be" in his autobiography seems heartfelt. "The results" of working with Lorant were beneficial—yet Lorant omitted Jarché from "his team of talented photojournalists at *Picture Post* magazine, which was launched in 1938. Perhaps Lorant recognised that, for all his experience, Jarché was not really a visual storyteller, but a one-picture man."[82] Given the reputation of the *Picture Post*, and the kind of one-upmanship common among his peers, Jarché's rejection by Lorant probably hurt him more than he would admit.

There was an expressly technical side to Jarché's work, as well. He was employed by Ilford Limited, experimenting on infrared film, which he found challenging and exciting.[83] Between 1959 and his death in 1965 Jarché was again employed by Ilford as a roving ambassador, giving well-received talks about his career.[84]

Employed as a photographer during the Second World War, Jarché was based in the Middle East, North Africa, and Burma, taking pictures for the *Herald* and

Weekly Illustrated. "Before the USA entered the war he was also an official photographer for *Life* magazine. He relished the two uniforms with which he was issued, particularly the American one, as it gave him priority with London taxis."[85]

After the war Jarché was reinstated at Odhams, "but the world of Fleet Street was changing. The *Daily Herald* was in decline, despite a Labour government being in power, as were the illustrated weeklies."[86] That Lorant had been forced to flee the country in 1940 contributed to this sluggishness. "The last great success for *Weekly Illustrated* and the *Herald* was the coronation of Elizabeth II."[87] That this assignment "resulted in the end of Jarché's career on both papers" is termed, in the *DNB*, an "irony." But how ironic was it? In many ways this story is consistent with the reputation of Jarché and others for being unscrupulous and coarse, and prefigures the hubbub surrounding Annie Leibovitz's photo shoot with the queen in 2007. At the coronation ceremony in 1953, Jarché "was given a privileged place in Westminster Abbey, and the story is that he shot permitted black and white film for Odhams Press as well as a parallel series in colour which he sold as a freelancer. As a result, it is said, he was sacked from Odhams, losing his pension six months before his retirement."[88] Jarché's color shoot supplied the cover and feature images for *Life*'s spread on the event, and was the first color image in a popular British Leica guide from 1953 to 1957, *The Leica Way*, by Andrew Matheson. Under the title "Vision of a Reign" Matheson underscored the historical significance of Jarché's achievement, which was the result of a stupendous effort and officially sanctioned: "The climax of a historical occasion of a generation, the coronation of Her Majesty Queen Elizabeth II, was taken from the Triforum in Westminster Abbey. This was the first time that a coronation had been photographed in colour. James Jarché, who was present as the only official colour still photographer, had to take up his position in the Abbey at four o'clock in the morning, and was not able to leave it until 4:30 in the afternoon. For two hours he was in a kneeling position, looking down on the ceremony from a distance of about 100 feet."[89]

In addition to his reticence in adapting to the Leica, there might have been some distance between Jarché and the émigré photographers, especially under Lorant at *Picture Post*, due to language barriers as well as their levels of political sophistication. Many of them, including the Hungarians, were German speakers, and some knew Yiddish. Knowing only English, and possibly French, Jarché may have been shut out of their conversations or simply uninterested. But more important, there were indeed two strains among the photographers, as identified by Gidal and Swaffer: the urchin and the intellectual. Swaffer's ideal type was Jarché, while Gidal's was Salomon, who was often referred to using his title of "Dr." He had trained as a lawyer, and therefore his credentials allowed for this form of address.

James Jarché, *Vision of a Reign* (1953). It was reported that shooting the coronation in color got Jarché into trouble, but it also earned him a *Life* cover, which was a coveted prize among photographers. This version is slightly different from the *Life* cover. From Andrew Matheson, *The Leica Way,* 4th ed. (New York: Focal Press, 1957), opposite p. 16. Private collection.

Salomon was a colossal figure in the history of photojournalism, having pioneered a "candid" style that came to be accepted as the norm in newspapers and pictorial magazines. His photographs appeared originally in the German press, but his role in the evolution of Fleet Street photography, and journalism generally, was immense. Salomon was famous enough to be "presented to Elizabeth, the Queen Mother, following a concert conducted at The Hague in 1932 by Wilhelm Furtwängler." Elizabeth was said to have remarked, "'Oh, I was wondering all through the concert what instrument you played.' The fact was that Salomon had been taking photographs from a tripod while seated in the orchestra among the musicians. The resemblance of the tripod to a music stand accomplished the deception Salomon needed to make closeup photographs of the conductor unobtrusively."[90]

He "was one of the first photographers to use a miniature camera for news pictures."[91] Although it would not enjoy the same fame and longevity as the smaller and sexier Leica, the Ermanox was Salomon's first tool in the trade, and he was regarded as its most astute user. According to Gernsheim, the main advantage of the Ermanox was that it allowed for indoor photography without special lighting, and the enlargements had exceptional clarity. Apparently Salomon's son, Peter [Hunter], who became a distinguished photographer in his own right, and head of a photo agency in the Netherlands after the Second World War, asked Gernsheim to explain his father's choice of equipment, as Hunter was writing on his father's life and work.[92] Gernsheim's friendship with Peter went back to the early 1930s. In 1971 Gernsheim wrote, "I shall never forgive myself for having missed the opportunity of meeting this great photographer [Salomon] during my long stay at The Hague in the summer of 1933, spending whole days in the company of Peter on the beach in Scheveningen. What a pity I was not interested in photography then!"[93] At that time there was no reason for Gernsheim to suspect that the trajectory of his career as an art historian would be impeded.

After having acquired no small measure of fame mainly with the Ermanox, Salomon "immediately recognized" the versatility of the Leica.[94] This contributed to "the candidness and instantaneousness that had been the aim of documentary, social, and historical-minded photographers since the invention of the camera." The legend of Salomon mainly stemmed from his "audacity and ingeniousness" in managing to capture "behind the scenes glimpses of internationally famous political personalities at the League of Nations conferences in the late 1920s." A joke at the time ran that in order to hold an international conclave, one needed three things: "a few Foreign Secretaries, a table, and Dr. Erich Salomon." Peter Pollack writes that "[w]hen the Nazis destroyed the great publishing

house of Ullstein with its three picture magazines, one of the casualties was Dr. Erich Salomon. Celebrated photographers like Alfred Eisenstaedt, Philip Halsman, and Fritz Goro left to become world renowned for their talents."[95] Salomon was resident in the Netherlands at precisely the wrong moment; he was transported to Theresienstadt, and then Auschwitz.

Although most accounts (but not all) of Salomon note his death in the Holocaust, there is no suggestion by scholars or critics of any "Jewish sensitivity" in his approach. Salomon's Jewish sympathies, though, were probably passed over, given his background. He was born into a well-heeled Jewish banking family, "studied law and in 1912 married a second cousin who was Dutch by birth."[96] This is why he happened to be in the Netherlands when the Nazis invaded.

As a conscript in the German army in the First World War, "he was taken prisoner in the first battle of the Marne," in September 1914. "Spending four years in French prison camps provided Salomon with an opportunity to perfect his French—an asset that was to stand him in good stead during his later, friendly contacts with French politicians. The unsettled conditions prevailing in Germany in the strife-torn and inflationary post-war years" compelled him to pursue different livelihoods one after another.

Salomon saw "his inheritance dwindling away (his father had died before the war)" and was hired as a "representative of a Düsseldorf bank on the Berlin Stock Exchange." Failing at that, he became director of a piano manufacturing company, an unlikely success in the depression. Salomon then joined "a car-hire firm with a stock of two battery-driven cars including chauffeurs." His subsequent position was described by Gernsheim as "surreal": Salomon advertised as "'Lawyer gives information on tax measures to clients in the side-car of his motorcycle. Why not enjoy a ride through beautiful landscape and learn how to save on your taxes at the same time?'" This did not provide a solid livelihood, but its sheer creativity lead to a job offer for Salomon from the Ullstein publishing house.

Placed in charge of Ullstein's outdoor promotions, he now traveled on trains to determine the best spots for advertising. In 1926, when a contractor misplaced some ads and a legal dispute ensued, Salomon borrowed a camera to supply evidence. He recalled this experience as his first substantial contact with photography. The next year Salomon commissioned photographs of "a natural catastrophe he had witnessed, then rushed them to the *Berliner Illustrirte*, which published two. Being left with a small profit after deducting his expenses, he decided to become owner of the camera himself and with his 13 × 18 cm (5 × 7 in.) press camera supplemented the family's Sunday outings with occasional features for the Ullstein papers."[97] He swiftly became a leading figure internationally.

Erich Salomon, "Stanley Baldwin (left) and Prime Minister Ramsay
MacDonald at the first press conference after the formation of the
National Government, Foreign Office, 26 August 1931." This
appeared in several British newspapers. bpk/Erich Salomon.

Among Salomon's signature pieces are some of the most incisive glimpses of
British politics and society in existence, such as his August 1931 candid "photo-
graphs of former political adversaries [Ramsay] MacDonald and [Stanley] Bald-
win announcing the formation of a coalition government," which "perfectly dis-
tilled the essence of their uneasy and unlikely partnership."[98] His photograph of
Lady Desborough and Miss Eleanor Brougham caught unguarded at a reception
was something completely different from what had been produced by British
photographers.[99] Although Salomon worked on assignment, and as a freelancer
sought to take pictures that would net him a good return, there is evidence that
Salomon exercised a fair amount of autonomy in his choice of subjects. This
separates him, as well, from Jarché and his highly competent contemporaries,
such as Reuben (1906–1967), Moishe, and Barnet Saidman, who also emerged
from their family's photography business.[100]

In Salomon's impressive body of work, fascists and antisemites have their masks of civility stripped away. In this he was perfectly in sync with Lorant's approach. Salomon's son, Otto (1913–2006; later Peter Hunter) imitated his father's style, catching people in motion and thereby producing stunning candid portraits, such as a glimpse of John F. Kennedy at an embassy ball for the birthday of his sister Eunice. In the work of both Erich and Otto Salomon. advocates of Jewish rights are treated sympathetically. In the British context Albert Einstein, Chaim Weizmann, Lord Rothschild, and Otto Schiff are presented as reputable leaders.[101] What might be termed the normalization of Jewish political leadership, which began as a motif in the Zionist press,[102] was taken up above all by Salomon and Hunter.[103]

Erich Salomon, "Lady Desborough (left) and Miss Eleanor Brougham at a reception in the Dutch legation, 1937." Not risqué, but certainly unguarded. bpk/Erich Salomon.

Erich Salomon, *Erich and Otto Salomon at the Savoy (London), 1935*. Otto Salomon would later
be known as Peter Hunter. Hunter was more dedicated to trumpeting the legacy of his own
father rather than his own importance as a photographer. bpk/Erich Salomon.

The spotty treatment of Salomon and nearly total eclipse of Hunter also de-
rive from Salomon's characterization as an outsider who surreptitiously infil-
trated the upper echelons of society and government. He made a point of being
attired appropriately for whatever occasion he was filming in order to blend in.
Yet he also established excellent relations with politicians and royals. In this way
he was building on the earlier tradition of Jewish court photographers.[104] Salo-
mon's first agent, Leon Daniel, recalled that Salomon was a man of few words.
But he possessed "an extremely warm personality, a wonderful smile, and ap-
pealing eyes. He made friends easily."[105] Salomon did not, however, follow the

press-photographers' convention of being pushy. The word "jostle" is never associated with him. He persevered in attempting to capture the picture he desired, and always tried to gain official permission. But failing this he would resort to subtle maneuvers and astounding "ingenuity" to disguise his camera, and never sought to bring attention to himself.[106] "On assignment, he dressed for the occasion, usually in tails or tuxedo, and invariably carried a tripod. His attitude at any event was always that of a guest who happened to have a camera with him, and when the spirit moved him, to use it."[107]

Otto Salomon (Peter Hunter), *JFK*. John F. Kennedy (1917–1963) with an unidentified guest at a birthday party for his sister Eunice (1921–2009), at the residence of his father, Ambassador Joseph P. Kennedy, London, June 22, 1939. © Magnum Collection/Magnum Photos.

Erich Salomon, "Science and politics meet" during a reception for the English prime minister, Ramsay MacDonald, July 28, 1931, Berlin. In this somewhat posh company, Albert Einstein (third from right) looks like he might rather be elsewhere. bpk/Erich Salomon.

Concerning the techniques he employed, Salomon wrote that

The work of a press photographer who aspires to be more than just a craftsman is in a continuous struggle for his image. As the hunter is a captive of his passion to pursue his game, so the photographer is obsessed by the unique photograph that he wants to obtain. It is a continual battle against prejudices resulting from photographers who still work with flashes, against the administration, the employees, the police, the security guards, against poor lighting and the enormous problems in taking photographs of people in motion. They must be caught at the precise moment when they are not moving. Then there is the fight against time, for every newspaper has its deadline that must be met. Above all, a photojournalist must have infinite patience, must never become flustered. He must be on top of all events and know when and where they take place. If necessary, he must use all sorts of tricks, even if they do not always work.[108]

HE ISN'T A PIPER, BUT A CANDID CAMERAMAN

Dr. Erich Salomon, one of the world's most famous photographers, whose pictures of Toscanini and others we publish in this issue, finds a new way of taking pictures in Scotland. The arrow shows the hidden camera.

Erich Salomon, "He isn't a piper, but a candid cameraman," in *Lilliput* (Jan.–June 1938), p. 273. Salomon, like many of the photographers of his generation, had a reputation for warmth, sincerity, and a sense of humor. He was not beyond making fun of himself. Despite his fame and connections he was murdered by the Nazis. bpk/Erich Salomon.

Salomon's career served as a model for those who knew him personally, such as Alfred Eisenstaedt, whose work also appeared frequently in British newspapers and magazines. Eisenstaedt's reputation, though, was made mainly between Germany and the United States, particularly after he became a featured photographer for *Life* magazine as both a portraitist and press photographer in the scrum.

Lorant was keen to spot and use the talent of Eisenstaedt and Salomon. Salomon's candid shots were especially amenable to Lorant's penchant for juxtapositions. Lorant no doubt noticed Salomon's genius in capturing motion.[109] His picture, for instance, of "Oscar Pulvermacher of the *Daily Telegraph*, London," shows Pulvermacher (1882–1958) fidgeting with his pencil.[110] Both Lorant and Salomon surely knew the tragicomic story behind the scene. Pulvermacher, although not a photographer, had suffered a fate similar to many of theirs—that is, a precipitous decline in family fortunes. His father's family made batteries and other much-desired utilitarian products related to electricity. In addition they hawked a so-called medical device that could have been the very definition of quackery,[111] the "Galvanic Pile Belt," which was said to cure all manner of disease by channeling the body's electro-magnetism. His mother's family made

Erich Salomon, "Mine are all right," juxtaposed to Keystone [agency], "Manicure," in *Lilliput* (Jan.–June 1938), pp. 246–247. The foreign secretary, Anthony Eden (1897–1977), was no slouch when it came to personal grooming. Private collection.

ELECTIVE AFFINITIES *in* PHOTOJOURNALISM

Erich Salomon, *Oscar Pulvermacher*. Pulvermacher was known to have
been dismayed at the *Daily Mail's* failure to challenge the Nazi regime,
and went to *The Telegraph*. bpk/Erich Salomon. Courtesy of George
Eastman House, International Museum of Photography and Film.

carpetbags. Augusta (née Fiedler), his mother, widowed when Oscar was a teen-
ager, lost her fortune to a con artist. Oscar had to fend for himself, first working
as a delivery boy and then as a messenger for the *Daily Mail*. He ascended the
ranks at that paper, becoming an editor in 1929. Like Lorant, he was famed for
achieving a record circulation. "In 1933 he disagreed with the sympathetic pol-
icy toward Hitler of the paper's owner, Lord Rothermere, and resigned. A month
later he was engaged by the *Daily Telegraph* to reorganize its news services dur-
ing World War II and was its northern editor in Manchester."[112] In this and other
photographs, Salomon approximates film, showing his subjects as excited, pas-
sive, or even bored.[113]

In 1971 Erich Auerbach (1911–1977) acknowledged his debt to "the incom-
parable Dr. Erich Salomon, the photographer who has not to this day been sur-
passed (he perished in Auschwitz) who taught me though we never met."[114] Au-
erbach "was born in Falkenau (now Sokolov) in the Sudetenland, Bohemia (now
the Czech Republic) in 1911. His father, a doctor with a passion for music, en-
couraged his son to learn piano and violin."[115] Auerbach considered himself very
fortunate to have landed in Britain before the outbreak of the Second World
War, and to have received an outstanding musical education in Prague and
Karlsbad—although he did not believe he possessed special musical gifts.[116] Like
others with similar middle-class backgrounds, he was destitute upon arriving in
Britain as a refugee.

Auerbach replicated aspects of Salomon's career, but on a smaller scale. In London he became "official photographer to Dr. Beneš' Czech government in exile"[117]—when Salomon was already trapped in the Netherlands. Auerbach's fame rests largely on his photographs of musicians, many of which he obtained using the Salomon style of blending in. "Conductors and soloists from all over the world flocked to London during the 1950s, and Auerbach was able to get into sessions to which no ordinary photographer would have been allowed access."[118] Lord Goodman (1913–1995), a friend of Auerbach, wrote in a lighthearted introduction to one of Auerbach's books that he "is not a news photographer. I do not know what he would do with a Cup Final crowd or a plane-crash—probably a competent job. He is a [leading] portraitist of living people and especially of intellectuals."[119] Goodman was oblivious to the fact that a large share of Auerbach's livelihood did indeed derive from newspaper work. As a freelancer Auerbach contributed regularly to the *Daily Herald, Sunday Times, Observer,* and *Illustrated London News.*

Despite Auerbach's modesty about his musical ability, "the fact that he could play" the piano, well enough, "endeared him to his subjects."[120] He used his insider status among musicians, which grew over time, to forge his own niche in the market. Other photographers, especially émigrés, were able to establish reputations for expertise in specialized realms. Wolf Suschitzky, as mentioned earlier, became known as an excellent photographer of both animals and children. Although Suschitzky is reticent about seeing Jewishness as significant in his life, he admitted that he probably would never have turned to photography had antisemitism not forced him to flee his native Austria. His desire, had he been free to follow his greatest passion, would have been to train and work as a zoologist.[121] It is not surprising, then, that by the early 1950s he was known as a leading photographer of animals. One of his competitors for preeminence in this area was another émigré photographer, Ylla, the working name of Camilla Koffler (1911–1955). Although never based professionally in Britain, she was a frequent and much-beloved contributor to the publications of Lorant.[122]

Not all photographers who had developed subspecialties in the 1920s and 30s, however, were able to apply their experience in the British market. Zoltán Glass (1903–1982) was an established photographer of motor racing and the automobile industry upon his emigration to Britain in 1939. He was never, however, able to make much headway in these particular fields in his new country. As was the case with scores in his cohort, Glass had a background in both art and photography—as a cartoonist and a retoucher. As a twenty-two-year-old he moved to Berlin and worked as "the picture editor of a Berlin evening paper, the *5–8 Uhr Abendblatt,* and then, from 1931, as a photojournalist on a more important daily, the *Berliner Tageblatt,*"[123] the flagship publication of the Mosse publishing house.

A large number of the photojournalists who passed through Germany in the 1920s and 1930s had worked for either the Ullstein or the Mosse firm, as did Salomon and Eisenstaedt.[124]

Glass prospered in Weimar Berlin. He worked "as a freelance commercial photographer and journalist" and established two agencies: Reclaphot, for general advertising, and Autophot, dedicated to automobiles. The latter was his greatest passion. Glass himself was an "amateur racer" and "keen motorsport enthusiast." He photographed "most of the big races held in Germany between 1931 and 1936, at the Nurburgring and Avus circuit near Berlin. His photos recording the success of the Mercedes-Benz team received immediate and widespread public acclaim and helped establish the iconography of German technological achievements. Glass's motoring work also included documentary and reportage photographs taken at car shows and factories, plus published shots commissioned by clients such as Daimler-Benz, Auto Union, and Shell. As a result, he developed strong personal friendships with a number of leading figures in the Berlin advertising world, including Peter de Peterson of the J. Walter Thompson agency."[125] In 1935 the Nazis made a special point of eliminating Jews, who had not been rejected previously, from motor sports clubs.[126]

Glass was at the center of activities glamorizing cars, generally, and auto racing. As this was an international phenomenon, and German cars had a reputation for superb engineering, it is not surprising that Glass was well connected. De Peterson, who was a relative of Vladimir Nabokov and nicknamed "Petrouska," would himself be reassigned to London after a stint in Bombay.[127] "De Peterson was able to help" Glass escape the Third Reich. From early 1936, Glass "found himself excluded from employment by German media and was dismissed from his regular assignments for the *Berliner Tageblatt*." At this point the newspaper was no longer under the control of the Jewish Mosse family, but the Nazis tried, as much as possible, to maintain well-known brand names—so that confidence in formerly respected firms would be maintained. Glass "decided that, with de Peterson's assistance, he would base himself in London while continuing to run his photo agencies in Berlin as best he could."[128] No doubt it helped that Glass's brother, Stefan (Stephen), also a photographer, had already moved to London.

In the wake of Reichskristallnacht (November 9 and 10, 1938), "Glass's relationships with Mercedes, Auto Union and other clients were terminated. He was forced to flee Berlin altogether, also bringing along with him his entire set of negatives. Fortunately de Peterson was able to arrange an immigration permit allowing him to settle in London, where he was given work by another Jewish refugee, Arthur Springarn, owner of Sackville Advertising in Sackville Street, W1."[129] Springarn may have changed his name, as there seems to be no trace of him beyond the accounts of Glass.

Sometime after the war commenced Glass's cameras were impounded, and he was "only able to operate" through a British assistant.[130] This obviously limited his (legal) work opportunities. Nevertheless Glass managed to find assignments during the war years. His photos appeared in the *Daily Mirror* and *Life*. He may have had a connection to the "Pix" agency of Leon Daniels. He was published at least thirty-nine times in the *Picture Post*, through a relationship that began during Lorant's editorship.[131] Through photos now being hawked on the Internet one can reconstruct several of Glass's photo shoots, which typically were published without attribution. He had been quite close to Lorant, as Lorant used Glass's studio to create the first mock-up (dummy) of *Lilliput*, and he paid Glass's utility bills.[132] Glass was not interned as an enemy alien. But because he could not legally carry cameras and his mobility was curtailed he was prevented from resuming the kind of profession he had thought would be possible in England.

Job offers were, predictably, "slow and patchy," but Glass was assisted by a close friend, "another Hungarian refugee, Arpad Elfer, who lived in the same apartment block at 48 Chesil Court."[133] Elfer studied art, and originally worked as an "art director," that is, photography editor, in Berlin. In 1933 he relocated, as did so many "non-Aryans," to Paris, and two years later joined "the London firm of Colman, Prentis, and Varley [CPV]," a formidable advertising agency. Glass and Elfer were quite a duo. Elfer has been described as "one of the most charismatic and creative directors of post-war advertising. He was a superb visualiser who could encapsulate the mood, style and desirability of a product in ways that would excite the client and appeal to the public."[134] The stable of artists at CPV included Abram Games, "who had a contract for the [national airline] BEA/BOAC account between 1946 and 1949."[135] Since Elfer served in the Pioneer Corps, a military detachment with a large number of Jewish refugees until 1946, it was not until the early 1950s that Glass was able to profit substantially from this relationship. It helped that Glass was naturalized in 1948. There was a rumor that Glass secretly maintained a photography studio in Cheyne Walk, Chelsea, between 1946 and 1948.[136] Most likely this was true, as he had to operate under the radar of government authorities.

Substantial offers from automobile manufacturers and the motor sport world failed to materialize for Glass even after 1948. As a photographer mainly working for CPV and other advertising firms, though, he used techniques he had honed as an automotive photographer. This "involved the use of oblique camera angles, dramatic lighting, and overlapping multiple exposures. The discreet and tasteful employment of scantily-clad models added a new dimension."[137] Lorant had been featuring models in revealing costumes and even bare-breasted ladies since his film magazine career.[138] "By the mid-1950s," after reconstituting his studio, "Zolly" (as Glass was known) "had consolidated his reputation as one of

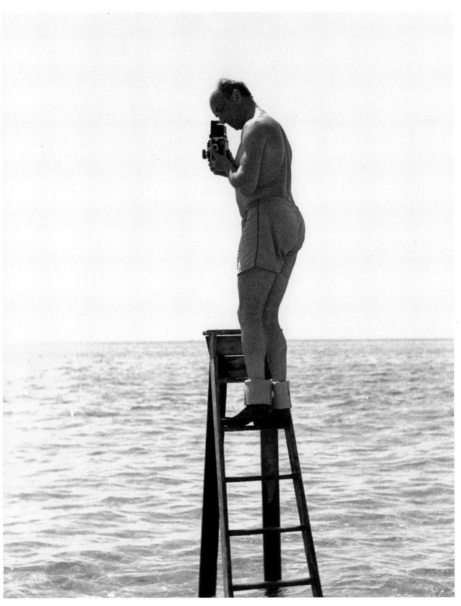

Zoltán Glass, *Self-Portrait*. 1964. 10322846 Zoltán Glass/National Media
Museum/Science and Society Picture Library.

the most successful fashion and advertising photographers in London." He also installed himself as an agency head. Glass "developed a novel arrangement by which young, aspiring photographers could use the facilities at his studios free of charge, paying him a percentage of their income by way of rent" and "many celebrated photographers began their careers in this way."[139]

Glass was able to reconnect to the magazine *Lilliput*, to which he had contributed while it was edited by Lorant. In the first issue of *Lilliput* Lorant used at least one of Glass's photographs. With the caption "MEGALOMANIA" it showed a tiny kitten under the statue of a lion.[140] The first picture of the magazine, of a woman on a trapeze who appears to be topless, might also have been the work of Glass, but is unattributed. Odhams Press, which also employed Jarché, "was another CPV client." The character of *Lilliput*, a small "gentleman's magazine that featured an assortment of titillating articles and risqué humour, together with photographic essays from such respected talents as Bill Brandt and Brassai," was a perfect outlet for Glass. "Working jointly with Elfer, Glass produced many photo-stories for *Lilliput* between 1948 and 1956, all exhibiting the light and humourous reportage style he had made his own."[141]

Glass, then, was on the way toward pioneering another specialty: soft-core pornography, "known euphemistically as naturist photography." As models he mainly employed "au pair girls who were happy to bare all for £5." It is known that "from 1953 he built up a clandestine, parallel business producing arty, erotic nude studies, which he exported in bulk to America, Germany, and Scandinavia. The proceeds were deposited in a variety of foreign banks." Glass did very well. His income was so substantial "that by 1964 he had made enough to sell his Chelsea studio to a consortium of British photographers" and relocate to "the French Riviera with his common-law wife Pat, a former cabaret dancer. He died there on February 24, 1981, at the age of 78, leaving neither offspring nor a will."[142]

Glass did, however, find a way to share the wealth. Although he may have paid most of his models a pittance, some went on to notable careers. His model Pam Green, mentioned previously for her part in *Peeping Tom*, with George Harrison Marks,[143] published a number of magazines that might be seen as the start of the "lad" genre. While Marks's and Green's efforts are thought to have little "lasting merit" as photography,[144] the opposite is true of Glass. In the twenty-first century his automobiles and nudes are high-priced collectors' items. In contrast to the soft-core porn films of Marks, most of the cinematic progeny of Jewish photojournalists is in good to superlative feature films for general audiences, and noted documentaries, such as one finds in the motion picture work of the Korda family, and Wolf Suschitzky and his "cameramen" sons, Peter and Adam.[145]

GLASS LONDON

MEGALOMANIA

Zoltán Glass, "Megalomania," in *Lilliput* (July–Dec. 1937), p. 44. Most often Lorant's juxtapositions used separate photos. Zoltán Glass got the joke across in one frame. Private collection.

Zoltán Glass, *Pam Green,* full view. May 3, 1955. 10456649 Zoltán Glass/National Media Museum/Science and Society Picture Library.

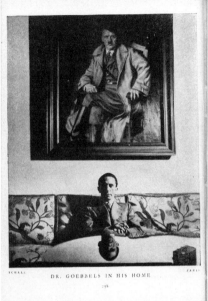
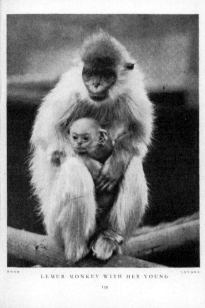

SCHALL DR. GOEBBELS IN HIS HOME PARIS BOND LEMUR MONKEY WITH HER YOUNG LONDON

Schall, "Dr. Goebbels in his home," juxtaposed with Bond, "Lemur monkey with her young," in *Lilliput* (July–Dec. 1937), pp. 138–139.

Moreover, the kind of creative photography that appeared in *Lilliput* was of a different order than the pictures in *Kamera*. The first incarnation of *Lilliput* under Lorant was somewhat risqué, but, more important, it was clever. It had an anti-fascist political bias but wore its politics lightly.[146] One of the reasons pictures of animals were such favorites of Lorant is that he often juxtaposed animals with political and cultural figures—what Lorant himself termed "the humour of the unexpected."[147] His personal style was marked by using pictures, especially sequences, to tell a story, and juxtaposing photographs to create a certain effect.[148] Thinking back on his earliest editorial work for the *Ufa* film magazine, Lorant saw it as his task to provide the moviegoing audience with news about the movies and their stars but also, more importantly, to tell interesting stories about the movies themselves and moviemaking.[149]

The photographer with whom Lorant felt a special affinity was Salomon.[150] There are a number of reasons for this besides Salomon's expertise as a press photographer. (Personally, Lorant considered him a real gentleman.) In addition to replicating motion, Salomon also let his audience in on the process of photography. Even when Salomon was behind the camera, he too had become part of

the greater scene, and wished to reveal the process of how "news" was made and digested.[151] Salomon, especially in his pictures of people reading newspapers that contained his own photos, conveys an appreciation for how the reception of photographs, by the newspaper and magazine-reading public, comprises part of the phenomenon.[152] For instance, why would everyone on the Tube, and in the park, be reading the same newspaper, the *Sunday Dispatch*, on June 30, 1935? These photographs show something extremely unusual for the time. It is important to recall that there were many newspapers from which people might choose, and a typical informal gathering, such as in a park, would usually share at least a few different papers. In London's Underground, before the days of free newspapers, there would have been a great diversity of papers present even in the same train car. But this particular day's *Dispatch* was extraordinary, because of the work of Salomon. It featured courtroom scenes and political meetings, the likes of which had never before been captured in the press. The front page proclaims the "MOST VALUABLE PHOTOGRAPH EVER TAKEN":

> "The man with the magic camera," Dr. Erich Salomon, has come to England. Lord Hewart, Lord Chief Justice of England, has graciously given the *Sunday Dispatch* permission to print the above photograph, greatest and most valuable Dr. Salomon has ever taken. It is of Lord Chief Justice and Mr. Justice Avory (the story of whose life and trials is appearing in the *Sunday Dispatch*) in the Court of Criminal Appeal during the hearing of a case. Neither judge knew the photo was being taken. No other such picture has ever been obtained. The *Sunday Dispatch* is able to print it exclusively. How Dr. Salomon takes his pictures is told in the Back Page.

Lorant was the most imaginative and influential photography editor in Britain. By 1939, the position of *Picture Post* within British journalism was unparalleled. At the outbreak of the Second World War, the idea that *Picture Post* was the best vehicle with which to approach the public raised few eyebrows. Lorant was the main reason for its success.[153] Any historical treatment of Lorant's tenure in Britain, however, can only partially rely on documentary evidence, because his naturalization dossier, which apparently was copious, was destroyed in 1961. It has been British government policy to get rid of the files of those denied naturalization twenty years after a negative decision. The only exception that has been made, of preserving a file out of historical interest, concerned that of Karl Marx.[154]

It remains a massive embarrassment for the country that Lorant was forced to leave Britain. His entry in the *Dictionary of National Biography* offers no comment on the circumstances behind his leaving, making it seem as if he left on his

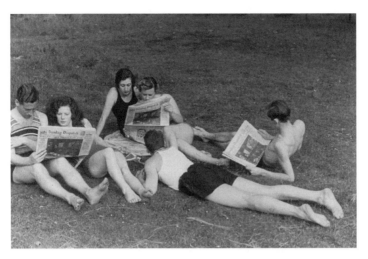

Erich Salomon, *Salomon's Readers,* 1935. Courtesy of George
Eastman House, International Museum of Photography
and Film. bpk/Erich Salomon.

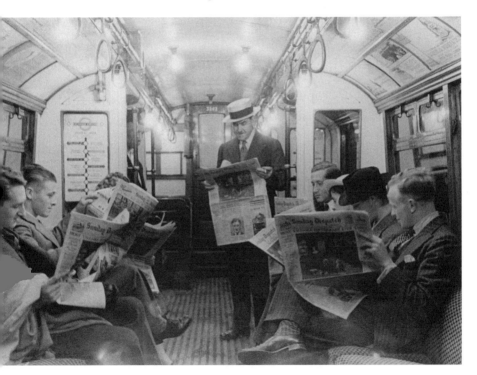

Erich Salomon, *Salomon's Readers (2)*. London's Underground:
Sunday Dispatch, June 30, 1935. bpk/Erich Salomon.

own volition: "Lorant emigrated to America in 1940, like many of his creative and talented peers."[155] On the surface this is true, but the reality could not have been more vexed. Lorant was compelled to leave Britain because government policy made it impossible for him to continue as editor of *Picture Post*—despite the fact that the magazine was deeply involved in service to the administration, and Lorant was a key player. He even had to suffer the indignity of having his bicycle "confiscated by the Edgware Police."[156]

Stefan Lorant himself did not even know who some of the most crucial people were who denied him naturalization—a circle including the Home Secretary John Anderson, Parliamentary Under-Secretary of State for the Home Department Osbert Peake, Parliamentary Secretary Harold Nicolson, Information Minister Lord John Reith, Private Secretary to the Minister of Information (the sixth) Lord Hood, and, finally, the Director of the National Gallery Sir Kenneth Clark, who also worked for the Information Ministry. Had Kenneth Clark made a more strenuous effort, there is a good chance that the Home Office might have allowed Lorant to remain. If this was an act of omission, it was still reprehensible for Clark to insinuate that Lorant's leave-taking was akin to shirking responsibility, writing in September 1940 that Lorant had "done a bunk to the USA."[157] Clark knew full well what had precipitated Lorant's departure on July 20, 1940.[158]

Yet these men, along with Brendan Bracken (who led the Ministry of Information), shared the conviction that "the Hulton *tribe* are good propagandists" (emphasis added),[159] and therefore valuable to the war effort. The leading member of that "tribe" was Lorant. The Jewish innuendo was clear and suggests that men such as Bracken and Clark were not comfortable with the fact that Lorant mingled as easily as he did with dignitaries. Interestingly, in a 1939 photo essay on Winston Churchill in the *Picture Post*, Lorant retouched himself out of a picture with Churchill.[160]

In a letter which has not been preserved in British records, Bracken, then the secretary to Churchill, wrote to Lorant, on June 20, 1940: "It would be improper for the Prime Minister to ask the Home Secretary to speed up the process of naturalizing an individual." But he added: "The very remarkable work you have done since you came to England, and your record in relation to Hitler are obvious grounds for special consideration of your case. And these should be submitted to the Home Secretary by the Ministry of Information."[161]

Lorant's route to Britain would be traversed by many others. He was born Istvan Reich in Budapest, February 22, 1901—on the same street where Theodor Herzl had lived some forty years earlier. It is also the home of the city's Great Synagogue. "His parents," Izso (Imre) and Irén (née Guttmann), "were Hungarian Jews."[162] Lorant's biographer, Thomas Willimowski, adds that Lorant's father's

Kurt Hutton, *Stefan Lorant and Winston Churchill*. Taken at Churchill's country home in
Chartwell, Kent, Feb. 25, 1939, for photographs to accompany the article "Churchill: He
has taken part in wars. He has held many of the high offices of the Crown. He has written
books admitted to be great. But at 64 the greatest moment of his life has to come,"
by Wickham Steed, *Picture Post*, vol. 2, n. 8, Feb. 25, 1939, pp. 16–23. This one,
showing Lorant with Churchill, would never appear in *Picture Post*.
Hulton Archive/Getty Images.

name was "Israel" and that he was raised in "a middle-class Jewish family."[163]
Lorant, though, claimed that his father was Catholic.[164] But this need not be a
contradiction. Given that his father was a photographer who also managed a
large studio serving the Habsburg court, he may have been baptized Catholic, as
it was typical for Jews with royal appointments to convert.[165] The household,
Lorant recalls, was areligious—no particular rites were followed. His father's ca-
reer was significant on several levels. He had worked, first, "in newspapers, and
then as a court photographer." He was something of a picture editor, having "as-
sembled a commemorative photography volume for the royal family in 1896."[166]

JEWS *and* PHOTOGRAPHY *in* BRITAIN

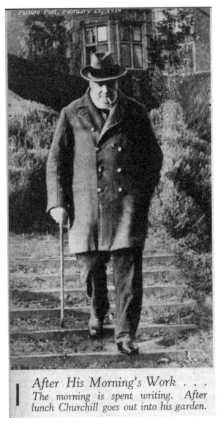

Kurt Hutton, "After His Morning's Work . . . The morning is spent writing.
After lunch Churchill goes out into his garden," *Picture Post*, vol. 2, no. 8,
Feb. 25, 1939, p. 18. One gets no sense that Churchill was
accompanied by Stefan Lorant.

The young Stefan learned developing and became a good photographer himself. During a family holiday at Lake Balaton he produced and sold postcards. He succeeded in offering pictures to photographic magazines, especially of politicians and stars of the stage. He had a photograph published prior to his sixteenth birthday in *Das Interessante Blatt* of Vienna, showing the coronation of King Karl in Budapest, even though he could barely see above the crowd.[167] He became particularly adept at flash photography.[168] Lorant was—like so many others who would go from the studio, to the darkroom, to the pasteup board—sensitive to the constructedness of photographs, and how photographs made up a page of a newspaper, magazine, and book.

The fact that Lorant was employed, as a teenager, by the short-lived communist government of Bela Kun after the First World War[169] may have been a part of the negative case against him in Britain in 1941. He first left Hungary at age eighteen. On his journey, while in Tetschen-Bodenbach (also Bodenbach, present-day Podmokly, Czech Republic), he encountered a man he later realized was Franz Kafka. As a photographer he self-consciously drew on what he regarded as the particular photographic traditions of both Hungary and Germany.[170] "Between 1920 and 1925, first in Austria and then in Germany, Stefan Lorant (as he thereafter called himself) worked on fourteen films for the emerging silent film industry. Initially he made still photographs, before becoming a cameraman, a scriptwriter, and a director, all within a single year. His first film, on Mozart's life, loves, and suffering, *Mozart, Leben, Lieben und Leiden* (1920), established him as a much sought-after cameraman."[171]

In Vienna Lorant was involved in three expressly Jewish projects. In the summer of 1920 he was cameraman for the film *Das Judenmädel* (The Jewish young lady), for which he also shot still photos. Directed by Otto Kreisler, it starred Ferdinand Bonn, Eugen Neufeld, and Molly Picon—the latter was one of the greatest of the Yiddish screen stars.[172] In the fall of the same year he directed and shot a documentary film of the Zionist Congress held in Karlsbad (*Die Zionist Congress*),[173] capturing, among others, Chaim Weizmann, Martin Buber, Vladimir Jabotinsky, and Nahum Goldmann.[174] In 1921 he took photographs for the film *Die tote Hochzeitgast* (The dead wedding guest).[175] Perhaps some of his other films, which are lost, also had Jewish themes or characters. In 1925, "after having mastered the German language, he began writing articles for Berlin magazines based largely on his knowledge of the film industry and its stars."[176] One of his projects was a movie about filmmaking which he believed was the first of its kind.[177] Lorant found filmmaking more tedious than exciting. He came to prefer writing articles, such as those he did for *B-Z* (*Berliner Zeitung*).[178]

Lorant did, however, enjoy the camaraderie among those in the film business, as well as the gossip and amorous possibilities.[179] Ernst Lubitsch, who also had started as a photographer, was one of the people he most respected and recalled fondly.[180] Another one of his close colleagues and friends was Karl Freund (1890–1969),[181] cinematographer for *The Golem* (1920) and Walter Ruttmann's *Berlin: Symphony of a Metropolis* (1927). In speaking of the credit Freund deserved for the success of the *I Love Lucy* television show in America Lorant could have been describing his own instrumental role in the making of *Life* magazine.[182] Desi Arnaz was more honest and generous in accounting for the success of his and Lucille Ball's hit series, giving Freund a great share of credit, than Luce was in recounting the history of *Life*.[183]

Within a few years Lorant had become the editor of four new picture magazines: *Das Magazin* (1925), *Ufa Magazin* (1926)[184]/(later renamed) *Film Magazin*,[185] *Bilder Courier* (1927–1928),"[186] and *Film-Ton-Kunst* (1926–1927).[187] In 1928 he took over as "the Berlin editor of the *Münchner Illustrierte Presse*, for which he eventually rose to be editor-in-chief."[188] *Das Magazin* is described by Lorant as "the first modern pictorial magazine," which had a particular interest in filmmaking. It also pioneered "pictorial journalism," that is, using pictures to tell a story, as opposed to supplying an illustration to supplement an article. At *Das Magazin* Lorant cultivated relationships—with photographers such as Brassaï, Moholy-Nagy, Eisenstaedt, Kertesz, Salomon, John Heartfield (Herzfelde), and Munkácsi, and agents such as Leon Daniel (later, Pix), Dephot, Guttmann, and Birnbach[189]—that he would carry over into Britain and the United States.

In his role as editor of the *Münchner Illustrierte Presse*, Lorant had contact with Nazi spokesmen and leaders before 1933, as they wished to present themselves as respectable to the press.[190] Bert Garai claims that he went so far as to become a party member in order to infiltrate its meetings for news and photos.[191] Surely Garai was one of few, if any other party members who would have described the Jews of Warsaw, in 1924, as "amazingly sturdy and handsome young Jews, most of whom wore black peaked caps."[192] The Nazis would not have automatically associated Lorant with what was termed the "Jewish" and "liberal" press, because his paper was owned by Catholics. It probably helped that no one ever referred to him by his former name. But when the Nazis had the chance after the seizure of power, they imprisoned Lorant almost immediately. His editing and cosmopolitan style were clearly not to Hitler's taste. Lorant had published Joseph Roth and countless other Jewish writers, and had featured those who were among the conservatives' and Nazis' sharpest critics.[193]

Upon his release, after nearly seven months, Lorant "returned to Budapest, where he wrote (what was to become) *I Was Hitler's Prisoner*, published in London in 1935, and later as one of the first Penguin paperbacks. During this period in Budapest he edited *Pesti Naplo Magazin* (1933–34), an early example of a weekly illustrated newspaper supplement."[194] Given the general political environment, and especially the rising antisemitism in interwar Hungary, Lorant found his situation deteriorating. He wished to get to Britain in order to publish the book about his prison experience as a warning to the world about Hitler and also as a springboard for a journalistic career in London.[195]

Lorant had visited Britain at least once, in 1930, which turned him into something of an Anglophile,[196] and apparently helped in his attempt to relocate to London in April 1934. Almost immediately upon entering Britain, he tried to

establish a magazine similar to those he had edited in Central Europe; this effort resulted in the founding of the *Weekly Illustrated*. The first few issues included several of his own photographs.[197] One of his chief aims was to create a pictorial magazine much less expensive than those already on offer.[198]

Although it is acknowledged that *Weekly Illustrated* became "influential" in remarkably short order,[199] Lorant's expansion of the magazine's circulation has been underappreciated. His relationship with Tom Hopkinson began here. "I was doing everything myself," Lorant later recalls. "The only help I had" was Hopkinson, "who wrote many of the captions for the pictures and some of the explanatory texts."[200] The public recognized that there had been nothing like it before. The magazine also had a huge but unacknowledged impact in the United States. Henry Luce visited Lorant in 1934, with the purpose of using his magazine as a model for a similar publication.[201] "He came to the office and told me that, in America, he was planning to publish an illustrated magazine, something on the line of *Weekly Illustrated* and the German pictorial weeklies. Kurt Korff, the former chief editor of the *Berliner Illustrirte Zeitung*, was preparing the dummy for him in New York. Luce asked me for all the issues of *Weekly Illustrated* and invited me to the Savoy, where he was staying, to meet his beautiful wife."[202] Following the success of *Weekly Illustrated*, Lorant founded the previously mentioned *Lilliput*, in 1937.

Of course photography was far from an entirely Jewish affair, and many of the famous photographers, such as Bill Brandt, Hoppe, and Cecil Beaton, were non-Jews. Given the pressure of Nazi antisemitic policy, there were now increasing numbers of Jewish and left-leaning photographers in Britain and the rest of Europe, outside of Germany, who desperately needed work. Lorant was happy to help them, and saw this as a boon to his vision for *Lilliput*. He specifically credits the networks among refugees when explaining the origins and success of the magazine. Many of them were incredibly talented, as well as irreverent—such as Irwin Blumenfeld.[203] Lorant regarded one of Blumenfeld's photos, part of a series that now fetches thousands of dollars, as "the best picture of the year" in 1938. Blumenfeld, in many ways similar to Zoltán Glass, is one of the few in the group to speak effusively and humorously about his Jewishness. He, too, was a close friend of Lorant,[204] while also benefiting from the assistance of Beaton.[205] The self-portrait which serves as the frontispiece of his autobiography shows Blumenfeld, with his wife and children in the background, himself naked, with the off-kilter camera in front of his penis.[206]

Many of the photographers published in *Lilliput* from between 1938 and 1940 are untraceable. Some of the names may have been made up. Because a

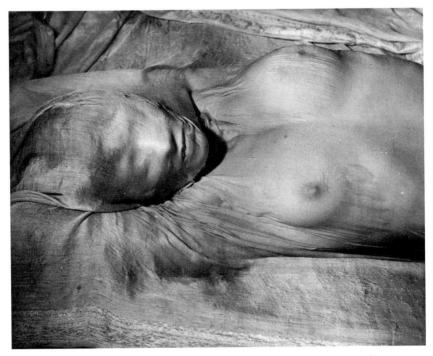

Erwin Blumenfeld, *Nude under Wet Silk, Paris, 1937*. This is from the same series as
Blumenfeld's photograph touted as "The best picture of the year: veiled figure" in
Lilliput (July–Dec. 1937), p. 345. © The Estate of Erwin Blumenfeld.

great number of the photographers in Britain, and other countries, were either
living or working illegally, they did not want their names published.[207] There is a
possibility, though, that several of them did not escape the Nazis and were mur-
dered. With the exception of Salomon, we know only those who got away.

In just a few years Lorant proved himself to be one of the leading entrepre-
neurs in British publishing. His next and final creation in London was the weekly
Picture Post, in 1938. He edited *Picture Post*, in addition to *Lilliput*, until leaving
the country. "Within a year he brought *Picture Post* to a circulation of 1.7 million,
and statistics from the time indicate that it was read by half the adult population
of England. *Picture Post* provided a logical progression in and arguably the pin-
nacle of his creative achievement."[208] With the license to advertise *Lilliput* in *Pic-
ture Post* (and vice versa) he managed to interweave both publications. Lorant
recognized that John Heartfield's "Kaiser Adolf was a masterpiece of political
art," and showed it prominently in both magazines. "Combining photographs of

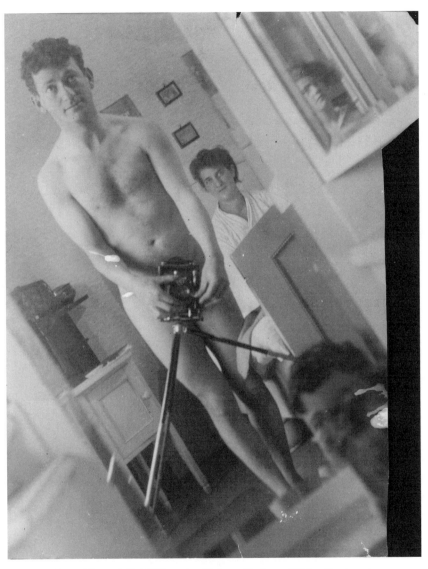

Erwin Blumenfeld, *Self-Portrait with Lena, Lisette, and Heinz*, Zandvoort,
Holland, 1932. Not your usual photographer's self-portrait.
© The Estate of Erwin Blumenfeld.

FROM THE CURRENT ISSUE OF *LILLIPUT*
Masterpieces of Political Art: " Kaiser Adolf"
This striking satire is typical of the work of John Heartfield. Combining photographs of the ex-
Kaiser and Hitler, he has given Hitler the upturned moustaches, plumed helmet and gorgeous
uniform of Wilhelm II. Seven more photo-montages like this are in this number of *Lilliput*.

John Heartfield, montage in ad: "The Current Issue of *Lilliput*," in *Picture Post*, May 6, 1939,
p. 8. Born Helmut Herzfeld (1891–1968), Heartfield is one of the best-known photographers
employed by Lorant. The ad boasts of a circulation raised from an original 75,000, in July 1937,
to 260,000, in May 1939, asserting, "Its photographs have set a new standard for illustrated
periodicals, and discovered a new technique of humour, the picture comparisons for which
LILLIPUT is famous all over the world." This claim was indeed well founded. © The
Heartfield Community of Heirs/VG Bild-Kunst, Bonn and DACS, London, 2014.

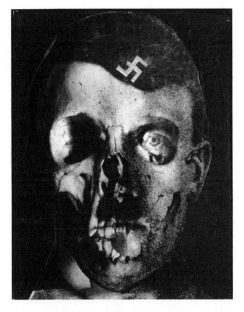

Erwin Blumenfeld, *Grauenfresse [mug of horror]/Hitler.*
Montage, Holland, 1933. Collage and ink on photomontage.
© The Estate of Erwin Blumenfeld.

the ex-Kaiser and Hitler, he has given Hitler the upturned mustaches, plumed helmet, and gorgeous uniform of Wilhelm II. Seven more montages like these are in this number of *Lilliput.*" Blumenfeld, too, produced equally devastating (but less-known) images of Hitler that were "used as anti-Hitler propaganda by the Allies in 1943."[209]

In part due to the brilliance of photographers such as Blumenfeld, Glass, and Heartfield, Lorant was thrilled to report that from July 1937 to May 1939 the circulation of *Lilliput* had grown "from 75,000 to 260,000."[210] It has been little noticed, however, that these magazines also spread a self-consciously anti-racist and anti-antisemitic visual discourse as never before articulated in the pictorial press.

Lorant's career flourished in the United States, as well, but not so much in the realm of magazines. Almost in parallel to Helmut Gernsheim in Britain, Lorant wrote a number of photographic histories on American and world historical themes. He would never, however, be as near the center of power in the United States as he was in Britain between the outbreak of the Second World War and his forced emigration. Within a year of having arrived in the United States,

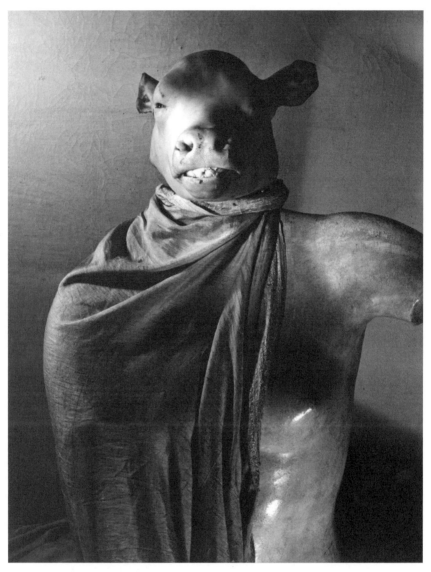

Erwin Blumenfeld, "The Minotaur or the Dictator." Paris, 1937.
Vintage gelatin silver print. © The Estate of Erwin Blumenfeld.

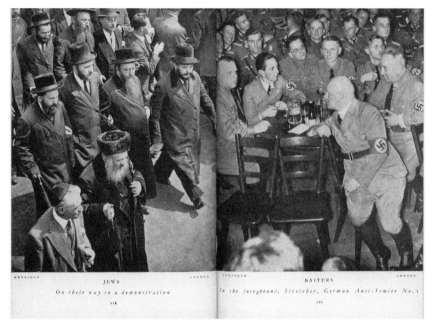

Keystone [agency], "Jews" versus "Baiters," in *Lilliput*
(July–Dec. 1937), pp. 218–219. Private collection.

"Lorant's first pictorial biography, *Lincoln, His Life in Photographs* (1941), was published. Later editions provide the most complete collection of Lincoln portraits."[211] Lorant and Gernsheim shared an interest in American Civil War–era photography, and together helped to bring prominence to photographers such as Matthew Brady.[212] "Politically astute, Lorant visually analysed and illustrated the development of American democracy through its people and its cities." Upon his death in 1997 Lorant was just short of being a millionaire,[213] but his feeling of being treated harshly, first by the British government, and then by Tom Hopkinson, always stuck in his craw.

One of the photographers used frequently by Lorant, and who especially gained prominence in *Picture Post*, was Robert Capa. This was highly unusual, because during Lorant's tenure most of the photographers in *Picture Post* were not specified. Lorant deemed Capa the world's premiere combat photographer.

Capa, a Hungarian Jew, was defined largely by the fact that he was—like so many others who would play an immense role in photojournalism—forced to flee Nazi Europe. Biographies of Capa, while acknowledging his Jewish back-

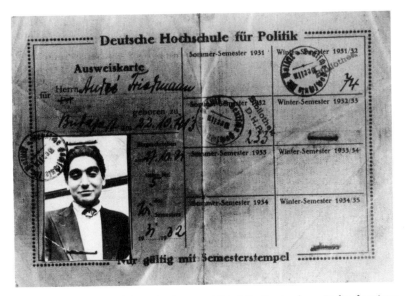

Robert Capa's student card from the German Political Studies Academy, Berlin, for winter semester 1931–1932. This is a reminder that much of the day-to-day work of many photographers had mainly practical purposes, such as producing photographs for identification documents. This photo was taken before Andre Friedmann's tranformation into Robert Capa, which was a joint effort of himself and his partner, Gerda Taro. Like Capa, Taro was killed on assignment. © Collection Capa/Magnum Photos.

ground, are more likely to dwell on his "Hungarian-ness" rather than his Jewish-ness.[214] It is well known that he left Hungary for Berlin at age seventeen and worked in the darkroom of the Dephot photo agency. Felix Man claimed that "the famous Capa (Robert [sic] Friedmann)[215] learnt everything from me,"[216] which probably was something of an exaggeration. Simon Guttman, who hired André Friedman, offers a different perspective. Guttman asserts that "it was Judaism that brought Friedmann to Dephot and thus to photography." David Shneer writes that "Guttman's interest in esoteric Judaism led to his first meeting with Friedmann at a discussion group conducted by Oskar Goldberg, a Berlin-based Kabbalist and numerologist."[217] Capa might also have been there for the girls.

With the exception of Shneer and Gidal, the resistance to seeing Capa's Jew-ishness as important is furthermore perplexing, because his own autobiography, *Slightly Out of Focus*, however evasive, is unequivocal about his Jewish identity. His account merits more serious consideration than it has thus far received if we wish to better understand and reconstruct the social world and proclivities of photography, outside of Nazi Europe, in the 1940s and early 50s.

Slightly Out of Focus begins with Capa in his cramped, disheveled studio apartment on New York's Ninth Street, "a big bed in the corner, and telephone on the floor. No other furniture—not even a clock." In one day's mail were three letters, one an overdue electric bill, and another "from the Department of Justice [of the United States], informing me that I, Robert Capa, formerly Hungarian, at present nothing definite, was hereby classified as a potentially enemy alien, and as such to give up my camera, binoculars, and firearms, and that I would have to apply for a special permit for any trip that would take me more than ten miles from New York."[218] Capa's dilemma in New York was not much different from the situation of his colleagues in Britain, whose movements and pursuit of their livelihood were severely restricted. "The third letter was from the editor of *Collier's* magazine. He said that *Collier's*, after pondering over my scrapbook for two

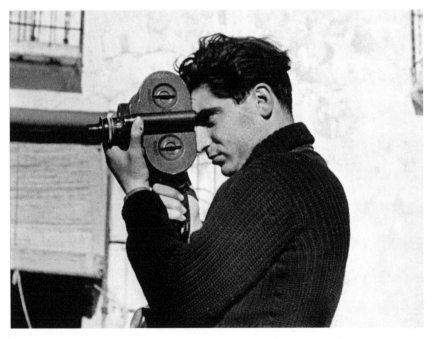

Gerda Taro, "The Greatest War Photographer in the World: Robert Capa," in *Picture Post*, vol. 1, no. 10, Dec. 3, 1938. Caption beneath the photo: "In the following pages you see a series of pictures of the Spanish War. Regular readers of 'Picture Post' know that we do not lightly praise the work we publish. We present these pictures as simply the finest pictures of front-line action ever taken. They are the work of Robert Capa. Capa is a Hungarian by birth; but, being small and dark, he is often taken for a Spaniard. He likes working in Spain better than anywhere in the world. He is a passionate democrat, and he lives to take photographs. Over a year ago, Capa's wife, on her way back to join her husband in Paris, was killed in Spain." Gerda Taro © International Center of Photography.

months, was suddenly convinced that I was a great war photographer, and would be very pleased to have me do a special visiting assignment; that a reservation had been obtained for me on a boat leaving for England in forty-eight hours; and that enclosed was a check for $1500 in advance."[219] Capa was, indeed, a great war photographer. But he probably would not have caught the editor's eye at *Collier's* if not for his promotion by Lorant.

"Here was an interesting problem," Capa continued. "If I'd had a typewriter and sufficient character, I would have written back to *Collier's*, telling them that I was an enemy alien, that I could not go even to New Jersey, let alone England, and that the only place I could take my camera was the Enemy Aliens' Property Board down at City Hall."[220] It is well known that Capa was able to take up *Collier's* offer and further enhance his reputation, especially because of his work during the D-Day landing. For Capa, however, getting there and telling the tale were half the fun.

> Next morning, the British consul general in New York remarked that my case was highly unusual—but that the war was highly unusual too. He gave me a very usual-looking piece of white paper, asked me to put down my name, explain why I hadn't any passport, and state my reasons for travelling.
>
> I wrote that my name was Robert Capa; that I was born in Budapest; that Admiral von Horthy and the Hungarian government had never liked me, and that I had never liked them; that the Hungarian Consulate, since Hitler's annexation of Hungary, refused to say that I was not a Hungarian, nor would they say that I was; that, so long as Hitler was in charge of Hungary, I definitely refused to say that I was; that I was born deeply covered by Jewish grandparents on every side; and that I hated the Nazis and felt that my pictures would be useful as propaganda against them.[221]

As he was born André Friedmann, and his mother was a Berkowitz, Capa's Jewish descent was inescapable. Capa, like Lorant, was famous, or infamous as the case may be, for enjoying the company of numerous women. In addition, despite the claims of both Man and Guttman, it was in fact two rather strong Jewish women who were crucial in setting and steering Capa's vocation as a photographer: Eva Besnyö (1910–2002) and Gerda Taro (1910–1937). Besnyö turned him into an aspiring professional photographer, and Taro helped fashion him out of "André Friedman," and into "Robert Capa."[222]

For the most part Capa leaves his earlier life out of *Slightly Out of Focus* in order to concentrate on the Second World War and its immediate aftermath. At the very center of his narrative is an analogy between the importance of the

myth of the Exodus to the Jews, and the reality of D-Day to the French and the rest of the free world.[223] It also is peppered with vignettes including "the Jewish medic" who was infinitely braver than he himself upon landing at "Easy Red" beach;[224] and Lieutenant Colonel Abrams, who "looked like a cigar-smoking Jewish king."[225]

Interestingly, Capa chose not to take pictures of the remains and survivors of Nazi death factories, which "were swarming with photographers, and every new picture of horror served only to diminish the total effect. Now for a short day, everyone will see what happened to those poor devils in those camps; tomorrow, very few will care what happens to them in the future."[226] Perhaps the fate of the European Jews was simply too raw, and he knew too well that the world from which he had sprung was destroyed. The "surviving remnant" was, in some ways, an extension of his close-knit family. Part of Capa's incentive in founding the Magnum agency in 1947 was his desire to help his brother Cornell, by institutionalizing their partnership. Capa also was dedicated to assisting family members and friends who had survived the Holocaust, some of whom aspired to make their livelihoods in photography.[227]

To the extent that there was some element of choice in his assignments, Capa devoted substantial effort to capturing the new Jewish life as it was struggling to materialize in Palestine and the state of Israel. The sympathy with which Zionism was portrayed was one of the factors that went into the assessment of how pro- or anti-government a publication was in Britain, at the time of the violent dissolution of the mandate for Palestine and the emergence of the state of Israel.[228] As a regular for *Picture Post*, then, Capa may have been perceived as supplying photos that were critical of government policy. His photographs from the 1947/48 War and Israel's early years of statehood have an unsettled quality, as opposed to the typically sharp, glossy images of buildings, farms, and bronzed *haluzim* from Zionist publications.[229] People look pensive, occasionally unkempt, sweaty, and dirty.[230] Along with the Jews who sought refuge in the *yishuv* and Israel, Capa also lent sympathy, realism, and dignity to the Jews who remained in Europe.[231]

The supposed "love affair" of the Western press with Israel, and by extension, the remnant of European Jewry, was understandably more pronounced in the United States than Britain. Sympathy for Jews and Zionism, although certainly a consequence of growing awareness of the Holocaust, was also in no small part a product of larger historical currents having little or nothing to do with Zionism or Israel per se. Hunter, Salomon, Chim (David Seymour), and Capa—but also their close friends and colleagues like Eisenstaedt, Cartier-Bresson, and Margaret Bourke-White—had a greater impact on concretizing the idea that Zionism

Robert Capa, "The central front. The Haganah, marching towards the front line, to defend a Kibbutz, May 1948," in *Images of War* (London: Paul Hamlyn, 1964), 156. This photograph appeared in numerous publications, including the popular *Report on Israel* by Irwin Shaw and Robert Capa (New York: Simon and Schuster, 1950). Robert Capa © International Center of Photography.

ultimately was on the side of good, with Jews and Israel integrated into a sea of greater humanity, than has been noticed or appreciated. They had a huge influence on the respect, even reverence, shown to organized efforts on behalf of world Jewry, and linked the plight of Jewish Displaced Persons (DPs) in Europe with the fate of Zionism. A visual idiom of a legitimate Jewish nation, realized as Israel, was accepted as normal.

Prior to this, Jews in Britain, under Lorant, had been presented as decent, proper British subjects by refugee and native-born photographers alike. An early issue of *Picture Post* shows a scene, photographed by Humphrey Spender (brother of poet Stephen Spender), whose own Jewish connections were tenuous, that was both realistic and respectful: "The Yiddisher Parliament Meets. Not far from the London Hospital, is a little open square known locally as the 'Yiddisher Parliament'—though others besides Jews are 'members.' Here on any day of the week rage keen discussions."[232] Spender also photographed a respectable

Jewish family assembled in Whitechapel around the dinner table. In contrast to Nazi thinking and propaganda up until 1945, Jews were rendered, by the photojournalists dominating British and American newsstands, as human beings.

Especially striking in this regard are the photographs, shot in December 1938 by Kurt Hutton and Gerti Deutsch for *Picture Post,* of the first arrivals on the Kindertransport to London. Deutsch herself had only just landed in London after fleeing Vienna from the Anschluss and was employed by Lorant. Within four months she became engaged and married the recently divorced Tom Hopkinson.[233] She immediately was cast in the role of documenting but also interpreting the current wave of migration to Britain of which she was a part. As opposed to seeing herself as an advocate for the refugees, Deutsch was and remained "relatively apolitical."[234] Their pictures showed handsome, smiling

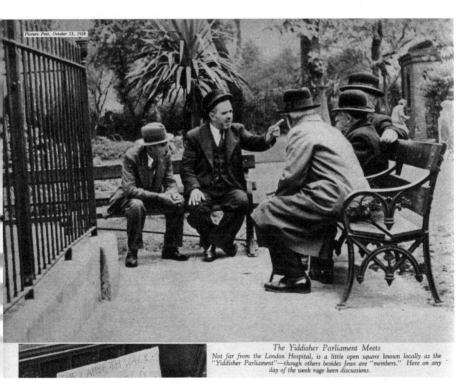

Picture Post, October 15, 1938

The Yiddisher Parliament Meets
Not far from the London Hospital, is a little open square known locally as the "Yiddisher Parliament"—though others besides Jews are "members." Here on any day of the week rage keen discussions.

Unattributed [Humphrey Spender], photos to accompany "The Yiddisher Parliament Meets," *Picture Post,* vol. 1, no. 3, Oct. 15, 1938, p. 24. "The stranger who treads the pavements of Whitechapel is bound to sense the almost aggressive vitality of the life that flows there. These people are standing with both feet on the ground. They are holding tightly onto reality with both hands. There is not a man living who can lay claim to a fibre of better quality than these Jews and Cockneys" (25).

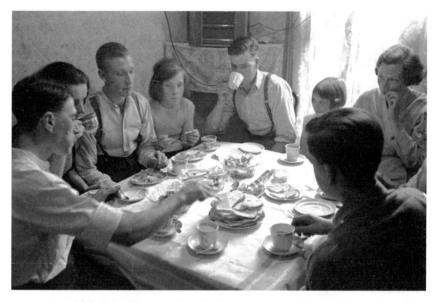

Unattributed [Humphrey Spender], "Family Tea in an East End Home. Catering is not easy.
Mother-in-charge of a family may very well have to feed a dozen—and most of them get
in at different times on week-days," *Picture Post*, vol. 1, no. 3, Oct. 15, 1938, p. 24.
Hulton Archive/Getty Images.

teenage boys and were accompanied by captions like "His First English Lesson:
Many Knew a Little English. All had a lesson the first day they arrived"; and
"'Seems All Right Over Here': A wealthy Jew had sent new clothes for all. But
most had brought enough with them."[235] *Picture Post* assured its readers that
these young refugees were utterly respectable. Obviously their plight was des-
perate, but they would not become a burden to the British. The pictures also
clearly showed these normal, happy children as exhibiting no trace of the ugly
and threatening stereotypes that the Nazis and their followers attributed to Jews.
"They are in a land," the lead article proclaimed, "where they will not be despised
on account of race!"[236] It might be tempting to envision the humane portrayal of
the East End Jews by Spender, and of the Kindertransport by Hutton and
Deutsch, as well as Capa's sensitive treatment of the Haganah, as some kind of
plot. But the confluence of their perspectives showing compassion for Jews, as
individuals and members of an ethnic group and nation, is more a coincidence.

Perhaps the next-most significant émigrés, after Lorant, for the introduction
of a new approach to interwar and wartime photojournalism were the husband
and wife team of Hans and Elsbeth Juda. Their main journal, *The Ambassador*,

which originally appeared as *International Textiles*, has mainly been analyzed and appreciated for its contribution to the promotion of textiles specifically and design more generally. As a recent volume of the Victoria and Albert Museum makes clear, the effort of the Judas emerged out of their situation as refugees from Nazi Germany.[237] Like Eisenstaedt, Salomon, and many others, Hans Juda had worked for the Mosse publishing house covering the textile industry for the *Berliner Tageblatt*.[238] He did not, though, have expertise in photography per se, but had made his name mainly as a financial journalist. His mind was always aware, however, of the connections between politics and economics, and how economic policy could be influenced through an "intelligent" and attractive publication. "It is as if the state of the world were not yet bad enough," the opening statement in *International Textiles* (1933) reads.

> The paradox "Everybody wishes to sell, nobody to buy" still holds sway. Yet no economic system can serve the interests of one country alone; every undertaking, whether it will or not, must link up with the economic system of the world. *International Textiles* realises this. It fulfils the task of source of information for and connecting link between the textile industries and the various countries. In four languages it appeals to the textile interests of the whole world. In four languages it also urges economic co-operation. Civilised man is distinguished from the savage by clothing and superior intelligence. This periodical is devoted to clothing in all its aspects. It is also intended to serve the cause of this intelligence.[239]

In addition to its stated aims, the journal emerged as stridently anti-fascist and supported the positive integration of Jews, especially refugees, into the UK and world markets. In a subtle way it fought the demonization and denigration of Jews and "Jewish businesses" by serving as a champion for commercial networks that rejected anti-Jewish prejudice. Interestingly, though, it did not expressly try to subvert the trade with Nazi Germany, and reported on and advertised "German fashions."[240] A plea for firms to maintain their "foreign representatives" seemed to implore German companies to support their employees abroad who were being forced out of their jobs.[241]

At least as important as the articles, though, were the ads for Jewish-owned firms, some of which had apparently relocated from Central Europe to Britain, the United States, and other countries: "Same High Quality But New Address."[242] Similar to Lorant's presentation of Jews as normal and unproblematic, Hans Juda ensured that the trade journal with the most vital connection to the livelihoods of Jews resisted stereotypes and chauvinism, allowing Jews and unmistakably Jewish businesses to hold their rightful place in the commercial landscape.

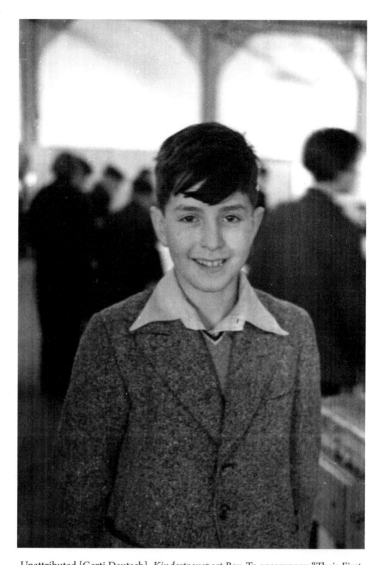

Unattributed [Gerti Deutsch], *Kindertransport Boy*. To accompany "Their First Day in England. Several hundred German-Jewish children—forerunners of several thousand who will be trained to establish themselves in the colonies— are already in this country. Here you see them on their first day in the land which has become their own." The caption of the images reads: "One of the Unnamed Guests. Their names and addresses had to be kept secret—for the sake of those left behind," *Picture Post*, vol. 1, no. 12, Dec. 17, 1938, p. 56. Hulton Archive/Getty Images.

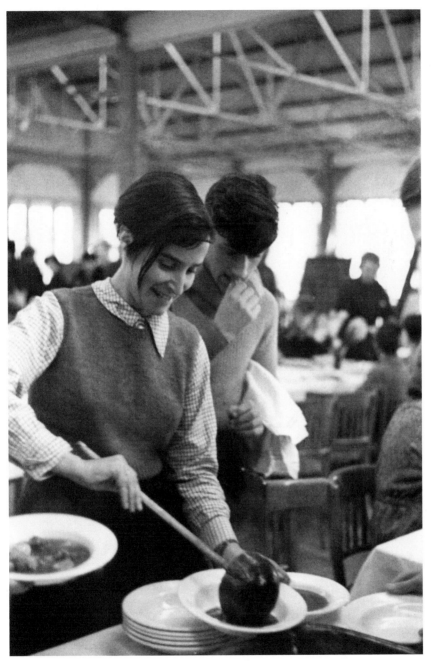

Gerti Deutsch, *Kindertransport Girl*. This was taken in the shoot for the article "Their First Day in England" but was not then published. Location identified as Dovercourt Bay camp, near Harwich in Essex, 1938. Hulton Archive/Getty Images.

Unattributed [Elsbeth Juda], ad for Women's Wear Limited,
65 Margaret Street, London, *International Textiles*, no. 8,
1941, p. 5. This was most likely shot for the journal edited
by her husband, *International Textiles* (renamed *The
Ambassador*). Victoria and Albert Museum.

The photography was done mainly by Elsbeth, whose initial role had been to conduct "interviews in English" for journal articles, because Hans was not yet proficient enough in speaking the language.[243] In Germany she had "studied photography under Lucia Moholy of the Bauhaus and became a fulltime professional fashion and advertising photographer, under the name of 'Jay.'"[244] At first she worked as a freelance photographer in London and also took photographs for *International Textiles*. After her own studio was destroyed in the Blitz, her husband remarked: "Look, there's a job here that needs doing and you had your fling." So she "took over as photographer and assistant editor at [what was then titled] *The Ambassador*."[245] In a behind-the-scenes-type ad, a woman photographer is shown—one of the few, if any, to portray how "a shoot" works.[246]

Although *The Ambassador* might be marginalized as a "trade journal" it became extremely important for British business generally, and for the economic life of its Jews. Certainly politics and aesthetics were significant: but Elsbeth Juda made clear that the first goal of her husband and herself was "making a living"[247]—and exerting their unstinting, most imaginative efforts toward producing a striking magazine in which Jews were unapologetically both behind the scenes and in the front ranks of nearly every aspect of the textile business. As distinctive as they were, the Judas, too, wove themselves into the complex history of Jews and photography in Britain.

Photographic Practice at the Warburg Institute, 1933–1948

I N A WARBURG INSTITUTE photographic exhibition of 1943, "Portrait and Character," led by Sir Kenneth Clark (1903–1983), the opening panel showed a dozen views of one woman. Clark, whom we have seen playing a key role in the rejection of Stefan Lorant's application for naturalization, was a preeminent art historian, curator, and arts administrator. He had been director of London's National Gallery since 1933, and was not known as a champion of either photography or a great deal of what constituted modern art.[1]

The picture series illustrated a simple point: that a number of possibilities of perception exist when approaching "character." The panel also was intended to both challenge and draw a lesson from the myth of photographic objectivity—the notion that the camera does not lie. Clark and the Warburg curators recognized that the camera is not just a recording instrument—a great deal depends on the skill of the person taking the photograph, on how it is executed, and then on how it is developed, cropped, printed, and framed. What we confront in this instance is a dozen very different images of the same person. Of course it is cliché to say that beauty is in the eye of the beholder. But Clark, a formidable scholar, and the Warburg Institute, a bastion of scholarly erudition, wished to drive home a similar point about representations of people, as individuals and as groups. One's perspective and subsequent analysis about the relationship between a picture and "character" depend a great deal on the person or corporate entity portraying that "character."

In addition to addressing the fundamental problem of perspective, there is a rich and interesting history behind this initial segment of the exhibition that represents the evolving approach of the Warburg Institute to photography.[2] The photographer who took the disparate images of the single individual was Lotte Meitner-Graf (1899–1973).[3] Lotte Meitner-Graf was born to a Jewish family in

Vienna and established a photography studio there in 1920. Eventually she had premises in the city center and counted as her clientele a number of "artists, musicians, and scientists"—until the wave of antisemitism accompanying the Anschluss compelled her to emigrate. She was fortunate to land safely in Britain and to be able to resume and reconstruct her career, owing largely to émigrés who had fled earlier. Meitner-Graf, in part because of the connections afforded by her illustrious sister-in-law, physicist Lise Meitner (1878–1968), is mainly remembered as a portrait photographer who had several scientists and intellectuals among her sitters, such as a leading medical academic in London, Max Leonard Rosenheim (1908–1972), and the famed African American contralto, Marian Anderson (1897–1993).[4] Anderson also was photographed by Trude Fleischmann from Vienna, whose work appeared in Lorant's *Münchner Illustrierte Presse*. She fled to London via Paris after the Anschluss, eventually settling in New York.[5]

Meitner-Graf was, to be sure, a talented photographer who forged a successful and distinctive career. In retrospect, as a foreigner, specifically a Jewish refugee from Central Europe (despite having formally converted from Judaism)—she was representative of a number of currents. Along with her work as a portrait photographer with a studio on Old Bond Street, Meitner-Graf also photographed works of art. This is probably how she came to the attention of Clark. The photographing of art and architecture—not mainly for postcards or other consumables,[6] but as a part of collecting, scholarship, and curatorship—became something of a Jewish industry in London in the interwar and war years.[7]

The Warburg Institute was (and is) not a "Jewish" institution in any official sense—except in the eyes of the Nazis. It was (and remains) a library and research center focused on the classics, on the academic study of Western (and Eastern) civilizations from antiquity to the Renaissance. The library, founded by Aby M. Warburg (1866–1929),[8] originated in Hamburg, moved to London in 1933, and officially has been part of the University of London since 1944. It never was dedicated to serving expressly Jewish interests, but it was established, sustained, and developed primarily through the work and support of men and women with Jewish connections. Aby Warburg's family business, a Jewish-owned investment bank and related financial enterprises, enabled the library to germinate in the first place, and the New York branch of the family facilitated its relocation to Britain in 1933.

During roughly the first decade of its reestablishment in London, the Warburg was perceived as a "Jewish" institution. The Society for the Protection of Science and Learning (SPSL), which was one of the most proactive forces

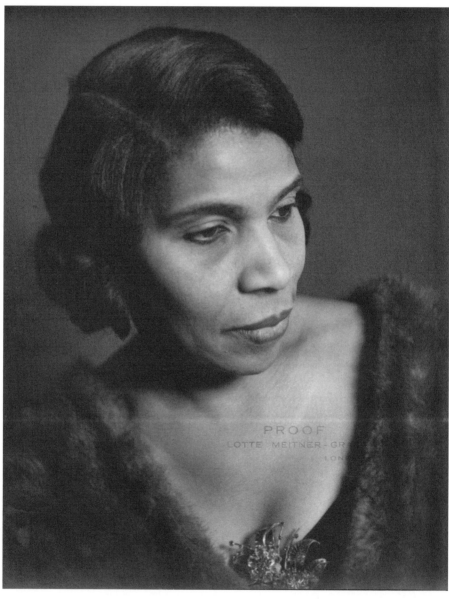

Lotte Meitner-Graf, *Marian Anderson* (1897–1993). Anderson is recalled for several "firsts":
she was the first African American to be invited to entertain at the White House, and
the first to perform with the New York Metropolitan Opera; no doubt she made
many other such pioneering appearances. Estate of Lotte Meitner-Graf,
Bridgeman Art Library (London).

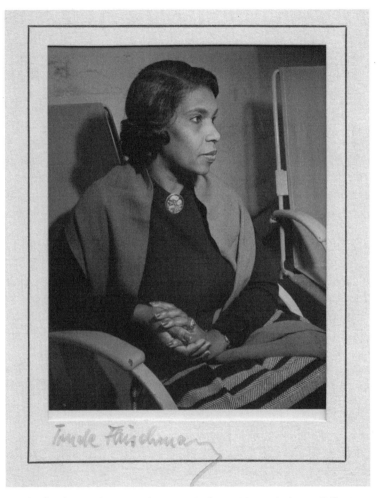

Trude Fleischmann (1895–1990), *Marian Anderson*. Marian Anderson Collection, Kislak Center for Special Collections, Rare Books and Manuscripts, University of Pennsylvania.

assisting Jewish refugee scholars in interwar and wartime Britain, asserted in 1939 that "*As a Jewish foundation, and with a predominantly Jewish staff*, the Institute was in actual physical danger in 1933. It was moved to London in 1933, ostensibly loaned by the German Government for the first three years, but is now secured as an integral part of London University, and is recognised as one of the most valuable additions to learning which has resulted from the political developments in Germany" (emphasis added).[9]

The individual outside of the family who was most crucial in transforming Warburg's library into a research institute in 1921 was Fritz Saxl (1890–1948). "The further development of the Institute, especially after Warburg's death in 1929, was guided by Saxl, whose interests ranged over the history of art and religion, from the study of Mithraic monuments and astrological manuscripts to Rembrandt and Velázquez. Like Warburg, Saxl taught at the University of Hamburg, where Erwin Panofsky and Ernst Cassirer were his colleagues. The publications which appeared under his editorship show how large was the circle of scholars whom he attracted and who helped to shape the Institute's outlook and traditions."[10] In the London setting Saxl was unrelenting in his efforts to secure its place in British and world academe and to continually enhance its role. His efforts in assisting refugees went far beyond the confines of the Warburg itself. In the confidential appraisal cited above, Saxl was lauded for having "given invaluable help to the Society [for the Protection of Science and Learning] on behalf of refugee scholars."[11]

Gertrud Bing (1899–1962), who as assistant director of the Warburg from 1933 to 1955 worked alongside Saxl and Henri Frankfurt (1897–1954), begins her biographical reminiscence of her life partner and colleague, Fritz Saxl, by recalling that he emanated from

> one of those Central European Jewish families for whom Vienna used to be the first stage on the road to emancipation. His grandparents owned a shop in Senftenberg, a small town in that part of Bohemia which has since become notorious as the Sudetenland. Saxl used to relate that when he visited them as a child he was thrashed in turn by German boys for being a Jew and by Czech boys for being a German. But he remembered with pleasure that his grandfather used to study the Talmud in a back room during leisure hours spared from making a scant living; to seek refuge in learning seemed to him a dignified way of turning one's back on the hardships of life. In view of these handicaps of place and circumstance it may seem surprising that his father should have been given any opportunity at all of receiving a higher education—especially as this meant that he was sent to

Unattributed, *Fritz Saxl* (1890–1948) *and Gertrud Bing* (1892–1964).
Warburg Institute.

Prague at the age of nine and then left to fend for himself; but no-one in his sur-
roundings seems to have thought this unusual. . . . Like most of his generation
[Saxl's father] renounced religious orthodoxy, and his children received little Jew-
ish education. But he found other channels for that taste for learning which the
tradition of Talmudic exegesis and the study of Jewish law and faith often imparts
to its heirs; his interests were divided between higher mathematics and the com-
parative study of Indo-Germanic languages. [Fritz] Saxl had to learn Latin at the
age of five, Greek and Hebrew at seven or eight, Sanskrit at eleven.[12]

Saxl's Jewish consciousness, however, was not limited to warm childhood
memories. Dorothea McEwan reveals that in the wake of the First World War he
identified, with pronounced enthusiasm, with the Zionist cause. Saxl was par-
ticularly struck by Martin Buber's notion that a "New Jewish Art" must accom-
pany the Jews' national reawakening.[13] Saxl likewise implored "Jewish youth to
study the problems of the fine arts." While lauding "Max Liebermann as the
greatest Jewish artist of the past generations," Saxl qualified that "what was re-
quired in Palestine" to enact the Zionist program "was not the creation of a
'Klein-Europa,'" a little-Europe, "but something new." Reflecting the thinking
behind the creation of the Bezalel School of Arts and Crafts in Jerusalem in 1906,
Saxl "advocated practical instruction and education to create high-quality, taste-
ful housing, apartments, books, [and] materials. Fine arts in all their branches
were important. . . . [T]he active mind" had to be coordinated with the active
hand as the "pervasive spirit in Jewish work." McEwan characterizes Saxl's Zion-
ism as a phase he transcended as an adult in favor of "internationalism and
socialism."[14]

Although there is no evidence of residual Zionist feeling, Saxl's ongoing work
at the Warburg from 1933 onward evinces at least three aspects of continuity
with his earlier Jewish nationalist fervor: a concern for making Jews as "produc-
tive" as possible; a desire to have Jews develop and be perceived as a "normal"
nation; and consistently acting on the principle that Jews must be mutually ac-
countable for each other.

Interestingly, Zionism since 1897 had been in the avant-garde of using photo-
graphic media, but this was taken for granted.[15] As McEwan astutely observes, in
addition to their academic studies, interest in the potential of photography for
pedagogical and political purposes provided further common ground between
Saxl and Aby Warburg, along with their passion for art history and the classics.[16]

Warburg's uncompleted picture atlas project also may be seen as sowing the
seeds for the photographic projects of the Warburg in London. "Warburg cre-
ated large panels that he covered with a black cloth backdrop and then adorned

with a collage of images that included reproductions from books and visual materials from newspapers and daily life." According to Emily Levine, "[b]eginning in 1924, Warburg presented groups of these screens, devoted to themes such as the relationship between north and south, Florentine civic culture, and the role of astrology, to scholars and friends."[17]

The cardinal fact that the Warburg Institute relocated to London from Germany in 1933 derived from the Jewish bedrock of the enterprise, despite the fact that this is rarely reflected in official accounts.[18] Although there were other "foreigners" in London in the 1930s and 40s, the men and women in the Warburg orbit were different. As opposed to, say, non-Jewish Poles or Greeks, who also comprised communities of affinity in exile, the Warburg's "foreigners" did not envision a return to their homeland.[19] By no means does this mean that they predicted or anticipated the Holocaust. But the members of the Warburg Institute, from the moment they landed in London, were not animated by the possibility of a return to Germany, given that the seismic shift in attitudes embodied by National Socialism could not possibly be overturned in the foreseeable future. They saw themselves as having lost their homes and homeland. The intellectual climate in Nazi Germany, even in its early days, could never accommodate the Warburg's critical method. Their stay in Britain would, by necessity, have to be permanent. Although rarely articulated in a forthright manner (as it was by the SPSL), the common understanding was that the Warburg Institute, although it included a number of non-Jews, was a supremely Jewish-friendly society.

In the context of its time, particularly in contrast to the German scene from which it was excluded, a salient fact of the approach of the Warburg was its utter rejection of race in both its overarching academic enterprise and in the way it dealt with the individuals in its midst. Certainly, in terms of religious identification and observance, Judaism was meaningless or tenuous to most members of the Warburg Institute. There were, among them, "half-Jews," converts from Judaism, and a few gentiles. But the inescapable fact was that their Jewish-refugee identity would shadow them as well in Britain.

What was it, then, that tied photography to the Warburg? First and foremost, it was respect for photography as a leading instrument of the academic research that they pioneered and prized. It was not that other institutions, such as Harvard and Yale, and Oxford and Cambridge, did not use photographs in their study of art.[20] Their objective, however, was to serve their own faculty and students, not scholars at large. Contemporary photographic enterprises focused on the history of art and architecture were intended mainly for the institutions in which they were founded, and in the case of what came to be known as Foto Marburg, nationally derived and focused. After the Nazi takeover, this branch of

Marburg's university enthusiastically served to record and consolidate the plunder of the Third Reich. "Photocampaigns" devised by Foto Marburg for the Baltics and France were expressly antisemitic. It is telling, though, that their wartime photographic unit included thirty-five prisoners,[21] that is, men and possibly women working as slave-laborers.

But the attitude of the Warburg was different—in respect to the prominence given to this aspect of their mission, and to the notion that it would be accessible to every scholar engaged in related work. As we shall see, the idea of a national spirit or racial essence was rejected out of hand—which is part of the reason the Warburg project, as well as the related work of the Gernsheims—has proven to be so valuable. The Warburg's goal was not simply to make its research and resources available for its scholars to do their own work, or to do their work better, but to open the door of the Warburg to the rest of the scholarly world. McEwan argues that the prime motive for photographic exhibitions at the Warburg was to strengthen the sullen wartime spirits of the surrounding population, and thereby, concomitantly, to bolster and spread its reputation.[22] While this was indeed part of the story, Helmut Gernsheim is more accurate in emphasizing that the Warburg Institute's engagement with photography in the war years was a way to make itself relevant and useful to the British government and to a community that spread far beyond the confines of academe.[23] The very idea that this was a possibility, and the ways the Warburg sought to bring such an idea to fruition, had much more to do with the confluence of Jews and photography than even Gernsheim imagined. He was too much in the thick of it to have critical distance from the phenomenon, in which he assumed a leading role.[24]

Although the camera remained an instrument, a means to understand art and material culture from earlier ages, the Warburg allowed for greater prestige to be accorded photography than did any contemporary museum or academic environment. The Warburg fundamentally repositioned the previous role of photography as undertaken at leading universities, and even the newly minted Courtauld Institute. Included in this process was the possibility of allowing for the professionalization of photography, as related to scholarly pursuits. This paradigm shift was nevertheless contested, and there was a great deal of resistance—such as in the conflict between Gernsheim and Rudolf Wittkower (1901–1971), as has been illuminated by Christy Anderson.[25] But the fact remains that the Warburg provided the cultural space for such a change to occur—moving toward the notion of photography as art on its own terms.

Helmut Gernsheim, we shall see, sought to merge mid-twentieth-century photography with what he saw as an existing national tradition in Britain, which ought to be esteemed and reinvested with tremendous pride. Gernsheim, and to

a lesser extent the Warburg Institute as a body, sought to transform photography into a dynamic force of its own. There were others who attempted to creatively unite the worlds of art and architectural history with photography—such as Stella Kramrisch (1896–1993) and Heidi Heimann (1904–1993), who also played large roles in Warburg exhibitions. Lesser-known figures who helped to bring art history to a wider public through photography—such as Alfred Carlebach, in his work for Anthony Blunt, apparently through the Tate—have left barely a trace in the archives,[26] and entire books filled with their photographs do not necessarily mention their names.[27] The work of Carlebach, and others such as Lotte Meitner-Graf and Paul Laib (1869–1958)[28] are largely forgotten or ignored, partly because they did not articulate a discourse about their photographic endeavors as Gernsheim did. Gernsheim, particularly in his revolutionary work on Victorian photography in Britain, sought to expose and cultivate photography's glorious past and extend its brilliance into the future.[29]

Inasmuch as the Warburg's embrace of, and approach to, photography was informed by the circumstances and characteristics of Jewish social trends, its work was assisted by sympathetic individuals and institutions in Britain—notably Kenneth Clark in his various roles in government and the arts, and Samuel Courtauld and the Courtauld Institute. In all of the Warburg publications and addresses, acknowledgment and praise for such help was effusive, and cooperative ventures were always matters of special pride.

In retrospective treatments of the Warburg and the Courtauld, the fact that the vast majority of the work under their auspices (and this is true, as well, of Kenneth Clark) was free of racism, stereotypes, and even British national chauvinism is barely noticed and therefore underappreciated. The utter rejection of race as a scholarly concern, in terms of distinguishing human races from each other in any sort of hierarchy, was remarkable for its time. It must be said, though, that Clark had his reservations about photography and, like many, was put off by Gernsheim.[30] We also have seen that he failed to stand up for Stefan Lorant, not having the backbone to consistently challenge antisemitism.

But the stance Clark took publicly and the types of programs he supported were important. What was explicitly rejected, in the arts establishments that cooperated with the Warburg, was the notion that Jews constituted a separate race. This was not the case in other quarters of British society, such as the elitist and Christian-centered BBC, those engaged in foreign policy—where the notion of a Jewish race often arose in discussions of immigration and policy in Palestine[31]— and in the medical establishment—especially among those interested in eugenics and hereditary diseases such as diabetes.[32] In a brilliant, quiet, and understated way—and all the more powerfully and effectively because of this—the Warburg

Institute exhibition in 1943, suggested by Kenneth Clark, was a complete repudiation of racial ways of thinking about civilization, its progress, and its prospects. In this way, photography was a handmaid to truth to a greater degree than many other means of analysis, as it complemented efforts to strip away the myths that allowed racism to emerge and flourish. The Warburg Institute was the anti-racist and anti-racialist institution par excellence. But no one seems to have noticed. This, it might be said, was one of the subtle ways in which its Jewishness was manifested.

·Clark's beneficence to the Warburg Institute, and adherence to its methodology, stems from his 1928 encounter with Aby Warburg, in Rome, which Clark said "changed my life." Warburg, to Clark, "was without doubt the most original thinker on art history of our time, and entirely changed the course of art-historical studies. His point of view could be described as a reaction against the formalist or stylistic approach of [Giovanni] Morelli (1816–1891) and Bernard Berenson."[33] At the outset of his career, Clark had been a protégé of Berenson (1865–1959), a Lithuanian-born American-Jewish art collector and historian.[34] In terms of intellectual impact on Clark, however, there was no equal to Warburg. Aby Warburg's thought about art, Clark wrote, "moved in an entirely different way" from that of Morelli and Berenson.

> Instead of thinking of works of art as life-enhancing representations he thought of them as symbols, and he believed that the art historian should concern himself with the origin, meaning, and transmission of symbolic images. The Renaissance was his chosen field of enquiry, partly because renaissance art contained a large number of such symbolic images; and partly because he had the true German love of Italy. He accumulated vast learning, but his writings are all fragments. He should not have been an art historian, but a poet like Holderlin. He himself said that if he had been five inches taller (he was even shorter than Berenson) he would have become an actor, and I can believe it, for he had, to an uncanny degree, the gift of mimesis. . . . Symbols are a dangerous branch of study as they easily lead to magic; and magic leads to the loss of reason. Warburg went out of his mind in 1918, but by 1927, under the nun-like care of Dr. [Gertrud] Bing, he was sufficiently recovered to visit Rome and give a lecture. Dr. [Ernst] Steinmann, the director of the Herziana, knowing that my German was imperfect, arranged for us to sit in the front row, and Warburg, who preferred to talk to an individual, directed the whole lecture at me. It lasted over two hours and I understood about two-thirds. But it was enough.[35]

F. E. Reiss, "The princesses enjoyed the informal occasion just as much as their parents," in the article "The Pictures Come Back. The King and Queen go to the National Gallery to see the first pictures which have been returned from their wartime hide-out in Wales," *Picture Post*, June 9, 1945, p. 12. Kenneth Clark is playing host to the royal family and Vincent Massey, high commissioner for Canada. The princesses, at this moment, appear less interested than their elders. Getty Images.

His conversion to Warburg's perspective effected an abrupt step back from Berenson and the commitment to "trying to answer the kind of questions that had occupied Warburg."[36]

Distinct from many who hailed from "'the idle rich'" in England,[37] Clark found the company and even mentorship of short Jewish men congenial—if not "lovable." Clark was remarkably forthcoming about what he believed to be the differences between the Christian and Jewish art collectors he met in London.

> In our youth . . . it was customary for Christian collectors to boast of how little they had paid for their prizes. "Picked it up for a few coppers" was the usual phrase. Jewish collectors, on the other hand, were proud to tell one what sacrifices they had made to obtain their treasures. Henry Oppenheimer, one of the most lovable of the old-style collectors, used to say "Ven I tell old Lippmann vat I pay for it, he says 'Mein Gott, Oppenheimer, you are crazy.'" There can be no doubt which of these standpoints denotes the greater love of art; and it is also probable that the Jewish approach leads to more material advantage. Anyone who followed Herr Oppenheimer's advice "py de pest" ["buy the best"] would have had a far greater return on his money than the bargain-hunter.[38]

Clark, in retrospect, was immensely proud that he helped rescue the War-burg, as a library as well as an institute whose members' lives, or at least their well-being and livelihoods, were at stake. In 1933 Clark received an urgent tele-phone call from Saxl, whom he did not know personally. Saxl

> had presumably heard from Dr. Bing that I had been present at Warburg's last lecture. He said, in guarded terms, that the time had come for the Institute to leave Germany, and wondered if there was any chance of it being established in Oxford. I knew enough about University politics to realise that this could not be done without several years of lobbying, during which time the Library would have been seized by the Nazis and the Library staff sent to concentration camps. But I said I would do what I could.

The call from Saxl had interrupted the Clarks' dinner, where Arthur and Jane Lee (Lord and Lady Lee) were their guests. When Clark explained the matter to Lee, Lee exclaimed

> "This could be something for the Courtauld" (he had persuaded Sam Courtauld to found an Institute for Art History bearing his name), and when I described the marvels of the Warburg Library (which I had never visited) and the devotion of the staff, Arthur was convinced and moved into action. First of all he had to per-suade the University of London to accept the Library, but, as time was running short, Arthur somehow bullied the Hamburg authorities into sending over the whole Library as a personal loan to himself [as director of the National Gallery]. He then took a floor of Thames House, which was entirely empty, and had the Library arranged there. Only someone with his will and obstinacy could have done all this, and it showed that men of action are sometimes useful in the world of scholarship.[39]

Clark had no doubt that the Warburg Institute's love of art was as profound as it could possibly be. He was not bothered by the entrepreneurial cast of their pub-lic exhibitions, and he was probably truly honored to have had a leading part in its reestablishment.

In the Warburg Institute's annual report (1934–1935), the first issued after its relocation to London, a considerable amount of attention was devoted to its "photographic departments" as a special point of pride. "The greatest improve-ment which has been effected in the organisation of the Institute is in the photo-graphic section. It is due to its new administrator, Dr. Wittkower."[40] Rudolf Witt-kower was born in Berlin, and like most of his colleagues at the Warburg, had

been thrown out of his position (at the University of Cologne) on "racial" grounds. Upon entering Britain he identified himself as a Reform Jew, and was initially sustained by a grant of £50 from the Jewish Board of Guardians.[41] In his first year in London he and his wife were barely able to live.[42] But Wittkower was a special case at the Warburg, and among Jewish émigrés in general, because he was a British subject—by virtue of the fact that his father, Henry, was born in London in 1865.[43] What this meant, in practical terms, is that Wittkower was not interned as an alien and could travel freely throughout the country, which was especially important for his work with Gernsheim on the National Buildings Record project. Wittkower's wife, Margot (Holzmann), who was a teacher at the Odenwaldschule, also was dismissed from her post in 1933 due to her "race."[44]

In terms of his scholarly career, Wittkower "brought the history of architecture, which had lagged behind other branches of art history, into line with the sister discipline by applying to it the scientific approach and sensitive analysis which had long been in use by historians of painting. In addition to developing [his] method he also discovered new territories, and was the first writer to systematically chart the field of Baroque architecture."[45] Obviously Wittkower was highly valuable to the Warburg. Given the scarcity of academic appointments, the best fit they could find for him was as the head of photography. This was not, however, a random match. Given the kind of work in which Wittkower had been engaged, photography was a good fit, and his appointment would have some unintended and unexpected results.[46]

Under Wittkower the "systematic order" of the photographic collection was "supplemented by a number of card-indexes with cross references" to "*bring us nearer to our idea of making the photographic collection an adequate counterpart of the book collection. The arrangement of books and photographs alike is de-*signed to set out our problem in the clearest possible manner. As the books give a picture of the history of the classical tradition in art, literature, and science, seen through the medium of words, so the collection of photographs will give a complimentary picture through the medium of imagery" (emphasis added).[47] The notion of treating photographs with the same respect accorded books, as principal tools of the Warburg method, was not to be taken lightly. Moreover, the Institute saw this as a realm in which they could take the lead among British museums and universities and enhance their service to the scholarly world generally. "For this purpose we have started upon the long task of completing as far and as systematically as possible our iconographical collection, beginning with graphic art and painting. We are most grateful to the authorities of the British Museum for their encouraging assistance in selecting and recording the relevant objects in the Print Room and Manuscript Department."[48] This was accomplished with

Walter and Gertrud Gernsheim as chief operatives, as we shall see below. "Owing to our limited resources, we have not been able this year to take more than approximately 1500 photographs in the British Museum, which is only a fraction of what this collection offers for our purposes; but we hope to continue on a larger scale next year."[49]

Their intention was no secret: for photography to become something of a growth industry within the Warburg. "A second opportunity is afforded by the Witt Library. Our thanks go to Sir Robert Witt, who has given us permission to use his collection for our purposes and to index all the classical representations contained therein. Unfortunately our personnel has not proved large enough to attack at once the task of introducing so great a number of new items."[50]

The Witt Library, which eventually passed to the Courtauld, originated as the photography collection of Robert Witt and his wife while they were undergraduates at Oxford in the early 1890s. Although it contained perhaps more images than any other collection of its type, it included all kinds of reproductions of varying quality, as breadth rather than quality was Witt's chief concern.[51] Within this collection, some thousands of photographs were taken by Paul Laib, a London photographer originally from Hamburg, who established a studio in Hampstead in 1896, and later moved to Kensington.[52] "A third enlargement of our collection," Saxl continued, "will some day have to include sculpture, for which again the Conway Library at the Courtauld Institute offers excellent facilities."[53] The photographing of sculpture was ardently taken up as a specialty by a number of photographers, including the aforementioned Lotte Meitner-Graf, who had already been practicing it while in Vienna,[54] and Alfred Carlebach, who was a lawyer in Germany but turned his hobby of photography into his vocation after settling in Britain.[55]

The report further stated that the photography department had "many voluntary helpers." This was indeed true, but one of the unofficial tasks of the Institute was to provide as many paying jobs for émigrés as it could. The volunteer corps "has made it possible to get the systematic arrangement of the material in hand so far established that we can hope in future to devote our time more fully to the collection of new material. It is our intention that our collection of photographs shall be of use not only to our own readers, but to all, no matter where, who are working on problems similar to our own. Our photographic department has been of considerable help in establishing contact with English and foreign students."

Professionalization of the unit was to proceed apace. A twin goal was to establish close cooperation and official partnerships with similar bodies, especially the Courtauld Institute.[56] "Both Institutes have a combined interest in another

enterprise. Dr. Scharf, of London, together with Dr. [Ludwig] Burchard, of Berlin, began years ago to collect material to determine which of the classic works of sculpture were known to the artists of the Renaissance and how far they made use of them."[57] Alfred Scharf (1900–1965) and Ludwig Burchard (1886–1960) were also refugees. Scharf, an expert and later dealer in Renaissance paintings, was originally from Königsberg; his father died in 1933, and he succeeded in getting his mother to England in 1939.[58] Burchard, a leading scholar on Peter Paul Rubens, was Protestant, but because his mother was Jewish, he was ejected from his position in Germany in 1935. "Dr. Scharf is proceeding with this work by systematically searching through the Print Room of the British Museum and other collections, making photographs of all the available prints and drawings after classic sculptures and arranging them in a card index, together with notes on their influence on Renaissance and baroque art. This index, which will take Dr. Scharf several years to complete, will constitute a most valuable contribution to our knowledge of the quality and extent of the classical influence on the art of the sixteenth and seventeenth centuries."[59] Scharf's relationship to the project initiated by Walter and Gertrud Gernsheim is unclear. All in all, although there were some exceptions, the network of those involved in things photographic were "non-Aryans" who had begun careers in art history, and the vast majority were interned by the British in 1940.

It is little wonder, then, that from 1939 to 1948, the Warburg Institute held six photographic exhibitions, in addition to participating in joint projects with the Courtauld Institute, the Churchill Club, and various government ministries. In her survey of the exhibitions, Dorothea McEwan discusses how the experiences in the First World War of both Aby Warburg and Fritz Saxl left them with familiarity, facility, and affection for photography as a means of propaganda.[60] But there might have been a Jewish dimension to their wartime work as well, as Jews were possibly assigned to photographic assignments due to the perceived affinity between Jews and photography.[61] Albeit posed as "speculation," Michael Steinberg argues that Aby Warburg's approach to the study of images may have had more to do with the nexus between Jews and photography than typically assumed.[62]

Bing recalled that after 1933 "Saxl's own work went, with Wittkower's help, into the making of large-scale photographic exhibitions in which the technical and secretarial facilities of the Institute could be fully employed."[63] This notion of the exhibitions as a make-work program is fundamental. But it was not a quick fix, a way to compensate for the absence of originals, or, primarily, a "morale boosting exercise."[64] It was, Bing correctly asserted, part of how the Institute conceived its mission in the long term. "The exhibitions demonstrated that, without

any loss of accuracy or concessions to popular taste, scholarly matters could be presented in a form *which pleased the eye and captured the imagination of non-specialists*. This was in itself a surprise from an Institute which up till then had enjoyed the doubtful reputation of being the home of only the most exclusive kind of learning. For Saxl the making of these exhibitions was no stop-gap but a matter of conviction" (emphasis added).[65] What Bing does not mention, however, is the extent to which this was made possible, and flourished, via the long-standing connections of Jews to photography. In particular, those who moved from art history to photography emerged as a sort of avant-garde.[66]

The Warburg-based exhibitions were "The Visual Approach to the Classics" (1939), "Donatello in Photographs" (1940), "Indian Art" (1940), "British Art and the Mediterranean" (1941), "Portrait of Character" (1943), and the "Fritz Saxl Memorial Exhibition" (1948). In their entirety these projects may be seen as part of an intellectualized, ethnic self-mobilization of a cohort—scholars concerned with broadcasting their work to the non-academic public, and ardently embracing photography as a major part of this effort. In order to reconstruct this work and its impact it is important not simply to examine its immediate reception—especially through reviews, which were cultivated and monitored by the Warburg Institute. The fruits of these projects also were disseminated and further mediated in publications of Gernsheim that were facilitated, quite often, through networks of other "foreigners." In this way the work that originated in the Warburg Institute found its way into the pages of the *London Illustrated*, *Lilliput*, and *Picture Post* of Stefan Lorant (and Lorant's successors), into the spectacular output of Nikolaus Pevsner in art, architectural guides, and several varieties of academic to popular histories, and into the realm of art history publishing through concerns such as Phaidon, Adprint, and Thames and Hudson. The extent to which Gernsheim and Pevsner provided mutual support is most explicit in their collaboration on a book, *Focus on Architecture and Sculpture* (1949).

The first of the major Warburg Institute exhibitions, commenced in spring 1939, was "The Visual Approach to the Classics." The task the Institute set for itself was a tall order: it was supposed to appeal to specialists, as it was timed to coincide with the annual meeting of the Classical Association. Yet simultaneously it aspired to "show how the study of the classics can be made living to the ordinary schoolboy by use of photographs of ancient works of art."[67] What was left unstated was their objective of demonstrating the distinctive method of analysis of the Warburg Institute—placing works of art and material culture, such as monuments and buildings, in their disparate historical contexts, and in particular, to comprehend the mythologies that informed the work of artists and craftsmen, underscoring symbolism. The catalogue of the exhibition consists of

thirty-one photographs; it never appeared in published form.[68] The Institute sought to illuminate, emphasizing change over time, the original context and creation of classical sculpture and architecture "from the block-shaped figure to the free-standing statue," highlighting Egyptian influences,[69] or, "from rigid attitude to flowing movement" as in the case of the Greek plastic arts.[70] In a section labeled "Expression," photographs demonstrated that the classical tradition depicted a huge range of emotion—"from grief to smile,"[71] as opposed to the notion, à la Winckelmann, that quiet calm pervaded all ancient sculpture.[72] The announcement for the show stated that its exhibits had been selected

> not only to display representative specimens of Greek art, but above all to illustrate some of the fundamental ideas in the Greek view of life. They have, therefore, been grouped according to certain leading themes—the evolution of religion, drama, music, athletics—and arranged in such a way that, it is hoped, the central points will appear clearly with only the minimum of comment and relevant quotations from the Greek literature. . . . [A]n effort has been made to select examples which will appeal to the present generation, and for this reason many works generally regarded as among the masterpieces of Greek art have been omitted, because they are only known in Roman copies or because they have become stale in the eyes of the student through too frequent reproduction in every handbook. In many cases, it is felt, an enlarged detail from a vase will, because of its unfamiliarity, be more striking, and therefore more effective in conveying the idea underlying it, than the most celebrated statue of the "Best Period."[73]

This was a gamble. By avoiding the most familiar images, there was a chance that they might alienate those who knew something about the classics. The clarity and quality of the photographs, and the compelling material presented, were often said to speak for themselves. But the organization and setting were crucial. The exhibition could serve a pedagogical function only if the overarching arrangement and juxtapositions were intelligently and cogently designed.

The men and women of the Warburg Institute were by no means rabble-rousers. Yet the opening remarks of the director, Saxl—stated matter-of-factly—were audacious, coming from an individual, although now granted citizenship, who would have been regarded by many as a foreigner. "In this country, as in others," Saxl began, "of recent years there has been a sharp decline in the number of those who learn Latin and Greek. Although teaching methods may be blamed for this decline, a movement so universal and so forceful cannot be checked by improving methods. We have to admit that the classical ideal (in education) worked very well when higher education was first introduced on a democratic basis, but

that now other ideas and more pressing needs give rise to a new curriculum."[74]

Literacy and numeracy had to be the educational priority of any modern society. But from the perspective of the Warburg, this was insufficient to ensure an education including reverence, appreciation, and respect for all of humanity, across national boundaries and including past, present, and future. Saxl claimed that a diverse group saw a reinvigoration of the classics as urgent: "[T]here is still a considerable number of men of very different upbringing, profession and tendencies, who insist that the education of the future must imbue the rising younger generation with a strong historic sense as well as with the capacity to carry forward the mechanisms of our society. . . . History on the one hand, science on the other, are the pillars of the future education."[75] The "science" he had in mind was not exclusively science in the Anglo-American sense, of natural sciences and disciplines wedded to technology, but "Wissenschaft"—as it was known in German to refer to all branches of academic research and knowledge.[76]

What Saxl was inferring, but not stating explicitly, was that the theory posed by the Nazis and their followers—the mythology of the Aryan as the crucible and greatest exponent of civilization—was rubbish. There was, in the Warburgian method, no allowing for race as a means of analysis, as conceived by the Nazis and the less extreme adherents of so-called race science.

The only way which seems to remain open is the visual approach. *Through the eye we can guide the pupil to originals of art, just as formerly he was introduced to originals of literature. Since art is the self-expression of a people, as are religion, literature, and science, we are able by the visual approach to teach what appears to us essential in the achievement of the classics.* The problem is to provide a selection of works of art which will give adequate and clear expression to the developments which took place at the beginning of our civilisation. . . . In order to illustrate the main idea a more unusual selection has been made, of vases, terracottas, coins etc. *It has also been borne in mind that modern children are much more accustomed to good photography than is the present-day archaeologist. They have grown up surrounded by Underground, Zoo, and other posters, illustrated books, periodicals and newspapers—all of which use the greatly improved technique of photography which scholars, for material and other reasons, are slow to apply. We look upon the works of the ancients in a different way from the last generation, and modern photography is able to present these new images to the spectator.* (emphasis added)[77]

Perhaps because his manner was gentle, and this was, after all, a museum exhibition, Saxl's program was not understood as being radical or a threat to the established order. In fact, the effort was cast as an exercise to shore up and propagate

the native culture. But the project was nevertheless totally novel: to impart education in the classics through a different medium: photography. This would be the way to reach out to the young, by meeting them on familiar ground.[78]

This was not simply an exhibition to be enjoyed, and to serve as the stuff of education in a vague and fleeting sense. There was an entrepreneurial aspect to Saxl's appeal that was never commented upon. Although he was not selling pictures as postcards or collectibles, he hoped that the exhibition would lead to the Warburg Institute being contracted to provide this particular exhibition, or perhaps a version of it, for school libraries throughout the country. Indeed, this was an aspect of the Institute's impassioned endeavor to make itself useful to the country—but also to fashion itself into a flourishing workshop for the spread of its ideas. In their heated controversies with Gernsheim over the proper place of photography in the Warburg universe, Saxl and Wittkower asserted that photography mainly served an instrumental purpose. Even so, they were less than totally forthcoming about the extent to which photography constituted a large share of the means by which the Institute might be able to establish, sell, and sustain itself.[79] If anything, this initial exhibition revealed that the Institute perceived a demand for photography as one of the most likely outcomes of its work, and that the Institute would, along with its more rarefied intellectual labour, be able to manufacture the required goods in their own premises, as part of their general enterprise. Although they were not a profit-making business, this was a way to make the Institute useful and to further ensconce it not only in academe, but in the wider educational environment.

"There seems little reason to doubt," Saxl continued, "that if such a collection of pictures were to form part of the school library the general (realisation) of our debt to Greece and Rome would be greatly increased. It would not be sufficient to include the photographs in a travelling library, to be shown at a school only for a short time. Such a mass of material is hard to digest even for an educated adult, and in the schools it should therefore form the store to be drawn upon at any time by the teacher for his immediate purposes. Nor are small size reproductions to be suitable/recommended, which have to be shown with the help of a lantern. Lantern slides in a darkened room has something unreal about them, and the memory of them passes quickly."[80] Illustrated books, then, could not achieve the same aim, nor could slides. "The photographs should be reproduced in quite a large size, and the pupil should become as accustomed to seeing and understanding them as to reading a text."[81] In other words, what the audience experienced—however much it was appreciated—was not enough. The process had to be institutionalized, and the way to effect this was through the intensification of the efforts of the Warburg.

Around twenty public institutions, including secondary schools, expressed interest "in reproductions of the exhibition photographs," but it is not known how many followed through.[82] To be sure, young people were bombarded with images. Yet the Warburg Institute could teach them to learn and think critically through photography. Clear, large photographs could and should serve as the next text for the present and coming generations. Nothing like this existed. "It is indeed to be hoped," Saxl proclaimed, "that a new method on these lines *will lead the younger generation to a better understanding of the genesis of European history*. Few things are more important at the present time than a strong feeling for the values of history" (emphasis added).[83]

The few exhibition reviews that appeared were overwhelmingly positive. In *The Listener*, the official organ of the BBC, Roger Hinks reiterated Saxl's appeal. "What we need," he implored, "is a great effort of propaganda, designed to convince an indifferent and incredulous world, that the Greeks and Romans, so far from being remote and alien and 'dead,' not only lived in the same world as ourselves, but also discovered some facts of eternal importance about it which we have allowed ourselves to forget." In answering this "spiritual need" the Warburg Institute applied "enterprise" and "imagination" as never before. "It needed a body like the Warburg Institute, which approached the whole problem from a different point of view, to establish a fruitful relation between the word and image." Hinks was smitten.[84]

One reviewer, commending the exhibition for its presentation of "Greek Without Tears," identified "Dr. Rudof Wittkower and Dr. Pacht" as responsible for the exhibition, which in large measure they were. Pacht's own research focused on medieval painting. Saxl's vision, however, was fundamental. But who actually took the pictures? The majority, apparently, were photographed and enlarged by Otto Fein, whose original role in the Warburg Institute in Hamburg was that of bookbinder. It seems that Fein had no professional training in photography, but when the need arose at the Warburg Institute (in Hamburg) for photographs to facilitate the method articulated by Aby Warburg and his followers, he was asked to learn the required skills. He became a competent photographer. But more than that, he was a much-beloved figure in the Warburg. A gentle and self-effacing man, he was particularly esteemed because he did not, in fact, have to leave Germany. He was not Jewish. He also was respected because he came from a working-class background that apparently had no tolerance for antisemitism. Indeed, Fein played an increasing part in the work of the Warburg, but there is no evidence that he did anything but follow instructions to the best of his ability.[85] Fein's obsequious way of doing photography for the Warburg would change, however, when Jews came into the orbit of the Institute who had

both training—sometimes in great depth—in art history—and a sense of photography as an art in its own right.

Beginning in 1939, Fein was joined by Edelheid (Heidi) Heimann (1903–1993), a medievalist who specialized in the iconography of eleventh- and twelfth-century English manuscripts and twelfth-century French sculpture. The hiring of Heimann as a photographer was perhaps an indication of the growing workload of Fein. Also, it may have been some concession, however inadvertent, that it was helpful to have someone doing the photographing who had a background in art history. (The Gernsheims took this for granted.) There were other reasons for hiring Heimann. Her grant money had run out, and the Warburg had always dedicated itself to offering employment to refugees. Heimann was well known to Saxl, since she had studied art history under Panofsky in Hamburg. Indeed, in her doctoral thesis she "acknowledged her greatest debt to Panofsky and to the Warburg Library."[86] Saxl was aware too that she had been responsible for providing the photo-documentation in her research.[87]

By the time of the "English Art and the Mediterranean" exhibition, it seems that Heimann was undertaking a fair share of the Warburg's photographic work. She did almost all of the photography not supplied by the guest curator, Stella Kramrisch, for the India exhibition, to be discussed below.[88] Although she remained a scholar, Heimann practiced photography for a different audience from 1941 through 1952, working for the *Picture Post*. One of her rare attributed photographs appeared in the *British Journal Photographic Annual* of 1952. "Freelance contracts in publishing and journalism provided irregular employment and then, from 1955, she was able to resume her academic career through a part-time appointment in the Photographic Collection of the Warburg Institute. From 1958 until her retirement in 1964, she was the Assistant Curator of the Photographic Collection, the only full-time appointment she ever held."[89] Heimann's parents were said to have killed themselves in Theresienstadt in October 1942.[90] Upon her death, Heimann left a bequest to the Institute to enable the acquisition of books and photographs.[91]

The most profound, dramatic, and unsettling shift in the roles and attitudes toward photography at the Warburg came with the hiring of Helmut Gernsheim, who was recruited specifically to take part in the National Buildings Record initiative in early 1942.[92] Yet there were other émigrés, with some sort of Jewish association, who supplemented the photographic work undertaken by Fein and stamped the confluence of art history and photography with their own character. Among them were Enriquetta Harris (1910–2006), an expert on Spanish art, who assisted in organizing the photographic collection and later became its administrator;[93] and Leopold David Ettlinger (1913–1989), a historian of the

Italian Renaissance who had photographed archaeological artifacts at the University of Halle, and who would become curator of the Warburg's photographic collection in 1948. Ettlinger was part-Jewish, and converted to Catholicism late in life. He would later succeed Ernst Gombrich as the Durning Lawrence Professor for Art History at the Slade School of University College London,[94] and become long-term chair of the Department of Art History at the University of California, Berkeley. Ettlinger was brought to London by the Warburg, but Saxl was unable to offer him substantial work. Nikolaus Pevsner, though, was able to get him a job "as a social worker in children's refugee camps" under the auspices of the Movement for the Care of Children from Germany, 1940–1941. Along with "other Warburg refugees," Ettlinger was "interned briefly in 1940 on the Isle of Man." Upon his return to London "he was made a member of the Warburg Institute," becoming a lecturer while also tending to its photographic collection.[95]

The next photographic exhibition by the Warburg was more modest, focused on the early fifteenth-century sculptor Donatello; it consisted of eighteen photographs. The list of exhibits specifies that "all the photographs in this exhibition were executed by Messrs. G. Brogi, Florence (photographer G. Malinotti) under the personal supervision of Dr. Jenö Lanyi."[96] Lanyi, attempting to establish himself in Britain, identified as a Reformed Jew.[97] "The photographs are the private property of Dr. Lanyi."[98] The Italian institute that produced this show was more advanced than the Warburg in mentioning the provenance of photographs. Lanyi was born a Hungarian Jew in Varna (present-day Slovakia), and expelled from Florence in 1938, because of the racial laws of fascist Italy.[99] The Warburg tried, but did not succeed, in making a place for Lanyi. Gertrud Bing wrote that "[t]he photographs which he has made of Donatello's works are the most beautiful I have ever seen made of sculptures, and reveal quite unexpected aspects." Thanks to the support of an unusually generous patron Lanyi had been able to commission thousands of photographs for his research.[100] In a testimonial Saxl argued that Lanyi was the preeminent scholar of Donatello, and that photography was integral to his research and distinctive contribution to art history and aesthetics. "Hundreds of photographs which he had taken are the basis of his work—photographs which are not only of outstanding beauty but which are the best commentary on Dr. Lanyi's attributions. These photographs, concentrating as they do on those parts of the sculptures which have never been observed by anybody else, reveal the quality of the work of the artist better than any words could do. They are the expression of his great artistic sensibility."[101] While en route to United States—for permanent emigration—Lanyi was killed when his ship was torpedoed. His wife, Monika, the daughter of Thomas Mann, survived the attack.

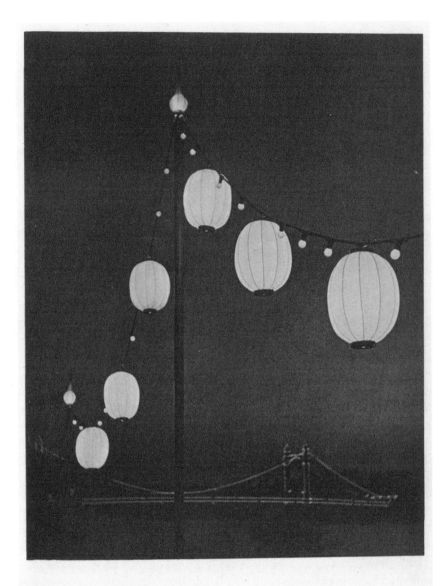

FESTIVAL LANTERNS E. HEIMANN

E. [Edelheid, "Heidi"] Heimann (London), "Festival Lanterns," in *The British
Journal Photographic Almanac, 1952* (London: Henry Greenwood, 1952).
Private collection.

One of the critics who wrote an extensive and effusive review of Lanyi's show was art historian Anthony Blunt—who had also employed, and helped secure the legal rights for, Jewish photographers in Britain, including Alfred Carlebach. Blunt asserted: "Let those who think they know about Donatello visit the exhibition of photographs after his works . . . and they will find many surprises. The photographs have been specially taken by Brogi [a distinguished Italian photographer] under the direct supervision of Dr. Jenö Lanyi, and the combination of technical skill with an intimate and scholarly knowledge of the artist's work has achieved startling results. From the material presented it is possible to form a clearer picture of the artist's methods than can be achieved from the direct study of the originals by the usual methods."[102] Blunt, like Clark, would often serve as an advocate of the photographic impulse of the Warburg. Although it passed without comment, there was no mistaking the Jewish subject matter of one of Donatello's best-known works: David, which stressed "the didactic aim" of the artist as "the victory of virtue over vice."[103]

The following exhibition of the Warburg, on Indian art, was the first that went outside the scope of its explorations of Western civilization. It explicitly acknowledged the complementary nature of photography and scholarship—as the scholar/curator, Stella Kramrisch, also was responsible for most of the photographs. "A proper understanding of the Indian tradition," the brief description of the exhibition read, "requires a closer and a different kind of study than the generally educated public can give. . . . The visual approach introduces the student to the monuments from the perceptible and the intelligible side. The monuments guide him from aesthetic appreciation to intellectual understanding." In response to the argument that photographs are necessarily inauthentic, when compared to museum objects or extant material culture, the Warburg went on the offensive. It affirmed that for this particular subject, outside of India one could find nothing but partial representations. "Indian sculptures in museum collections are only fragments of a whole. They are detached from the body of the temple to which they belong, detached also from the setting in which they appear, from the light which envelops them and is reflected from them. The photographs show the light, or the darkness, in which the sculptures dwell on the walls and in the interior of the Indian temples, and help to visualize the original context to which they belong. They illustrate, in their juxtaposition, the consistency of Indian thought underlying the variety of forms in which it had been clad through thousands of years in the many regional schools of the Indian continent."[104]

Kramrisch was born in Nikolsburg, Austria (now Mikulov in the Czech Republic), and received her PhD from the University of Vienna in 1919. Within

four years she attained recognition as the first professor of Indian art at the University of Calcutta, having "laid the foundations for its systematic study."[105] In London she was based at the Courtauld Institute before being recruited for a chair at the University of Pennsylvania. Later she assisted Eliot Elisofon, most famous as a *Life* magazine photographer, as he sought to bring Indian art to a much wider public in the early 1960s.[106] It is little wonder that the members of the Warburg saw in her a kindred spirit. Yet she also was a refugee, not so much in search of a home, but desperate for a more secure environment and greater recognition. Photography was one of the prime tools of her research. As a graduate student in Vienna, she had been "inspired by photographs of the early images at Sanchi and Ajanta," leading her to conduct research "on early Buddhist art from those two sites."[107]

The response to her Warburg-sponsored presentation, which included some 250 photographs, was fantastic. "For once," the Birmingham *Gazette* reported, "the organisers do not apologise for showing photographs instead of the real thing."[108] There was one somewhat snide comment, repeated in a few papers, that the exhibition was a convenient replacement for a Royal Academy show of Indian art that was canceled due to the war.[109] A more weighty reservation was that photography in black and white could not possibly combine the color, scale, and tactile quality of the originals.[110] But overall the critical acclaim was resounding.

In some respects Kramrisch's combined scholarly and curatorial endeavor, and its reception, can be seen as a precursor to multiculturalism. This meant stimulating and feeding interest in a topic that would have been considered foreign to the vast public in Britain. Additionally, there was something of a political edge. Some critics argued that the British needed to be especially engaged in this subject, given the extent to which their own empire had imposed itself on and benefited from its imperial project in India. It was incumbent on the educated public, then, to learn more about, and take more active responsibility in, shaping the future of India. This was put forward most expressly by critic Herbert Read,[111] who, like Kenneth Clark and Anthony Blunt, was a key supporter of the Warburg's photographic mission.

Even given the benefit of hindsight and the increasing sensitivity to cultural difference, Kramrisch's work in the 1930s and 40s is exemplary for its absence of traits connected with "orientalism," especially as characterized by Edward Said.[112] Her presentation bears no trace of condescension, in terms of Indian civilization being portrayed negatively in the context of English, white, or Western culture. Perhaps this is unsurprising, given the extent to which Kramrisch followed the Warburg program of exploring symbolism, contexts, and continuities.

The events that accompanied the exhibition included "lectures on the cultural relations between east and west." The first of these was delivered by Professor Paul Ernst Kahle (1875–1964), an orientalist and scholar of the Old Testament, and a German who emigrated to Britain in 1938. Kahle, as a Lutheran pastor working in an increasingly antisemitic climate, staunchly maintained his scholarly integrity and employed a Jewish research assistant when this was taboo. His family followed his example in offering assistance to Jewish acquaintances, and he was therefore forced to leave Germany.[113]

Basil Gray (1904–1989), who lectured on "Mughal Painting as an Introduction to Indian Art," had begun his studies in Vienna with Josef Stryzgowski, as did Kramrisch, but Gray remained particularly close to Otto Demus (1902–1990), a Catholic, who became an outspoken critic of the Nazis and fled to England in 1939.[114] In his remarks Gray stressed the significance of Kramrisch's scholarship in the field. Rather than approaching the subject as something remote from the audience, he explained that "Moghul artists studied many European pictures," and conversely, "their skill was recognised in Europe, and famous artists such as Rembrandt and Sir Joshua Reynolds paid tribute to them, saying they were worthy to rank beside the work of the old masters."[115]

The third lecture was offered by Dora Gordine (1895–1991), on "The Beauty of Asiatic Sculpture." Gordine was herself a renowned sculptor. Born in Latvia and raised in Talinn and St. Petersburg, she studied in Paris and settled in London in the mid-1920s. Her immediate family, despite wealth and connections, did not escape the Nazi genocide: two of her siblings were murdered in Estonia in 1941, while one of her brothers managed to escape to London. Gordine, through her life and art, was revered as a link between cultures and also as an artist whose work was unquestionably of the highest order.

None of these talks concerned Jewish subjects or concerns, but each individual speaker embodied a thoroughgoing rejection of antisemitism. In total they prefigured an inclusive academic establishment and discussion, far beyond any that had been known in British "orientalist" circles previously.[116] The only references to Kramrisch's origins in exhibition reviews identified her as "a woman scholar of Czech extraction"[117] and "Hungarian by birth."[118]

As much as it might be said that Jews would invariably stand to improve their own condition in Britain if more sympathetic attention was paid to the foreign cultures and peoples that had encountered the British Empire, Kramrisch and her work can be seen as paradigmatic in another respect. Jews, and the Warburg as a quasi-Jewish institutional form par excellence, came to be regarded as appropriate interlocutors or mediators of anything non-native to Britain that became part of the country's culture.[119] Especially in the next two major exhibi-

tions, the Warburg assumed the role of explaining things that were long past and had originated in far away places. It furthermore became one of the great explicators of British culture and history to the British themselves.[120] In Herbert Read's estimation, "[T]his exhibition is one of the few cultural activities being carried on in our war-ridden metropolis, and for this reason alone it deserves wide public support; but at any time, and at this time more than ever, it should remind us of our cultural responsibilities, and of our shameful neglect of them in the past."[121]

In the Institute's annual report for 1940–1941 Kramrisch and her exhibition were cited as a highlight of the year. Giving particular credit to Kramrisch for her photography, Saxl related that "[t]he photographs were of unusual beauty, and the spectator received, through careful use of headlines and caption, aesthetic impressions and instruction at the same time. An Exhibition which appealed both to the emotional and to the intellectual side was obviously well suited to war-time."[122] Gertrud Bing, though, clarified elsewhere that much of the photographic work had been done by Heidi Heimann.[123] It was, indeed, a huge success: "Although it was open during weeks of intensive bombing, more visitors came to this Exhibition than to the Greek and Roman ones." The selflessness and cooperative spirit evinced in Kramrisch's Warburg project were palpable: "We are greatly indebted to Dr. Kramrisch for the arrangement of the Exhibition, to which she devoted four months of uninterrupted work, without remuneration. That it was technically possible to hold it was due to the fact that Miss Kramrisch had brought some of her own photographs from India, and that she had access not only to the Courtauld Institute photographs (excavated from Devon) but also those of the India Office Library and the Royal Asiatic Society. Everywhere we found the greatest readiness to cooperate."[124]

The next exhibition held at the Warburg Institute premises—December 1941 to February 1942, and displayed in the provinces until January 1944—"English Art and the Mediterranean," was possibly the largest photographic exhibition held in Britain up until that time, and among the most formidable ever to appear in a museum. Certainly the earlier exhibitions were designed to speak to a British public and to fill a specific void in the current cultural landscape. "English Art and the Mediterranean," and in its published form, *British Art and the Mediterranean*,[125] was the most unequivocally "English" of the Warburg Institute's photographic enterprises. It also signaled, especially through the photographs of Helmut Gernsheim, a new way of envisioning art and architecture.

"The object" of the exhibition was "to show the way in which classical models from the Mediterranean were brought to England and transformed by the native craftsmen and artists into something specifically English. Many connections be-

tween the British Isles and the countries bordering on the Mediterranean existed throughout the centuries, and every fresh contact resulted in a new wave of Mediterranean influences on English art."[126] The message could not have been more Warburgian. As opposed to a linear trajectory from a primordial essence into a purely national manifestation, what was normally seen as "quintessentially English," had, the exhibition asserted, come largely from beyond its shores and was mediated by the island's inhabitants.

This was not meant to be a slight to the English. The point, rather, was to emphasize that British culture and history owed a great deal to what lay outside. "The process" of the creation of English art "is no slavish imitation but a continuous transformation of southern models by English artists," which could be "illustrated from early primitive times to this day. For instance, the formalised Greek ornaments became in the hands of Celtic craftsmen more fluid and irregular, thereby expressing a difference in temperament. Or taking as another example the hieratic art of the Byzantine Empire which had crystallised into a solemn rigidity: native artists accepted the general lay-out of the pictures but invested the figures with violent emotions which showed their own new and fervent conception of Christianity."[127] The Christian faith in England, the exhibition demonstrated, was not so much a thing-in-itself but a force that had been subjected to and forged by historical forces. In large measure the exhibition also was dedicated to architecture, in which "the transformation reached its climax in Robert Adam; he used Roman decoration freely but gave it a new rhythmic and draughtsmanlike style which is as characteristically English as the irregular Celtic ornament and the emotional quality of the 12th centuries."[128]

The leaflet distributed at the exhibition opening did not comment on the obvious wartime context and exigencies of the offering. In the Oxford University Press publication of 1948, though, with some semblance of perspective, Saxl and Wittkower stated that the exhibition had been conceived and executed "[i]n 1941, when the Mediterranean had become a battleground. . . . The exhibition was on view in London and in a number of provincial museums, and met with a greater response than we had anticipated. At a period when inter-European relations were disrupted by the war, it was stimulating to observe in the arts of the country the age-long impact of the Mediterranean tradition on the British mind."[129] It was, indeed, a way to remind the public of interconnections and relatively peaceful cultural transmission, as opposed to conflict.

A particularly intriguing segment of the show was "English Caricature and Its Italian Ancestry." Although the endeavor was rigorously historical, the Central European émigrés could not have worked with this sort of profile-picture

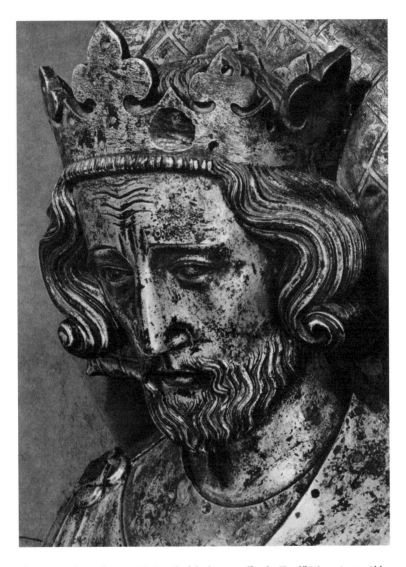

Helmut Gernsheim, "Henry III, Detail of the bronze effigy by Torel," Westminster Abbey.
This photograph is not attributed to Gernsheim in the spectacular Warburg Institute
volume *British Art and the Mediterranean*, by Saxl and Wittkower, [section] 32–33:
"Reflections of Italian Thirteenth and Fourteenth Century Art in England. 32. The
Cosmati at Westminster." It seems that Gernsheim had to climb on top of the effigy
in order to produce such a spectacular photograph. He was probably the first
to ever perform such gymnastic feats in England in the service
of photography. Warburg Institute.

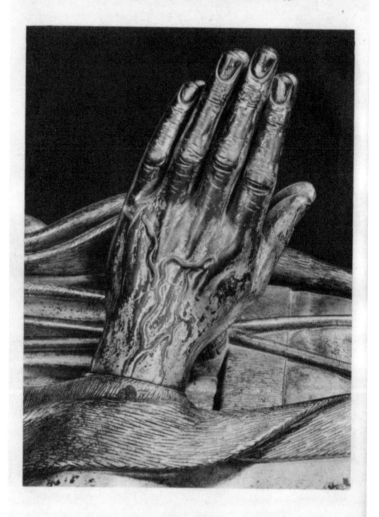

HANDS OF HENRY VII, WESTMINSTER ABBEY HELMUT GERNSHEIM

Helmut Gernsheim, "Hands of Henry VII," Westminster
Abbey. Besides Warburg Institute shows and publications,
this photograph was also published in *The British Journal
Photographic Almanac, 1952*. Warburg Institute.

without being reminded of the pseudo-racial science "diagrams" of the Nazis—and totally pulling the ground out from beneath those, as a distortion of historical trends from the sixteenth century.[130] The juxtaposition of the "Physiognomy Studies" of Charles Lebrun (1619–1690) against a "woodcut from Giambattisa della Porta's *Della Fisionomia dell'Huomo*" (1586), as well as a print by William Hogarth (1697–1764), left no doubt that what the Nazis touted as "racial biology" was a bowdlerization of selected artistic trends that had nothing to do with any reality of race.[131] This message was complemented by the commentary about Louis François Roubiliac's monument to Handel in Westminster Abbey (1761): "It is significant of this period when connoisseurs believed that art should be unfettered by nationalist prejudices, that a French sculptor was commissioned to execute the memorial statue to a German-born musician, whose genius did much to establish Italian music in Great Britain and Ireland."[132] Gernsheim used this photograph several times in his publications.

Interestingly, the basic fact that the exhibition was in the form of photography prompted an apologetic explanation in the catalogue for the exhibition in 1943 that contained no photographs. This was not repeated in the 1948 edition (which was mainly photographic). "To give an adequate picture of the extent and quality of the relations between English art and the arts of the Mediterranean," Saxl and Wittkower averred, "would require a complete museum"—which no one, and certainly not in 1943, would have expected. "This photographic exhibition," by no means a substitute for original works, "presents the subject in a small compass." Most likely, those anticipating seeing their "favourites" might be disappointed. "And it cannot be claimed that the photographs exhibited here always represent the best achievements of modern photography."[133]

The latter point was a concession to the fact that the quality of the photographs varied tremendously. But they did not say what they knew: that Gernsheim's stood out as the most striking.[134]

Continuing qualifications that appear in both the 1943 and 1948 catalogues (with only slight changes, to allow for "readers" instead of "viewers" or "visitors"), Saxl and Wittkower warn their audience that

> there is a certain difference in the treatment of the material, which is also reflected in the guide, between the periods before and after 1500. This, we think, is less due to the difference in outlook of those who arranged the exhibition than it is inherent in the nature of their subjects.
>
> The first part covers 2000 years, the second part 300, while approximately the same number of sections has been allotted to each.

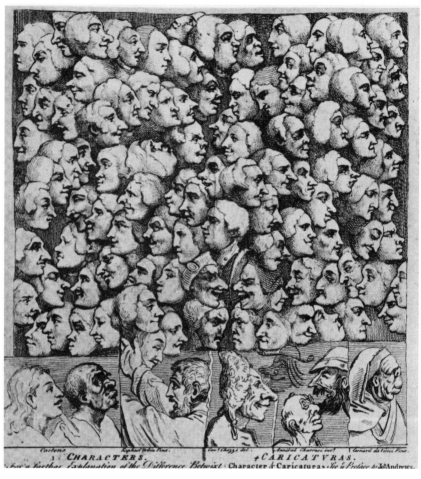

[Section] 62: "English Caricature and Its Italian Ancestry," 1. William Hogarth (1697–1764). "Subscription-ticket for the Marriage a la Mode prints. 1748." In *British Art and the Mediterranean*, by Saxl and Wittkower. The main point was the "character" should not be confused with "caricature." Warburg Institute.

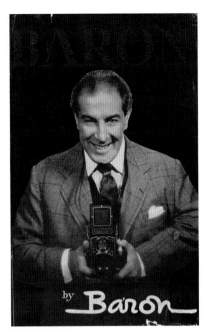

Cover of Baron by Baron
(London: Frederick Muller, 1957).

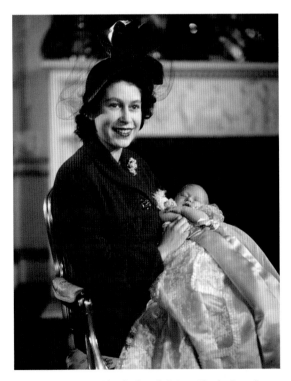

Baron, *Princess Elizabeth with Prince Charles* (1947).
Photograph by Baron, Camera Press London.

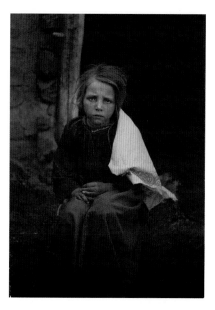

N. E. Luboschez, *Russian Girl in Famine* (ca. 1910). Gelatin silver print. Harry Ransom Center, University of Texas.

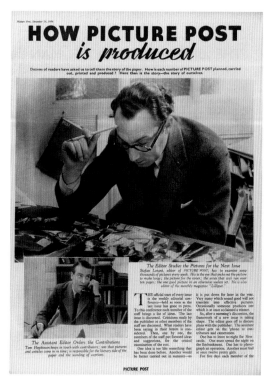

Stefan Lorant on top with a pencil to his brain, Tom Hopkinson, below, on the phone. Unattributed [Kurt Hutton], "How *Picture Post* Is Produced," *Picture Post* 59, Dec. 24, 1938, p. 64. Kurt Hutton/Getty Images.

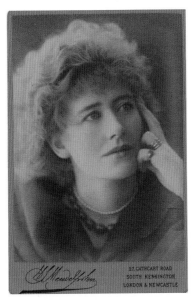

H. S. Mendelssohn, Ellen Terry, 1883. Albumen cabinet card, 1883. Image size 5⅝ × 4 in. (142 × 102 mm). © National Portrait Gallery, London.

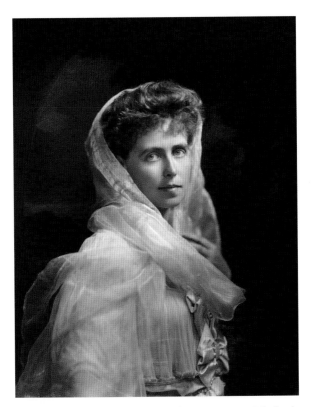

H. W. Barnett, Crown Princess Marie of Romania, 1902. Whole-plate glass negative, 1902. © National Portrait Gallery, London.

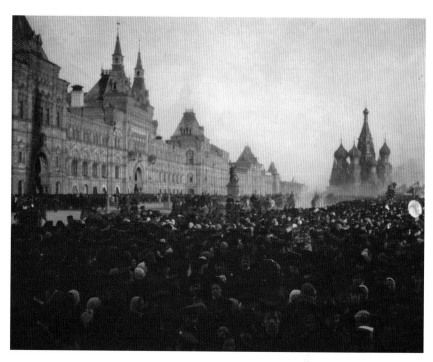

N. E. Luboschez, *Moscow Demonstration* (ca. 1910). Gelatin silver print. Harry Ransom Center, University of Texas.

Gisèle Freund, *Virginia Woolf.* Diapositive couleur, diapositive 24 × 36 mm. 1939. © Estate Gisèle Freund/Réunion des Musées Nationaux, Agence Photographique.

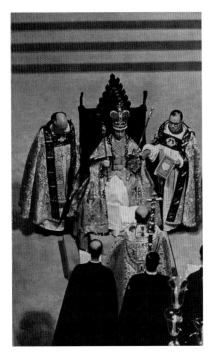

Jarché, *Vision of a Reign*. From Andrew Matheson, The Leica Way, 4th ed. (London: Focal Press, 1957), opposite p. 16. Private collection.

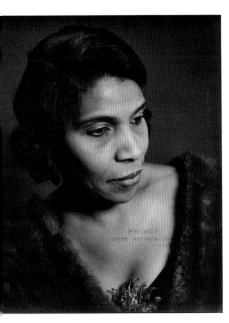

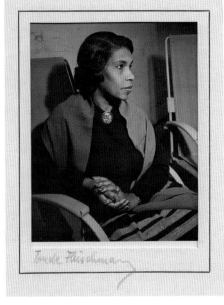

Lotte Meitner-Graf, *Marian Anderson* (1897–1993). Estate of Lotte Meitner-Graf, Bridgeman Art Library (London).

Trude Fleischmann (1895–1990), *Marian Anderson*. Marian Anderson Collection, Kislak Center for Special Collections, Rare Books and Manuscripts, University of Pennsylvania.

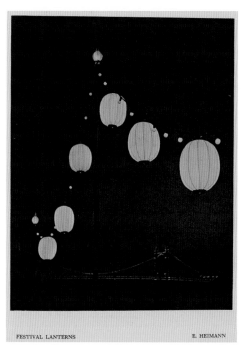

E. [Edelheid, "Heidi"] Heimann (London), "Festival Lanterns," in *The British Journal Photographic Almanac*, 1952 (London: Henry Greenwood, 1952). Private collection.

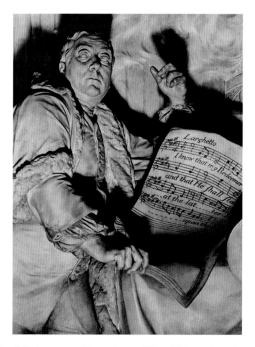

Handel Monument, Westminster Abbey. Helmut Gernsheim,
"1. Louis François Roubiliac." Warburg Institute.

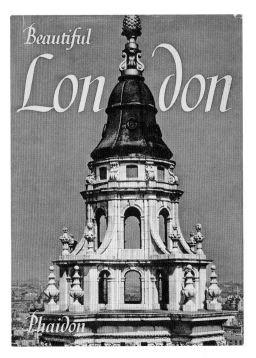

Cover of *Beautiful London* (1950), by Helmut Gernsheim. Sammlung Gernsheim, Reiss-Engelhorn-Museen Mannheim.

Michael Gernsheim (ca. 1705–1792), the last Judenbischof of Worms. Private collection.

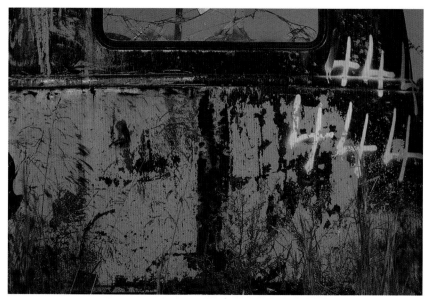

Ferenc Berko, "Car Junkyard, Tennessee, USA, 1963," in *Ferenc Berko, 60 Years of Photography*, 108. The Ferenc Berko Archive.

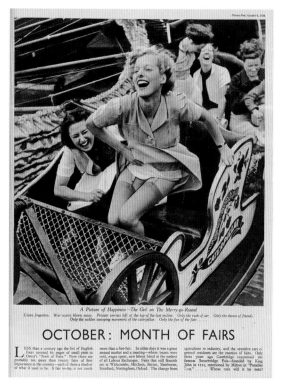

Unattributed [Kurt Hutton], "A Picture of Happiness—The Girl on the Merry-go-Round," in *Picture Post*, vol. 1, no. 2, Oct. 8, 1938, p. 77. Kurt Hutton/Getty Images.

In the kaleidoscopic survey, therefore, which is unrolled before the eyes of visitors, the first half resembles those cinema pictures where the opening of a flower from the bud is shown as a consecutive movement, while the second half is like those which show a horse jumping over a fence, in a number of shots recording every single position of the leaping animal. (emphasis added)[135]

This was a particularly apt analogy, a fabulous way of relating the apparently disparate disciplines, and it was quoted in Herbert Read's review.[136]

The few sparse comments concerning the actual photographing of the material—which differ in the texts of 1941, 1943, and 1948—reveal a lot about the evolution of photography at the Warburg Institute. Following the earlier practice of relegating the photographer (Fein) to an anonymous instrumental role, the one-page précis for the exhibition in 1941 did not mention who was responsible for the photographs. The 1943 guide (which might have been available earlier) acknowledged that "whatever merit there may be in the appearance of the exhibition is due to the photographic work of Mr. O. Fein and Miss A. Heimann.

[Section] 62: "English Caricature and Its Italian Ancestry," 3. Woodcut from Giambatista della Porta's *Della Fisionomia dell'Huomo, 1586,* and 4. Charles Lebrun (1619–1690). "Physiognomical studies. Two of a series of drawings preparatory for engravings. Louvre, Paris." In *British Art and the Mediterranean,* by Saxl and Wittkower. As opposed to racial thought, the notion displayed here was almost a forerunner to Darwin, showing human affinities to animals. Warburg Institute.

Helmut Gernsheim, "1. Louis François Roubiliac. Detail from the monument to Handel, Westminster Abbey, 1761," in [section] 60: "Italian Opera in Eighteenth-Century England," in *British Art and the Mediterranean*, by Saxl and Wittkower. Gernsheim only achieved such clarity by taking the trouble to clean the monument and flood-light it. Warburg Institute.

They have worked untiringly over the enlargement and presentation of material from which it was not always easy to achieve the best possible results."[137] Although this statement is true it also is incomplete and misleading. The name conspicuously absent is that of Helmut Gernsheim, who had produced a large portion of the photographs, especially those dealing with architecture. But because the Warburg Institute found itself embroiled in a protracted, bitter dispute with Gernsheim over whether he should get credit for his individual photographic work, Saxl and Wittkower chose to omit him completely. They also were appalled that Gernsheim had been rude to Fein, in public. There is no doubt, though, that many of the most striking photographs in the exhibition were those of Gernsheim, as they would frequently surface in his publications in his own name, such as *New Photo Vision* (1942), *Focus on Architecture and Sculpture* (1949, with a foreword by Nikolaus Pevsner), *Beautiful London* (1950, 1953), and several others.

Strangely, in the preface to the 1948 publication, there is no mention of Heidi Heimann—although her photographs most likely were included. Heimann, who was modest and self-effacing, possibly requested that mentions of her name be removed. Another name, however, appears in connection with photographs: "Professor Paul Jacobsthal advised on the Celtic part, and most of the Celtic reproductions are taken from his own negatives."[138] Jacobsthal (1880–1957), too, had been compelled to flee Nazi Germany due to his Jewish background.[139]

At the close of the paragraph in which the authors record their "gratitude" to "public institutions and private owners," they state that "almost every entry in this book gives evidence of photographs and information supplied by public libraries, museums, art galleries, and institutions."[140] These photographs, needless to say, had not been taken by the institutions but by individual photographers. Gernsheim launched his battle to clearly and consistently acknowledge the provenance of a photograph when he believed his own efforts were given short shrift in the photographic exhibitions at the Churchill Club, Courtauld Institute, and elsewhere, which were the fruits of his labor for the National Buildings Record project. These overlapped with the other photographic enterprises of the Warburg Institute.

Interestingly, the penultimate paragraph of the 1948 preface to *British Art in the Mediterranean* does in fact assert: "Many original photographs were taken by Mr. O. Fein, staff photographer of the Warburg Institute, and by Mr. H. Gernsheim. The burden of the photographic work for this publication rested on Mr. Fein."[141] Surely the photographic responsibilities for the exhibition rested mainly with Fein—and perhaps Heimann—because of Gernsheim's quarrel with the Warburg that eventually resulted in his dismissal, a rather tortured process that

Helmut Gernsheim, *Exterior of St. Paul's*.
Warburg Institute.

PHOTOGRAPHIC PRACTICE *at the* WARBURG INSTITUTE

Helmut Gernsheim, *Interior of St. Paul's.*
Warburg Institute.

began in December 1944 and lasted into January 1945. By 1948, Gernsheim was already turning his attention away from his own photographic practice toward writing on photography as a critic and historian, and forging a career as a collector of photography.

Even decades later, it seems, the tension with Gernsheim was too raw to confront directly. In 1998 the Warburg republished a homage to Saxl by Gertrud Bing. She had written that during the war "there were public needs which the Institute could fittingly help to fill. One of them was the photographic record of important buildings threatened by destruction from bombs. The National Buildings Record, established for this specific purpose, was in its infancy and dependent on the valiant but haphazard efforts of amateurs and the indifferent equipment of provincial studios. Some rewarding tasks, such as the photographing of the British Museum, No. 10 Downing Street, the royal effigies at Westminster

Abbey, were therefore gladly entrusted to a photographer working on behalf of the Institute under Wittkower's expert guidance."[142] Yet no matter who was getting or giving the credit, there is no doubt that Gernsheim's extraordinary photographs contributed substantially to the success of the exhibition and the subsequent publication.

In addition to the exhibition per se and the 1948 book, the quantity and quality of lectures connected with the "England and the Mediterranean" production was fantastic. At least nine were held in 1941, and eighteen in 1942. The lecturers were a mix of native scholars and émigrés.[143] The initial review in the *Times* set the tone for a chorus of acclaim, and was especially prescient in underscoring the themes of transmission and mediation in the very title: "Britain as Interpreter." Placing the exhibition in the context of ongoing discussions concerning photography and the historical moment, the review concluded that

> The theme of the exhibition is one upon which thoughtful people must ponder a good deal to-day, when Greece is an ally, Italy by her ruler's perverse choice an enemy, and North Africa a battlefield. But however great the dislocations of the present time, the days are bound to come, sooner or later, when this ancient affinity between the British Isles and what is permanent in the civilization of the Mediterranean will reassert itself. Meanwhile the exhibition, which has no political purpose to serve, can give one good cause for satisfaction. To have absorbed through so many centuries so many riches, and to have converted them to things new, individual, and intensely characteristic, ready to be sent on to new lands in new continents, is to have played a part of an interpreter which cannot have been in vain.[144]

There was a more than a subtle parallel between the theme of England as "interpreter," as noticed by the reviewer, and the role, via photography, of the Warburg as an interpreter of British culture. As much as the *Times* succinctly situated the exhibition in its contemporary context, a review by Peter Naumberg in the German-language anti-Nazi publication *Die Zeitung* was explicit about the relationship between the presentation and the method pioneered by Aby Warburg and others who had been expelled from the Nazi Reich. Naumberg singled out England for providing refuge for the Warburg Institute. As the Warburg represented the greatest embodiment of an activist, humanistic tradition that had formerly been part of German culture—now England held the honor of being the greatest bearer of the classical legacy.[145] A similar review appeared in the *Architectural Review*, and might have been partly a translation of Naumberg's piece. This is not surprising, given that Pevsner, an editor of the journal,

delivered the concluding lecture in the series connected with the show. Pevsner, as noted elsewhere, had long been close to Gernsheim. This article ended with an expressly political and practical suggestion: "Now this exhibition will, it is to be hoped, act on a wider public and convince it of the immense value of the institute's work."[146]

Herbert Read's lengthy and laudatory review in the *Listener* described how the exhibition had sprung from a self-conscious theory about the possibilities and potential of photography, executed in an extremely specific, professional, and creative manner. The ultimate consequence was "*a new art . . . the art of visual education*" (emphasis added). The apostles of photography, he warned, had gone too far in proclaiming their "preference for the photograph" over the original, but he found convincing the organizer's claim that the photographs had an effect similar to moving, or even motion, pictures.[147] An editorial in the *Burlington Magazine* was likewise effusive in its praise for the exhibition, noting its timeliness, novelty, and, in particular, the way that photographs were used, "with remarkable power of striking documentation . . . as thrilling an experience as watching the most exciting drama."[148]

When it became a traveling exhibition, the response was enthusiastic, even bordering on ecstatic. "The Warburg Institute," wrote a reviewer in the Yorkshire *Evening Press*, "serves and promotes research on the survival and revival of classical antiquity in art, life, and religion. *It is controlled by scholars of high European standing*, and great point is made of the interrelation of fields of study too often divided between specialists" (emphasis added). The exhibition demonstrated that "the study of art is never divided from the study of history as a whole, and new and fruitful lines of research result from this treatment, which introduces the whole problem of how culture passes from one country to another."[149] There could scarcely have been a stronger repudiation of the notion of national cultures as entities unto themselves. The internationalist, cosmopolitan lesson of the Warburg, through the vehicle of photography—now being recognized as a force and even an art in its own right—was well learned.

The next major photographic project of the Warburg Institute, "Portrait and Character," was led by Kenneth Clark for the Council for the Encouragement of Music and the Arts (CEMA) in 1943 (as mentioned at the beginning of this chapter). Here Jews and modern art were inextricably part and parcel of the classical inheritance. The small printed guide related that "in this exhibition, the portraits are shown as examples of character-drawing, and not as representations of famous men and women. The famous excite historical interest, but the majority of old master portraits that we admire in galleries are of unknown personalities, or even when names are known, they may convey little."[150] Interest in

Old Master drawings had been stimulated by the photographic work of Gernsheim.[151] "They interest us because a good portrait is a biography, the artist's vision of a character. . . . But the artist's solution is always subject to the conditions of his own time.[152]

Under the rubric of "The Task of the Portrait Painter" the first panel was Lotte Meitner-Graf's contribution,[153] "The Various Aspects of a Single Face Shown by the Camera." Beginning in the present moment, Clark wrote, "[p]hotography and the cinema have made everybody conscious of the many variations of a face. Photographs of the same person taken with different lighting and background, in different dress, looking upwards or downwards, in profile or full face, can be most dissimilar. We talk of photographs which are not a good likeness, meaning that the attitude of the sitter is unusual or the expression unfamiliar, but not that the camera has taken an imaginary face. The eye of the camera is impartial, and a good likeness results only from the selective faculties of the photographer."[154] Certainly Clark was going a long way in crediting the photographer for the fabrication of the image, but he was still on the side of photography more as a vehicle of technology than art in itself.

Clark had indeed set himself a challenging agenda. In an undated statement regarding the purpose of the exhibition, Saxl wrote:

> Portraiture being nowadays unpopular, Sir Kenneth Clark suggested we should make it the subject of an Exhibition to help the public to become more portrait-minded. But it is obviously difficult to make an exhibition attractive if its theme does not attract, and even if people were enthusiastic, it is not easy to present them with two hundred faces of black and white photographs.
>
> Under these circumstances we decided that it would be best to appeal neither to the emotions of the visitor nor to his historical interests but to demonstrate PORTRAITURE AS CHARACTER DRAWING. The problem "how can the artist achieve the expression of a character" lies within the traditional field of our research—the study of symbols. The screens of this exhibition deal with different aspects of this study in relation to portraiture. The mind behind the sitter's face can be read by means of certain signs, by an interplay of curves, by symmetrical or asymmetrical forms, by light and shade. In this sense the exhibition is on the lines of the old physiognomists, and of Charles Darwin's "Expression of the Emotions in Man and Animal."[155]

To Saxl and the Warburg, the qualification "old" with "physiognomists" was crucial. Physiognomy, as prized and practiced by the Nazis, was abhorrent to them.

The man in the street who strays into the exhibition may find amusement in the variety of faces and of fashions, but the more serious-minded interested in this line of thought may derive some more lasting enjoyment. He may, as we did in preparing the exhibition, learn to observe more closely the human face in life, in transient moods, the movement of the hands, the expression of the eyes. He may thus be led to consider how can be expressed in the language of forms what lies hidden in nature, in other words portraiture as one of the most immediate of symbolic expressions in art.[156]

The exhibition was meant to be, on the one hand, historical but also, on the other, to resist the typical use of history in displays of portraiture. This point was epitomized in a *Newcastle Journal* review stating that the intention was "to foster an understanding of the portrait as a form of artistic expression rather than presenting the great figures of history or to show the portrait as a historical study."[157] Again, the reception of a Warburg exhibition was stimulated and shaped by the criticism of Herbert Read: "A technique has been evolved which makes for unity of impression and ease of apprehension."[158] Clarifying his idea that painting remained superior to photography as a means of portraiture, Read would not have agreed with Gernsheim that the photographer is in equal measure an artist, yet the extent to which he acknowledged the fields as "complementary" was a huge advance for photography,[159] consistent with the cause of Gernsheim and Newhall, and most forcefully articulated in the first instance by Alfred Stieglitz.

Again praise was lavished on a Warburg photographic exhibition. Among the few discordant cries was a piece in the *Sunday Times* chastising the organizers for being too specialized,[160] but this was an exception. As opposed to Read's qualification of photography's subordination to painting, a very different message was expressed in the public lectures of Pevsner that accompanied the exhibition on at least two occasions. One report on Pevsner's talks concluded, "For some time photography tried to imitate painting. That stage was over, and *it had been discovered that photography could be an autonomous branch of portrait art*"[161] (emphasis added).

The last of the major photographic exhibitions by the Warburg (June 15–26, 1948), as a memorial to Fritz Saxl, was staged after the end of the war, when the Institute was already well ensconced as a constituent element of the University of London. The notions of using photography as a means of boosting morale among a war-ravaged population, or as a means of proving the Institute's usefulness, were no longer so immediate. A great deal of thought was put into how best to memorialize the legacy of Saxl, concomitant with the ongoing work of the Warburg Institute. At the opening of the exhibition, Rudolf Wittkower explained:

This is an exhibition in memory of a great scholar who, like any other, had to use the written or spoken word. We are all familiar with memorial exhibitions for artists, but as far as I know this is the first attempt ever made to present the life work of a scholar in visual form. Yet, when we were wondering how best to pay homage to our friend and teacher, Fritz Saxl, the idea of a visual bibliography, as it were, occurred quite spontaneously. And the reason is very simple. In all Saxl's work visual objects were the centre and point of focus. . . . Inevitably the exhibition expresses the aims of the Institute.[162]

This underscored not only Saxl's acceptance of photography as a means of transmitting art and scholarly ideas, but his comfort with photography, and the extent to which it had been embraced as a significant, legitimate, and even dynamic element of the Warburg. What had started and originally been nurtured under the auspices of the Warburg Institute, however, would be taken up in largest measure by Gernsheim, who was something of a cross between a mishandled stepchild and an enfant terrible of the Warburg. Gertrud Bing perceptively claimed that the photographic work of the Warburg, in the service of the National Buildings Record project, revealed "an exacting training and strict adherence to evidence, *while at the same time it opened another range of historically significant facts and more imaginative approach to the arts than that which [the Warburg Institute] had made familiar*"[163] (emphasis added). Certainly this was true for the work of Gernsheim and Wittkower on British architecture. But the same could be said for the Warburg's approach to photography generally. It represented and manifested "a more imaginative approach to the arts" than any of its predecessors or contemporaries, and this had been facilitated by the nexus between Jews and photography.

The Brothers Gernsheim, Part I

A N OLD JEWISH JOKE tells of a man who, at the time of his death, belonged to no *shul*. The family, though, was able to purchase a cemetery plot, and contracted a newly ordained rabbi, for whom it would be his first funeral. Meeting the surviving relatives, the earnest rabbi had a hard time drawing out something to say, of a personal nature, in the eulogy. Then, at the graveside, after offering a few platitudes, the rabbi pleaded, "Can't anyone say something about the deceased?" From the back of the small crowd came a response: "The brother was worse!"

Nothing so distasteful happened at the memorials for Helmut and Walter Gernsheim. Many who made the acquaintance of Helmut found him delightful and charming. Both Walter and Helmut were known, and praised in print, for the kindness, diligence, and energy they bestowed on scholars previously unknown to them. Both were legendary for providing incisive, thoughtful answers, with graciousness, to researchers' queries.[1] But in the second decade of the twenty-first century one still hears, off the record, how unseemly the Gernsheims were. I have been informed that Helmut Gernsheim was not only brusque and arrogant, but untrustworthy. Suffice it to say that something of their rather prickly personalities is revealed in letters and other documentary evidence. Helen Barlow notes in the *DNB* that although Helmut Gernsheim could be forceful and uncompromising and did not suffer fools gladly, he also was usually right—even when his detractors had the last word.[2] His "importance to photography cannot be overstated. The Gernsheim collection immeasurably enriches our photographic inheritance, and the scholarship that he built upon the collection was instrumental in establishing the academic history of photo-history."[3]

Although there is no question that Helmut was the more significant of the brothers in the overall history of photography, Walter enabled Helmut's career at crucial points, and was himself critical in establishing an integral place for

photography in fine arts scholarship. If Helmut is not given enough attention—and some of it is still tinged with anti-foreigner sentiment[4]—even less is said about Walter Gernsheim.

They both could be described, in the summer of 1940, as souls adrift, with no sense of what lay ahead. The same counterproductive "national security" rationale that had shunted Stefan Lorant to America propelled fellow "enemy alien" Helmut Gernsheim to a Liverpool port.[5] There he boarded a ship, the *Dunera*, on which he came close to losing his life in the North Atlantic. The *Dunera* narrowly escaped destruction by a Nazi U-boat in the most intense phase of this campaign, on July 11, 1940.[6] It had hardly been a luxury cruise from the outset. The rickety ship's capacity was one thousand six hundred, but well over two thousand were aboard. Most were Jewish refugees, packed among "genuine prisoners of war"—around two hundred Italians and two hundred fifty Nazi soldiers.[7] After being damaged the *Dunera* was diverted to Australia, despite being ill-equipped to undertake such an arduous trip. It is little wonder that the improvised journey became harrowing.

A Labourite who was sensitive to the plight of Jews, Colonel Josiah Clement Wedgwood, "protested in the House of Commons" on February 25, 1941, "against the treatment accorded passengers on the refugee ship *Dunera,*" describing "conditions aboard the ship as unjust and inhuman." Rumor had it that compared to the enemy troops, the refugees were treated with shocking cruelty. Wedgwood

> called on the government to publish the findings of an inquiry and asserted that wedding rings and other articles taken from the refugees should be returned to them with compensation. . . . Some, if not all, of the refugees had suffered losses. By taking steps to provide immediate compensation, however, and to see that disciplinary action was taken in cases where it was found to be necessary, he hoped that the matter would be dealt with as the House would wish and that any reflections upon the good name of Britain would be dissipated.[8]

The prejudices of the ship's commander, Lieutenant-Colonel William Scott, became a matter of record. "I would like to give my personal views," he volunteered,

> on (a) Nazi Germans, (b) Italians, and (c), German and Austrian Jews.
>
> (a) Having warned this group prior to sailing of my methods should trouble arise through them, their behaviour has been exemplary, they are a fine type, honest and straightforward, and extremely well-disciplined. I am quite prepared to admit, however, that they are highly dangerous.

(b) Italians. This group are filthy in their habits, without a vestige of discipline, and cowards to a degree.

(c) Can only be described as subversive liars, demanding and arrogant and I have taken steps to bring them into my line of thought. They will quote any person from a Prime Minister to the President of the United States as personal references, and they are definitely not to be trusted in word or deed.[9]

The *Dunera* has since become quasi-famous as the subject of a feature film,[10] an obscure documentary sourcebook,[11] and a few monographs and articles.[12] Within these records, however, Gernsheim is barely noticed[13] among a cohort now seen as "one of the greatest influxes of academic and artistic talent to have entered Australia on a single vessel."[14]

He had embarked with the idea that his destination was the hinterland of Canada,[15] persuaded by the appeal of Vincent Massey, then governor general of Canada.[16] In addition to getting away from the Blitz, Helmut imagined that he could contribute to the British war effort as an agricultural worker. As late as January 1945, Walter tried volunteering for farm labor as his obligatory period of "national service" but was ignored.[17] For Helmut, tilling the Canadian soil seemed preferable to suffering the fate of other enemy aliens on the British mainland or islands, who had little or nothing to do. Gernsheim and boredom did not go together. Both Helmut and Walter were fiercely driven by a desire to pursue productive work, especially projects which engaged art and culture.

Helmut did not wish to share the dismal fate of Walter, who had been interned on the Isle of Man since early June 1940. Four years later, after Helmut had started working at the Warburg Institute, he implored Fritz Saxl to try to relieve the distress of his brother and sister-in-law. Specifically, he presented the case to Saxl that the kind of photographic work in which his brother and his wife were engaged should be seen as contributing to the war effort. Not only did Saxl sympathize with this, but he himself had been instrumental in steering the Gernsheims on this course years before. Walter's situation, however, was complicated.[18] Part of the reason he was left to languish for so long was that there was little understanding of who he was and why he had come to be doing what he was as a photographer. Although what is now termed "the Gernsheim Photographic Corpus of Drawings" is feted as a treasured preservation project,[19] the work that he had undertaken since 1937 did not make any impression on British authorities in the 1940s.

Walter arrived in Britain in 1934 as a refugee from Nazi Germany. He probably had been baptized as a Protestant. When requested to specify his religion on a form, given the choices of "Jewish Orthodox, Jewish Reformed, Protestant,

Walter Gernsheim, *Self-Portrait*.
Private collection.

Catholic, [and] Other," he opted not to choose any.[20] Karl, the father of Walter, Helmut, and their older brother, Hans, was "a historian of literature who taught in an honorary capacity at the University of Munich."[21] He was born a Jew and converted "to Protestantism before his marriage."[22] Karl was among the less celebrated of the high-powered "hardy tribe" of the Gernsheims. (Helmut Gernsheim himself used this expression to emphasize the family's unusual longevity.)[23] Their most revered son was Friedrich Gernsheim (1839–1916), a composer and scholar of music whose career occupies the greatest share of Helmut's idiosyncratic version of the family history.[24] Interestingly, Friedrich was possibly the most Jewishly engaged of Helmut and Walter's ancestors, except for the smattering of rabbis.[25] Friedrich's legacy initially was most pronounced in Israel,[26] but in the last decades he has been rediscovered as one of the more important nineteenth-century Jewish composers in the secular realm.[27]

For the Gernsheims, attaining fame, wealth, and renown in matters scientific as well as in the arts was the rule rather than the exception. But in the 1930s, the larger family group ran the gamut from so-called full Aryans, such as Walter and Helmut's mother, Hermine née Scholz,[28] to "full" Jews, to those with only traces of Jewish lineage.[29] An uncle, one of Hermine's brothers, was "a committed Nazi."[30]

Given that Walter's future father-in-law, Fritz Landauer, was famous as a synagogue architect,[31] it would have been odd for him to call himself Protestant. He had, in a way, reentered the Jewish fold by becoming engaged to an unequivocally Jewish woman.[32] When Walter began studying the history of art, archaeology, and Slavic philology at the University of Munich in May 1928, he had no reason to think that his heredity would make a difference in his career—except, perhaps, for getting something of a leg up due to the elite status of his family.[33] But those under whom Walter studied were unlikely to enhance his options as an art historian after his flight from Germany. This partly explains his turn to photography.

Walter had worked under three distinguished scholars. The first was Erich Berneker, an ethnic German born in St. Petersburg, who became a leading Slavicist. His *Russische Grammatik* and Slavic etymological dictionary were standard texts for decades, even in Britain.[34] He died in 1937, and may have been ill a few years previously. Ernst Buschor (1886–1961) was a foremost historian of the art of antiquity. In the early 1930s he was enamoured of Nazi thought, like most German academics. It has been noted, however, that his major work, published in 1942, *Vom Sinn der griechischen Standbilder*,[35] did not seem to be tainted, to any great degree, by Nazi ideology. "After the war he was one of the first professors to be stripped of his position for his complicity with the Nazi government."[36]

Unattributed, *Interior of Willesden Green Federated Synagogue*,
Heathfield Park, London, designed by Fritz Landauer. Architectural
Press Archive/RIBA Library Photographs Collection.

Walter's more problematic mentor, who also caused issues for his former student Nikolaus Pevsner,[37] was Wilhelm Pinder (1878–1947). Pinder was a truly innovative architectural historian, especially in his attempt to show similarities between living organisms and architecture. His articulation of the essence of German artistic creation,[38] though, recalled the racist and antisemitic thought of Richard Wagner. Pinder was inconsistent as far as Nazi ideology and his relations with individual Jews were concerned. He did not share the distaste of Hitler and others for so-called degenerate modern art, and at least "one of his students" suspected that his Nazi sympathies were lukewarm.[39]

But Pinder vigorously championed the idea of the "Volk" in his academic work while it was fashionable, and these writings often were laced with antisemitism. Pinder apparently did not find this combination objectionable. Perhaps even more striking, though, was the lead role he played in publicly denouncing the art historian August Liebmann Mayer (1885–1944).[40] Pinder's original aim was Mayer's expulsion, not his extermination. Mayer's scholarship was so important for the field that his work appeared in Germany as late as 1943.[41] Mayer escaped to France in 1934 but was caught in the Nazi net after the German occupation and murdered in Auschwitz.[42]

Despite mentioning Pinder in his academic lineage, Walter Gernsheim could not possibly use him as a reference in 1935. He must have felt secure enough that Buschor and Berneker would supply him with positive evaluations, along with Rudolf Kömstedt of Cologne, less famous than the others, who apparently was not as smitten with Nazi ideology as Pinder.[43] The final two names he listed became far more significant in the re-creation of his career: Erwin Panofsky (1892–1968), who was then at Princeton University, and Fritz Saxl, of the Warburg Institute.[44]

In retrospect, the most interesting thing about Walter's presentation of himself during his early months in London (1934–1935) is that there is no mention of any expertise or even interest in photography—which would become the thrust of his career. There is no hint that he would become the father of the "Gernsheim Corpus." Typical for their time, the Gernsheim family visited photographers regularly, for instance at the Tietz department store. Remaining family photos include the three boys, in 1915, dressed as German soldiers, and a baby picture of Helmut. As a young man Walter either trained himself with great proficiency, or perhaps he learned from his girlfriend, later wife.

When Walter arrived in London in 1934 he was engaged to be married to a Jewish woman, daughter of the architect F. J. Landauer, Gertrud (also Gertrude), whom he apparently had met in Munich. There is a chance that, at the beginning, they were living with his in-laws or other relatives. As of 1935, under

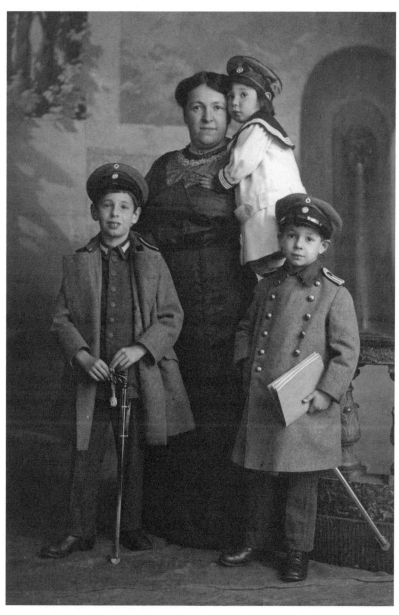

Photogr. Abt. ("photography department") Hermann Tietz [department store],
Munich, *Gernsheim Children, with Their Mother, Dressed as German Soldiers in the
Great War*, 1915. Baby Helmut is in white, above his brother Walter, with oldest
brother, Hans, left. Even after leaving London for Lugano, Switzerland, Helmut
Gernsheim referred to himself as an "Englishman." Private collection.

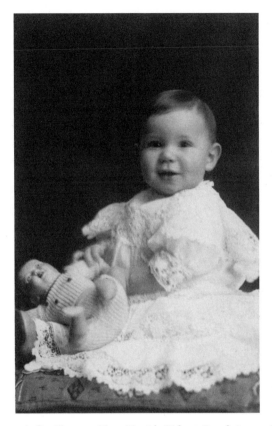

Photogr. Atelier Hermann Tietz, Munich, *Helmut Gernsheim as a Baby.*
Verso: Postkarte. This was taken by a department store photographer.
Private collection.

"permanent address" Walter listed the Warburg Institute, which probably was the closest thing he had to a home. He was living off of £2 weekly from the Academic Assistance Council, the forerunner to the Society for the Protection of Science and Learning. This was the main body to attempt to render him aid.

Although Walter said he would "like best to stay in England," he indicated that in addition to the United States, he was willing to relocate to "the Far East, the U.S.S.R., and South America."[45] He drew two conclusions from his immersion in the United Kingdom. First, there was little chance he could make a living as an academic art historian, a path that had apparently already become problematic in Germany due to the mounting antisemitism. He had no income or official position to report for 1932–1933.[46]

The other notion, which he probably formulated with the assistance, if not at the outright suggestion of Fritz Saxl, was to try to provide for himself by merging his knowledge of art history and photography by taking photographs of Old Master drawings that would be especially useful to scholars. In early November 1934, Walter expressed his appreciation to the Academic Assistance Council for sponsoring his "subsidiary work at the Courtauld Institute," which possibly involved the cooperative photographic venture between the Warburg Institute and the Courtauld mentioned earlier. Saxl was instrumental in arranging Walter's initial appointment as well as its extension.[47] A long memo in 1935, apparently from the Council, depicted Walter's "job prospects" as dismal. He was "determined to continue studying art history. No money. Lives on charity of friends and this is not assured for any specific time." There was "[a]bsolutely no use for Gernsheim to return to Germany he says as his family could not support him and he could not find work. [C. M.] Skepper [from the Academic Assistance Council] suggests re-training. Gernsheim [P]rotestant faith so Palestine, he says, out of the question."[48] Asserting that he was "Protestant" at this point probably was a means of eliminating the option of Palestine, in which he was totally uninterested. In contrast, we will see that Helmut was sympathetic to Zionism, and took pride in the founding of the Jewish state. "[Walter] Gernsheim wants to earn money teaching languages. German, French, Italian, Latin. Also German literature. Skepper said A. A. C. not likely to help."[49] Refugees who could teach languages were plentiful.

But the mention of "retraining" most likely encouraged Saxl to suggest that Walter move, officially, in a photographic direction. Walter was, it seemed, at the end of his rope.[50] Given that this was, at best, a tenuous proposition, Walter assumed that he would have to find another means to earn a livelihood, which he would do by founding an art gallery. Not surprisingly, support for this came from a Jewish connection arranged through Saxl—Otto Schiff (1875–1952), who was one of the most effective advocates for refugees and exercised his own private charity with discretion.[51] Schiff was sympathetically captured by Peter Hunter at the time.[52] Walter himself might not have known then that critical funds came from Schiff.[53] Later, however, when trying to reestablish the "Photographicum" project, he specifically mentioned "Mr. Otto Schiff" as having taken "a personal interest in our scheme."[54] Walter set up in 5 Stratford Place, just north of Oxford Street. He held exhibitions of "Old master drawings from 1 February to 6 March 1937,"[55] "drawings of the Bolognese school, May 10th to June 19th, 1937," and "representative drawings by living French sculptors, June–July 1938," for which he produced small catalogues.[56] He also exhibited photographs by Helmut in October 1937.[57]

Most likely the show of his brother's photos was the first instance, in London, that Old Master drawings and avant-garde—*neue Sachlichkeit* (new objectivity)—photographs had been displayed in the same space.[58] Many of these probably appeared in Helmut's first book, *New Photo Vision* of 1942, the ideas for which had germinated in the middle of nowhere, in Australia (as discussed below). Not even the Gernsheim brothers themselves appreciated how revolutionary this was. To most observers, though, photography in an art gallery was simply odd. London had no equivalent to either Alfred Stieglitz or Julien Levy, who were the first to present photography with painting and sculpture, but Eric Estorick (1913–1993) would later assume such a role with a focus on Italy.[59] It seems that no one bothered to review Helmut's work.

In the writings about architect Fritz Josef Landauer (1883–1968) and his industrial-designer son, Walter Landor (1913–1995), both of whom are praised for their creativity and modernist sensitivity, there is only a passing reference to Fritz's daughter, and Walter Landauer/Landor's sister, Gertrud. It stands to reason, however, that given her father's association with the avant-garde in the applied arts, including the Bauhaus and International movements, Gertrud may have seen the potential for merging photography and art. She received her MA at the newly minted Courtauld in 1934, when the various photography schemes were launched.[60] Certainly photography was significant in her father's world.

We know that Walter realized, by 1937, that photography was a better bet for Jews in Britain than most other fields. While in Germany he increasingly employed photography in his research, and trained himself well.[61] Perhaps Walter and Gertrud had come to the fusion of photography and art together. From the very beginning the ventures of both Gernsheims in photography and art had been partnerships: Walter with Gertrud, and Helmut with Alison née Eames.[62] In this way they were unknowingly following the path of Beaumont Newhall and his wife, Nancy.

In his more than four years of internment on the Isle of Man, Walter tried repeatedly to gain his freedom and return to photographing art. On August 22, 1944, he wrote:

> Invited by the representative of the Ministry of Labour, Gertrud and I drew up a statement to be forwarded by him, outlining our qualifications and experience, and summing up an offer to take up cultural or linguistic work. This statement [was] handed in at the camp office on March 10, 1944, and no offer was obtained or enquiry ever made since that date.
>
> I therefore think it likely that the Ministry of Labour would consider to give permission for us now, to pursue the work we were doing in common interest

with The British Museum and other institutions. You will remember that this work is based mainly on export—I hold a War Office Permit—and therefore in the national interest not only on the strength of its documentary value but also from an economical point of view. After an interval of well over four years of internment, the first and obvious chance that opens an existence for us again offers itself in the use of our collected research material from the National Art Treasures, on the continued publication of which co-operation and subscription of the interested bodies were based. Practically all of our combined effort from the beginning of the war up to the date of internment on June 4, 1940, that is to say the preparing of many thousand items of documentary work, was rendered useless and still is, at a time when its exploitation would serve a good purpose, as the originals are bound to remain inaccessible for a time.

The Trustees of the British Museum, by making them available to us after evacuation, have testified to the expediency of this work and so have the Keeper, Mr. Hind, and the Assistant Keeper, Mr. Popham, of the Department of Prints and Drawings in their applications for our release in 1940.

Our release depends first on an occupation approved by the Ministry of Labour. I should be glad if an application for this approval would be made by an authority who could point out the national importance of this work, on behalf of both of us, as Gertrud has collaborated with me in this work since 1936, and I could not attempt to cope singlehanded with both this work and the many technical details involved. You will note the similar purpose of our scheme, on a different scale, to the one under which you are doing useful service.[63]

In the end, Walter argued that the same logic behind the National Buildings Record project should be applied to his enterprise.[64] "Dr. Saxl's earlier offer of help encourages me to ask you whether you would ask his kind assistance in this matter. The Warburg Institute availed itself of my edition for mythological subjects." In addition to claiming Otto Schiff's support, Walter mentioned "Sir Kenneth Clark, who was a subscriber for the National Gallery [and] would be able to extend his help to me." In the end he stated emphatically, "We are resolved to stake all on this one issue, which we regard as a test of what is to be considered a suitable occupation."[65]

Saxl confirmed that "before the war Mr. Walter Gernsheim and his wife had started a scheme under which they took photographs of old master drawings preserved in this country." Although there is no sense of how they had been able, or how long it took, to cultivate their clientele, Saxl elaborated that they had "a fairly large circle of subscribers, public galleries, and universities almost

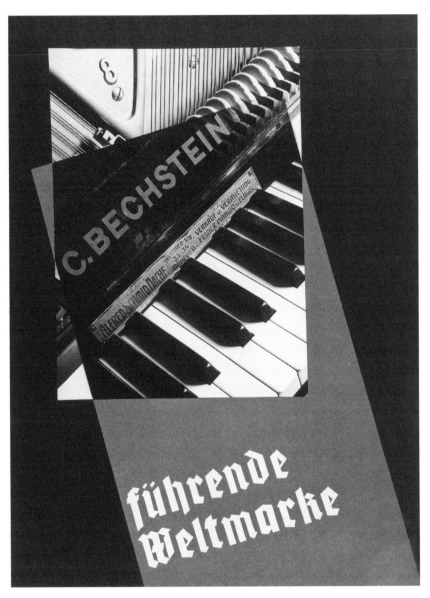

Study for a poster for Bechstein pianos. The photograph in the poster is the final image in Gernsheim's book *New Photo Vision* (1942). Gernsheim wrote, "This is not a photo-montage. The effect was obtained by enlarging portions of two photographs to the same sheet. The strongly pronounced diagonal 'movement' of the horizontal and vertical planes which divides the picture in X-form accentuates the idea of the rhythm which we associate with the piano."

exclusively in the United States who were regularly provided with these photographs." Even if Panofsky did not actively help, his name would have been meaningful as the preeminent successor to Aby Warburg in the United States. "Every negative of a drawing which [Gernsheim] took in this country was printed in so and so many copies, and the whole sets of drawings were sent over to American subscribers."[66] Possibly Walter and Gertrud were using the premises of the art gallery for photographic work, or the facilities of Gertrud's father. Their endeavor "was sufficiently remunerative for Dr. and Mrs. Gernsheim to earn their living."[67] Walter was no salesman à la H. W. Barnett or Arnold Jarché. His product was unique.

As stated earlier, the contemporary photographic enterprises focused on the history of art and architecture were intended mainly for the institutions in which they were founded; one example was Foto Marburg. After the Nazi takeover, this branch of the university enthusiastically served the Nazi cause to record and consolidate the treasures of regions conquered by the Third Reich. "Photocampaigns" devised by Foto Marburg for the Baltics and France were expressly antisemitic. Gertrud and Walter Gernsheim's project had no national boundaries in terms of subject matter, although business could not have been transacted with German universities or with any institutions within the Nazi orbit[68] between September 1939 and the demise of the Third Reich.

Ironically, Walter Gernsheim was arrested in June 1940 while he was on a visit to Aberystwyth to make photographs as specified in a government contract. With this the work "came to an end." Saxl contended, "[T]here is no doubt that this is an extremely valuable scheme, and its importance was acknowledged by a War Office permit which Mr. Gernsheim holds. It is of value not only to the American institutions which through him received material that would otherwise be inaccessible to them, but also to this country, from the point of view of export."[69] In light of the Battle of Britain and the ongoing Nazi menace, the Gernsheims had performed an even greater, distinctive service—documenting precious works of art and manuscripts held by the nation that were threatened with destruction or, just as bad, falling into Nazi clutches. "I have no doubt," Saxl continued, "that if Mr. Gernsheim were released to take up his occupation again he would have no difficulty in re-establishing contact with his American subscribers."[70]

Dealing with Gertrud and Walter Gernsheim was exasperating for even well-intended authorities.[71] The fact that few understood, let alone appreciated, the significance of their work for the fine arts no doubt added to their estrangement. They seemed to be "unreasonable," unwilling to accommodate themselves to the

exigencies of wartime.[72] One member of the organization that was trying to assist them lamented that "the Gernsheim attitude does great harm to the cause of the refugees."[73] Their only respite from total idleness was a short period when they were invited to participate on archaeological excavations on the Isle of Man.[74]

To be sure, they and their cohort had done nothing wrong. Their incarceration was a consequence of how they were administratively defined. But part of Walter and Gertrud's continued difficulty was the predicament of photography during the war, and even in the immediate postwar period. As we have seen in the case of Zoltán Glass, British officials were hesitant to give "enemy aliens" permission to possess cameras and pursue photographic vocations. It also seems that the Gernsheims were pacifists of an extreme sort. They objected as a matter of principle to overtly serving the war effort, even for Britain, which was at war with the Nazis—but they did not make this clear at the beginning of their incarceration. This stigmatized them in the refugee milieu. Eventually, though, Walter agreed to accept a teaching position in lieu of some other form of "national service," an appointment which he grew to like.[75] Walter decided, despite his rather surprising success in teaching language, literature, and drama, to resume his "corpus" project when he received permission. This was a consequence of special pleading by Saxl and others.

When Walter and Gertrud Gernsheim were released from internment on November 15, 1944, they had no means of support, since the Ministry of Labour had "not given definite written permission to continue" their "former photography of Old Masters." A recommendation in their favor was expected to be forthcoming from Kenneth Clark.[76] Few pulled more weight in government circles generally. Addressing the Ministry of Labour, the Gernsheims argued that they were "entitled to exceptional treatment in the matter of freedom from labour controls."[77]

The records do not specify exactly why the authorities eventually changed their minds, but the intervention of one particular interested party, David Daube (1909–1999), seems to have mattered. Daube, who is largely forgotten in Britain, also was a refugee from Nazi Germany. He too was interned, albeit briefly, on the Isle of Man. Daube wrote to "Joe" Skemp, whom he knew personally, at the SPSL. Skemp, a "keen Baptist" and scholar of Greek philosophy, began in 1936 to take an active role in refugee relief. At that time Skemp was at Manchester University, while remaining a fellow at Cambridge, as was Daube.[78] Daube asked that the Gernsheims be allowed to pursue their research. "Mrs. Gernsheim is an old friend of my wife's. We hope that after so many years of hardship and isolation, it will be possible for them to resume the work for which they are so highly

qualified."[79] Gertrud Gernsheim was the daughter of a German-Jewish refugee architect. Daube's wife, Herta Aufsesser, was the sister of German-Jewish refugee architects.[80] Similar to Gertrud's father Fritz Landauer, Hans Aufsseser (later Tindall), brother-in-law of Daube, was a distinctly modernist architect and designer.[81]

Skemp consulted the Gernsheims again, and learned that Walter would now be willing to teach classics as his form of service.[82] Strenuous effort was expended in finding him a position. Part of the reason such pains were taken to deal with the Gernsheims, who tried everyone's patience, was Daube. Elected to a teaching fellowship at Gonville and Caius, he was a rising star at Cambridge and considered one of the sharpest minds of the academic legal community. Daube had a traditionally observant, Orthodox background in Germany, and was perceived as a voice of profound moral authority.[83] It is not known if the Gernsheims were aware of this intervention.

Throughout his life, Daube was dedicated to alleviating all forms of injustice.[84] Like many other Jewish refugees who loomed large in interwar Britain and the immediate postwar period, Daube is rarely recalled, in part because he resigned the Regius Chair in Civil Law he had held in Oxford, since 1954, in order to assume a professorship and directorship at the Robbins Hebraic and Roman Law Collections at Boalt Hall, the law school of the University of California, Berkeley. He was revered as one of the stellar refugee scholars at Berkeley.[85] Daube's influence, even in the 1940s, reached far beyond Jewish concerns. Among other lasting achievements, he undertook New Testament scholarship from a legal-historical perspective that was considered "revolutionary."[86]

In any event, within less than three years the reestablished "Photographicum" was booming. This was, after all, a time of great expansion for American universities, as the GI Bill meant that thousands of ex-servicemen would have the opportunity for higher education. In 1948 Walter wrote a letter to the *College Art Journal*.[87] It was a way of publicizing the project and also castigating those who had not yet joined the bandwagon of the "Corpus Photographicum of Drawings." Walter's brimming confidence and authority could not be a more striking contrast to his utter despondence as an internee. A few years earlier his home had been ruined by German bombs and his career was in tatters.[88] This letter was apparently the first and last time he would address a broad public.

A fellow art historian confessed to me the other day that his work was seriously hampered by the inaccessibility of part of the drawings in his specialized field, whilst he found it very difficult to obtain photographs. So he asked me if I could

think of any source he had not tapped yet. And there I was, having the whole material he wanted, and having found it as difficult to know about his work as he did to learn about mine.

Gernsheim correctly surmised that this was a two-way problem. Not only did he need to locate the possible institutions and clients interested in his service, but he had to figure out a means for people in the field to "discover" him. Walter continues:

> Certainly, some of the foremost museums in Europe and the United States have, from 1937 onward, been regular subscribers to my editions of drawings . . . but only in a few instances have these photographs been made accessible to a wider range of students.[89]

There was, of course, no need to mention the interruption of this work between 1940 and 1945.[90]

Gernsheim's project complemented the increased value placed on drawings and manuscripts as art in themselves, as well as their role in conceiving and executing all varieties of art and architecture. Scholars also were beginning to discern the project's relevance in studying the range of fields associated with music.[91] But this was still in its infancy.

> However, the number of drawings I publish—about twelve hundred every year at present, with the intention of gradually reaching the pre-war aim of twenty-four hundred—is accumulating fast, and some institutions which may easily manage to subscribe year by year, may find it difficult later on to make funds available for the whole material published up-to-date, while I may find it increasingly difficult to provide back numbers within a short time.[92]

This was, indeed, an unusual kind of subscription. It was quite different, say, from taking a scholarly journal—something totally new. It provided access to nearly primary sources in art history on an unprecedented scale.

Gernsheim also found that he had to confront the blinkered idea of "the specialized scholar who thinks he already has made a survey" of the entirety of a field. "Well, the work of no artist has been more exhaustively published than that of Dürer, yet only a few months ago, in a public collection, I photographed for the first time a Dürer drawing completely unknown in the literature." Gernsheim admitted that "it is not always easy to get to know about all the existing

material in a collection, even if all the desired information is readily given. I was hunting up and down a museum through various storerooms and wings for a quattrocento drawing, the existence of which was known to me. And when at last it had been pronounced untraceable, I found it in an inconspicuous place—on the wall." Not worried about being taken as immodest, he asserted that "a surprising number of early Renaissance drawings have come to light through my work."

He self-consciously attempted to enhance and expand the field. Many Renaissance artists were "well published, but many were totally omitted," and there were "unreproduced versos of reproduced rectos."[93] This sounds very simple but it took someone to act on it. The fronts and backs of things deserved to be photographed, as they often contained important data or images. This was similar to his brother Helmut's epiphany of having statues and buildings cleaned before taking their photographs. After one knows of it, it sounds absurdly obvious.

As had been the practice at the Warburg, Gernsheim stressed that scholars needed as many examples (with variations) and as much detail as possible. To be sure, the project's vast scope was a means for Gernsheim to make money. But in this appeal for "cultural responsibility" and the need to spread scholarly resources as far and wide as possible, Gernsheim was taking up the mantle of the Warburg Institute, and the democratizing efforts of scholars and even art patrons such as Paul Cassirer from before the First World War.[94]

Walter Gernsheim sought to distance himself and his endeavour from "commercial photographers" dealing with the fine arts, whom he derided for seeking only "sensational discoveries" and reproductions from "the greatest artists." In contrast, Gernsheim embraced "the neglected and forgotten periods and artists. This applies likewise to collections, and the lesser ones alternate with the important ones in my editions." In addition to the photographs themselves, he also offered all of the related data to researchers, "for which my wife collaborates with me on my travels," such as: "reference number of collection, attribution, subject, medium and color of background, and measurements of each drawing. In addition, in the catalogues and at the back of the photographic prints, drawings bear our own serial numbers. These editions with their corresponding catalogue pages are known as the Corpus Photographicum." His wife was in large part entrusted with the systemization of the enterprise, which was a major selling point.[95] The work also proved to be resilient due to the Gernsheims' complete rejection of racially or even nationally inflected forms of analysis.

But if this was all so important, such a vast advance making the work of scholars more efficient and comprehensive, why the plea? Gernsheim could not

admit outright what he knew: that photography, even as a means to better and more creative scholarship, was not respected as it should be. The reason for the relative ignorance of his enterprise, Gernsheim wrote,

> lies in the very conditions of the undertaking. As I have no financial backing from any institution, the scheme ought to be self-supporting on the subscriptions but alas it is not; the subscriptions up to now covering only part of the expenses. So, with the funds at my disposal, having the choice between going ahead with the scheme at a loss—or publicity for the scheme, I chose the former hoping that in the end work will win. All the more grateful am I for this opportunity to give you some particulars about the Corpus Photographicum, and so to bridge a lamentable lack of contact.[96]

It is not known at what point Walter turned a profit, but it certainly happened. In the end it provided him a comfortable and lucrative livelihood. Already quite successful up until the 1990s, the project was able to reap immense benefits from the advent of the Internet.

Scores of major universities and art centers now hold the collection. By 1954, Gernsheim's sweep included the Warburg Institute, the British Museum, the Louvre, the Galleria degli Uffizi in Florence, and the museums of Besançon, Dijon, Lyons, and Rouen. In the United States at least four institutions carried complete sets: the Cleveland Museum, the Frick Art Reference Library, and, under a shared arrangement, the Prints and Photographs Division of the Library of Congress and the National Gallery in Washington, DC.[97] Except for the *College Art Journal*, there was little or no interest in Gernsheim's appeal in 1948—but among experts the word spread.[98]

Walter Gernsheim was an apostle for the study of drawing as well as photography. When he decided to forgo teaching,[99] his handlers at the Society for the Protection of Science and Learning were baffled.[100] They saw his shift of career as consistent with his difficult personality. They did not realize, however, that his experience as a secondary school teacher probably convinced him, to an even greater degree, of both the practicability and the need for the project he had begun. Over time a broad consensus emerged that drawings and manuscripts were as valuable and significant as Gernsheim thought they were. His "Photographicum" is held by many of the world's most prestigious museums and universities.

Eventually Walter Gernsheim resumed his career as an art collector and dealer as well, in conjunction with the photography project. In 1976, he purchased Michelangelo's *Study of a Male Torso* at Sotheby's in London for £178,200,

which was then "about $318,214, a record for an old master drawing at the time." In 2005, in his nineties, Walter Gernsheim put the drawing up for auction at Christie's in New York for around $4 million.[101] It did not fetch its reserve price, with a top bid of $3.2 million—but the value of such work was sharply rising. "Another Michelangelo drawing, *The Risen Christ*, sold at Christie's in 2000 for $12.3 million, again a record for an old master drawing at auction."[102] It is remarkable to recall that concern for transmitting Old Master drawings would have barely registered in 1944, when the Gernsheims sought release from their internment, or in 1937, when they commenced the project. Walter Gernsheim's prescience, along with that of Saxl, was incredible. Walter helped to create and then stoke the market for such work by giving it greater visibility and accessibility. In this case, the value of "the work of art through its mechanical reproduction" enabled its esteem, and even its cash value, to skyrocket.

His brother Helmut saw no choice but to get away from London, and the country, in the midst of the Battle of Britain—in which he was neither invited nor allowed to serve as a soldier. Helmut assumed that volunteering for such an expedition, in Canada, would leave him in the good graces of His Majesty's government when the hostilities abated.[103] As Claude Sui has noted, in a number of respects the bizarre episode on the *Dunera* and the Hay camp helped fashion Helmut Gernsheim into the distinctive figure he was to become in the next decades in Britain.[104] But Helmut rarely spoke about this experience, and it is not mentioned in his substantial, sympathetic *Dictionary of National Biography* entry.[105] Gernsheim did, however, dwell at some length on it in his interview with Val Williams in 1995.[106]

In the early years of Nazi rule Helmut Gernsheim studied art history. Overwhelmingly on the advice of his brother, he learned photography, and specifically sought training in color photography.[107] Yet when the miserable *Dunera* finally landed in Australia, photography was not an option. The internees were there, after all, because it was thought that they presented a security risk. Everything of value they had had on board was stolen by the troops "guarding" them. They could not, then, be free to use something like a camera—an instrument for subterfuge second only to a two-way radio or a firearm. But this prohibition did not take Helmut's mind off of photography.

Later Helmut said that while the Hay compound looked like a concentration camp, with an electrified fence, its inmates were unmolested. Soldiers avoided entering the camp. It had, in fact, "been planned for Nazi prisoners."[108] Hay was tiny and insignificant, so remote from any metropolitan area, 750 kilometers west of Sydney, that the term "isolation" did not do it justice.[109] The extreme heat,

parched desert environment, and sight of springing kangaroos made it even more bizarre. Although the conditions were harsh there were a host of liberties offered to internees. Such excessively liberal perquisites were a result of the British having "admitted that a great injustice had been done to the internees."[110] There was no limit on the number of magazines and books an internee could receive, as long as these were deemed innocuous by censors.

Gernsheim had a number of friends and family members in the United States, Britain, and elsewhere who were able to send him the books and periodicals he requested.[111] Some of his relatives, especially in New York, were well-off, and kept him supplied. One of his older cousins, Michael Gernsheim, who died in 1933, was a "founder-partner of the celebrated New York bankers Kuhn, Loeb & Co."[112] In addition to photographic journals, which would form the basis for much of his later work,[113] Gernsheim also received an English translation of Erich Stenger's *Die Photographie in Kultur und Technik: Ihre Geschichte während hundert Jahren* (1938).[114] There was a Jewish story here, as well, of which he may have been aware.[115] The translator, who also wrote extensive additional notes, was Edward Epstean (1868–1945); he had earlier translated another seminal work, the *Geschichte der Photographie* (originally 1932) by Josef Maria Eder.

Epstean, said to be "born and educated in Bohemia,"[116] was himself "a pioneer in photoengraving and a collector of literature on photography."[117] One of the nearest precursors to Gernsheim, he "began collecting books about the history and science of photography in order to aid his own work, beginning in 1892." Epstean also had been interested in "the application of photography to the graphic arts."[118] He maintained good relations with many of the German scholars with whom he worked even after the rise of the Nazis. Most likely Beaumont Newhall, to be discussed below, could not help thinking of Epstean when he encountered Gernsheim. Epstean, too, was a tad problematic, accused of shady practices as a publisher.[119] Although Epstean was successful financially, he was distressed because one of the aspects of his career he most enjoyed was working as an interlocutor between the photographic realms of the United States and Europe—a service which the Nazis ended.[120]

Besides holding great respect for Epstean, Beaumont Newhall was touched by the plight of another refugee from Hitler, who also can be seen as one of Gernsheim's forerunners, Heinrich Schwartz (also Schwarz) (1894–1974).[121] Although Newhall could read German, he was most impressed by Schwarz's book on David Octavius Hill, which was eloquently translated into English and handsomely published in 1932. Schwarz, whose conversion to Catholicism was meaningless to the Nazis, got out of Germany in time and found employment in

the United States—first as a librarian at the Rhode Island School of Design, and later as a professor at Wesleyan University in Connecticut. In 1940, though, Newhall thought that Schwarz was woefully unappreciated. Two years before reading Gernsheim's *New Photo Vision*, Newhall wrote his colleague, Walter Clark, that Schwarz was the "author of an excellent monograph on David Octavius Hill." Schwarz had "lost his entire fortune when the Nazis occupied Austria. He has arrived in the USA with a large collection on the history of photography and is seeking employment." Newhall asserted that "if Kodak is contemplating a museum of photography with the Cromer collection as the nucleus, they will want a curator" and that he couldn't "think of a better person than Dr. Schwarz. If they need additional references, they can also consult Mr. Epstean and Mr. Huebsch of Viking Press."[122] B. W. Huebsch (1896–1964), "a pioneering American Jewish publisher," was interested in photography but is probably best remembered as a champion of James Joyce.[123] This sincere and wise suggestion by Newhall, however, fell on deaf ears. Newhall's comments also reveal his awareness of informal Jewish networks.

Knowing his obvious interest in photography, Helmut Gernsheim's friends and relatives also took the opportunity to send him relevant books. Perhaps there were times when they could not locate those he had requested. "A fellow prisoner," Claude Sui writes, "lent him the paperback on photography by Lucia Moholy that he had already read in England." That, along with the Stenger history, "awakened his interest in the history of photography and served as the basis for the lectures he held for camp inmates. These were his first steps as a historian of photography, and he began to take notes for his first publication, *New Photo Vision*."[124] He was at the camp in Hay from September 7, 1940, to May 22, 1941.[125] Eventually Gernsheim was permitted "to take passport photos of the inmates, which were required for visa applications for other countries," but not entrusted with a lab.[126]

A number of internees established study circles, gave lectures, and even offered lecture series that approximated adult education or even university courses.[127] They built, Gernsheim recalled, "a kind of university."[128] The diversity of perspectives and life experience among the inmates was vast. Their ranks included "doctors, social democrats, Talmudists, anarchists, professors, communists, entrepreneurs, individualists, skilled artisans, Zionists, Catholics, missionaries for vegetarianism, artists of all varieties, and manual laborers"[129] and a dozen professional photographers.[130] Perhaps some of them were among the ten or twelve who attended Gernsheim's classes.[131] Highly organized sporting events, with inmates claiming the names of their beloved European teams, as well as

theater and musical ensembles flourished.[132] In his encounters with fellow internees, which were unavoidable, Gernsheim was pleased to learn that there was quite a lot of interest in photography. This had even been true on the ship.[133]

He would not be able to teach photography, per se, as there were no cameras, equipment, and darkroom facilities generally available. But he could lecture to them about photography. Although Sui is no doubt correct that the camp ignited Gernsheim's enthusiasm for the history of photography, it also is true that his twin passions for art history and photography coalesced in a different direction. It was in Australia, it seems, where Gernsheim began to formulate his complex view of photographic history and practice in Britain, in particular. The camp at Hay was not an environment where one had to watch what one said. It was well beyond the pale. One of the few things that united the diverse Jewish captives was their sense of injustice at the hands of the British.[134] Gernsheim certainly believed that Britain had a great and glorious photographic history, providing many of its path-breakers and most illustrious practitioners. Yet he found that its conventions since the First World War were retrograde, if not downright mediocre—especially compared to the scene he knew so well in Germany. Gernsheim would learn only later that he was following a route similar to that of H. W. Barnett, in pushing the field forward and also sharply bemoaning the current situation.[135]

A critical mass of internees found photography criticism and the history of photography fascinating. Given the books and other material he was regularly receiving, it became clear to Gernsheim that he could offer not just a lecture, but an entire series of classes on photography's history. It was here, Sui argues, that Gernsheim began to think systematically about the history of the field. Even though Gernsheim is not especially well remembered among the *Dunera* cohort, he recalls having a receptive audience. Given that most were from Central or East Central Europe, largely middle-class Jews, it is little wonder they were sympathetic to Gernsheim's perspective. One did not have to be an intellectual or critic to see Britain as backward. Especially with their bitter treatment aboard ship, it would have been easy to agree that the British lacked sophistication.

Shortly before embarking on his traumatic voyage, Helmut had an encounter with another "enemy alien" that was more influential than scholars and critics have realized. At the Huyton camp near Liverpool, he shared a tent with Nikolaus Pevsner.[136] It is possible they already knew each other. After all, Pevsner and Walter Gernsheim shared the same Doktorvater, which is akin to, perhaps even stronger than, a blood relation. Both Pevsner and Helmut later lived in London. There is not, therefore, much of a paper trail for their relationship. Yet they were quite close, and seem to have influenced each other. Two examples of their

explicit collaboration are Gernsheim's book *Focus on Architecture and Sculpture* (1949), for which Pevsner provided the foreword, and Pevsner's comments concerning Gernsheim's plan for a national museum of photography in Britain, to be discussed below.[137]

Gernsheim's stay in Australia brought him to two other camps. The first was Orange, where he was held from May 22, 1941, to July 24, 1941. Conditions there were far better than at Hay, because it had been purpose-built for Japanese POWs. His last stint was in "the Tatura camp near Shepparton (north of Melbourne), where he remained until his release on 1 October 1941." Tatura, despite his nominal captivity, was a comfortable, almost luxurious holiday spot.

Gernsheim was thrilled and relieved to head back to London. Otto Salomon (later Peter Hunter), the son of Erich Salomon, was on the same boat.[138] They became friendly, as revealed earlier, but Helmut did not make use of this opportunity to learn as much as possible about his shipmate's father. Most likely, in October 1941, Gernsheim was mainly imagining a book about photography in Britain. He desperately sought to become part of the British photographic establishment, but he also wanted to, emphatically, put it in its place.

Helmut Gernsheim's social orbit, after his return to Britain, included acquaintances from the *Dunera*. He remained friendly with Wolfgang Josephs (later Peter W. Johnson) and a man identified only as "Teddy." Helmut's nickname, among the *Dunera* group, was "Nuppel." In 1960, upon seeing in the *Amateur Photographer* magazine that Gernsheim had "been honoured by the Deutsche Gesellschaft für Photographie, which I am sure was an impressive event as they usually are in the 'Vaterland,'" Johnson invited Gernsheim to address a progressive Jewish organization, the "New Jewish Society," in which he was active.[139] Several months earlier Helmut had been asked to address the London Jewish Graduates' Association at Hillel House, which indicates that he was on the local radar as a prominent Jew in his field.[140]

As mentioned, the period of the Second World War and some years afterward proved difficult for many photographers. It was hard to make a living in austerity Britain. Gernsheim was, however, creative and entrepreneurial. Before the *Dunera* episode, he was one of only a few commercial color photographers in the country. One of these, D. A. Spencer,[141] worked for Kodak, and the other was Bela Gaspar.[142] Gaspar, originally from Hungary, was another refugee and a fascinating, multitalented figure who was a great innovator in color film. His brief career in Britain remains to be examined. Toward the end of his career Gernsheim would be increasingly interested in color photography, but motion picture film was one of the few photography-related fields in which he did not try his luck.

Over time Gernsheim's creativity was directed to turning the history of photography into a cogent field. Although he did not entirely give up taking photographs himself, his energy was devoted increasingly to collecting photographs, curating exhibitions, and writing histories of photography together with his wife. Gernsheim was aware that he was charting a new branch of cultural production and knowledge. Of course there were others who had collected photographs. But when he began he was not aware of anyone who had collected with an eye to assembling a historically representative collection, and to self-consciously erecting a comprehensive history of the field in order for photography to achieve a status akin to painting and sculpture.[143] These were, of course, complimentary activities. Later he learned that Louis Walton Sipley had been engaged in similar activities in the United States, although Sipley was more concerned with photography's technical aspects. Gernsheim would become closer to Sipley and his wife than anyone else, with the possible exception of Beaumont and Nancy Newhall.[144] His subsequent close friendships with photographers Tim Gidal, Gisèle Freund, and Ferenc Berko in particular made him think about the connections of Jews to photography.

As discussed earlier, Helmut Gernsheim's main institutional home during World War II, apart from the milieu around the *Dunera* excursion, was the Warburg Institute. He vigorously sought employment at the Warburg for three reasons: it already was known for offering assistance to refugees, as it did for Walter; the Warburg had established large-scale photography projects; and it was involved in the National Buildings Record project. His wife had seen press reports about this and informed him while he was still in Australia.[145] Both of them assumed Helmut's main occupation would continue as a photographer.[146]

At the end of December 1941, presenting himself to the Warburg Institute, Helmut summed up his career as follows:

I studied photography at the Staatslehranstalt fuer Lichtbildwesen in Munich for two years and took a final degree there with first class honours in all subjects, theoretical and practical. My main interest was always in architectural photography and art reproduction. Before I came to England in July 1937 I took a number of photographs, for the National Museum in Munich; for Dr. Schlegel, formerly of the Marburg Institute of Art I did a complete series of the Romanesque church of Altenstadt in Bavaria, a rather important work as it was brought before the highest authorities and gave occasion for renovation works which were carried out later on. I also collaborated with Dr. Walter Hege[147] on his book *Bavarian Baroque and Rococo Churches* for which I prepared the Uvachrome Colour plates.

In this country I did all the photographic work for the Sabin Gallery, for Mrs. Mendelssohn-Bartholdy, Mr. Helmut Ruhemann, for the sculptor Georg Ehrlich and Ewein [Ervin] Bossanyi, occasional work for the Studio etc. I also have taken a number of photographs of St. George's Chapel in Windsor which I should like to show you.

When war broke out I offered my services to His Majesty's Government and was duly enrolled in the Central Register of the Ministry for Labour and National Service.

In August of last year I received an appointment as professor for photography at the Laboratory for Anthropology at Santa Fe, New Mexico, U.S.A., but alas I had been interned in the general invasion fever in July and was on my way to Australia.

Four weeks ago I returned to this country from Australia having been released from internment by the Home Secretary for my special qualifications.

May I add in conclusion I am brother of Dr. Walter Gernsheim, formerly of 5, Stratford Place, W. 1.

I should welcome the pleasure of making personal contact with you and I am looking forward to the favour of your kind reply.[148]

Gernsheim appealed to the director, Saxl, on the basis of his professional qualifications, but also with the reminder of his status as a stateless refugee with no place of return in the foreseeable future. He did not mention the *Dunera*. His most relevant work had been the photographing of churches, but Helmut also was counting on his connections to the orbit of German Jewish émigrés, especially his brother, to help secure a position.

In addition to Walter, who had published a book, launched an art gallery, and begun the Old Master drawings photography venture, he named a few others who he thought would lend credence to his application. Helmut Ruhemann (1891–1973), "one of the leading picture restorers of his generation," like the staff of the Warburg, fled Germany almost immediately after the Nazi takeover. He was, however, well ensconced in the British art scene, "where he already had clients among leading London art dealers." Since 1929 he had been the lead restorer at "the Kaiser Friedrich Museum, Berlin." Ruhemann's approach to restoration was regarded as extreme, as he advocated "the complete removal of old varnish in cleaning pictures"—which occasionally had unfortunate effects.[149] Georg Ehrlich (1897–1966), a refugee from Vienna, was a successful sculptor; he also had been a draughtsman and etcher, and roomed in the same building as Walter Gernsheim.[150] Ervin Bossanyi, a Jewish refugee originally from Hungary, was "best known for his glorious stained glass." He received commissions for

significant projects in London including Goldsmith's Library in Senate House of the University of London, the Tate Gallery (now the Tate Britain), and the Victoria and Albert Museum.[151]

The biggest name Helmut dropped was that of Edith Mendelssohn-Bartholdy (1882–1969). Her striking portrait appears in his book *The Man behind the Camera* (1948). Although baptized Protestant, she too was compelled to leave Nazi Germany in 1934. Mrs. Mendelssohn Bartholdy's name resonated in many contexts. In addition to her own diverse charitable activities for social causes and the arts, the family was famous for contributions to philosophy and music, and her husband's ancestors had founded and directed the major German film corporation Agfa. It is likely that she, too, supported Walter Gernsheim's gallery and photography project. As we have seen, Helmut Gernsheim's tenure at the Warburg was highly productive and consequential, yet tempestuous. He left under a dark cloud.

He was undaunted, though, in the effort to make his way, if not as a photographer, then as the man to explain photography, and disseminate a finer feeling for it, in the wider world. Helmut attempted to forge relationships with nearly anyone he learned of who was interested in photography, and occasionally expressed his dismay when his overtures were ignored or rebuffed.

In addition to the significance of his scholarship, Helmut is regarded as one of history's savviest and most prolific collectors of photography. His relationship with Beaumont Newhall was central to this endeavor, as has been discussed by Flukinger and others. Although Gernsheim sometimes described their meeting of minds as a matter of happenstance, with Newhall discovering his work on his own, this was not exactly the case. In September 1944 Helmut suggested to his publisher that *New Photo Vision* be sent to Newhall, who was then at the Museum of Modern Art in New York.[152] He also sent Newhall a friendly, flattering letter,[153] and the response he received, which Newhall sent from Italy on November 20, 1944, left him elated.

> I purchased your *New Photo Vision* in Cairo in the summer of '43 and found it a most interesting and stimulating book. I well remember the satisfaction I found in your thesis, so in agreement with my own philosophy of photography. There has been so little genuine esthetic criticism of photography as an independent art form that it is a real pleasure to make the acquaintance of a fellow critic. Perhaps our paths may cross; I look forward to meeting you.
>
> In the meanwhile please accept the copy of my *Photography, A Short Critical History* which I am asking the Museum of Modern Art to send you in exchange for your generous and welcome gift.[154]

Newhall far more reserved than Gernsheim in approaching fellow scholars. Part of this may have stemmed from lingering insecurities from his days at Harvard. But once a colleague had established contact, Newhall welcomed her or him into his tent of the appreciation of photography. He had a critical eye, and a sharp sense of talent. He was no pushover when it came to reviewing articles and book manuscripts. But Newhall's manner was gentle, and both he and his wife, Nancy, were, as far as Gernsheim was concerned, warm, generous souls.

In the midst of the Second World War and its immediate aftermath, Newhall encouraged Helmut to scour secondhand shops and estate sales in London and the provinces in order to preserve and further investigate the heritage of photography, something that few considered worthwhile at the time. The assumption was that this effort at private acquisition would assist Gernsheim in his research, because he was not connected to a library, archive, or museum, as was Newhall. In retrospect, although Gernsheim himself was already an expert and his knowledge was growing exponentially, the suggestions and information offered by Newhall would prove to be of immense value to him.

Their common interest in photography apart, Gernsheim was drawn to Newhall because he represented an ideal type: a real American blue blood, a dyed-in-the-wool member of America's upper crust, for whom an elite boarding school and Harvard were rites of passage. They were sincerely good and helpful to each other. It seems that Newhall experienced the better side of Gernsheim's complex and volatile personality. Gernsheim tried assiduously to nurture his relationship with Newhall, and Newhall was always willing to allow Gernsheim the benefit of the doubt.

Along with their shared passion for photography, it seems that the relationship between Newhall and Gernsheim was colored by a particular Jewish/non-Jewish dynamic—although neither talked about this publicly. In 1940, when the subject arose of who should be considered for the directorship of the Eastman House museum, Newhall (who then seemed well ensconced at New York's Museum of Modern Art) said that Heinrich Schwarz, a refugee, was a superb candidate.[155] One wonders if Newhall was being subtly subversive in this instance, because Kodak was known to be unwelcoming to Jews—despite the fact that its most illustrious researchers, Mannes and Godowsky, two Jewish boys from New York, were the inventors of Kodachrome.

In 1979 Gernsheim sent Newhall the family history that he wrote for the *Year Book of the Leo Baeck Institute*, to be discussed below.[156] This appears to be one of a handful of instances in which Gernsheim affirmed—to Newhall—his tie to Judaism. In any case their allusions to religion were always subdued—as both

Helmut Gernsheim, *Edith Mendelssohn-Bartholdy*, 1946, in Helmut Gernsheim, ed., *The Man behind the Camera*, 35. "This portrait is entirely unretouched. Perhaps one day the public will grow tired of flattering, empty, and characterless portraits from which all personality has been effaced" (34). The words are Gernsheim's but the thought was that of Barnett and Bucovich as well. Sammlung Gernsheim, Reiss-Engelhorn-Museen Mannheim. ·

men (and their spouses) were highly secular. Gernsheim apparently never shared with Newhall his interest in Jews and photography, as he did with Tim Gidal, Gisèle Freund, and Franz Berko.

But the fact that Gernsheim was a refugee from Nazi Germany, an internee aboard the infamous *Dunera*, and unmistakably of Jewish origin, figured into the equation for Newhall—by far the most important person in the nascent field of the history of photography. Newhall's generosity toward Gernsheim was partly due to the fact that Newhall was, without any awareness of it, a "philosemite." As both of their careers evolved, Newhall certainly was sensitive to the reality that many in the world of the arts regarded Gernsheim as an outsider and a difficult character—but he never let that hinder his support of, and compassion toward, his friend.

Although this line of argument is necessarily speculative, it seems that part of Newhall's fascination with photography derived from its Jewish associations. For Newhall, photography as an emergent fine art was part and parcel of a cultural constellation emanating from New York City that had Alfred Stieglitz at its center. Stieglitz, in his time, was something of an emblematic Jew of New York, much in the same way that Woody Allen came to be seen as the (albeit areligious) archetypal Jew of New York in the 1970s. As a student at Harvard, Newhall was deeply grateful for the advice and guidance he received, over a number of years, from his teacher Paul Sachs (1878–1965). Sachs had retired early from his family's business, the banking house Goldman Sachs. It was Sachs, the first teacher of what came to be called museum or curatorial studies, who provided Newhall with an entrée to Stieglitz. He also supplied him with the names and addresses of other Jewish collectors at a time when photography was still regarded as marginal or lacking in respectability.[157]

The story may seem unremarkable thus far, given that Stieglitz was famed for his gregariousness, embracing (some more forcefully than others) all of the visitors to his cutting-edge galleries, "291" and "An American Place." Yet Stieglitz not only welcomed Newhall into his galleries and home—he also took him into his darkroom. Newhall would never forget this experience, which was, to him, akin to initiation into a religious rite by a founder of the faith.[158]

Newhall revered Ansel Adams (1902–1984) as the greatest of all photographers, and one whose portrayals of the American West were particularly illustrative of an American aesthetic. Interestingly, when Helmut Gernsheim became concerned with the question of Jews in photography, he explicitly asked Adams if he was Jewish, and received this response: "With great regret I must state that I have no trace of Jewish blood in my veins at all. I have searched diligently but

no luck! Most of my friends are Jewish, and most of the people who accomplish things in this world are Jewish. I am sorry I cannot answer in the affirmative!"[159]

Although he rated Adams's photography above all others, Newhall prized Stieglitz as the progenitor of a universal, cosmopolitan, exhilaratingly vibrant world of photography that found expression in the work of his protégé, Paul Strand, and photojournalists such as Eisenstaedt and Arthur Felig (1899–1968, better known as Weegee), whose work he esteemed as art. Few others were willing to go that far in the 1940s.

Newhall encouraged Gernsheim to appreciate the "pressmen" such as Weegee, but this aspect of photography was not then to Gernsheim's taste.[160] Gernsheim's tremendous regard for Erich Salomon was the exception to the rule. In the capsule biographies of a wide range of photographers in a 1962 publication, the only individual Gernsheim identifies as "Jewish" is Weegee. He surely was aware that at least a dozen others were Jews, especially the émigrés he knew personally, such as Erich Auerbach.[161] In what might be seen as an eruption of Jewish self-hatred, Gernsheim denigrated photojournalists, agents, and editors as uncouth.[162] Newhall, on the other hand, found such figures enchanting and occasionally credited them with the elevation of press photography to an artistic genre in its own right.[163] In later years, Gernsheim not only expressed pride in the great numbers of Jews in photography, including photojournalism, but he would even claim a proprietary interest in the subject.[164]

On the surface, and as revealed in the extensive correspondence between Helmut Gernsheim and Beaumont Newhall, it is apparent that their primary bond was dedication to the promotion of a better understanding of, and appreciation for, photography as a legitimate form of fine art. Although both men had a scholarly disposition and were painstakingly precise in all of their endeavors, they were not scholars in a conventional sense. Neither held a regular university-level appointment. Around the time of the death of Gernsheim's first wife, Alison, Newhall speculated that one of the grounds for his attraction to Gernsheim lay in the fact that they both worked as part of a husband-and-wife team.[165] Newhall did not know that the first model of this type of relationship, for Gernsheim, was that of his brother and his wife Gertrud. Rather than being relegated to secretarial or support roles, as was often the case with the wives of their peers, these respective spouses were as much primary investigators and analysts as they themselves. In one of his most personal asides, Newhall speculated that their connection also might have derived from both couples having remained childless.[166] In fact, all three couples—Walter and Gertrud Gernsheim, Helmut and Alison Gernsheim, and Beaumont and Nancy Newhall—had no progeny. Their

Charles E. Fraser, *Helmut and Alison Gernsheim Examining a Print*, October 1951.
This photograph appears in *The Gernsheim Collection*, ed. Roy Flukinger, 5 and
Helmut Gernsheim, Pionier der Fotogeschichte/Pioneer of Photo History, 18.
Sammlung Gernsheim, Reiss-Engelhorn-Museen Mannheim.

work, as opposed to children, consumed their energy and provided the focus of their lives. Helmut Gernsheim and Beaumont Newhall cared about the background and personal experiences of the other, even if the words "Jew" and "Christian" were never known to pass between them.

There is little evidence that Helmut exercised special sensitivity toward Jewish subjects, as did Lorant and many of the interwar and Second World War photojournalists before the 1970s. To the best of Newhall's knowledge, there were indeed "traces" of Jewishness in Gernsheim's work. But until becoming aware of Gernsheim's family history, his friend's efforts seemed marked more by the lengths he took to sidestep any Jewish questions.[167] With Newhall, Gernsheim rarely (if ever) mused about connections between Jews and photography. Newhall mulled the question over—even if he never said so in his publications. In a number of instances, in fact, he and his wife edited out references to Jewishness in writing about Stieglitz, Strand, and Helmut Gernsheim.[168] This was not a manifestation of antisemitism. It was, in their minds, a way of being extra kind and sensitive. They knew, though, that it somehow mattered. Eventually, Helmut Gernsheim, too, figured this out.

Not Harry Gresham

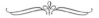

H ELMUT GERNSHEIM'S BOOKS, articles, and catalogues, which were greatly enhanced by his privately cultivated trove of photographs, apparatus, and publications, are fundamental to the history of photography.[1] Until 1969 he worked mainly in partnership with his wife, Alison.[2] Succeeding generations of photo historians have benefited immeasurably from the Gernsheims' prodigious research and insights. Helmut pursued a career in photography, he wrote and stated on several occasions, "entirely due to" the advice of his brother, Walter.[3] For a Jewish refugee such as himself, this was one of the few relatively unobstructed avenues in the domain of the arts. Once Gernsheim embarked on his journey as a historian of photography, however, there was little in his scholarly output that indicated his Jewish origins. There is no evidence that Protestantism, the faith into which he was baptized, or his mother's Catholicism, meant anything to Helmut. Concerning the background or outlook of Alison, little was said.[4] She too had an unconventional story, making her something of an outsider in polite society.[5]

In his interview with Val Williams, conducted over several days in 1995, Gernsheim recalls that his "foreignness" was consequential—but the issue of his Jewishness was only occasionally enjoined directly. This chapter explores his curatorial enterprises and relationships with publishers, in which Gernsheim's ethnicity was crucial but not always articulated. In publishing he frequently engaged the services of other refugees or made use of émigré networks. Jewish publishers, especially Harry Abrams (1905–1979) and George Braziller (b. 1916) in the United States, and Béla Horovitz (1898–1955) in Britain, were leaders in integrating photography into art history. Beaumont Newhall was both pleased and surprised when George Braziller sought to include his and Nancy's work under his "art history" imprint.[6] Alongside Harry Abrams, Peter Pollack was a

central figure in the burgeoning field of photography publishing,[7] and Pollack's correspondence with Gernsheim offers an excellent vantage point for observing its evolution.

The Gernsheims' publications often were tied to exhibitions based on Helmut's rapidly expanding collection. The most spectacular of these, which spurred his quest to establish a national museum of photography, was for the previously mentioned centenary of the 1851 Victorian exhibition sponsored by the Victoria and Albert Museum. The centenary events came under the umbrella of the Festival of Britain. The festival organizers sought to demonstrate that despite its war-torn condition, the country remained vital as a creative, industrial power. While it did not have the international perspective of the 1851 show,[8] there was an effort to pay homage to the extravaganza of a century before. Upon hearing in 1948 that the centenary would be marked by dedicated displays, Gernsheim immediately started lobbying for a Victorian photography installation. It made sense to the organizers, who could not refute Gernsheim's argument that photography had "played a large role" at the original event. "There was not one exhibitor who did not use photography," Gernsheim told them.[9]

Once the festival directors accepted his premise, they had to realize that there could be no serious candidate to run the exhibition other than Gernsheim. He also had solid connections to establishment figures in the arts through his work at the Warburg, even though his relationship with the institution itself had soured. Gernsheim recalls that Kenneth Clark was involved in the negotiations (conducted over the phone), asking about his collection and the kind of catalogue he envisioned. As opposed to simply displaying his photographs, Gernsheim wished to construct a totally Victorian space, a salon, so the audience would gain a better sense of the historical context. Although this idea was immediately controversial, he persevered.

Apparently the director of the Victoria and Albert, Sir Leigh Ashton (1897–1983) was disgusted by the proposal. He thought it smacked of being tacky, kitschy, and cheap—given that the furniture, including "Victorian wallpaper," a "loveseat," screens, and "stuffed pheasants" had mostly come from secondhand shops. He threatened to have Gernsheim's collection removed altogether if he insisted on having it displayed in such a manner. The official to whom Gernsheim was directly answerable, Phillip James (1901–1974), though, was in favor of the plan. Gernsheim, however meticulous a scholar, was too much a showman for Ashton's taste. Gernsheim failed to anticipate the mixed feelings that the recreation of a Victorian photographer's studio might elicit. Furthermore, he had no sensitivity for a possible confluence of apparently aesthetic judgments and antisemitism.

Gernsheim was aware that Ashton was "close" to the wife of Lord Rothermere, head of the *Daily Mail*,[10] Anne Geraldine Mary Charteris[11]—and he assumed she would like his display. (How he knew this is a mystery.) Gernsheim somehow engineered a private preview for Lady Rothermere, who gushingly called Gernsheim's concoction "wonderful." Ashton relented.[12] Conceivably Ashton resented this pressure and subsequently was even less inclined to help Gernsheim.

In the wake of the critical acclaim and general success associated with the centenary project, Gernsheim undertook strenuous efforts to institutionalize his collection as the basis of a national photography museum in Britain. He estimated that in five years his collection would grow too large for him to accommodate it in his own home. The photographs he purchased were often in lousy condition, and Gernsheim did not have the facilities to restore damaged works on any great scale.[13] Added to this were the increasing demands and continuous requests from writers, scholars, and the press for pictures and information—which they usually took without a thought that Gernsheim should be compensated for his professional services. Mounting commitments and aspirations for taking his work in new directions led him to conclude that the collection needed some sort of public, institutional structure.

It is not surprising that the person to whom Gernsheim turned in order to refine his proposal was Nikolaus Pevsner. He probably discussed it with his brother, Walter, as well. Gernsheim's initial plan is worth reproducing completely, as many of his points would be repeated and developed in his publications over the following decades. Draft "A" reads:

DRAFT SUGGESTION FOR THE FOUNDATION OF
A NATIONAL MUSEUM OF PHOTOGRAPHY.

Britain is the birthplace of photography as we know it today, and right through the Victorian era most of the epoch-making discoveries of photography were introduced by British inventors, and British photographers were internationally acknowledged as leading the world.

The present Arts Council exhibition at the Victoria and Albert Museum has come as a revelation to critics and public alike. Never before had photography—that truly Victorian offspring—been seen to such advantage, and one wonders how it was possible that these remarkable photographs, so immeasurably more interesting to us than the majority of paintings of the same period, should have remained hidden from the public gaze for so long, and indeed, why the entire field of Victorian photography should have suffered neglect and become the Cinderella of the arts.

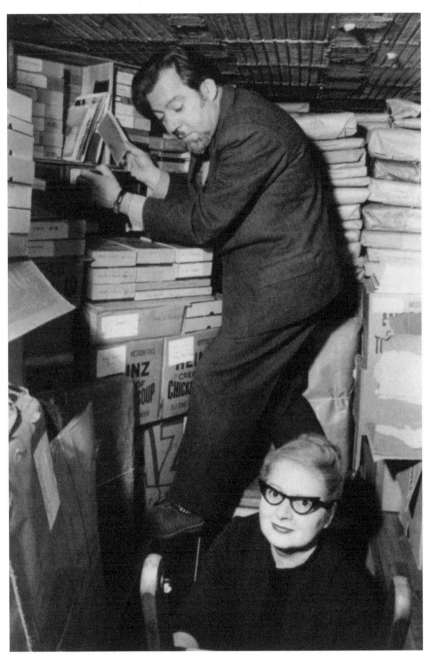

Charles E. Fraser, *Helmut and Alison Gernsheim in Their Attic* (1961).
Sammlung Gernsheim, Reiss-Engelhorn-Museen Mannheim.

Astonished at this situation in the very country which contributed so much to the evolution of photography, Helmut Gernsheim has for over six years, by his books and articles, focused attention on the great achievements of the past masters of the art—Hill, Cameron, Carroll, MacPherson, Fenton, and many others. During the same period he has built up what ranks today as a unique collection of British photography before 1900. It consists of

(1) Over 5,000 original photographs, including the finest collections of the greatest masters. About 2,000 of these are portraits of men and women eminent in the arts, science, politics, etc., which form in themselves a photographic portrait gallery of immense value to historians.

(2) A library of approximately 2000 books and journals on photography from 1839 to 1900, and several thousand cuttings and articles on photography from the non-photographic press.

(3) All the important publications of the 16th, 17th, and 18th centuries relating to the *camera obscura* and photo-chemistry, and leading up to the invention of photography itself: from Porta to Wollaston and from Schulze to Wedgwood.

(4) A most comprehensive collection of approximately 150 books illustrated with original stuck-in photographs, from Fox Talbot's "Pencil of Nature" on.

(5) Autograph letters and manuscripts of nearly all the leading British scientists and photographers who played an important part in the evolution of photography.

(6) Certain "milestones" in photographic cameras and associated equipment.

(7) Choice examples of all the various early forms of cheap portraiture prior to photography: miniatures, portraits on glass, Wedgwood plaques, silhouettes, physionotraces.

(8) Forerunners of cinematography: a large number of devices which produced for past generations the illusion of movement in one form or another.

(9) Of great importance to the historian are the archives—thousands of classified notes on almost every aspect of photography in the 19th century.

It is the desire of Helmut and Alison Gernsheim to present their collection to the nation, provided a permanent home can be found for it, and provided they retain its curatorship and have sufficient funds at their disposal to be able to add new acquisitions of unusual or historic interest. Just as the Angerstein Collection was the basis of the National Gallery, so the Gernsheim Collection could form an admirable nucleus for a National Museum of Photography. The establishment of such a museum is a matter of urgency, for already some rare specimens of the art have gone to American collections, whilst a great many have been irretrievably lost by destruction, due to ignorance.

In recent years there has been a steadily growing realisation of the advantages of photographic records over other methods of illustration, so far as 19th century social history, fashion, and portraiture are concerned; whilst photography as an art medium in its own right, and the magnificent contribution of British photographers towards it, is only beginning to find general appreciation. Twenty-five years ago, Roger Fry said: "Mrs. Cameron's photographs already bid fair to outlive most of the works of the artists who were her contemporaries."—and Roger Fry was not acquainted with the unsurpassed portraits of D. O. Hill, Thomas Annan, and many others, some of whom have remained unknown until the present exhibition at the Victoria and Albert Museum.

Quite apart from its immense educational value, it is clear that the proposed Museum would be a great boon to historians, journalists, art editors and publishers, who would be able to draw upon the Library and to obtain prints of the photographs for publication at the usual museum fees. For this purpose a photographic department should be attached to the Museum, similar to those at other Museums, to supply such prints, which would be Crown Copyright.

In its new acquisitions the Museum should not, of course, be limited to the period before 1900, but should acquire examples of the work of leading contemporary photographers throughout the world. The sponsors hope, by arranging frequent exhibitions and lectures, to stimulate an intelligent appreciation of photography and to raise its present standards.

The Museum would thus preserve for posterity the finest work of old and modern photographers, of any country. It would help in the education of public and students alike, and would give people in this country an opportunity not only to become acquainted with the great heritage of British photography, but also to see the best work of leading photographers in other lands, which would doubtless have a beneficial influence upon the present state of photography in this country.

Everyone is familiar with the invaluable work of the National Film Institute and Library. What has been achieved for the film—which is, after all, a younger brother of photography—can undoubtedly be achieved for photography also, and it is with this aim in view that Helmut and Alison Gernsheim are trying to marshal all the forces likely to assist the proposed National Museum of Photography.[14]

Gernsheim was decades ahead of any of his British contemporaries in proposing such an institution.

Some of the changes Pevsner suggested to Gernsheim's draft were narrowly stylistic. There were, however, a few significant "alterations." Pevsner advised him to tone down his claim that Victorian photographs were "so immeasurably more interesting to us than the majority of paintings of the same period." In-

stead, he instructed Gernsheim to say that they are "in every respect just as in-teresting." Pevsner also struck the phrase "the Cinderella of the arts," which Gernsheim used in several publications. He told Gernsheim to remove the refer-ence to "the National Film Institute and Library" and the "Angerstein collec-tion."[15] In the final version submitted for signatures and published in the *Times*, the National Film Institute was less pronounced while the comparison to the Angerstein collection was missing altogether.

The fact that the National Gallery collection was based on the purchase of the collection of John Julius Angerstein (1735–1823) was no secret. Gernsheim probably learned of the genesis of the National Gallery, in the first instance, from Walter. But Angerstein's origins were a matter of speculation, with some believ-ing him to be an illegitimate offspring of the Romanovs and others assuming him to be a "Russian Jew."[16] Pevsner felt this would not be a selling point. He also knew that the men concerned would not care about movies. Film was widely recognized as a field populated by Jews, and increasingly so since the influx of refugees beginning in the 1930s. Although he did not write much about film, Gernsheim was aware of its institutionalization. He knew that film's coming of age in Britain was a product, in part, of the efforts of his fellow Central European émigrés—such as those who influenced the work of Powell and Pressburger.[17] The devotees of the historical importance of film had made more headway in Britain than Gernsheim. Pevsner thought, though, that the explicit comparison to the British Film Institute and National Film Library should be introduced only in passing, rather than included as a major argument.

Gernsheim apparently attracted nine highly placed individuals to officially endorse his proposal: "Mr. Clive Bell, art critic; Sir Kenneth Clark, Professor of Fine Art at Cambridge; Mr. Ralph Deakin, Foreign Editor of *The Times*; Mr. Tom Hopkinson, former editor of *Picture Post*; Sir Gerald Kelly, President of the Royal Academy; Mr. Gilbert McAllister, Director, Parliamentary Association for World Government; Professor N. Pevsner, Professor of Fine Art at Oxford; Mr. J. B. Priestly, author; and Mr. J. R. H. Weaver, President of Trinity College, Oxford." Gernsheim thought, though, that Cecil Beaton, the famous society photographer, would lend his support. Supremely confident in the power of big names, Gernsheim underestimated how much energy, political heft, and money it would take to convince the authorities to act on his plan. He never succeeded in gaining the support of anyone who was willing to pledge a substantial sum of money to help turn his scheme into a reality.[18]

As late as the 1990s, in his interview with Val Williams, Gernsheim was dis-mayed that the approval of Kenneth Clark in particular was not decisive. He recalled correctly, however, that neither Clark nor Beaton signed the appeal that

was published in the *Times*. Gernsheim found Beaton's reticence especially "strange," because, he said, they had been "good friends."[19] In 2011 an intimate of Beaton told me that Gernsheim had "asked people to give him photographs for his museum, which he actually intended to sell." I assured her that Gernsheim was sincere about donating his entire collection to the British public. While protesting that Beaton was not an antisemite, she insinuated that Beaton deeply distrusted Gernsheim. She insisted that Beaton was unfairly accused of antisemitism only because one of his famous portraits of the Queen, appropriated by Jamie Reid for a Sex Pistols (record album) cover, "God Save the Queen" (1977), had replaced her eyes with swastikas.[20] Reid's deployment of swastikas, though, occurred long after Beaton's Jewish troubles.

The most public manifestation of Beaton's antisemitism happened in June 1938, when Hitler's Jew-hatred was already well known and British fascists were keen to follow his lead. In an illustration for a piece on New York high society by Frank Crowninshield in *Vogue*, Beaton produced a montage of related images, including skyscrapers, the front of the El Morocco, a nightclub band and patrons, cocktails, and cigarettes, a telegram, and newspaper pages with gossip columns. The telegram message read "PARTY DARLING LOVE KIKE." The gossip column included the line: "Mr. R. Andrew's Ball at the El Morocco brought out all the damned kikes in town." Walter Winchell replied in his real-life column that this "was not merely snobbery but also anti-Semitism."[21]

The publisher of *Vogue*, Condé Nast, took a huge loss by recalling the issue and printing another with a disclaimer, and Beaton resigned.[22] Edna Woolman Chase, *Vogue*'s editor, hoped at first that the incident "may not be more than a gossip wave," but also recognized that Beaton had himself brought about this "tragic mess."[23]

The *New York Times* stated that Beaton said he had apologized to Nast "'for all the confusion and trouble caused by an utterly thoughtless and irresponsible aberration of my artistic temperament.' 'I regret this ill-mannered expression of my irritation and annoyance, caused by some bad films I had just then seen,' he said. 'I know that none of my many Jewish friends will think that my silly little joke had any bearing on the standing of their great community.'"[24] Condé Nast, however, was forced to see it for what it was: "I was particularly distressed," he wrote, "that these slurring comments should have been printed in *Vogue*, especially during these days of cruel, vicious and unreasoning persecution of Jews."[25] "In time, the incident blew over and Beaton was reinstated at *Vogue*, where he continued to do fashion photography for several more decades."[26] It is possible to see Beaton's reported snide comment about Gernsheim as consistent with his eruptions of antisemitism.

Gernsheim did not seem able to differentiate between sincere friendships, such as those he apparently had with Pevsner, and certainly with Newhall, and professional relationships, such as with Beaton and Clark. We have already seen that Clark's role vis-à-vis Jews in the realm of photography was important yet inconsistent. He was virtually the godfather to the Warburg's reestablishment in Britain, and was especially significant in backing its large photographic exhibitions. He was supportive of the project of Walter Gernsheim, but was less than forceful as an advocate of his release from internment.[27] Clark was lukewarm or worse in backing Stefan Lorant's plea for naturalization. Clark might have made a difference in the disposition of Lorant's case had he taken a clear stand. But his indifference to Lorant's fate, and the tone of his comments suggest that he was not particularly vexed by Lorant being forced to leave the country.[28] As highly as Clark thought of Helmut Gernsheim's work as a collector and historian, and possibly even of his photography, on a personal level he did not much care for him.

It was, nevertheless, Clark who initiated contact with Gernsheim in early April 1950, prior to the Victorian photography show, "[o]n the strength of our acquaintance in the days when you were so kind as to help with exhibitions at the Churchill Club." Clark desired Gernsheim's assistance in preparing a lecture at Oxford on "Art and Photography." "I shall try," Clark said, "to define the kind and degree in which a photograph can be a work of art, and effect that this should and ultimately will have on our ideas about painting. I know that you have [by] far the finest collection of photographs which relate to this problem, and it would be of the greatest value to me [if] I might spend some time looking through it." Gernsheim was thrilled to be of service to Clark, a pillar of the establishment. He warned him, though, "my collection has now grown to over 5000 photographs. The majority of them can certainly well illustrate the theme of the degree in which a photograph can be a work of art. You might also like to see Ruskin's own photographic work, which I believe is exceedingly rare. I leave it to you to decide whether you would like to spend a whole day with us having a simple cold lunch, or if you feel that seeing too many photographs at once would be rather indigestible, perhaps you would rather spend two long afternoons here, let's say from 2 to 7."[29]

Clark's visit to the Gernsheims' residence to see the collection took place within the next few weeks. Either by a letter that is not extant, or a phone call, Gernsheim later requested that Clark return the photographs he had lent him. Clark sent them back with a warm note of thanks on May 5, 1950:

I am returning herewith the negatives and photographs which I borrowed from you. I am more grateful than I can say for your help, which of course made all the difference to my lecture.

In the end I used only a small part of the material which I had collected, and even then I used more than was desirable. I hope to make two essays out of the lecture, but before doing so I should like to consult you again, as I would not like anything which I write to seem to conflict with the admirable and, of course, far more expert work which you are doing in the same field.[30]

Helmut did not understand the code: "don't call me, I'll call you." The very next day he fired a letter back to Clark. He assumed, even though the Oxford assignment was complete, that Clark wished to see more of his collection. He also believed that Clark was an enthusiastic supporter of his enterprise in principle.

I am most grateful for the prompt return of the photographs and negatives. I hope you will forgive the reminder, but as it happened, you came the day after the British Council had approved a small selection of photographs for one of their exhibitions to travel abroad, and as your choice naturally fell on some of the same "plums," I was unable to proceed with the exhibition until the return of the material.

I am glad that the photographs were of some use to you, and shall be only too glad to show you some more of my collection. I wonder whether any afternoon in the week beginning May 15th would suit you? We could perhaps talk about the photographs over a cup of tea and then look at some more.

My wife and I are very happy that you take an interest in our subject. For a long time it seemed we were fighting a losing battle. Authorities are very hard to convince that early British photography holds a unique position in the history of photography, and that the early workers here have produced such fine pictures, which more than hold their own compared with Continental work. It took me a whole year to convince Mr. Philip James that here was magnificent work worthy of putting into an exhibition. He has at last relented—though he knows the pictures only from hearsay—and will let me have a small exhibition at the Victoria & Albert Museum next year, in the commemoration of the centenary of the first international photographic exhibition, which formed part of the Great Exhibition.[31]

Gernsheim managed to transform what had originally been proposed as a "small exhibition" into a major component of the event. James had been the deputy secretary of the Council for the Encouragement of Music and the Arts (CEMA)

since 1941 and was its director of art beginning in 1942. He was known as a proponent of innovation in the arts, and he obviously felt that there should be some place for photography at the Victoria and Albert Museum.[32] Clark cared, but he did not care enough to either send Gernsheim a note of congratulations concerning the exhibition or to schedule another date to see more photographs.

Nearly a month later, after receiving no response, Gernsheim tried again. "I wonder whether you ever received my letter of May 6th? When you would like to see me in connection with your essays, as mentioned in your last letter, perhaps you would ring me up." However polite this sounds, Gernsheim was in fact quite irritated.

> I shall naturally be delighted to give you any information I can for your own lectures and essays, but I should be grateful if you would keep this information, and the reproductions I lent you, for your personal purposes, at any rate until my history of British photography is out. I only mention this because a couple of days after you had been here, *Picture Post* telephoned and asked for information about the photographs for Firth's *Derby Day* and *Great Western Station*. I'm sure you will understand that I don't intend to set journalists, who know nothing about the history of photography and care less, on the track of interesting information which has been obtained during years of unsupported research.[33]

This was not the kind of reproach Clark appreciated. As much as he showed concern, however inconsistently, for refugees, he probably found Gernsheim's impulse to protect his own "unsupported" research crass and territorial. Worse, the request Gernsheim received from "journalists" had originated with Clark himself. He therefore attempted to put Gernsheim in his place as far as the free marketplace of ideas, and relations between gentlemanly scholars and professionals, were concerned.

> I am afraid I have got into the habit of dispensing information to my pupils and their friends (and Mr. Hopkinson is a personal friend of mine) without always thinking where the information come from. I can see that in the unique position *which you have made for yourself as the historian of photography* it is very tiresome for you to have your discoveries broadcast before you have been able to use them. I do not think it at all likely that I shall publish anything on the subject of photography, but should I do so I will let you look at the article in order that you may be quite sure that nothing in it seems to anticipate the points and discoveries which you will include in your history of photography. (emphasis added)[34]

As much as he longed to be in Clark's good graces, Gernsheim was perturbed that Clark had given some of the lantern slides lent to him to a fellow scholar, Charles Harvard Gibbs-Smith (1901–1981), who then approached Gernsheim with some questions.[35] Gibbs-Smith "was an aeronautical historian" and in the Second World War "was Director of the Photographic Division of the Ministry of Information. He joined the Victoria & Albert Museum in 1932 as an Assistant Keeper responsible for the photographic collections.[36] In 1947 he became Keeper of the Department of Public Relations, arranging exhibitions and writing on a wide variety of topics."[37] Gibbs-Smith appears in Gernsheim's recollections as one of the crucial individuals who might have enabled him to establish his museum in a National Trust property under the auspices of the Victoria and Albert Museum.[38]

When Gernsheim admonished him for sharing the slides with Gibbs-Smith, Clark's patience already had worn thin. From Gernsheim's perspective, Clark had been irresponsible—which never occurred to Clark. But the exchange between Clark and Gernsheim reveals much more than a disagreement over the handling of research material. Gernsheim was simply not in the same club of men such as Clark, Hopkinson, and Gibbs-Smith. And as much as they respected Gernsheim's expertise as a historian of photography, they did not accord it the same level of status, as equal to other fine arts, as did Gernsheim. Furthermore, they did not agree that the photographer of a work of art or architecture deserved to be given credit as a matter of course as a creator of the image. On November 21, 1950, Clark informed Gernsheim

My small collection of slides is a private collection and many of the slides are not even labelled. I did not write the labels for the slides of your photographs myself: It was done by my former secretary and, apparently, done inaccurately. But even if I had written them myself, *I certainly should not have written acknowledgements to the Gernsheim Collection on the labels any more than I would write the name of the collection in which the print of a Rembrandt etching was to be found.* (emphasis added)[39]

Clark's comment here is a reminder of the low, instrumental value accorded photography.

Clark nevertheless felt compelled to explain that

I lent the slides to Mr. Gibbs Smith as he had been so kind as to lend me some of his. I can not conceive that you would expect him in a lecture to make public acknowledgments to the Gernsheim Collection, and therefore I do not see how the

labels on the slides could have affected him. However, it is quite clear that nothing I do or say henceforth in connection with photography will fail to offend or worry you in some way, and as I have many other interests which occupy my time, I shall not have anything more to do with the subject. I have asked Mr. Gibbs Smith to send my slides on to you to dispose of as you think right.

Let me say again how grateful I was to you for letting me see your collection in the first place.[40]

Gernsheim did not understand that from a man like Clark this signaled the end of the conversation. He was, though, alarmed at the offense taken by Clark. Gernsheim immediately sought to undo the damage, but it was too late.

Clark's response, he pleaded, had been

based on a misunderstanding. I have never asked or even hinted that any lecturer should make a public acknowledgment for any photographs which come from my collection. But I do think that the lecturer himself should be provided with correct information as to the subject and sources of his illustrations. This is, after all, the normal procedure, and in the case of paper photographs such information is always indicated on the back.

I should be extremely sorry if you should drop your interest in photography. I have always been happy to assist anyone who is interested in this subject with information and photographs, and have done so on many occasions. I sincerely hope you will reconsider your decision and keep your lantern slides, but if you really do not wish to use them again, may I suggest that they would be of far greater use to the Victoria and Albert Museum than to me. Mr. Gibbs Smith already has some slides made from my photographs, where[as] I have no collection of slides at all.[41]

Six months later, when the exhibition of Victorian photography was running, Gernsheim sent Clark what seems to be a form letter, suggesting that if he had not already done so, he might see the show. The letter also mentioned Gernsheim's aspiration that it should "one day form the nucleus of a National Museum of Photography," as stated in the exhibition catalogue. He attached the memorandum, more-or-less the plan reprinted above. Clark's response was cordial. He expressed his support to Gernsheim, but Gernsheim seems to have underestimated Clark's qualification of his endorsement. He wrote Gernsheim that he had "visited the exhibition at the Victoria and Albert several times and greatly enjoyed it." He furthermore complimented Gernsheim and his wife for being

"exceedingly public spirited" in offering to donate their "unique collection to be the basis of a Museum of Photography." On the one hand, Clark said: "of course I should be most glad to be associated with any manifesto such as the one you enclosed." But he added: "I am not sure whether an independent museum is possible or even desirable in this case, but some independent collection is essential, and thanks to your foresight it will have a chance of becoming a great national possession."[42]

On the basis of this Gernsheim listed Clark as an official supporter of the project—but Clark declined to be so named. He wrote Gernsheim in October 1951 that "it is most disappointing to know that the authorities you have approached so far are not willing to co-operate with you in your setting up a public collection of photography" and added: "I still think that your collection would be best placed in the Victoria and Albert Museum."[43] Gernsheim would have been thrilled to have his collection adopted by the Victoria and Albert—but he also needed a means to make a living.[44] He pressed Clark for his explicit support until late 1953—but it was too late.

A brief correspondence between Clark and Gibbs-Smith offers an alternate perspective on Clark's feelings about Gernsheim and even photography. In a letter that accompanied the slides (to which Gernsheim refers in his remarks to Clark of November 1950), Clark informed Gibbs-Smith that his lecture on art and photography "was not a great success, as I tried to cover too wide a field, but think that I may yet make something out of it. I got a lot of interesting material from Gernsheim, and [a] little from *Picture Post*'s library. It's a fascinating subject, but in the end unsatisfactory, because photography is such an incomplete art."[45] We can assume in the next few months Helmut Gernsheim and photography became a topic of conversation between them. In November 1950 Clark wrote Gibbs-Smith:

I have received another offensive letter from Mr. Gernsheim about my slides of his photographs.

Since I first had the misfortune to borrow some of his photographs for use in a lecture, he has written me a number of protests that I have plagiarized his ideas or made wrong use of his material. I am too much occupied to be bothered with things of this kind and I have therefore written to him saying that I will return all my slides of photographs to him, and will make a point of not having anything to do with the history of photography in future.

It is unfortunate that this interesting subject has fallen into the hands of such an unattractive person.[46]

Gernsheim had no inkling of what Clark thought of him. The photography museum project had little chance of success in Britain without the enthusiastic support of Clark, such as that which he offered to the Warburg Institute in general, and to its photographic exhibitions in particular. In harboring and even articulating his distaste for Gernsheim, Clark would not have terribly offended his friends at the Warburg, who also had parted ways with Helmut Gernsheim. Unfortunately for Gernsheim and the fate of photography in Britain, however, Clark had been his best bet and most important potential advocate. Although there is no hard evidence of an antisemitic bias on Clark's part, his relations with both Gernsheim and Stefan Lorant reveal that he may indeed have had some kind of problem with Jews who he believed were overstepping bounds of comportment and respectability that he held dear.

In one very important respect, illuminated in the correspondence with Gibbs-Smith, Clark was deeply dishonest. The "interesting subject" of the history of photography had not, as he said, "fallen into Gernsheim's hands."[47] Clark failed to give Gernsheim credit for charting an unprecedented path in what was barely a nascent field only five years earlier. He certainly was conscious of the fact that Gernsheim was compelled to turn to photography, in place of art history, because he was a refugee and a Jew.

In addition, Clark was disingenuous in advising that Gernsheim's best course of action, to secure a home for his collection, was simply to donate it to the Victoria and Albert Museum. Gernsheim had come from an illustrious family, but he himself did not possess great wealth. Part of the impetus for finding an institutional home for the photographs and books was because he could not afford a large enough residence, or even rent a suitable space. Clark failed to recognize that Gernsheim was no Angerstein or conventional patron of art. Helmut and Alison genuinely needed a steady source of income, and they also wished to continue to use the collection in their historical work. They were, in fact, the best if not the only logical choice as curators. In this instance Clark generated a failure of both sympathy and imagination, which cost the nation dear.

One of the most promising ways for Gernsheim to establish his collection as a public institution, with himself and Alison as curators, was to situate it in an existing National Trust property. This was how the gallery devoted to the work of William Morris, for instance, came to be established around the same time.[48] There were thirty-two such National Trust establishments when Gernsheim launched his appeal. At one point he was offered the "barn" at Lacock Abbey,[49] but with the severe restriction that the enterprise be exclusively devoted to the work of William Talbot. In any event, Gernsheim considered the site impractical

because the barn itself was too small and structurally inadequate to house his collection. The other property mentioned to him as a possibility was Osterley Park, which has a Robert Adam mansion at its center.[50] The authorities had three critical objections to housing the collection in Osterley, Gernsheim recalled. The first was that he was not a "member" of the Victoria and Albert Museum. He did not understand why it would be so difficult to "make him a member." Apparently the problem was that he could not be an administrator of his own collection. He offered to donate it outright to the Victoria and Albert Museum, so it would be "no longer the collection of an outsider, a foreigner." Gibbs-Smith and the others "should have been proud," Gernsheim said, "of the former foreigner who did something for British photography."[51]

The other chief objections to the establishment at Osterley Park seemed bizarre. Gernsheim did not realize that one of these was the same complaint that was lodged against his Festival of Britain exhibition—by the same person, the director of the Victoria and Albert Museum, Leigh Ashton, who said he did not want "a Victorian parlor here," that is, in Osterley. As before, Gernsheim did not recognize the gravity of this response. Reservations also were raised because it was believed that there might be a possibility of a "fire" and that the government would ultimately be held accountable. In some respects this makes sense, as some photographic matter is, in fact, flammable. But there was a hint, similar to the mean-spirited accusation that Gernsheim requested photos for his own fortune, that his enterprise would be susceptible to arson. Gernsheim apparently had no clue that this was a well-known antisemitic canard—the charge that Jews frequently resort to arson in order to claim insurance money. It was only after he had exhausted all possibilities in Britain that Gernsheim attempted to find a home for his collection in Germany,[52] Sweden, under United Nations auspices, and then in the United States.

There were no Jewish or quasi-Jewish enablers to whom Gernsheim could turn and who were close enough to the centers of influence to make a difference in his British photographic museum bid. The world of publishing, however, was somewhat more fluid. Certainly the increasing middle-class consumption of illustrated art-books on the Continent, as well as in the United Kingdom, contributed to the success of Gernsheim's book ventures. The firm of George Harrap, which was known for printing lavish illustrations, had published the translation of Heinrich Schwarz's book on David Octavius Hill in 1932—but that apparently was a one-off.[53] Most likely Harrap acquired the title from the Viking Press in New York, which produced it in 1931. Harrap's published few, if any, other books on photography in the next decades. Gernsheim knew of and appreciated

Schwarz's work.[54] He had a used copy of the book in his collection and found it extremely informative.[55] In 1957 Schwarz gave him an inscribed volume.[56] Publishing with Viking or any other press in the United States did not seem a possibility to Gernsheim at this point. Interestingly, the other book on early British photography that particularly struck Gernsheim was Virginia Woolf and Roger Fry's text accompanying Julia Margaret Cameron's photographs, which was published by Leonard Woolf.[57]

Gernsheim published his first three books with a small company, Fountain Press, which had offices in Holborn, at 19 Cursitor Street, and later 46–47 Chancery Lane. Arthur C. Farr, whose background is not well known, was the head of the firm when Gernsheim was active. But Farr obviously was open to publishing the work of Jewish authors, and produced scores of books on photography each year, beginning in the early 1930s.

There were not many options in Britain besides Fountain. In the 1940s there was no such entity as a series in the history of photography, and the majority of photography books published, including those offered by Fountain, dealt with its technical and practical aspects. There were a few historical offerings, but these were mainly pictures with a minimum amount of text. All of this began to change dramatically in the late 1930s, however, with the efforts of refugees: Andor Kraszna-Krausz, who founded Focal Press, Walter Neurath, who established Thames and Hudson, and Béla Horovitz of Phaidon.[58] Gernsheim may not have had any appreciation for the fact that there was some kind of precedent for the work he did with Fountain, which had published at least three books of the philosopher turned photographer Marcel Natkin (1904–1963).[59]

Compared to the work of Gernsheim, Natkin's books were pithy and practical. He is now best remembered for his Leica users' guide. His *Photography and the Art of Seeing* (1935) is an exquisitely produced volume that included the work of eighteen photographers, including himself, Kertesz, and Man Ray.[60] Given the advances in camera and film technology by the mid-1930s, Natkin believed that amateurs of his day might begin to think more artistically about the photographs they composed, mainly by emulating professionals whose work was beginning to be recognized as art.[61] Two years later Natkin drew on the work of four of the photographers who had appeared in *Photography and the Art of Seeing*: Laure Albin Guillot, Pierre Boucher, Man Ray, and Roger Schall, for *Photography of the Nude*, also produced by Fountain Press. His point was simple but poignantly demonstrated in this brief survey: that "modern photography provides a splendid method of interpretation" of the nude.[62]

Given the novelty of his enterprise, publishing books that situated photography squarely in the realm of art was never going to be easy for Gernsheim. Along

with taking a distinctive approach to a new subject, he had exacting standards, and was frequently displeased during the production process. Had Fountain Press not existed, though, Gernsheim's publishing career might have suffered the same fate as his museum project. It may seem strange that he did not establish a relationship with Kraszna-Krausz's Focal Press. Most likely Gernsheim did speak with him, or meet with him personally. When informed by Beaumont Newhall that he himself would pursue publishing with Kraszna-Krausz, Gernsheim expressed this opinion:

> The Focal Press is no doubt a great success financially. They have a certain Continental slickness which other publishers in this country lack, and their books sell very quickly. . . . I have only one complaint against Kraszna Krausz: that he is inclined to put profit before production and that in one or two of his recent books (in particular Hoppe's *100,000 Exposures*) the material was badly mishandled. That is to say, the book (pocket size) is overcrowded with tiny photographs often running into each other without adequate separation, sitting on top of each other, where they produce a disturbing effect aesthetically; and in addition some pictures have been "modernized" by lopping off whole chunks on all sides. If you make a contract with Kraszna Krausz, which I very much hope you will, you should make it plain that you must be consulted on matters of production, at least as far as illustrative matter goes, should you have to provide this at all.[63]

Newhall did not believe that Kraszna-Krausz had the same discerning eye for creative photography as did Gernsheim, but he tremendously respected and admired him as "the sparkplug of the Focal Press."[64]

One of Gernsheim's early books, more than any other, presented a thorny dilemma due to his "foreignness": a study of Lewis Carroll as a photographer. Although often oblivious to how he was perceived, in this instance Gernsheim knew immediately that his background would make it difficult for publishers to see him as an appropriate author of such a book. Gernsheim always sought to "find a publisher" before beginning to write.[65] He apparently never submitted a complete manuscript to a press in advance, for consideration. Lewis Carroll, Gernsheim knew, was extolled as quintessentially British, and one of the great exemplars of British humor.

Lewis Carroll's photographs presented another problem: his "friendships" with children. Gernsheim sidestepped the question of what precisely these friendships entailed. But even with the heavy-handed censorship imposed by Carroll's relatives, from whom he obtained the photographs and diary entries, this was a delicate matter. Professionals and amateurs alike took photographs of

their own children, and professional photographers shot portraits of persons of all ages. On occasion, photographers might, say, take a picture of children encountered in a park or another public place. Carroll's intimate pictures of his "friends" were, at best, odd.

Fountain Press might not have been amenable to this project because this book would necessarily have to be more "literary" than Gernsheim's other work. Also, relations with this author grew increasingly testy with each book,[66] and Gernsheim felt that they were too small to handle a potential best seller.[67] Fountain, Gernsheim knew, was mainly concerned that its audience find its books useful as they sought to "improve" their own photography, and Farr, as an editor, challenged Gernsheim to be more precise and coherent.[68] The operators of Fountain were also upset and angry to learn that Gernsheim was publishing his *Masterpieces of Victorian Photography* with Phaidon, because they believed this topic overlapped considerably with the *History of Photography* he was contracted to write for Fountain.[69]

Although several of Carroll's photographs had been published before Gernsheim set himself the task, a fact which Gernsheim minimized in his pitch for publication,[70] no one previously had focused on Carroll as a photographer. Gernsheim believed that such a study was important for a better understanding of the man in total. Photography, if not for Gernsheim, might have been relegated to the realm of Carroll's "hobbies," along with playing chess.[71] Morton Cohen writes that Carroll "often gave private tuition to youngsters as well, and observers could not help noticing the stream of young females arriving at Christ Church and mounting Tom Quad staircase 7 to be taught and photographed by Mr. Dodgson. Remarkably, Christ Church actually allowed him to break through the roof above his rooms and build a glasshouse where he could photograph his protégées in daylight."[72] Cohen repeats Gernsheim's assertion that Carroll's "'photographic achievements [were] truly astonishing'" and that Carroll was "'the most outstanding photographer of children in the nineteenth century.'"[73]

Gernsheim therefore "went to Mr. Neurath," now known as the founder of Thames and Hudson. He was "not so famous then as now," Gernsheim said some fifty years later.[74] "Based for many years in a Georgian terrace in Bloomsbury," Thames and Hudson, it was later recalled, "attracted émigré talent, enhancing its cultivated central European flavour. One picture researcher, Georgina Bruckner, was a refugee from Communist Hungary; another, Alla Weaver, was a Russian who had learned English with Vladimir Nabokov; the firm's senior designer, Ruth Rosenberg, had studied typography in 1930s Berlin. Walter and Eva [Neurath] were not just the publishers but also the friends of artists, ranging from

Oskar Kokoschka to Henry Moore."[75] Gernsheim pursued Walter Neurath (1903–1967) "because being a foreigner I knew I would have difficulties."[76] Most likely he was aware that Neurath, too, had been "interned as an enemy alien on the Isle of Man."

As a principal of "the book 'packager' Adprint, Neurath was responsible for a series, *Britain in Pictures*, which was seen as proof of his loyalty to Britain, and he was released."[77] Adprint was "run by a fellow refugee, Wolfgang Foges (1910–1986),"[78] who left Vienna before the Anschluss because he was engaged to a British woman. In 1937, the same year Gernsheim arrived in Britain, Foges established Adprint "and made it a refugee rendezvous. It printed playing cards and catalogues, supplied teams of experts to produce books in 'packages,' all ready for publishers to bring out. Its cheap [equivalent of $1] *Britain in Pictures* series sold 4,000,000 copies." This series of one hundred twenty books covered "everything from windmills to cricket."[79] Adprint also published the first outstanding English-language history of photography, by Lucia Moholy (on whom more later).[80]

Gernsheim pursued Neurath because he believed his "non-British" identity would surely not be an obstacle with the Adprint crowd,[81] and relations had turned frosty with Fountain. Gernsheim presumed that the question "How can he understand the humor of Lewis Carroll?" would not be raised. He had experienced this problem earlier when he attempted to produce a photographic biography of Winston Churchill. He was warned that his "foreign name" made his authorship untenable. According to Gernsheim, even a Jewish publisher, George (later Lord) Weidenfeld, felt that readers would be put off by a "foreigner" presenting Churchill. Neurath's establishment, he thought, "would be the last people to have anything to say against me as a foreigner." Neurath himself probably had "heard it many times in his own life," and he would not countenance such an argument. Neurath confirmed Gernsheim's hope. The name of the author was "immaterial" to him.[82] In the end, an associate of Neurath, Max Parrish, published *Lewis Carroll as a Photographer* under his imprint. Parrish has been described as one of the three major figures to emerge from Wolfgang Foges's effort to "found a new and unexploited market for his visually orientated books."[83]

The only publisher to have approached Gernsheim after the success of the "Masterpieces of Victorian Photography" exhibition was Béla Horovitz of Phaidon Press, which republished the catalogue—with a foreword by Gibbs-Smith.[84] Horovitz's firm had been transferred to London from Vienna thanks to the intervention of Stanley Unwin, who had his company, George Allen and Unwin, "Aryanize" the Phaidon Verlag.[85] At first Gernsheim thought that Phaidon's offer for the Lewis Carroll book was "wonderful," until learning that they

were willing to offer him a maximum of only £50. He did, however, publish his book *Beautiful London* with Phaidon. It remains one of the outstanding illustrated volumes about London—a crowded field indeed.[86] In the interview with Val Williams, Gernsheim describes the presence of the "German and Austrian" publishers in London, Neurath and Horovitz, as a "curiosity."[87] But the same historical current that swept Gernsheim to London, and toward photography, had carried them as well. It was a happy coincidence that they too were pioneers in visual culture, helping Gernsheim in numerous ways.

In the United States, one of Gernsheim's main contacts in addition to Beaumont Newhall was Peter Pollack, who in the early 1950s was the photography curator at the Art Institute of Chicago, a position he single-handedly created. Trained at Chicago's Institute of Design (later the Illinois Institute of Technology) after World War II under László Moholy-Nagy, Pollack was even closer to Gernsheim—in terms of his preference for "New Objectivity" (or "New Realism") photography aesthetics—than was Newhall. In a series of articles for the journal *Motif*, Gernsheim wrote that Moholy-Nagy's work, up to 1930, was "tradition shattering," perhaps the highest praise imaginable. He was referring to photographs that appeared in Moholy-Nagy's *Malerei, Photographie, Film* (1925) and the volume *Foto-Auge*, edited by Franz Roh (1929).[88]

Toward the beginning of their relationship, Pollack tried to engage Gernsheim in something akin to Jewish banter: "I am sending you pamphlets and catalogues of my department [of the Art Institute], plus some others the museum has issued, and two magazines with some articles of mine [in handwriting] in my favorite sex magazine—ART PHOTOGRAPHY."[89] Gernsheim did not respond to this, even though he himself was keen to collect nudes.

In the next exchange Pollack sent Gernsheim his "exhibition folders on the work of Arnold Genthe and Margaret Bourke-White."[90] Shortly afterward Pollack had occasion to visit London. Upon their meeting it is likely that they discovered a great deal of common ground, such as their admiration for the work of László Moholy-Nagy, and their approach to the relationship between art and photography.[91] Gernsheim had been close to László's first wife, Lucia, and Pollack, to his second (and non-Jewish) wife, Sibyl. Lucia Moholy's photos and photo history had been especially stimulating to Gernsheim.[92] "[Hers] was probably the first book on the history of photography I read," Gernsheim said; he found it "excellent," even "wonderful."[93] He recalled with great fondness that Lucia Moholy visited one of his photography exhibitions held in his brother's gallery in 1937, and she invited him to see her own "at Brunswick Place, near King's

Cover of *Beautiful London* (1950), by Helmut Gernsheim. Sammlung
Gernsheim, Reiss-Engelhorn-Museen Mannheim.

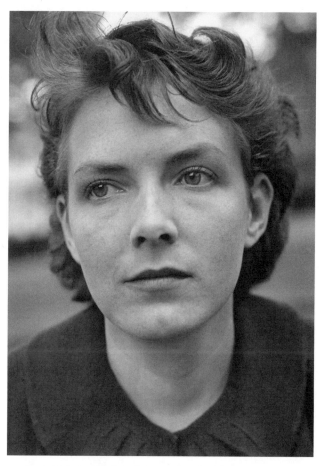

Lucia Moholy, *Inez Spender*, 1936. Writer and intellectual Inez
Spender (1914–1976) was the first wife of the poet Stephen Spender.
Modern resin-coated print, 1936. 16 × 12 in. (405 × 305 mm)
overall. © Estate of Lucia Moholy/DACS, London.

Lucia Moholy, *Michael Polanyi*, 1936. Polanyi (1891–1976), an émigré who became the first Jew to hold a chair in chemistry in a British university, was remarkable for his truly significant contributions to diverse fields, including economics and philosophy, as well as distinct branches of chemistry. Vintage bromide print, 1936. 4⅜ × 3¼ in. (112 × 83 mm) image size. © Estate of Lucia Moholy/DACS, London.

Cross station."[94] She was then making her living mainly as a portraitist. Among her sitters were a number of émigrés and prominent anti-fascists, such as poly-math Michael Polanyi (1891–1976) and writer Inez Spender, wife of the poet and sister-in-law of Humphrey (Agnes Marie Peam, 1914–1976).

"I saw her work and got to know her," Gernsheim recalled.[95] Her photographs obviously were not as famous as those of her former husband, and Gernsheim was possibly unaware that most of the photographs circulating of the famed Bauhaus were hers.[96] He suspected, though, that "a great many of the photo-grams" attributed to Lászlo were actually done by Lucia, even though "she never made a claim."[97]

Lászlo Moholy-Nagy was born Jewish and converted to Protestantism, but both he and Lucia Moholy-Nagy are included in Gernsheim's lists of Jewish pho-tographers.[98] The parallels between Lászlo Moholy-Nagy's thwarted attempt to establish a Bauhaus-like institution in the United Kingdom and Gernsheim's museum project have never been addressed. Despite notable commercial suc-cess, England offered Moholy-Nagy "no chance" to establish an avant-garde institution.[99]

Although they were competitors from the beginning, Gernsheim and Pollack helped each other substantially in the early days,[100] and Gernsheim relied on Pol-lack for favors one would only ask of a family member or close personal friend.[101] Both men were collectors of non-European sculpture, and Gernsheim was espe-cially touched when Pollack gave him a "fine Mexican figure" in 1958.[102] Pollack was focused on the United States, as opposed to Gernsheim's broad sweep,[103] and saw himself as a "historically accurate" popular writer, conceding that Gern-sheim was more a historian of photography.[104] Much of Pollack's work, though, was based on original scholarship, including interviews with photographers, and the courses he offered on the history of photography were of a high academic standard.[105]

Pollack had been instrumental in the development of photography publish-ing in the United States, first as a consultant, and later as a full-time associate for Harry Abrams. By 1960, in part through their mutual support and aggressive entrepreneurship, Pollack and Gernsheim had become tremendously effectual. Their networks were overwhelmingly Jewish, which is not surprising consider-ing that Béla Horovitz's Phaidon, George Braziller, and especially Harry Abrams were becoming leaders in the field. The major British and American university presses, in contrast, lagged seriously behind.

A first conflict ensued when Pollack alleged that Gernsheim had gone back on a promise to give Pollack permission to use one of his photographs, without a fee, for a revised and greatly expanded edition of his *Picture History of Photog-*

raphy.[106] The records show that Pollack was correct—Gernsheim had apparently changed his mind.[107] Pollack's belief that Gernsheim was being ungenerous and petty about his collection was a sign of a seething rivalry between them and the insecurity they felt in a marginal field. Apparently, the photography-history market was not big enough to accommodate Newhall, Gernsheim, and Pollack—and both Gernsheim and Pollack regarded their relationship with Newhall as indispensable. There was, as well, another level to their competitiveness: Pollack had his own "scheme" to create a national photography center. In the mid-1950s, he even expressed a desire to make the Gernsheim collection a part of this endeavor.[108]

Speaking directly about money in a way that never entered his communications with Newhall, in 1956 Gernsheim raised the possibility with Pollack that Dorothy Norman might be able to bring their respective plans to fruition. "Do you know Dorothy Norman?," Gernsheim asked.

> She has just written a most enthusiastic letter about our *History*, and said she would like to have my opinion on her manuscript on Stieglitz. I know her, of course, as Stieglitz's friend and editor of *Twice a Year*, and understand that she is very influential and very rich. I wonder, therefore, if she might be of some assistance in your scheme? She wrote that she would very much like to see me in the States, so in thanking her I mentioned en passant your proposal to bring us over with our exhibition, adding that the whole plan is rather costly and depends on the finances that you may be able to raise.[109]

Pollack never succeeded in getting substantial funds from Norman or anyone else to facilitate showing the Gernsheim collection in the United States. His most grand proposal did, in fact, materialize—but not under his own direction. Cornell Capa acknowledged that what became the International Center of Photography (ICP) in New York City was consistent with extensive conversations he had had with Pollack.[110] After the establishment of the ICP, Pollack wrote Capa, "I hear great things about your 'gescheft' in photography. Congratulations to you and please convey a 'well done' to mutual friend Henry Margolies [Margolis] for his invaluable contribution to your remarkable achievement."[111] Capa wrote Pollack, "'Business' is booming, but we need a million dollars profit for this nonprofit 'gescheft.'"[112] *Gescheft* (or *gesheft*) is a broad Yiddish term for "deal." Upon his death in 1989, Harry Margolis was credited, among his many philanthropic activities, as "founding director of the International Center for Photography."[113] His contribution was vital in transforming a revived "permanent photography collection" at New York's Riverside Museum into the ICP.[114]

More serious than the differences between Pollack and Gernsheim over the use of photographs, which did not seem to make much of an impression on Gernsheim, was the inadvertent role played by Pollack in the most unsettling episode of Gernsheim's career.[115] After his attempt to house his photography collection in Britain came to naught, and his plans to relocate to Germany had stalled, a group of businesspeople and arts professionals in Detroit expressed interest in exhibiting the Gernsheim collection. The organizers further indicated that they wished to establish a permanent home for it in downtown Detroit. Gernsheim wrote Pollack that this plan was underway, but had almost immediately hit some snags. Pollack volunteered to put Gernsheim in touch with Lawrence Fleischmann (Fleischman),[116] a Detroit businessman. Pollack assured Gernsheim that Fleischmann was trustworthy and well connected.[117] But Pollack's contact did not help, and Gernsheim suffered a huge loss, cheated out of huge expenditures of time and money.[118] Apparently Gernsheim turned again to Fleischmann when it became clear that the deal was disintegrating, and worse, that it had never been what it seemed. But there is no evidence that Gernsheim ever succeeded in making contact with Fleischmann.

On several occasions Gernsheim would bemoan the "criminals" in Detroit who had done him in.[119] Certainly Pollack had only intended to assist Gernsheim. But neither Pollack nor the man he claimed as a confidant helped. Perhaps Pollack's offer of intervention led Gernsheim to think that the Detroit option would indeed work out. Pollack underestimated the extent to which Gernsheim's troubles in Detroit contributed to their increasingly tense relations.

In the end, Pollack came to loathe Gernsheim, as his name would come up whenever unpleasant issues regarding rights and charges for photographic reproductions arose.[120] The cold and bitter feeling between Pollack and Gernsheim can be starkly contrasted to the warm, fraternal bonds that Pollack often shared with Jewish photographers, agents, and curators for whom their Jewish identity was less problematic than it was (at that period) to Gernsheim—such as Philippe Halsmann, Arnold Newman, and Sanford Roth. Neither Pollack nor Gernsheim have so far been recognized for their roles in the inception of photography publishing as well as what might be termed an "art market" for photography.

Among Gernsheim's numerous professional relations up to the 1970s, one of his closest friendships, besides Beaumont Newhall, was perhaps with Louis Walton Sipley (1897–1968). Gernsheim did not typically close his correspondence with expressions of "love"—but he did so with Lou and Alice Sipley. Sipley, a mechanical and electrical engineer who became an entrepreneur and later "an art and graphic arts historian,"[121] founded the American Museum of Photography

in Philadelphia in 1940. Sipley contributed to a publication "devoted to the first century of photography" in 1939. As a consequence he "became concerned over how much irreplaceable historical material was being lost. He went to various museums, urging them to start photographic collections. When he met with no favorable response, he decided to found a museum himself."[122] Sipley tried but failed to relocate his museum to New York City, an effort that was revived after his death in 1968. A $10,000 donation from Ralph Baum, a German Jewish refugee who founded the Modernage photo processing business with its own gallery,[123] got it off the ground, but the museum went no further—despite expectations to the contrary.[124]

Sipley's collection, although less known than that of Gernsheim, was astounding, with over 50,000 photographs, five thousand books, and three hundred pieces of photographic apparatus, including a rare eighteenth-century *camera obscura*. Sipley also collected motion pictures, including an "experimental" film, *The Yellow Girl* (1916).[125] In 1970 the 3M Company bought the collection, which later was donated to the International Museum of Photography in Rochester.[126]

Gernsheim learned about Sipley around 1953 and wrote to him—but the letter was never received. He wrote again, with a clearer address, in 1955, after a "mutual friend," Tex Neville, encouraged Gernsheim to contact Sipley again. Almost immediately they began exchanging books to complement each other's collection. After the two met personally, when the Sipleys visited London, they started calling each other by first names ("Louis" and then "Lou," and "Lou and Alice") and their correspondence touched on more personal issues. Just around the time Gernsheim believed his collection was destined for Cologne, he and Sipley had their most direct discussion about joining forces.[127] For Sipley the only realistic change from Philadelphia would have been New York. Given the American focus of his work, there was no sense in even thinking about Europe. But for all of their good intentions and strenuous labor to elevate photography, in the form of a major museum, neither Sipley nor Gernsheim possessed the financial means or the connections to enact their plans.

Another colleague who was "appreciated immensely" by Gernsheim was Grace Mayer.[128] She had begun her career "at the Museum of the City of New York in 1930, when it was a fledgling institution in Gracie Mansion." There she organized "more than 100 shows, including the first notable Berenice Abbott exhibition in the United States." Edward Steichen was the most visible figure in photography in the New York museum world, but it was Mayer—first working with Beaumont Newhall, and later, Steichen—who was critical in making the Museum of Modern Art into a bastion of photography. "[I]n 1962 she became

curator of photography, organizing, among other things, the inaugural show in the Modern's first photography-collection galleries, which opened in 1964."[129] Upon her death, Peter Galassi, head curator of photography at the Museum of Modern Art, said that Mayer "was well ahead of her time in recognizing the art of photography. And generations of photographers are indebted to her careful and sympathetic attention to their work."[130]

Despite having resigned from the Museum of Modern Art some years earlier, Mayer arranged a lecture by Gernsheim at the museum in 1963. Gernsheim's list of nine invitees, in addition to those he assumed would "be invited automatically," may have included one or two non-Jews.[131] Notables included Otto Bettmann (1903–1998), Lew Feldman (1906–1972, to be discussed below), and Albert Boni (1892–1981)—all of whom may be considered behind-the-scenes giants in the history of photography.

That these networks of Jewish colleagues did not always yield satisfactory results did not dissuade Gernsheim from attempting to exploit such connections. In the end, the most important interlocutor responsible for the eventual extrication of Gernsheim's collection from Britain, and its placement in Austin, Texas, was the gregarious Jewish book and manuscript dealer, Lew Feldman. As Claude Sui notes, the intervening collapse and fallout of the *Showcase* scheme in Detroit helped turn the Texas bid into a reality.[132] Feldman was the key player between Gernsheim and the University of Texas. He "was imaginative and tenacious in acquiring rare works" as the founder of a firm called "The House of El Dieff"—composed from his initials, L. D. F.[133] Upon his death it was said "that there was hardly a 20th century manuscript that did not at one time or another pass through Mr. Feldman's hands. He was there to bid at every auction. . . . As a result, he was largely instrumental in building the unsurpassed collection at the University of Texas. He also helped enlarge the contents at the Berg Collection of the New York Public Library and the libraries of many private collectors."[134]

If Sipley could be said to stand at one end of the spectrum as a not-very-Jewish Jew, Feldman would have occupied the opposite end, as a cigar-chomping, pinky-ringed, deal-making Jew.[135] Similar to the invective hurled at Gernsheim, descriptions of Feldman could verge on the antisemitic. Charles Hamilton was perhaps his most bitter rival and fiercest critic, deriding Feldman as "a pompous thief." He "ridiculed Feldman's famous one-word slogan, QVALITY." Hamilton reportedly said, "My wife Diane could never decide whether Lew intended this word to be pronounced with a Yiddish accent or merely hoped it would give a classic flavor to his vulgarity by incorporating the Roman *u*." Further on, Hamilton wondered why such clients as the New York Public Library

"employed as an agent this exquisitely tasteless man who limped about with Mark Twain's silver-headed cane and a supercilious sneer on his fat upper lip."[136]

Hamilton himself elicited strong feelings: "His sometimes imperious personality was grating to other dealers, for whom he represented the brash upstart who, for all his enthusiasm for a letter in Lord Byron's own hand, would as gladly sell a Charles Manson autograph."[137] There is no doubt that Feldman was the more farsighted and a better businessman, even if he was famed for brazen tactics amid the genteel milieu of auction houses, archives, and libraries.

It is inconceivable that the Gernsheim Collection could ever have found its way to Austin if not for the relationship between Gernsheim and Feldman, and fundamentally, Feldman's relationship with Harry Ransom of the University of Texas.[138] When Feldman met him in the late 1950s Ransom already had shot up through the university's ranks and was its vice president and provost. He was elevated to the presidency in 1960. Although Ransom was not Jewish, like Newhall he had an unusual affinity for Jews.[139] Creating a role for himself as a tsar of acquisitions for Texas, he engaged with Jewish dealers of different backgrounds and areas of interest, as well as Jewish lawyers and business people, which distinguished him from many of his colleagues in the upper echelons of American universities and museums in the 1950s and 60s. It also made him unique among power brokers in Texas—and helps account for accusations or insinuations that he was driven by a desire to amass a personal fortune. Outside of Austin, the "white-shoe" elites of Houston and Dallas ruled the roost, those whose firms later would be revealed as maintaining unofficial quotas on the hiring and promotion of Jews—even into the 1970s.[140]

There is no doubt that Feldman made a lot of money from his relationship with Ransom and Texas, and that Ransom's career was boosted immeasurably through his acquisition program—which largely was facilitated by Feldman. Their collaboration, which cannot be disentangled from a close friendship, was legendary. But both men were ardently committed to fostering the greater intellectual riches of the University of Texas, and sought in the first instance to entice owners of valuable intellectual property simply to donate their material to the University.[141]

When the subject of the Gernsheim collection first arises in correspondence between Feldman and Ransom in 1962, it seems that they already had talked about it extensively. Claude Sui writes that Ransom

> made the Gernsheims two alternate offers on 24 May 1962 for the acquisition of their private photo collection: the complete purchase of the photo collection, or

the hiring of the Gernsheims—he as director, she as curator, with an annual salary of US $21,000 as well as a later pension. Unfortunately the University did not have sufficient space to exhibit the collection—it would have to keep it in an archive. Some months later Ransom told them that construction of the necessary facilities with a total floor space of about ten thousand square feet would cost approximately four million dollars and thus would not be possible. On learning this, the Gernsheims considered taking up renewed negotiations with Detroit, which was also more favorable in terms of geography and climate.[142]

Writing to Ransom while visiting London and after having met Gernsheim, and seen what he had to offer, Feldman pressed Ransom to proceed toward purchasing—apparently at a price that had been set between Gernsheim and Feldman. Had Feldman arrived much later, most of Gernsheim's prize photographs would already have been on their way to Detroit. In late May 1962, "the preliminary contract with the Gernsheims [and the University of Texas] was finally approved in London," and "the final contract was signed on 2 August 1963, also in London."[143] The agreement could never have progressed as it did, though, without the strenuous efforts of Feldman. "It would be superfluous," Feldman wrote to Ransom, "to repeat our considered opinion that this would be a fantastic opportunity for you to acquire this collection under the indicated terms. Since the Gernsheims at this moment would like and have very high hopes of being able to close on the matter, so that they can come to the U.S. some time in September, we look forward to decisive steps on your part at an early moment, in order to achieve this."[144]

As before in Britain, Gernsheim again requested a position, and even pensions and "survivor benefits" for himself and Alison[145]—which, among other things, made the purchase unusually complicated. Feldman was adamant, though, that it was a tremendous opportunity for the university, and worth the time and effort required to iron out the differences. He assured Ransom that he sympathized with his "position regarding the collection and the present impasse because of the too rigid stipulations of Mr. Gernsheim. When we meet with you, [we] will take up the question as to whether or not we might suggest alternatives that would take [care] of the situation for both parties, but at the moment we are taking the position of not writing to Mr. Gernsheim until we have discussed the matter with you face to face."[146]

Feldman was not simply a broker for Gernsheim. He took on the role of an advocate for Gernsheim's legitimacy, if not preeminence, in the arts, book, and manuscript world generally, and for photography to have a place at the table

with the established fine arts. Moreover, he had to argue, to Harry Ransom and other officials of the university and state of Texas, that Gernsheim was so important as the leader of the nascent field that all of the material related to photography also was worth a tidy sum. There is no doubt that his primary loyalty was to Harry Ransom, but at bottom, though, was Feldman's conviction that Gernsheim's collection was an authentic treasure that would prove to be of immense value.

In a long and thoughtful letter to Feldman of August 20, 1962, Ransom explained why it would be best to withdraw from the purchase. Gernsheim's

> stipulation of survivor's interest in two state salaries is against Texas law. Indeed, I doubt that any institution in the United States could contemplate such an arrangement. My implication, he has also suggested as a condition of his collection's establishment that something like two or three million dollars worth of space be dedicated at the permanent exhibition of the collection. Although an industry exclusively concerned with photography or a donor passionately interested in its history might be found to undertake such an allocation of space, it is completely outside the realm of possibility that we could devote state money to this purpose. The alternative would be to seek such a donor or such industrial support. That would take many months at best and might lead simply to later futility and frustration for Mr. Gernsheim. I think that the only fair recommendation that I can make, therefore, is for the University to bow out. I am as sorry as I can be: I do wish that we could have made arrangements to establish the Gernsheim collection in Texas.[147]

As Ransom made clear, he had a lot on his plate. His priorities were filling "gaps" in existing fields of strength, and supplementing those areas where Texas already was distinguishing itself, such as Latin American material and "the theatre collections" for which they had attracted substantial foundation support.[148]

Despite this reasonable and sincere response, Feldman did not take "no" for an answer. He felt that he had to meet with Ransom personally.[149] Although there is no paper trail to document Ransom's change of heart, Feldman's forceful, personal intervention turned the tide. Final terms were agreed by Gernsheim, Feldman, and Ransom in a letter of June 13, 1963. The next extant letter from Feldman to Gernsheim, October 22, 1963, assumes that the deal was plodding ahead—even though Gernsheim kept making modifications and adding demands. Although there would be bad feelings and recriminations on the part of Gernsheim and authorities in Austin for many years,[150] even decades, Feldman

was an honest broker. The negotiations probably would have been even more protracted had the Gernsheims not been reeling from the debacle in Detroit. Feldman convinced the Gernsheims to relent on a number of their demands, especially their role as custodians of the collection, and got Ransom to agree to what was, in the early 1960s, the highest price ever paid for photography: $300,000. It was to be delivered "in five payments of $60,000.00 in the years 1964, 1965, 1966, 1967, and 1968."[151] As of 2011, a rough estimate of the market value of the major pieces in the Gernsheim Collection was "well over" $30 million ($30,000,000).[152]

Although Feldman has never been recognized as having a special interest in photography, one may speculate that there were at least two impulses behind his adamant push for the Gernsheim collection. Once he saw it in London he felt that it had to end up in Ransom's hands. The photographs in themselves were extraordinary, and many of them, especially those by Lewis Carroll, were obviously part and parcel of a more comprehensive body of knowledge integral to literature and culture generally. It also is hard to imagine that he would have been unmoved by the brilliant photographs by Alfred Stieglitz, for which Gernsheim's appreciation was growing around that time.[153] Feldman was, after all, a "Hoboken Jew" like Stieglitz.

After the agreement Feldman was called on to smooth out the many problems that arose, some of which were complicated by deals surrounding the "Gernsheim Memorial Foundation in Detroit."[154] Other differences centered on the extent to which Gernsheim himself was to remain involved in supplementing his collection with the subvention of Texas.[155] As late as 1965 Gernsheim was still going through Feldman to work out arrangements.[156] Perhaps one of Feldman's greatest contributions toward making the deal a success flew totally under the radar: the role he played in getting the purchase approved by the State Board of Control (of Texas), bundling it into a number of purchases amounting to $1.2 million. This most likely helped to prevent the price paid for the photographs from creating a scandal.

In the covering letter to the executive director, Ransom described Feldman's attached précis as

> a description of an extensive and well-correlated group of research materials built around the unique Gernsheim collection. It has been assembled by the House of El Dieff in New York and is based upon an awareness of the needs of The University of Texas in the various fields represented. It would be impossible to obtain these materials by regular library purchase or by bids. The university has the opportunity to purchase this collection at a price not to exceed $1,200,000.

This document was filed July 15, 1964, long after Ransom had already spoken for the university.[157] This is not in itself unusual. But the way that Feldman embedded the Gernsheim collection among the other purchases was both highly creative and at least somewhat misleading. It remains a question, though, if anyone even bothered to read the document.

In the report accompanying the letter, "The Gernsheim Collection and Related Materials," Feldman distorts the character of the actual Gernsheim collection: "The Gernsheim Collection with its related materials is distinguished in several fields: history of photography, contemporary English and American literature, history of science, 15th century illuminated manuscripts, literary and historical iconography, and 19th century English and American literature."[158] However excellent it was, it was more limited than he revealed. For instance, Feldman does not clarify that the material pertaining to authors such as William Faulkner, Joseph Conrad, Eugene O'Neil, Henry Miller, Graham Greene, Walter Lippmann, T. S. Eliot, and others was from totally separate entities. It was an outright lie to say that the "Gernsheim Collection contains what will be perhaps the last major work in manuscript by D.H. Lawrence to appear on the market."[159]

Does this mean, then, that it might have been acquired under false pretenses? Yes and no. Feldman knew that he was not speaking the whole truth—but in this type of document he could not say that he estimated that the core of the collection, the photographs, would someday be worth a fortune. The possibility also exists that the unity and connectedness between the Gernsheim collection and the other purchases did exist—but mainly in the mind of Feldman. Much of what he described was not, by any stretch of the imagination, part of the Gernsheim collection, and the extent to which these segments were "related" is in many cases tenuous.

Some months after the Board of Control approval, Ransom wrote an extremely gracious letter of appreciation to Gernsheim, who had recently donated additional photographs and apparatus to the University of Texas that was valued at $5,000. It is no surprise that Ransom did not indicate the role that the collection played in appearing as the lynchpin of an acquisition "sweep" that went well beyond the Gernsheim collection in its own right.[160] It seems, however, that Gernsheim's trove did have a central place in the expansive sense of cultural production that was shared between Ransom and Feldman.

IN THE FORMIDABLE ANTHOLOGY dedicated to him by the Forum Internationale Photographie of the Reiss-Engelhorn Museum in Mannheim, which houses part of his archive, including his vast collection of color photography and later acquisitions, Helmut's second wife, Irene, avers, "Being Jewish, there was

no future for Helmut Gernsheim in the Germany of the 1930s. And it was thanks to photography that he was able to leave the country in 1937 and make a new life, and a career for himself, in London." As we have seen, when the collection mushroomed, he sought to establish a museum in London. After that failed, he tried "Paris, Stockholm, and a variety of German cities."[161] In his interview with Val Williams, Gernsheim is emphatic that being forthright about "Auschwitz" influenced his choices about suitable partners in Germany.[162] His close friend Gisèle Freund had mixed feelings about "the effort of the Germans to 'recuperate' me," which he probably shared.[163] Perhaps Gernsheim's German colleagues were unaware that this figured in his decisions.

One might also ask: would a German institution have initiated a relationship with Helmut Gernsheim had he not been a refugee from the Nazis? Similar to the restitutive, "affirmative action" (*Wiedergutmachung*) efforts of German institutions to embrace Alfred Eisenstaedt, Erich Salomon, and Gisèle Freund, reaching out to Gernsheim was partly a consequence of trying to recapture a history of brilliance and forward-thinking in photography that was savaged by antisemitism and the Holocaust. Film and photography are now regarded as major, sparkling elements of "Weimar culture." It is to their credit that Gernsheim's partners and custodians of his legacy in Germany are unaware that they had passed a litmus test concerning Auschwitz that might never have been clearly articulated. By no means was Gernsheim anti-German: but he was dismayed, even angered, when Germans claimed that they had "known nothing" about the fate of the Jews.[164]

Of central concern to this chapter is that Helmut Gernsheim was treated less than sympathetically in the attempt to establish his collection as the foundation of a national photography center in Britain. In contrast, a burgeoning society of publishers in London, energized by fellow émigrés, emerged as a hospitable partner in his pathbreaking photo-historical mission. On the one hand he showed the British how tremendous were their early contributions to photography, but on the other hand he kicked them in the arse for being so conservative, even ossified at the midpoint of the twentieth century. The country expressed no remorse for shipping Gernsheim off on the *Dunera* and, later, for obliging him to send his fabulous photography collection to Austin and Mannheim. Despite the laudatory and incisive entry on Gernsheim in the *DNB*, and the generous words of Colin Ford,[165] the conventional wisdom of many in British photographic circles is that Britain did not lose much to Austin and Mannheim.[166] If it is admitted that the country did sustain a vast cultural hemorrhage in this episode, this often is qualified with the contention that it could not have been avoided—given the wealth of America and Germany. This is untrue. The

acquisition of the Gernsheim collection by the University of Texas in the 1960s was controversial, even revolutionary. Photographs had never been bought for such a price. In retrospect it is possible to say that everyone, except for the British, got a lot of out this deal. Helmut Gernsheim, however, wished for his collection to stay in Britain, and worked ardently toward that end. His Jewishness, tied to his "foreignness," certainly played a part in his collection leaving the country.

Gernsheim seriously contemplated, at one point, changing his name to "Harry Gresham" in order to ease his acceptance in England but did not follow through. "Of course I would have had more success," he said, laughing. But once he opened his mouth, anyone "would have known I was a bloody foreigner."[167] His foreignness, which was inextricably connected to his Jewishness, impinged significantly on the paths open to him—or not. Had he indeed been Harry Gresham, a born and bred Englishman, would his eyes even have been open to the complex relationships between photography and art, and the history of photography?

Helmut Gernsheim, "Semite"

⁓⊰✽⊱⁓

I
T IS LIKELY that Helmut Gernsheim got wind of the fact that Peter Pollack was invited to write the article on "Jews and Photography" for the *Encyclopaedia Judaica* in the late 1960s.[1] He also may have heard that Arnold Newman was asked to lecture on the subject, as Newman contacted Beaumont Newhall for assistance.[2] Around that time Gernsheim began thinking about the importance of his own Jewishness, related to his realization that the overrepresentation of Jews in photography was no mere coincidence. From the early 1970s to the end of his life (1995), he seems to have found a community of affinity within the circle of those he knew from his varied photographic interests, whose company he had relished, and with whom he also shared an intuition that there was something special about the Jewish engagement with photography: Tim Gidal, Gisèle Freund, and Ferenc (Franz) Berko.[3]

It may be said that Gernsheim came to full-flower in his Jewishness by joining, helping to cultivate, and then becoming disaffected with the small-scale movement he himself had partly sparked. One of the high points of his fascination with the issue of Jews and photography was his featured appearance at a conference on the history of photography held at the Hebrew University of Jerusalem in the summer of 1988. He clearly was interested in some kind of teaching appointment there, which probably would have included special attention to Jews and photography. But the opportunity never materialized, and he soured on his informal association with Hebrew University and the Israel Museum when it seemed that their respective administrators mainly wished to exploit him for fundraising purposes.[4] Gernsheim was so Jewish by the early 1990s that he followed a familiar pattern: after a period of brief but intense involvement, he became disillusioned with Jewish institutional life.

Almost from the moment he fled Germany, Gernsheim took for granted the influence his ethnic-religious origins exercised on the course of his career. He never could forget that he had arrived in Britain as a Jewish refugee. "It is really part of my life," he said.[5] Other Jews, not surprisingly, regarded him as Jewish.[6] The increasing differentiation of his "foreignness" from his "Jewishness" as categories of self-identification was partly a product of his departure from England. His relocation to Switzerland was a consequence of the sale of his collection to the University of Texas. As Gernsheim contemplated his own history, within that of his own family and other German Jews, he saw that there had been connections between Jews and the history of photography that he had not previously found worthy of comment.

It is important to recall that Gernsheim had never concealed his Jewishness. After returning from Australian internment, he socialized, at least for some years, with his *Dunera* shipmates.[7] In presenting himself to Anglo-Jewry upon the launch of his "Victorian Photography" exhibition at the Festival of Britain in 1951, Gernsheim identified emphatically with the Jewish people, although not in a religious sense. A report in London's *Jewish Chronicle* (*JC*) stated that Gernsheim "expressed pride in his distinguished Jewish ancestry, specially mentioning his great-great grandfather, Michael Gernsheim, the last Judenbischof (the official designation of the head of the Jewish community) of Worms in the seventeenth century and his great uncle Michael Gernsheim (1839–1916), the composer."[8] "Mr. Gernsheim," the article continued, "was not brought up as a Jew, as his father had been converted to Christianity. 'At present,' said Mr. Gernsheim, 'I have no religious affiliation. But I feel most strongly attached to the Jewish people, and I take a personal interest in Zionism and the progress of Israel.'"[9] The narrative he related to the *Jewish Chronicle* was, not surprisingly, a Jewish story of his life and current aspirations. It is unknown if the *Jewish Chronicle* first approached Gernsheim, or vice versa. Either way, he seized the chance to present himself as a Jew.

"Mr. Gernsheim told me," the *JC* reporter noted, "that he settled in London in 1937." Readers of this paper needed no reminder of the impetus of his flight. "In 1940 he was interned, and was among those sent on the notorious ship *Dunera* to Australia. He was released the following year in order to undertake work of national importance for the Warburg Institute in London, where his duties comprised the photographing of important buildings and sculpture." His status as "the foremost authority in this country on the history and art of photography" was buttressed by his "many standard books on the subject." Gernsheim's concluding remark was highly significant: "It is my ambition . . . that this collection

shall form the nucleus of a national museum of photography. *In this way I hope to be able to express my gratitude to Britain*" (emphasis added).[10] Perhaps because he rarely articulated the connection between his personal history and his professional ambitions, this notion does not often enter into discussions of Gernsheim. The idea that using his collection as the basis for a national photography museum was a means of demonstrating his thanks to Britain for welcoming him as a refugee has until now not been part of the story.

Gernsheim followed up on his mention in the *Jewish Chronicle* with a personal letter to the literary editor, Hugh Harris. As was usual for him, Gernsheim pointed out the errors in the article. In this instance, he justified his corrections by saying that the mistakes "concern well-known people, and you might easily get a letter from a stranger who thought I did not know the facts about my distinguished forebears." Certainly it was unlikely for someone to be aware of such details. Gernsheim was mainly looking for a way to further his relationship with the *JC*, the leading Jewish newspaper in London. He wrote: "Michael Gernsheim, the last Judenbischof of Worms—and indeed, in Germany—lived in the *eighteenth century*. He died in 1792. The name of my great-uncle the composer, who, like my father, was also born in Worms, was *Friedrich* Gernsheim."[11]

Gernsheim learned that Harris had political sympathies similar to his own. Perhaps he had spoken to him on the phone. "You may be interested to learn," he wrote, "that I am a keen Federalist and have recently been elected to the Committee of the Parliamentary Association for World Government."[12] Harris replied in turn, saying that he was "the Hon. Secretary of the Jewish Peace Society." Harris likewise wished to continue the conversation with Gernsheim, to see if he might contribute work from his collection to the Anglo-Jewish Exhibition, "in connection with the Festival of Britain" to be held at University College London.[13]

Gernsheim seemed somewhat embarrassed that he did not have much to offer: portraits of "Dr. Adler, Chief Rabbi" (probably Hermann), Disraeli, Jacob Epstein (sculptor), and Joseph Conrad. About Conrad, Gernsheim asked: "Was he Jewish?" (Conrad, a Pole, was not a Jew.)[14] The show was enhanced by Gernsheim's pieces, but the conversation about the mutual political interests of Harris and Gernsheim ended due to Gernsheim's flurry of activity following the Victorian photography exhibition and a trip abroad.[15] Although it is not known if he officially joined the organization, in 1952 he sent a friendly letter to the Association of Jewish Refugees (AJR) in Great Britain, expressing his pleasure at being reviewed in their journal.[16] Card-carrying member or not, Gernsheim seemed happy to be counted among the Jewish refugees.[17]

Not surprisingly, other projects requiring "Jewish" photos sought Gernsheim's assistance. He was approached by the *Encyclopaedia Hebraica* in 1962.[18]

Responding to requests by an editor for specific portraits, Gernsheim suggested they consider showing "the first Jewish Lord Mayor of London, George F. Audel-Phillips, receiving a baronetcy from Queen Victoria during her Diamond Jubilee celebrations in 1897. It is a very 'photographic' water-colour. The Mayor is in his robes kneeling in front of the Queen, who is facing the onlooker. They are surrounded by several court officials and the Princess of Wales." He also offered "a good portrait of Disraeli . . . one taken at Queen Victoria's request."[19]

Some thirty years later, however, had there been a similar opportunity, Gernsheim probably would have responded differently to such queries. In addition to portraits of men such as Adler, Disraeli, and Jacob Epstein, he might have noted the significance of men such as Hugh Welch Diamond (1809–1886, a psychiatrist among the first to photographically capture "the insane"), *Picture Post* editor Stefan Lorant, Focal Press founder Andor Kraszna-Kraus, and himself.[20]

While most of his energy was devoted to building his collection, writing, staging exhibitions, and trying to find a permanent home for his mushrooming research material, Gernsheim ardently followed politics in Germany—especially on the alert for evidence of smoldering Nazism. In 1953 he sought to express his dismay at the "Naumann affair" and similar developments in the pages of the *New Statesman and Nation*, but his letter was unpublished. The Naumann affair was one of several incidents revealing that the denazification program of the Allies was, at best, inconsistent. A far-right group including prominent Nazis had sought to infiltrate a legal German veterans' organization, in order to incite a resurgence of far-right politics. The controversy that erupted around this case, however, mainly focused on whether or not the British occupation forces had pursued the case in a technically legal manner, rendering the British more culpable than pre- and post-1945 Nazis.

"The Naumann affair is still in people's memories," Gernsheim wrote,

> though curiously enough the British press (as well as the German) has kept an extraordinary silence about the outcome of this resurgence of Nazism. The three Western Powers still have High Commissioners in Germany, and if they wanted to, they could make it clear to the Federal German Government that Nazism will not be tolerated on any account. But what are they doing? Instead of re-educating the Germans, as was promised during and immediately after the war, people directly or indirectly responsible for crimes are let out of prison and are staging a comeback to prominence and wealth.[21]

Gernsheim was prompted to write at that moment by an incident that went unreported in the British press, at "Fallingbostel on Luneburg Heath." It must not

be ignored, Gernsheim pleaded, because it is in "the British zone." Formerly the site of "a military exercise ground," it "later became a prisoner-of-war camp, and after 1945 an internment camp for prominent Nazis, from local group leaders up to the Reich Minister of Justice." Gernsheim quoted from a newspaper clipping:

> [O]n this very spot a few days ago the former inmates of the internment camp held a meeting. But they did not only celebrate their reunion, they also made demands: in fact, they asked for no less than that they should be compensated for their internment-time at the same rate as inmates of concentration camps of the Third Reich for their term of imprisonment. In addition, compensation was demanded for all those who had to go into hiding after the end of the Third Reich. The car park, which was crowded with cars, from the Opel to the Mercedes, demonstrated excellently the extent to which these "innocent" ex-internees are in need of support. Spiritual comfort was dispensed to the "persecuted" by a certain unfrocked Pastor Jakobshagen from Bad Lauterberg in the Harz, once "Deutscher Christ," a retired Major, and [Nazi] Party Member No. 7000, who particularly honoured the dead and praised the ideas which they had once served. "Good and valuable seed was sown; it will ripen, and one day the harvest will come," he said.
>
> Because one assumes that their "valuable seed" is still so well remembered, one may be inclined to dismiss lightly these people who believe that their time has almost come again; but it is an unbearable thought that in 1953 our democracy has again become so suicidally patient that it puts up with such incredible provocation. The important behaviour of former prominent Nazis is an extremely serious symptom.[22]

In his own voice, Gernsheim asserted that

> [a]nybody who has travelled in Germany and can talk to Germans in their own language knows that Nazism is not a thing of the past, and those who turn a blind eye because they regard its resurgence in its present stage as unimportant, are making the same mistake as those who dismissed Hitler and the Party as unimportant in the 'twenties and early 'thirties. Or will a future Government say again with the callousness of the Chamberlain regime, that they have no intention of interfering with the internal affairs of Germany? There is still time, and we still have a right to stop neo-fascism, but once the Germans have become partners in [the] E. D. C. this may become impossible.[23]

Although Gernsheim was not the least bit Jewish in a religious sense, his staunch anti-Nazism was the chief article of his secular faith, as it was for thousands of other nonreligious Jews at the time.[24] On the one hand, Gernsheim seemed to have no inhibitions about dealing with Germany and Germans in the wake of Nazism. But he drew a firm line between those who he believed denied the depth of German culpability for Nazism and the Holocaust and those who he felt were more honest.[25]

In 1955, when his *History of Photography* was published by Oxford University Press, the *Jewish Chronicle* reminded its audience, in a brief announcement, that Gernsheim "traces his ancestry from a famous German Jewish family." Typical for *JC*, the opportunity was seized to establish a Jewish lineage for photography itself: "One of the earliest references is to Levi ben Gershon's account of the camera obscura in the early fourteenth century." Readers also were informed that "in this latest splendid volume he again advances his proposal for the establishment of a national—or international—museum and institute of photography."[26] Again, it is unclear if the *JC* came to Gernsheim or if he approached the *JC*.

Consistent with his interview in the *JC*, the only substantial (known) publication of Gernsheim outside of photographic matters was a history of his own family, "The Gernsheims of Worms," which appeared in the *Leo Baeck Institute Yearbook* (1979). (Perhaps there are expressly political statements regarding his views on "world government.") The Leo Baeck Institute (LBI), named after the leading progressive rabbi in Nazi Germany to have survived the Holocaust, was (and remains) the foremost institution dedicated to the history of German Jewry. Based in New York, it has branches in London, Jerusalem, and (more recently) Berlin. The placement of this article was a thoughtful decision on Gernsheim's part: he apparently wished to situate his family in the pantheon of German Jewish history.

Although he was never shy about taking credit for his vast accomplishments and expressing strong opinions about photography, Gernsheim did not chiefly write from a personal perspective. However, he did include himself, as a photographer, as one of the subjects in an early book, *The Man behind the Camera* (1948), which comprises nine brief autobiographies. As a matter of convention, acknowledgments and introductory comments in his publications are of a personal nature. Other notable places where he self-consciously integrates himself were his presentation of Lewis Carroll as a photographer[27] and his recovery of "the first photograph" of Niépce.[28] Gernsheim understood that in both of these he had become part of the story. But the personal aspect was a lead-in to the main subject, a tale of discovery involving Helmut Gernsheim as a historian of photography, which entailed no intimate tie to the subject itself.

"The Gernsheims of Worms" was different. It sprang from an ongoing discussion with Tim Gidal. Upon Gidal's suggestion, Gernsheim's initial thought was to prepare some brief entries about his own historically significant family members for a "Jewish Lexicon" planned by the LBI. Gidal then surmised that it would be better for Gernsheim to write more extensively about the family as a whole, and he asked the editor of the *LBI Year Book*, Arnold Paucker, to solicit an article from Gernsheim. Along with his appeal for the article, Paucker sent Gernsheim the volume from the previous year (1974).[29] "I shall be happy," Gernsheim responded, "to write a more extensive essay on the contributions the House of Gernsheim in Worms made both to Jewish History and German and British cultural life."[30] The (projected) section on Britain would be focused on himself.

Gernsheim presented Paucker with a dense, three-page letter summarizing his family history—much of which would be repeated in the published article. Not surprisingly, the letter is more conversational, and includes a number of personal references that are not as explicit as in the article. Among Gernsheim's suggestions is that a picture of his ancestor, Michael Gernsheim, "the last Judenbischof," be included: "A contemporary painting in my brother's possession shows him in his colourful Bishop's robes and the Doge-like pointed cap."[31] The greatest difference between Gernsheim's prospectus and the published article was the omission of his own story.

Gernsheim regaled Paucker with stories about his "own pioneering work in photo-history in England after World War II, three years of which I spent making extensive photographic surveys of the most important buildings and sculpture in the London area for the National Buildings Record. There were a number of exhibitions of my work at the Courtauld Institute, the Churchill Club, and the National Gallery [and] a one-man show at the Royal Photographic Society in 1948."[32] This was not completely accurate. Although the exhibitions Gernsheim mentioned did indeed feature his work, they did not show his photographs exclusively, and at the time his name was not mentioned as the photographer.

Gernsheim was, however, on the mark about the importance of this endeavor, and its results were spectacular—even if they remained unheralded. What was far more significant, however, in the history of photography, was the scathing criticism to which the Royal Society and its followers had been subjected in his first book, *New Photo Vision* (1942). On the one hand Gernsheim exaggerated the degree to which he was feted by the establishment. On the other he minimized the extent to which he had challenged, and even threatened, the field. It was, after all, his radicalism that attracted the attention of Beaumont Newhall and was the thrust behind his original publications.

Michael Gernsheim (ca. 1705–1792), the last Judenbischof of Worms.
Private collection.

"From 1945 onward," he continued, "my activity concentrated entirely on collecting, writing, lecturing, and arranging exhibitions on Victorian Photography, a field that was first researched by me and in which I became the world's leading expert." Although this was largely correct, certainly Newhall and others, including Lucia Moholy and Heinrich Schwarz, not only deserved credit, but could be seen as Gernsheim's forerunners.

> My twenty books and numerous exhibitions from my own collection in England, the Continent and the U.S.A., beginning with the Festival of Britain exhibition "Masterpieces of Victorian Photography from the Gernsheim Collection" at the Victoria & Albert Museum in 1951 are largely responsible for the renaissance and world-wide recognition photography has won in the last decade. My rediscovery in 1952 of the world's first camera picture by Nicephore Niepce, taken in 1826, changed both the date and the originator of the invention. It was as sensational as my rediscovery of Lewis Carroll's photographic work three years earlier. My *History of Photography* was published by the OUP [Oxford University Press] in 1955. The same year I was the British delegate to the UNESCO conference on Photography and Film in Paris. Four years later I was the first person to be awarded the German "Kulturpreis für Photographie"—the highest international award in this field.[33]

As suggested above, it is interesting that Gernsheim underscores his accomplishments within and as recognized by the mainstream—with which he was almost continuously at odds.

"The extensive Gernsheim Collection, one of the most important photo-historical collections in the world," he continued, "is housed since 1964 in the Humanities Research Center of the University of Texas at Austin which also offered me a professorship in 1962, as did the Folkwangschule at Essen three years earlier." What Gernsheim does not mention here—far more weighty than the American academic appointment, which was vague at best—was the unprecedented amount paid by Texas for his collection. Gernsheim played a huge role in the still unwritten story of the creation of the "art market" for photography. Concerning the offers from both Austin and Essen, he qualified that he "accepted neither as I wished to remain independent." That was not quite true either: for a number of reasons the terms did not emerge in a form which would have made it possible for him and Alison to fully accommodate themselves in these institutions. "Today," he concluded, "I am adviser to the Editor of the *Encyclopaedia Britannica* and several University and Museum collections."[34]

Gernsheim took up at least one other highly personal project, which constituted a departure from his earlier work. In 1972 he composed, and then in 1993 revised, a poem interweaving the history of photography and the perpetration of the Holocaust.

In den unsteten zwanziger Jahren
—vor und nach der Inflation—
kreirte Moholy-Nagy
Photogramme der Abstraktion.
Renger Patzsch verwandelte die Umwelt
in neuen Sichten
Sander verewigte den deutschen Spiesser
aller Schichten,
Salomon zeigte berühmte Männer
in unbewachten Augenblicken,
Man und Weber präsentierten das Leben des Volkes
in Photogeschichten.

In den dreissiger Jahren verherrlichte
Riefenstahl die Macht der Nazi Diktatur.
Heartfield's hellseherische Photomontagen
Offenbarten Göbbels Lügenmanie
und wiesen amt den Untergang der deutschen Kultur
Die Intelligentia—ob Jud oder Christ—
ging in die Emigration
Wer nicht konnte hätte den Stacheldraht
zur Konzentration.
Die Nazis behaupten
Die Juden seien an allem schuld
Drum nahm man ihnen Leben und Gut.

Ziegler bestimmte was Kunst war
und Goebbels was dekadent.
Den Besten war das Kunstschaffen verboten,
Die anderen folgten dem Trend.
Ja, "schöne" Zeiten machtet Ihr Deutschen durch
Der Spuk des "Tausendjährigen Reichs"
wer hat einem zwölf-jährigen Gefängnis worden

Das Tagebuch der jüdischen Anne Frank
Überlebte Adolfs paranoiden rassischen "Kampf."
Was bei den Nazis als dekadent galt
ist heute wieder Kunst,
und wo Gewalt herrschte
regiert endlich die Vernunft.

Sechs Millionen Juden wurden kaltblütig ermordet,
doch die Toten bestärkten die überlebenden .
in der Forderung nach einem eigenen Jüdischen Staat.[35]

In the erratic twenties
before and after the inflation
Moholy-Nagy crafted
Photograms of abstractions
Renger Patzsch transformed the environment
in new views Sander immortalized the German philistine
of all classes
Salomon showed famous men
in unguarded moments,
Man and Weber presented the life of the people
in photo-stories

In the thirties
Riefensthahl glorified the power of the Nazi dictatorship
Heartfield's photomontages clairvoyantly
revealed Goebbels' manic productivity
and reported how German culture had sunk so low
The intelligentsia, whether Jew or Christian
went into exile
Who could not have known the meaning of the barbed wire for
 "concentration"
The Nazis claimed
That the Jews were to blame for everything
Therefore one took lives and property from them

Ziegler determined what was art
and Goebbels, what was decadent
The best were prohibited from creating
the others followed the trend.
Yes, you Germans went through "beautiful" times
from the specter of the "Thousand Year Reich"
which was a twelve-year prison
the diary of the Jewish Anne Frank
survived the paranoid racial "struggle" of Adolf
What was considered decadent by the Nazis
Is once again art
And where violence ruled
reason governed at last.

Six million Jews were murdered in cold blood,
But the dead threatened the survivors
In the demand for a Jewish State.

It is not known if Gernsheim ever sought to publish this, or even showed it to anyone. The text strongly echoes the feelings he forcefully expressed to Val Williams about his abhorrence of Germans he met who claimed to have known nothing about the fate of the Jews, and those who denied widespread German culpability for the Holocaust. Perhaps even more important is that this seems to be the only place in his writing where Gernsheim deals with the relationship between modernity, aesthetics, and antisemitism. Although Jews were not exclusively the founders of trends in the new photography, certainly they were overrepresented, and were among its greatest practitioners and enthusiasts. A more explicit statement about Jews at photography's cutting edge was articulated by Tim Gidal in his article, "Jews in Photography" (1987), which derived in part from his relationship with Gernsheim.[36]

Despite such a stark drawing up of accounts, Gernsheim was far from having given up collecting and writing. His post-Texas acquisitions, including the superb color photos of Franz Berko, would form the heart of the collection bequeathed to the Reiss-Engelhorn Museum in Mannheim, which also would acquire the correspondence and books that had not been given to Texas. He was still collecting other artwork besides photographs.

Perhaps the greatest failing of Gernsheim's précis, after obfuscating the extent to which he had both created and unsettled a field, was not the inaccuracy of

individual points. In highlighting himself as a lone wolf, it ignores something that he was only beginning to discern: that connections between Jews were important to the history of photography. He never would have become a photographer without the advice and assistance of his brother; the Warburg Institute gave him an institutional home when he had no prospects; his initial publishers were often imprints of émigrés and refugees; Lew Feldman brokered the deal that brought him financial security and set his core collection in a permanent home.

While Gernsheim was waiting for a response from Paucker about the article, Gidal repeated his support: "I do hope you will write that essay! No excuses here, you Semite!"[37] Said in jest, this was a clear affirmation of their shared sense that Gernsheim needed to claim his place in Jewish history. Around that time Gidal and Gernsheim discussed writing a book together, composed of their conversations, which they referred to as "GG Gespräche" or "G3."[38] Discussing his own preparations for teaching a course about the history of photography at the Bezalel School of Art in Jerusalem, which was tied to the Hebrew University, Gidal then proposed that Gernsheim teach the history of photography course. Having Gernsheim teach would mean "that 'die Lehre geht aus von Jerusalem.'" Overall the situation in Israel was turbulent, but, Gidal boasted, it was "the most beautiful, most exciting country in the world, and Jerusalem is her crown, pardon the monarchistic chauvinistic express[ion], no leftypinky listening right now."[39]

It is worth dwelling on Gidal's comment, "die Lehre geht aus von Jerusalem." Literally it translates as "From Jerusalem will go forth the teaching (or "instruction," or "the law")." It is, though, a slight misquote of the biblical expression: "From Zion will go forth Torah" or "For instruction shall come forth from Zion." Gidal was secularizing the prophecy of Isaiah 2:1–4 which is closely repeated in Micah 4:1–3. It had been applied in many ways by Jews throughout their history, but probably most prominently as a foundational ideal of the Hebrew University of Jerusalem for those of Gidal's generation.[40] It was not simply a geographical or descriptive term: it inferred that sage-like wisdom and "oracles" would issue from a restored Jewish presence in their ancestral home of Zion, in Jerusalem. The main point here is that Gidal thought it appropriate that the greatest font of wisdom about the history of photography, Helmut Gernsheim, have a platform at Jerusalem's Hebrew University.

From that moment on, until about 1990,[41] Gernsheim would engage in a number of Jewish and Israeli-centered activities. But for the time being the pressing issue was the piece that Gernsheim was itching to write. Paucker advised Gernsheim that most of what he had to say about himself would not have a place in the *LBI Year Book*. The institute's "own research and publication programme," he wrote, "extends roughly as far as 1933/39 and deals on the whole with Ger-

many and Central Europe and not with later events after immigration. There are other projects, for instance a bibliographical handbook undertaken by another organisation, in connection with which I recently had a questionnaire forwarded to you, but as far as we are concerned this is largely outside our terms of reference.[42] You could of course append a brief note on your work in England and we would also list your major publications etc. in the usual list of contributors."[43]

This was not exactly a kick in the teeth, but not what Gernsheim wanted to hear. He was obviously looking for a place to situate his family and himself in Jewish history. There was, alas, to be no more continuity: "As the last three male Gernsheims have no issue the name will unfortunately die with us," Gernsheim bluntly stated.[44] The prospects of the name were not quite as dire as he feared, in part because of his narrow definition of "issue" as male offspring. Gernsheim's niece, Elisabeth, would choose to carry the name herself, in combining it with the name of her husband (Ulrich Beck), both of whom continued the family tradition of being renowned scholars. Helmut Gernsheim's family account made it into the 1979 volume of the *LBI Year Book*, a fairly long gestation. Surprisingly, Gernsheim does not appear in Gidal's article on Jews and photography of 1987 in the *LBI Year Book*, even though his discussions with Gernsheim had to have influenced his work.[45]

As stated earlier, "The Gernsheims of Worms" mainly discusses the most eminent member of the family, composer and conductor Friedrich Gernsheim. Although Gernsheim wrote in both the letter to Paucker and the article that Friedrich was "largely forgotten" in the late 1970s, his ancestor was in fact famous enough to have had a street named after him in Worms.[46] As Paucker warned, there would not be space allotted for Helmut's achievements. Though Helmut did not feature explicitly in the article, he did situate himself in the text by referring to "my grandmother," "my grandfather," "my uncle," and a "cousin."

Along with the Jewish enclaves of Speyer and Mainz, the Jews of Worms were one of the three foundational communities of Ashkenaz (Central European Jewry). All three were devastated, but not totally destroyed, in the Crusades long before Helmut's ancestor reached the city in the late sixteenth century. The core history of his family resonated deeply with his own. "The founder of the Gernsheim family," he begins, "came to Germany as a refugee from Spain following the expulsion of the Jews from that country in 1492. Nothing is known about him, not even his name; merely the fact that this Sefardic Jew settled in the little township of Gernsheim on the Rhine from which he took his new name."[47]

Gernsheim's claim that his family is Sephardi—that is, originating from medieval Spain or Portugal—may be apocryphal. It was typical for German Jews of the nineteenth- and early twentieth-century elite, as well as their Anglo-Jewish

counterparts, to claim a Sephardic background—because this suggested a status superior to Jews stemming from Eastern Europe.[48]

But however questionable or clouded in mystery were the Gernsheims' beginnings, the family's endpoint was clear. "The last Gernsheim in Worms," Helmut wrote, "Dr. med. Friedrich Gernsheim," a namesake of the musician, "committed suicide with his wife [in] July 1938 in order to escape a worse fate at the hands of the Nazis. Thus we can look back on 400 years of family genealogy and history."[49] This statement, undoubtedly true, is perhaps of greater historical interest than he realized. Had the double suicide occurred in the context of the November Pogrom of 1938, it would have been less remarkable. Friedrich Gernsheim and his wife had already become so distraught in the summer of 1938 that they took their own lives. It is no accident that Gernsheim commences his article with his forebear entering Germany as a refugee and not as a migrant seeking a better future. Nazi stigmatization framed this fascinating, deeply personal portrait.

None of this is not to say that Judaism mattered to Gernsheim as a religion. But his belonging to a fragmented community of those with Jewish origins was important in several respects. On the one hand, Jewish networks, related to photography and art, proved invaluable to Gernsheim from the moment he entered Britain. His brother's connection to the Warburg Institute, leading to the National Buildings Record assignment that provided the basis for several of Helmut's later publications, was essential. I have argued that Jewishness, inseparable from his condition as a refugee, was an unspoken yet critical factor in his extraordinarily fruitful relationship with Beaumont Newhall.[50] In large measure, Helmut's brother Walter was correct: photography was unusually welcoming to Jews, and one of the best means for a Jew to engage the fine arts was through photography—as opposed to art history per se. Obviously Helmut Gernsheim, as part of a two-person industry, was the most powerful agent and catalyst in his own career, for better or for worse. But nearly every twist, upturn, and downturn reveals some sort of Jewish aspect, even when it is unstated or seems to be irrelevant. Perhaps most telling, along with his brief interview in the *JC*, and published family history, are the lists of Jewish photographers that Gernsheim compiled (the first of which is dated 1981 and includes himself) and his poem about the Holocaust.[51]

While in the throes of work on his family history, Gernsheim warmed to the idea of an appointment in Jerusalem, although he knew it would be difficult to arrange. "You throw out a delightful suggestion," he replied to Gidal, "to run a course on the history of photography at Jerusalem university." He assumed this undertaking would offer a more positive experience than the ones he said he had

declined in Austin and Essen, or the one he had taken on for Franklin College, "an American junior university with only a two-year course" in Lugano, Switzerland. The latter he had given up after one year, "disgusted with the laziness of these rich youngsters who only wanted to get away from home." The Hebrew University of Jerusalem, he surmised, would be an entirely "different proposition." He feared, though, that the academic calendar might not suit him, and that the university, which seemed to be in a continual funding crisis, would not even be able to allow for his basic subsistence.[52]

While Gernsheim was becoming better known worldwide as an authority on photography, he also was increasingly being recognized as a Jew. He was informed in 1986 that a biographical entry on him was being prepared for the *Encyclopedia Judaica Year Book*, a series of supplements to the *Encyclopaedia Judaica* of 1971. Gernsheim was happy to furnish information, far more than what was asked. This would allow for the kind of reckoning that he had not been permitted in the *Leo Baeck Institute Year Book*. No doubt he was happy to be honored and acknowledged in this way, but he did find one aspect of the proposal unsettling. "Miss (Yael) Maman mentions," Gernsheim wrote tersely to Yehoshua Nir, "that the forthcoming *Year Book* will include an article on 'Jews in Photography.' Such a list was prepared by me in 1981 and copies were given to Dr. Tim Gidal, an American journalist working on the staff of *Popular Photography*, and a few other interested people. I enclose a copy of my list and wonder who has had the audacity to copy me?"[53] The identity of the American journalist is not known; aside from Tim Gidal the candidates could have been Gisèle Freund and Ferenc (Franz, to Gernsheim) Berko.

His "discovery" of Berko in 1977, and their friendship, were especially meaningful to him. Perhaps the fact that their "non-Aryan" identities were foisted on them by the Nazis was an important bond—as neither had been raised as a Jew and, by religious definitions, they would not have been considered Jewish.[54] Berko was born Berkowitz in Nagyvarad, Hungary, in 1916, in territory that became Romanian after the 1920 Treaty of Trianon. In 1921 his family moved to Dresden. In an interview with Karl Steinroth in 1991, Berko recalled that

> my father, whose family was originally Jewish and had converted to Calvinism, was an agnostic. He was not interested in politics but by his intellectual make-up was a liberal. He was a disciple of Freud, and specialized in the treatment of nervous diseases. He had been widely published in scientific publications and books. He saw the dangers of rightist dictatorship and welcomed the opportunity to become the head of the psychiatric department of a well-known, even fashionable clinic outside Dresden, in the liberal climate of the Weimar Republic.[55]

Ferenc Berko, "Car Junkyard, Tennessee, USA," in *Ferenc Berko,*
60 Years of Photography, 108. The Ferenc Berko Archive.

In addition to their similar class backgrounds, both Gernsheim and Berko were Anglophiles. After Hitler's rise to power Berko was sent to England to finish his schooling. Having visited previously on a student exchange, Berko "liked England very much." Overall his experience was extremely fortuitous. The esteemed photographer E. O. Hoppe lent him a helping hand, and Berko won a major photographic competition sponsored by Boots, Britain's leading pharmacy chain.[56]

Anticipating that he would be interned during wartime, Berko left England for India, where he pursued film as well as photography. He was a cameraman for the "first and very successful Indian imitation of a 'Tarzan' film." Following the Second World War Berko was again briefly in England, where he enjoyed some professional success. Bill Brandt "made a selection for a portfolio" of his work in *Lilliput,* and the Victoria and Albert Museum exhibited a series of South Indian bronzes he had shot for collectors. In a later stint he created "photo stories" for the Powell and Pressburger feature film *The Return of the Pimpernel.*[57] Berko continued his career in Chicago and Aspen after 1948, and by the early 1990s leading critics had placed him among the most creative photographers of the mid-twentieth century.[58]

Gernsheim was most struck by Berko's work in color, which became a more intense passion for Gernsheim after his collection was transferred to Austin. Berko also was a talented photographer of nudes; both enjoyed artful photos of beautiful women. Berko, however, went further than Gernsheim in his photographic engagement with Jews.[59] An exquisite but little-recognized volume of Berko's work (1994), with brief essays by Colin Ford and Gernsheim, is the only book project of Gernsheim's (during his lifetime) to include unequivocally "Jewish" photographs.

Ferenc Berko, "Bombay, India, 1941," in *Ferenc Berko, 60 Years of Photography*, 82. The Ferenc Berko Archive.

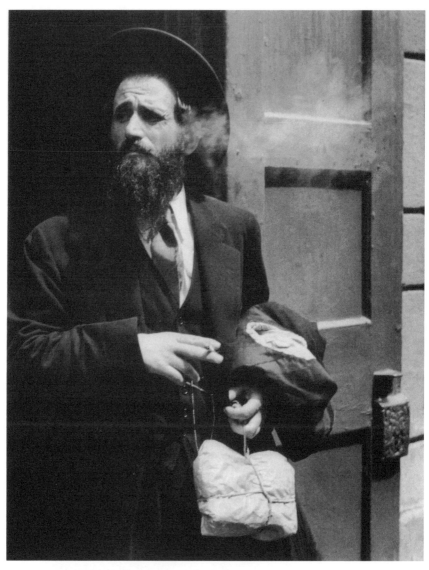

Ferenc Berko, "Budapest, Hungary, 1937 [Jew smoking]," in *Ferenc Berko,*
60 Years of Photography, 27. The Ferenc Berko Archive.

Perhaps Gernsheim was going to be "copied" in the imagined article for the *Encyclopaedia Judaica*, but it is more likely that its editors mainly wished to enhance the material supplied by Peter Pollack, which they had severely limited.[60]

When the *Encyclopaedia Judaica* was being prepared in the 1960s, "Jews and photography" had not been seen as a very important topic, but in retrospect some editors (and their readers) were starting to realize that many extremely significant Jews, who had not primarily made their mark in Jewish affairs, were conspicuous by their absence in the *Judaica*.

In Nir's response, he sidesteps the problem of Gernsheim having been "copied" by telling him that "the biographical section of photographers has been postponed and will appear in the next issue." Nir also assured Gernsheim that he would use the material he had forwarded.[61] Gernsheim's claim that the subject was his alone also is complicated by Arnold Newman's continued engagement with the topic.[62] Newman, too, had drawn up several lists of Jews in photography for talks he delivered in New York (1968) and at the Bezalel Institute in Jerusalem (1979).[63] In some respects the Israelis were operating along parallel tracks, or duplicating their efforts to further photography in the country, in the unconnected approaches to both Newman and Gernsheim, which had the aim of finding a place for photography's history in Israeli academe.[64] Newman, though, had a much more long-standing and pronounced relationship with Zionist bodies and Israel than did Gernsheim.[65]

In his next letter to Nir, Gernsheim thanked him for sending his book, which Gernsheim informed him was not exactly new to him: he "had the pleasure of seeing" the proofs, as his "opinion was [solicited] concerning [Nir's] promotion to full professor" at the Hebrew University. Gernsheim showed that he was quite familiar with Nir's subject and, also true to form, pointed out a mistake in Nir's text. His criticism, though, was mixed with generosity, as he also offered to send a book, *Dialogues with Photography*, which included an extensive interview with him.[66] Nir claimed to be surprised to hear that Gernsheim was consulted about his promotion, and made it clear that he wished to continue and develop their acquaintance. He had *Dialogues*, but did not possess Gernsheim's most recent comprehensive history of photography, available only in German—which was too expensive for him to purchase. He also revealed his kinship with Gernsheim by saying, "I do read fluently German (being, by birth, German speaking, from Czechoslovakia), and would appreciate if you could suggest to your publisher to send me a review copy."[67]

Nir later expressed his deep regret that due to its "extremely difficult financial situation," the Hebrew University could not possibly invite and honor Gernsheim in an appropriate manner.[68] Gernsheim did, however, finally participate

in a symposium, "Focus East," at the Israel Museum on July 26, 1988, for which he was the keynote speaker; the topic was the history of photography, and the participants included colleagues from the Hebrew University.[69] He was joined in the event by Yigal Zaloma, Mordechai Omer, Arthur Ollman, Yeshayahu Nir, Françoise Heilbrun, Christian Bouillon, Stephen White, and Nissan Perez. The conference coincided with an exhibition, "The Travelling Photographer and the Orient."[70]

The experience was so positive that a return visit and follow-up events were discussed almost immediately. Colleagues from the symposium corresponded with Gernsheim and visited him in Switzerland. But within two years the initiative—to gather a group concerned with issues related to Jews and photography—was moribund, at least as far as Gernsheim was concerned. Speaking for himself and his (second) wife, Gernsheim wrote, "Irene and I have decided against any participation in the 25/1/1 anniversary celebration of the Israel Museum."[71] He was put off by the concentration of energy, by the Israelis, toward persuading him to donate items from his collection, and to offer some for sale "to benefit a fund to promote the study of photography."[72] Gernsheim was not happy. "When Nissan (Perez) suggested two years ago to the invited photography experts that we should all meet again this autumn for the opening of a photography department," he wrote, "we thought it a splendid idea, for this small group had meanwhile become a family of friends with Nissan a wonderful host." This was not, however, how the imagined role for him was emerging. "Hobnobbing with money society is, however, not to our taste. This celebration will, we are sure, create many new supporters of your splendid museum. And you will not miss us in the crowd. We are full of admiration for what Israel has achieved and we will no doubt enrich your collections one day with small gifts."[73]

Although Gernsheim would not have that much longer to live, Israel squandered a chance to help establish the history of photography in the country. There is no doubt, though, that Britain failed more spectacularly to reap the fruits of his endeavors. Lamenting the likelihood of receiving some kind of official honor in Britain, Gernsheim wrote Gidal: "The British honoured Cartier-Bresson at Oxford though he hadn't done a thing for them, and whilst I put British photography on the map they cannot 'forgive' me for selling my collection to the States, as if I were to blame for their own stupidity in not wanting it!"[74]

Whether there was, in fact, much Israeli interest in photography's history, as conceived by Gernsheim, is unclear. Most experts in the country were concerned with the issue of how Jews were represented, and how the field developed in Palestine and Israel. Indeed, Nir's piece in the *Encyclopaedia Judaica Year Book*

(1987) was exclusively on Jews as the subjects of photography.[75] A serious attempt to update Peter Pollack's 1971 article on Jews and photography apparently was never made. Indeed, even the second edition of the *Encyclopaedia Judaica* of 2007 simply reprints Pollack's article, with a few dates added, and appends Nir's contribution, along with one other on Israeli photography. Nir's promise notwithstanding, Gernsheim never made it into any supplemental *Year Book*.

The first of Gernsheim's extant lists, titled "Jews Prominent in Photography," is subtitled "Including people of Jewish extraction." A note at the top states that it was "Compiled by H. G. 1981." It was written sometime after June 1980: by then Gernsheim had learned that Ansel Adams, and possibly others, were not members of "the tribe."[76] The names, overwhelmingly of photographers, with some comments, comprised

Adam-Salomon, Antoine

Allmand, Alexander

Almasy, Paul

Arbus, Diane née Nemerov

Auerbach, Erich

Avedon, Richard

Barnbaum, Bruce

Benjamin, Walter (born Detlev Holz)

Beny, Roloff

Berko, Ferenc

Bernhard, Ruth

Bidermanas, Israel (known as "Izis")

Bierman, Aenne

Bing, Ilse

Biow, Hermann

Blumenfeld, Erwin

Bonfils, Andrien

Bonfils, Felix

Boni, Albert

Bourke-White, Margaret (half-Jewish)

Brassai (born Gyula Halasz)

Breuhl, Anton

Brodovitch, Alexei

Burrin, Roselinna (born Mandel)

Capa, Cornel (born Friedmann)

Capa, Robert (Andrei Friedmann)

Casparius, Hans G.

Davidson, Bruce

Deschin, Jacob

Diamond, Hugh Welch

Eisenstaedt, Alfred

Elisofon, Eliot

Erfurth, Hugo

Errell, Richard

Fehr, Gertrude née Fuld

Feininger, Andreas?

Folberg, Nils

Frank, Robert

Freed, Leonard

Friedlander, Lee

Fruend, Giséle

Gabor, Denis (Nobelpreis 1971)

Gernsheim, Helmut

Gidal, Tim (Ignaz Nahum Gidalevitch)

Godine, David (publisher)

Godowsky, Leopold (Kodachrome)

Gorny, Hein

Goro, Fritz

Graeff, Werner (married to Klara Kohn)
Guttmann, Heinrich (journalist)
Halsmann, Philippe
Heartfield, John (Herzfeld, Helmut)
Henle, Fritz
Hine, Lewis
Hutton, Kurt (Hübschmann)
Izis (see Bidermanas)
Jacobi, Lotte
Jussim, Estellee
Kalischer, Clemens
Kallmus, Dora (pseudo. Madame d'Ora)
Kane, Art
Kar, Ida
Karsh, Yousef
Käsebier, Gertrude
Kepes, Gyorgy
Keppler, Victor
Kertesz, Andre
Klein, William
Kraszna-Krausz, Andor (publisher)
Krull, Germaine
Lehr, Janet (dealer)
Lerski, Helmar
Levinson, Joel
Levitt, Helen
Lieberman, Alexander
Liebling, Jerome
Lippmann, Gabriel (Nobelpreis 1908)
List, Herbert
Lorant, Stefan
Lumiére, Auguste
Lumiére, Louis
Lyon, Danny
Lyon, Nathan (educator)
Mannes, Leopold (Kodachrome 1935)
Maywald, Wilhelm
Meyer, Adolf Baron de

Meyerowitz, Joel
Mili, Gijon
Model, Lisette
Moholy-Nagy, László
Moholy-Nagy, Lucia?
Moses, Stefan
Munkácsi, Martin
Neikrug, Marg (dealer)
Newman, Arnold
Newton, Helmut
Nürnberg, Walter
Perutz, Otto (manufacturer)
Ray, Man (pseudo. for Emmanuel
Radnitsky)
Ronis, Wily
Rose, Ben
Rosenblum, Naomi
Rosenblum, Walter
Rothstein, Arthur
Salomon, Erich
Szafransky, Kurt (dirct. public. Ullstein)
Seymour, David (born Szymin; "Chim")
Shahn, Ben (painter and photographer)
Sieff, Jeanloup
Siskind, Aaron
Sontag, Susan (writer)
Sterenberg, Abram
Stern, Bert
Stieglitz, Alfred
Steiner, Ralph
Stock, Dennis (born Stöckl)
Strand, Paul (born Stransky)
Suschitzky, Walter
Tausk, Petr
Traub, Charles
Traube, Arthur (Uvachrome 1916)
Vidal, Leon
Vishniac, Roman

Vitali, Lamberto

Waldman, Max

Weegee (b. Arthur Feelig)

Weiner, Dan

Witkin, Lee

Wolf, Daniel (dealer)

White, Stephen (dealer and writer)

Yavno, Max

This evidently was the first of at least three such lists. There are a few errors—such the inclusion of Hugh Welch Diamond,[77] German Krull, and Yousef Karsh. And there are some strange omissions—such as Nahum Luboschez, historian and collector Edward Epstean, and historian Heinrich Schwarz, whose work was well known to Gernsheim. The second list added a few more: "Baron (born Nahum)," that is, Sterling Henry Nahum, discussed earlier; Chargesheimer (Carl-Heinz Hargesheimer), who worked in postwar West Germany; Kaspar Fleischmann, a young "dealer" from Switzerland; Ralph Gibson; Françoise Heilbrun, a French photo historian and curator; and the animal photographer Camilla Koffler (1911–1955), known as Ylla. Gernsheim may have composed this list after he entered discussions about an exhibition of his own photography to be held in Hamburg. The show ran originally in Hamburg, at the Galerie F. C. Grundlach, then went to the Spectrum Photogalerie in Hannover's art museum, and finally, to his own former hometown, Munich, at the city museum.[78] Around the same time there was a proposed exhibition of photographs of Felix H. Man in the Staatsbibliothek in Berlin.[79]

For the latter Gernsheim told Gidal that he would "contribute a foreword to the catalogue" that would be "outspoken on the Jewish question."[80] For the first time, in print, Gernsheim addressed what the Nazi antisemitic campaign meant to photography. While Felix Man was in Vancouver, Gernsheim wrote, "where he intended to go on to Japan, he received news of the dispossession of the Ullstein publishing house by the Nazis and the simultaneous dismissal of the Jewish chief editor of the *BIZ* [*Berliner Illustrirte Zeitung*], Kurt Korff, and likewise the Jewish director of its illustration department, Kurt Szafranski. Man was summoned by Germany's new masters, but refused, as directed by Dr. Goebbels, to join the Reich Press Chamber. Membership in that organization was necessary in order to be permitted to work. As a political opponent of Nazism he chose to emigrate and went to England in 1940."[81] In the same piece Gernsheim called attention to the Jewishness of Stefan Lorant. "In June 1940," he wrote, "the German troops were 20km off the coast of England." The country faced imminent invasion. "Stefan Lorant went to America. He, as a Jew, did not want to be Hitler's Prisoner a second time."[82] Gernsheim was right that Lorant's identity figured

prominently in his departure—but it had not, as we have seen, been Lorant's choice. Gernsheim, though, had no reason to doubt the widespread belief that Lorant had "fled."

The next known Jewish list of Gernsheim's was prompted by correspondence from George Gilbert, who was preparing a book about Jews and photography. Gilbert was not a historian of photography, but a more popular, quirky photography writer and journalist. Most likely, Gernsheim sent a copy of a list of Jews in photography before the one sent to Gilbert "on 6 Sept. 94 by air." The latter apparently included some additions to the earlier lists and brief explanations of those for whom Gilbert had little or no information. There were still some mistakes. It is illuminating, though, for its revelation of Gernsheim's relation to some of the lesser-known individuals, such as this remark about "Ollman, Arthur (1947–) American instructor-photographer. Director of the Museum of Photographic Arts, Balboa Park, San Diego." "I met him and Heilbrun," Gernsheim wrote, "when we were speakers at a symposium at the Israel Museum, Jerusalem. He told me he and his wife were Jewish." Regarding "Misrach, Richard (1949)," Gernsheim added: "Enquire from his agent in San Francisco, the Fraenkel Gallery (also Jewish) whether Misrach belongs."[83] Here Gernsheim was showing that his facility with the Jewish world had limits, as he did not know that "Misrach," meaning "East" in Hebrew, was a common Jewish name among Sephardi and eastern Jewries. After "Traub, Charles (1945–) American," Gernsheim commented: "Former director of Light Gallery, New York. As an agent of Aaron Siskind[.] I had dinner with both in Milan at Siskind's exhibition at the Diaphragma [Diaframma] Gallery, when he told me of being a Jew."[84] Gernsheim apparently met Traub and Siskind in 1980,[85] which was around the time he enquired of Ansel Adams,[86] and others, if they had Jewish origins. What Gernsheim also conveys, through the names and remarks, is that he considers the curatorship and marketing of photography as critical for appreciating its history.

It is not surprising that Gernsheim helped Gilbert. In his acknowledgments, immediately after he thanks his wife, Gilbert says that he is "indebted to historian Dr. Helmut Gernsheim of Switzerland for his ongoing suggestions and much-valued research and experience. He died before he could see how his numerous contributions enriched the scope of this project."[87] Throughout his career Gernsheim had given everything from single bits of data to storehouses of information to anyone who asked. Gilbert was far from the most brilliant or esteemed person to seek Gernsheim's advice. Gernsheim not only helped him, but praised the project—which certainly was not up to his own standards. The blurb on Gilbert's book reads: "I heartily congratulate you on a fine and much needed

compilation and compendium. I appreciate you letting me see a draft of the text." His words—if Gilbert quoted him correctly—are measured. The book is riddled with errors and has not been taken very seriously outside of Jewish circles. Gilbert, in other publications, and possibly this one too, had taken liberties with the work of others—including "embellishments" and adding his "unattributed opinions" even in apparent quotes.[88] Certainly Gernsheim knew it was not a great book. But his endorsement may be seen as indicative of the fact that he did, indeed, wish to see Jews in general, as well as himself, get more credit for animating the entire photographic field. Future work on Gernsheim and others would be well served by looking at Jewishness not only as something to be treated in passing as part of an individual's origins, but as a vital factor throughout their lives.

Unattributed, *Andor Kraszna-Krausz*, ca. 1970. National Media
Museum/Science and Society Picture Library.

EPILOGUE

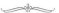

KARL MARX, in no small part through his intensive investigation of the British economy, predicted that capitalist societies, as inherently volatile entities, would experience incessant booms and busts. Although the system (so far) has never collapsed as Marx foretold, manifestations of highly exaggerated wealth-creation and income-depletion continue to bedevil Britain, which is especially troubling for those on the losing end. Along with erratic jumps in fortunes and misfortunes, British society is prone to bursts of destabilization of its politics and culture through scandals. Perhaps this derives, at least in part, from the activities of cutthroat newspapers. Whether shrill or stuffy, they seem to thrive on tales of the lurid and unsavory. Of the thousands of press items that may be characterized as scandalous, at least a few have involved the practice of photography. Not surprisingly, some of these reveal Jewish dimensions. Countless other scandals stem from photographs, per se, such as celebrities in various states of dress and undress, including those caught having their toes sucked. But the latter will not concern us here.

There is some irony in the fact that Helmut Gernsheim had nothing to do with any photographic brouhaha in Britain from the early 1960s onward. A national photography center finally did emerge as part of the National Media Museum in Bradford in 1983.[1] A refugee from Hitler's Europe did indeed provide essential material for turning it into a research institute—but that individual was Andor Kraszna-Krausz, not Helmut Gernsheim.[2] In association with the founding of this museum, however, Gernsheim was recognized by the awarding of an honorary degree from the University of Bradford. The National Media Museum collection is formidable, but it would be far richer if it held the treasures of Gernsheim that are now housed in Austin and Mannheim.

A medium-strength controversy about photography's role in British national life arose in the late 1970s. The famed American portraitist Arnold Newman (1918–2006) was contracted to photograph a group deemed "Great British"— which would materialize initially as an exhibition in the National Portrait Gallery.[3] "It is a most exciting project," Newman wrote to a friend, "over fifty portraits of the Great British (men and women in government, arts, theatre, business, sports, etc). The London *Sunday Times* will feature the portraits at the same time the [National] Portrait Gallery will exhibit them in April. A book is also being done on the series."[4] Part of the rationale for this project was continuity: Britain once had been a leader in photography. In order to both recognize and reclaim that status, it should make an effort to contract the world's preeminent portraitist to capture the most formidable of its great and good. A number of capsule histories of the history of photography in Britain appeared in light of Newman's project, which ranged from poorly informed to ludicrous. None of them gave due credit to Barnett, Salomon, Lorant, or Gernsheim, opting instead to grant pride of place to the *Sunday Times*.[5]

The press notice for the opening of the exhibition stated,

> The National Portrait Gallery has been collecting portraits of eminent Britons since 1865, naturally concentrating on paintings. For the past six years [beginning around 1972] it has also been acquiring the best possible photographic portraits and has now commissioned a series of these from the distinguished American, Arnold Newman. Arnold Newman, who celebrates his 60th birthday this year, has been one of the world's most famous photographers since the 1940s, his work having frequently appeared in *Life, Harpers Bazaar, Time, Holiday*, etc. He has specialized in personalities in the arts and his portraits of Stravinsky and Picasso in particular are classics. He has photographed every American President since Harry S. Truman. His pictures of Henry Moore, Harold Macmillan, and Shelagh Delaney were purchased by the Trustees of the Gallery in 1975.[6]

The main debate about the selection of Arnold Newman concerned his Americanness. Why did an American have to be imported for such an overtly British assignment? In an interview for the BBC Newman was pointedly interrogated: "Why is an American doing this? Are there special links with Britain?"[7] Newman, obviously, was not responsible for his own selection. Although it would never be articulated in print, might a subtext of this controversy have been that Newman was not only an American—but also an American Jew? How could

he, then, relate to those he was to photograph? Those arguing for him made the case that he was simply the best man for the job.

It was indeed an interesting task, which for the most part Newman seemed to enjoy. Among the highlights was his experience with "the Archbishops of Canterbury and Westminster [and] the Moderator of the Free Church Council." The commentary for that photo reads:

> If we had shot this in a chapel it might have had a more religious aspect, but I felt that as it had three different faiths the background should be neutral. It is in fact a corridor at Lambeth Palace. The shadows are dark but there is a warmth and friendliness. Aware of the different branches of the church represented here I told them I wanted to make the picture non-denominational. With crisp logic [and with the good humor of the group], Cardinal Hume, resplendent in his scarlet robes, looked at me with a twinkle and said: "And how do you propose to do that?" I couldn't think of a quick answer. Later, as I was making a Polaroid to check the lighting, I said: "this is the time when a photographer prays, when he is taking a photograph." There was a pause, then the Archbishop of Canterbury turned to the others and said: "Gentlemen, I think we should do something for Mr. Newman!"[8]

But there were some frustrations. A few among the greatest Britons declined to participate: the Queen, the Prince of Wales, and Margaret Thatcher. Still, the show went on. Although there were a number of good reviews, the consensus among critics is that *The Great British* is far from Arnold Newman's best or more interesting work.

In the midst of this project there arose another, smaller controversy. After turning Newman down, Prince Charles made a point of having an official portrait taken by a less illustrious American-Jewish photographer with whom he happened to be friendly, Bernard Schwartz. "The story goes," a columnist in the *Amateur Photographer* noted, "that Mr. Schwartz, 64, forked out £10,000 for the privilege of having our future king pose for his camera—an audience denied other photographers, even those of the calibre of Arnold Newman. . . . As everyone knows, our royals do not directly involve themselves in money-raising transactions, so the tale deserves examination in some detail." For many it had a "highly unsavoury" whiff. But the columnist mainly wished to show that nothing untoward had transpired, and the prince had the best of intentions in trying to generate funds for the Silver Jubilee Trust. Schwartz was friendly with Margaret Thatcher, who also had refused Newman. In sum, Prince Charles was exonerated

Arnold Newman, *Religious Leaders* in *The Great British/Photographs by Arnold Newman*, no. 26. "Nu, so where's the Chief Rabbi?" Bromide print, 1978? 22½ × 16¼ in. (572 × 413 mm). © Arnold Newman/Getty Images.

from any explicit wrongdoing, but his taste was certainly called into question. "I suggest," the article concluded, "that the Prince should be made aware that certain photographers are undoubtedly important chroniclers of history, and a sitting with them is not a chore but an investment, for students of history in the decades ahead. Arnold Newman is such a photographer."[9]

It is safe to say that this criticism has proven correct: after coming to photography late in life, Schwartz certainly was competent, but he is not considered to be on a par with Arnold Newman. Both men, however, employed consistent gimmicks. Newman liked to portray his subjects in some kind of professional context, often with a tool of his or her trade. Schwartz preferred to make his subject's hands prominent—thinking that this was an especially telling indicator of character. Interestingly, even though Newman was rejected by Prince Charles, the royal photographer of choice—Bernard Schwartz—was still an American Jew. And he was quite a Jewish Jew at that.

As mentioned in the preface, some decades later, in 2007, it appeared that Prince Charles's mother, the Queen, had a downright nasty experience with the photographer Annie Leibovitz. A preview of the television report about the photo shoot depicted the Queen storming off in a huff—even livid—with the photographer.

When celebrity photographer Annie Leibovitz suggested that Queen Elizabeth II . . . take off her crown, the Queen didn't exactly respond, "Off with her head," but she was definitely far from amused. . . . The royal wrath was incurred in March, according to a forthcoming BBC documentary, when the queen sat for four portraits by Ms. Leibovitz in advance of a visit to the United States. Ms. Leibovitz, whose works include a naked, very pregnant Demi Moore and a nude John Lennon hugging a clothed Yoko Ono, suggested that the queen, who was wearing ceremonial robes, remove her crown. "I think it will look better without the crown because the garter rose is so . . ." Ms. Leibovitz said. The queen interrupted her, "Less dressy?" she asked. "What do you think this is?" she asked, pointing at what she was wearing and giving the photographer an icy stare. The queen then stalked off, trailed by an official bearing the train of her blue velvet cape, while she told another servant: "I'm not changing anything. I've had enough dressing like this, thank you very much." The BBC documentary, "A Year with the Queen," a behind-the-scenes look at royal life, was filmed over the last year and will be broadcast in September or October. The BBC1 controller, Peter Fincham, described the scene with Ms. Leibovitz as "a very memorable little sequence."[10]

Touché, BBC! They seemed to have videoed the Queen off-guard, capturing her reputed haughtiness and icy demeanor. In the first instance the preview for this exposé, created for the BBC by the RDF Media Group, was distinctly unflattering to the Queen. In addition, it presented Leibovitz, depicted in the press release as a quasi-pornographer, as pushy and lacking the proper deference toward the Queen. One might also have wondered: did the royals have a problem with Jews—especially the subset of Jewish photographers? After all, Leibovitz was an American, a Jew, a lesbian, and known as a somewhat difficult personality. Aha! Of course she would provoke an ugly scene with the Queen!

But a closer look at the events, conducted by "Voice of the Listener and Viewer, a broadcasting watchdog group," revealed that the supposed tiff between Leibovitz and the Queen was completely fabricated.[11] No friction or ill feelings had arisen between them. The appearance of a row was achieved through intentionally duplicitous editing. But it seemed to the creators of the television show, RDF, and the BBC, that the Queen and Leibovitz *should* have clashed. The two got along, in fact, very well. This, however, would not have made for a very spicy story. Or at least that is what the myopic TV executives thought.

The BBC was forced to admit "the actual sequence of events was misrepresented." The network officially apologized to Queen Elizabeth II and Leibovitz. As it turned out Peter Fincham, the head of the BBC, and the creative director of RDF Media, Stephen Lambert, were the ones who lost their heads. In the wake of an official enquiry that found "misjudgments, poor practice, and ineffective systems" at the BBC, both Fincham and Lambert resigned. "Mr. Fincham had told journalists in July that the documentary would show the queen storming out of the photo shoot. He learned within hours that this was untrue, but did not offer a correction until the following day."[12]

There is a story—or more precisely, there are several interrelated stories—to be told about the Queen and her intimates with regard to Jews and photography. With the exception of Cecil Beaton, most of the photographers who were invited to officially photograph the Queen and other members of the royal family either were of Jewish origin, or else had a clear-cut connection to Jews in photography. One of the photographers responsible for a huge share of the Queen's portraits, before and after her ascension, was Dorothy Wilding. Wilding was not born Jewish, but she had an unconventional background that made her sensitive to having to struggle for respectability. After deciding on a career in photography, she wisely surmised that mastery of retouching was a critical part of a photographer's repertoire. She attempted to find "the best possible person" with whom to train, "and in the end I did. He was a craftsman named Chandler. He worked for

a well-known and excellent photographer named [H.] Walter Barnett in Knights-bridge." Although working as a "pupil retoucher to Ernest Chandler" she was more generally under the tutelage of Barnett.[13]

But as we have seen, the connection of the royal family to Jews and photography was even more remarkable and intimate than indicated by the link between Wilding and Barnett. The Queen and the Duke of Edinburgh often availed themselves of the services of Baron Nahum, with whom they were on extremely friendly terms. Baron Nahum, compared to Barnett and most of his predecessors, was much more forthright about his Jewishness. In his autobiography, Baron asserts: "No one born with the name Baron Nahum, the son of an Italian Jew from Tripoli, has the right to assume that he would be accepted without question into the closely integrated society of Great Britain. Yet born in England, I grew up an English boy, became an Englishman, and never for one moment doubted my English heritage, or heard anyone doubt it for me."[14]

Baron was emphatic that his Jewishness was not simply a matter of distant relations. "I am Jewish and proud of it," he affirmed.[15] Like Gernsheim, he basked in the knowledge that his relatives had been leaders of their Jewish communities and distinguished themselves in various ways. The Nahums' tale, too, was marked by exile. "My father," Baron related, "was a shipper of Spanish-Jewish origin whose family fled from Spain to Tripoli during the Inquisition. There they prospered and became the heads of the Jewish community. My father and his eldest brother came over to Manchester about 1860 to open a British branch, importing Esparto grass (from which high-grade paper is made), barley, maize, and other cereals from Africa, while exporting to Tripoli cotton and manufactured goods." As of 1956, "[t]he main branch of my family is still in Tripoli, and my twin brother Jack and I remain on close terms with our first cousins, Halfalla, Clementi, and Shalom Nahum."[16] Baron's father, though, lost his fortune in 1931, in the wake of the Depression.[17] Although not religiously observant, his mother was active in a number of Jewish charities and social causes.[18] For the most part Baron was self-taught as a photographer. He noted, however, that one book was especially helpful in his training: Marcel Natkin's treatise on the Leica.[19]

Baron's references to Jewishness form no small part of his account. He retells with particular relish a story of Edith Sitwell about Hemingway, the archetypal tough-guy, being put in his place:

It was in his Paris period, and he was sitting in the Dôme Café in Montparnasse revelling in the success of his book *Fiesta*, which features a rather distasteful figure of a Jew. A man came up to Hemingway and said: "My name is Loeb. I believe you

have written the character of a Jew in *Fiesta* around me." Hemingway decided the fellow was a crank and ignored him, reaching for the bottle. Whereupon Mr. Loeb picked Hemingway up with one arm and threw him over his shoulder, then walked off without looking back. I forgot which of Hemingway's limbs was broken.[20]

In the brilliant expression of Leo Marks, the "Esparanto of being Jewish," as understood by Baron, Capa, and Lorant, included the sentiment that Ernest Hemingway wasn't really such a tough guy after all. Capa's photograph of Hemingway, published by Lorant in *Lilliput*, is perhaps the most disparaging and unmanly depiction of Hemingway ever to appear.

In contrast, for Barnett and Lew Feldman, Mark Twain was always appropriated with pride, as among his other qualities he was famous for defending Jews and having no patience for antisemites.

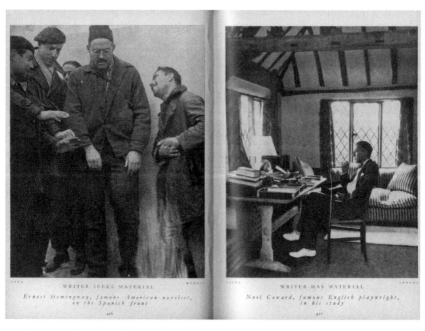

Robert Capa, "Writer Seeks Material: Ernest Hemingway, famous American novelist, on the Spanish Front, Madrid," juxtaposed to Sasha, "Writer Has Material: Noel Coward, famous English playwright, in his study," in *Lilliput* (Jan.–June 1938), pp. 416–417. It is now labeled "Ernest Hemingway, visiting the Front Lives, Valencia, December 1937," entirely divested of its humorous edge. *Lilliput* accentuates Hemingway looking a bit out of sorts, compared to the cool and composed Noel Coward. Robert Capa © International Center of Photography.

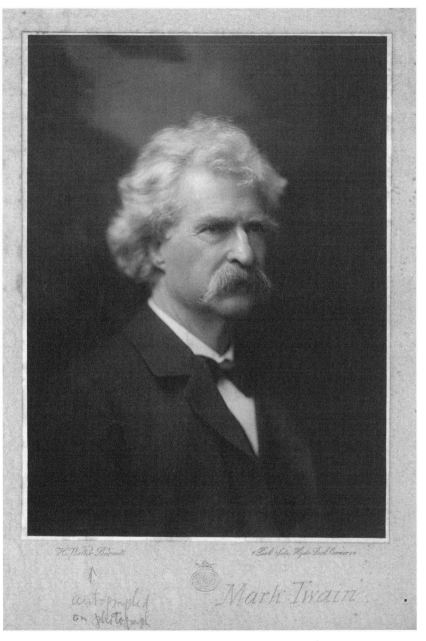

H. W. Barnett, *Mark Twain*. In terms of favored photographic icons, Jews
especially had a soft spot for illustrious non-Jews who were known for
supporting Jewish rights. Harry Ransom Center, University of Texas.

The most famous photographer with Jewish origins related to the royal family is no doubt Anthony Armstrong-Jones, later Lord Snowdon, who was married to Princess Margaret from 1960 to 1978, and therefore brother-in-law to the Queen. An official biography of Snowdon by Helen Cathcart asserts that "[p]robably he and Baron never realized that they shared some coincidences of background. The Nahums emigrated to England and set up as cotton merchants in Manchester in the very year the Messels first established themselves as bankers in London, and besides, like Ronnie Armstrong-Jones, Baron's own brother was a barrister."[21] Cathcart's treatment of Snowdon is generally solid, but she is probably wrong to assume that they were oblivious to their similarities.

In his personal stock-taking in 1980, Snowdon situates the Jewish strain of his background at the forefront. He dedicates his autobiography "To the memory of my uncle Oliver Messel," who made possible his photographic training with Baron. A brief statement about his origins concludes with a discussion of the Jewish branch of the family. Similar to Gernsheim and Baron, Snowdon's pride in his Jewish ancestry is unabashed. "Another ancestor was Alfred Messel, the architect of the Wertheim Department Store in Berlin and a pioneer in the use of metal and glass." A photograph of the building accompanies his biography. "The Messel side of the family included the founder of the Messels, the City bankers, and Oliver Messel," to whom the book was dedicated, "who dominated English theatre and opera design for thirty years."[22] Snowdon elaborated on this relationship:

My uncle, Oliver Messel, was a very strong influence on my life and work. When I was six, he let me help him make some masks in his studio . . . Later I went with him on my first visit to Venice, where he taught me to use my eyes. He was unquestionably the outstanding theatre director of his day. In 1932 his white on white set for Cochran's *La Belle Helene* got a standing ovation every night: it had an enormous influence on interior decorators of the Thirties. He developed his own kind of romantic baroque with productions at Covent Garden and his costumes and sets for Glyndebourne, which were what everybody longed for after the austerity of the war. He had a flawless sense of colour; but he will perhaps be best remembered for his own original form of romanticism in *Ring Round the Moon* and *House of Flowers*.

He was a master of illusion and make believe; often you'd find that he'd personally made a chandelier with sticky paper and fuse-wire, or constructed the dancers' head-dresses out of pipe cleaners. When I was a child I found a bird's nest in his London garden; on inspection I discovered it was made by him and the eggs were china and hand painted.

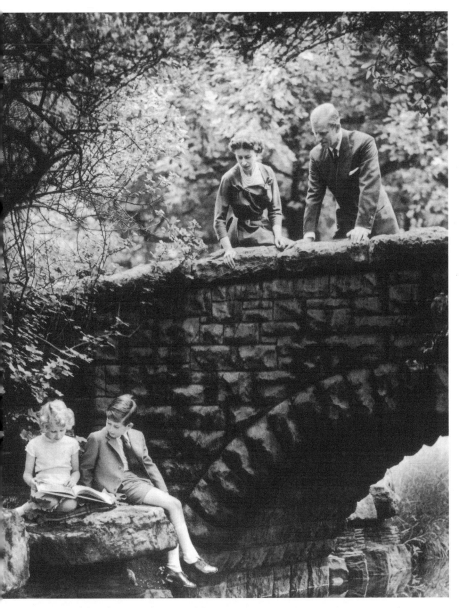

Royal family by Snowdon. On the grounds of Buckingham Palace, 1957.
Photograph by Snowdon.

He was extremely practical, making all his own models, down to the last detail. He had the respect of everyone in the theatre because he knew which way the fabric was cut and how every prop could be made. He would work all night. He had endless energy, was very strong willed, in fact a perfectionist.[23]

A photograph accompanying this reminiscence showed "Oliver Messel in his garden in Pelham Palace with Cecil Beaton."[24] Just like Kenneth Clark, when it came to Jews Beaton ran hot and cold.

Although Snowdon obviously hailed from wealthy and distinguished lines and became the ultimate insider, his autobiography reveals a number of characteristics that are now familiar. He portrays himself, like Jarché, as a bad boy. His blurb for the year 1943 states: "Left prep school. Headmaster's report read 'Armstong-Jones may be good at something, but it's nothing we teach here.'" His summary for 1950 says: "Coxed Cambridge in the Boat Race. Won by 3 lengths. The only time in the history of the Boat Race that the oars touched. Failed exams. Left Cambridge." Like Gernsheim, his photography was invigorated by a passion for art and architecture, and he resisted photographing buildings without acknowledging wear-and-tear and the ravages of the war.[25] "1945[:] Revived Eton Photographic Society. [Snowdon's] picture of Upper School after bombing

Snowdon, "Sunday Lunchtime, Bridge House Hotel, Canning Town," 1950. This "society" photographer could make himself at home in London's earthiest East End haunts. Photograph by Snowdon.

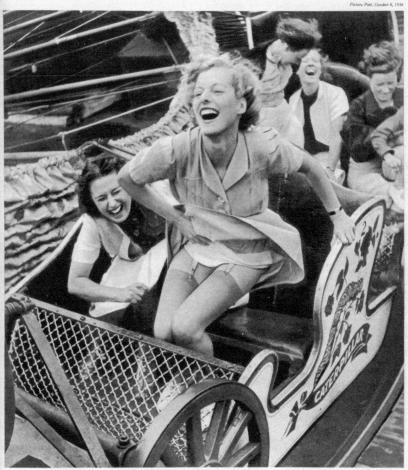

Picture Post, October 8, 1938

A Picture of Happiness—The Girl on The Merry-go-Round

Crises forgotten. War scares blown away. Private worries left at the top of the last incline. Only the rush of air. Only the shouts of friends. Only the sudden swooping movement of the caterpillar. Only the fun of the fair . . .

OCTOBER: MONTH OF FAIRS

LESS than a century ago the list of English Fairs covered 62 pages of small print in Owen's "Book of Fairs." Now there are probably not more than twenty fairs of first importance in the country—each of them a shadow of what it used to be. A fair to-day is not much more than a fun-fair. In olden days it was a great annual market and a meeting—where beasts were sold, wages spent, new labour hired at the earliest of all Labour Exchanges. Fairs that still flourish are at Widecombe, Mitcham, Barnet, Sherborne, Stratford, Nottingham, Oxford. The change from agriculture to industry, and the sensitive ears of genteel residents are the enemies of fairs. Only three years ago Cambridge suppressed the famous Stourbridge Fair—founded by King John in 1211, mentioned by Milton in "Paradise Lost." . . . Whose turn will it be next?

Unattributed [Kurt Hutton], "A Picture of Happiness—The Girl on the Merry-go-Round," in *Picture Post*, vol. 1, no. 2, Oct. 8, 1938, p. 77. The caption reads: "Crises forgotten. War scares blown away. Private worries left at the top of the last incline. Only the rush of air. Only the shouts of friends. Only the sudden swooping movement of the caterpillar. Only the fun of the fair . . ." Hutton was born Hübschmann (1893–1960), fleeing Germany in 1934. Although most of his photos in *Picture Post*, like this iconic image, were unattributed, he was well known as one of Stefan Lorant's most important photographers. Kurt Hutton/Getty Images.

criticized by the Eton *Chronicle*: 'This photograph would have been more lively if there had been people in it.'" [26] Also similar to Gernsheim, Snowdon took an interest in Israel, and the picture book from his first visit, including both color and black-and-white photos, is one of the most outstanding (although little noticed) of the hundreds in this genre.[27] He also seems to follow the tradition of Jewish photographers by being artsy, self-deprecating, and debonair.

Yet even while ensconced in the elite, Snowdon was not squeamish about conventional respectability, as indicated by his fabulous panorama: "Sunday lunchtime at the Bridge House Hotel, Canning Town, 1958. Girls from the Windmill Theatre would work there on their day off, and men would watch while their wives cooked lunch."[28] Only twenty years earlier, Kurt Hutton's mildly risqué portrait of exuberance in *Picture Post*, "A Picture of Happiness—The Girl on the Merry-go-Round,"—now deemed a classic, did not even identify the photographer.[29] Snowdon is not (yet) taken as seriously as a photographer as he perhaps deserves. This too is a legacy he has inherited—to be both obsequious and irreverent. Snowdon is part of a rich tapestry, replete with colorful, exceptionally creative characters and stunning images, that thus far has barely merited a footnote: the story of Jews and photography in Britain.

NOTES

INTRODUCTION

1. David Conway, *Jewry in Music: Entry to the Profession from the Enlightenment to Richard Wagner* (Cambridge: Cambridge University Press, 2012); Philip Bohlman, ed., *Jewish Musical Modernism, Old and New* (Chicago: University of Chicago Press, 2008).

2. Adapted from Lisa Silverman, *Becoming Austrians: Jews and Culture between the World Wars* (Oxford: Oxford University Press, 2012), 4. Although Silverman deals with Austria, I found several of her formulations applicable to the study of secular Jews in Britain; see also Silverman, "Reconsidering the Margins: Jewishness as an Analytic Framework," *Journal of Modern Jewish Studies* 8.1 (2009): 103–120.

3. Silverman, *Becoming Austrians*, 5.

4. Silverman, *Becoming Austrians*, 6.

5. Silverman, *Becoming Austrians*, 68. While this book was being prepared for publication an article came to my attention: Annette Vowinckel, "German (Jewish) Photojournalists in Exile: A Story of Networks and Success," *German History* 31.4 (2013): 473–496. The author was unaware of my formulation, in nearly the same words, in two publications: "Jews and Photojournalism: Between Contempt, Intimacy, and Celebrity," in *Die PRESSA/The PRESSA: Internationale Pressausstellung Köln 1928 und der jüdische Beitrag zum modernen Journalismus/International Press Exhibition Cologne 1928 and the Jewish Contributions to Modern Journalism*, ed. Suzanne Marten-Finnis and Michael Nagel (Bremen: Lumière, 2012), 2:627–639, and "'Jews in Photography': Conceiving a Field in the Papers of Peter Pollack," *Photography & Culture* 4.1 (March 2011): 7–28.

6. In a personal communication, William Meyers writes: "Lucjan Dobroszycki," a leading scholar of Polish Jewry, "once told me that if you had your portrait taken in Central or Eastern Europe any time before WW II it would probably have been taken by a Jew—even if you were the Czar" (sent to the author, Sept. 27, 2009). Chapter 1 extends this observation to Britain.

7. See Elizabeth Anne McCauley, *A. A. E. Disdéri and the Carte de Visite Portrait Photograph* (New Haven: Yale University Press, 1985); *Industrial Madness: Commercial Photography in Paris, 1848–1871* (New Haven: Yale University Press, 1994).

8. For an exception to rule—an Italian who actually was an Italian, see *Oscar Marzaroli: Photography, 1959–1968* (Edinburgh: Bourne, 2010).

9. See, for example, www.bbc.co.uk/whodoyouthinkyouare/past-stories/david-how-we-did -it_2.shtml (accessed Dec. 2013), concerning the great-grandfather of actor David Suchet.

10. Matthew S. Witkovsky, *foto: Modernity in Central Europe, 1918–1945* (Washington, DC: National Gallery of Art; London: Thames and Hudson, 2007); Ute Eskildsen, ed., *Street and Studio: An Urban History of Photography* (London: Tate, 2008); Roy Flukinger, *The Formative Decades: Photography in Great Britain, 1839–1920* (Austin: University of Texas Press, 1985). One of the great exceptions is Max Kosloff, ed., *New York: Capital of Photography* (New York: Jewish Museum; New Haven: Yale University Press, 2002); I greatly take issue with the notion of a "Jewish eye" in seeing and presenting New York City.

11. Mario Bucovich, *Photographs: 100 Selected Prints by Mario Bucovich with a Brief Treatise for Practical Work* (Hamilton Studios, 74a Regent Street, London W1, 1935), (section) 7. "Retouching and Material," unpaginated, BL.

12. See, for example, transcript of interview with Inge Ader, no. 18, RfV; transcript of interview with Ernst Flesch, no. 137, p. 17, RfV.

13. Alan Swarc, personal communication with the author, Oct. 30, 2012, concerning his mother, who worked as a retoucher for the famed London photographer "Boris."

14. Transcript of interview with Salman Stemmer, no. 116, pp. 24, 29–31, 43, RfV.

15. Nahum (Tim) Gidal, "Jews in Photography," *LBI Year Book* 32 (1987): 437–453.

16. Robert J. Hercock and George A. Jones, *Silver by the Ton: The History of Ilford Limited, 1879–1979* (London: McGraw Hill, 1979). There is no comprehensive history of Kodak's operations in the UK.

17. Helmut Gernsheim, *Creative Photography: Aesthetic Trends, 1839–1960* (New York: Bonanza Books, 1962), 241, 113; *FHG*, 226–227.

18. Photographs of Nahum Luboshez [Luboschez], 964:0598:0002, 964:0598:007, HGC.

19. Linda Gordon, *Dorothea Lange: A Life beyond Limits* (New York: Norton, 2009).

20. *FHG*, 226–227.

21. John Efron encouraged this line of argument as a means to differentiate my perspective from the argument for a "Jewish eye."

22. Bert Garai, *The Man from Keystone: Behind the Scenes of a Great Picture Agency, by the Man Who Scooped the World* (London: Frederick Muller, 1965); Stefan Lorant, *I Was Hitler's Prisoner: Leaves from a Prison Diary*, trans. James Cleugh (London: Victor Gollancz, 1935).

23. Entry for "Lorant, Stefan," in *Encyclopedia of American Photography* (Chicago: Crown, 1984).

24. I am grateful to Francis Hodgson for informing me of the significance of Hans Juda and Elsbeth Juda.

25. Todd Endelman, *The Jews of Britain, 1656–2000* (Berkeley: University of California Press, 2002); David Feldman, *Englishmen and Jews: Social Relations and Political Culture, 1840–1914* (New Haven: Yale University Press, 1994); Eugene Black, *The Social Politics of Anglo-Jewry, 1880–1920* (Oxford: Blackwell, 1988); Geoffrey Alderman, *Modern British Jewry* (Oxford: Clarendon Press, 1998).

26. *FHG*, 15, 17.

27. Martin Roman Deppner, ed., *Die verborgene Spur: Jüdische Wege durch die Moderne/The Hidden Trace: Jewish Paths through Modernity*, on behalf of the Felix-Nussbaum-Haus Osnabrück (Bramsche: Rasch, 2009); Roman Bezjak and Martin R. Deppner, eds., *Jüdisches: Fotografische Betrachtungen der Gegenwart in Deutschland* (Bielefeld: Nicolai, 2006).

28. Claude Sui, "Helmut Gernsheim: Pionier der Fotogeschichte und seine Sammlung," paper

presented at 32. Bielefelder Fotosymposium: "The Jewish Engagement with Photography," Nov. 29–30, 2012.

29. Helmut Gernsheim to Yehoshua Nir, July 1, 1986, RE.

30. This insight was inspired by the work of Julie Mell on locating older scholarship that reflected her concerns; see *The Myth of the Medieval Jewish Moneylender* (London: Palgrave-Macmillan, forthcoming), 27.

31. Helmut Gernsheim to Tim Gidal, Feb. 25, 1976, RE.

32. David Shneer, *Through Soviet Jewish Eyes: Photography, War, and the Holocaust* (New Brunswick, NJ: Rutgers University Press, 2012).

33. There are many versions of both essays. "The Work of Art in the Age of Mechanical Reproduction" was first published in German, in the *Zeitschrift für Sozialforschung* in 1936; "Little History of Photography" appeared in German originally in *Die Literarische Welt* in 1931.

34. Helmut Gernsheim to Tim Gidal, Jan. 2, 1976, RE.

35. Helmut Gernsheim to Tim Gidal, Feb. 25, 1976, RE.

36. Gisèle Freund, *Photography and Society* (London: Gordon Fraser, 1980), 95–100.

37. "*JEWS PROMINENT IN PHOTOGRAPHY*. Including people of Jewish extraction"; compiled by H. G. (1981), in RE. In the first version of the list Gernsheim mentions "Benjamin, Walter (Born Detlev Holz)." "Detlev Holz" was a pseudonym of Benjamin, but not his actual name.

38. Gisèle Freund, *Gisèle Freund, Photographer*, trans. John Shepley (New York: Abrams, 1985), 61–65.

39. Eric Jacobson, "Sparks in the Lens," paper presented at 32. Bielefelder Fotosymposium: "The Jewish Engagement with Photography," Nov. 29–30, 2012; forthcoming, Carl Von Ossietzky University Press (Oldenburg).

40. Maya Benton is curator of the Vishniac archive at New York's International Center for Photography, which held the exhibition "Roman Vishniac Rediscovered," Jan. 18–May 5, 2013; see Alana Newhouse, "A Closer Reading of Roman Vishniac," *New York Times*, April 1, 2010: www.nytimes.com/2010/04/04/magazine/04shtetl-t.html?pagewanted=all&_r=0 (accessed Aug. 2013).

41. See Berkowitz, "'Jews in Photography.'"

42. For a comparison with Jews in cinema, see Edward Marshall, "Ambivalent Images: Jewish Involvement and Representation in the British Entertainment Industry, 1880–1980" (PhD diss., University of Southampton, 2010), 120.

43. Shulamith Behr and Marian Malet, eds., *Arts in Exile in Britain, 1933–1945* (The Yearbook of the Research Centre for German and Austrian Exile Studies 6) (Amsterdam: Rodopi, 2005); Werner E. Mosse, ed., *Second Chance: Two Centuries of German-Speaking Jews in the United Kingdom* (Tübingen: J. C. B. Mohr, 1991).

44. Colin Ford, "Photography: Hungary's Greatest Export?," in *Eyewitness: Hungarian Photography in the Twentieth Century. Brassaï, Capa, Kertész, Moholy-Nagy, Munkácsi*, ed. Peter Baki, Colin Ford, and George Szirtes (London: Royal Academy of the Arts, 2011).

45. Personal communication with the author, June 14, 2013.

46. Among the most recent important studies is Elizabeth Anne McCauley and Jason Francisco, *The Steerage and Alfred Stieglitz* (Berkeley: University of California Press, 2012).

47. Waldo Frank, *Our America* (New York: Boni and Liveright, 1919), 186.

48. Thomas Craven, *Modern Art: The Men, the Movements, the Meaning* (New York: Simon and Schuster, 1934), 193. Despite Craven's obvious prejudice there are some interesting points in his assessment of Stieglitz.

49. Exceptions include Gail Levin, "Photography's 'Appeal' to Marsden Hartley," *Yale University Library Gazette* 68.1–2 (Oct. 1993): 12–42; Matthew Baigell, *Jewish Art in America: An Introduction* (Lanham, MD: Rowman and Littlefield, 2006), xxii.

50. Amy Levy, *The Romance of a Shop* (London: T. Fisher Unwin, 1888).

51. Amy Levy, *Reuben Sachs: A Sketch* (1888; New York: AMS Press, 1973).

52. Linda Hunt Beckman, *Amy Levy: Her Life and Letters* (Athens: Ohio University Press, 2000); Sharona Anne Levy, "Amy Levy: The Woman and Her Writings" (PhD diss., University of Oxford, 1989); Melvyn New, ed., *The Complete Novels and Selected Writings of Amy Levy* (Gainesville: University of Florida Press, 1993); Emma Jane Francis, "Poetic Licence: British Women's Poetry and the Sexual Division of Poetics and Culture, 1824–1889. Letitia Landon, Amy Levy, Emily Brontë" (PhD diss., Liverpool University, 1995); Nadia Valman, "Women and Jews in an Age of Emancipation (1845–1900): With Particular Reference to the Work of Grace Aguilar, Emily Marion Harris, Amy Levy, and Julia Frankau" (MA thesis, University of Leeds, 1992). See also Amy Levy, *The Romance of a Shop*, ed. Susan David Bernstein (Peterborough, ONT: Broadview Press, 2006).

53. Iris Meder and Andrea Winklbauer, *Vienna's Shooting Girls/ Jüdische Fotografinnen aus Wien* (Vienna: Jüdischen Museums der Stadt Wien and IPTS—Institut für Posttayloristische Studien, 2012).

54. Louis Golding, *Magnolia Street* (1932; Nottingham: Five Leaves, 2006), 39.

55. *Magnolia Street*, 99.

56. Hugh Cecil, introduction to Five Leaves edition (2006) of *Magnolia Street*, 7.

57. *Magnolia Street*, 99.

58. *Magnolia Street*, 99.

59. *Magnolia Street*, 99.

60. Edward Dimendberg, *Film Noir and the Spaces of Modernity* (Cambridge, MA: Harvard University Press, 2004), 48–68.

61. *Magnolia Street*, 99–100.

62. *Magnolia Street*, 99–100.

63. *Magnolia Street*, 100.

64. *Magnolia Street*, 301.

65. *Magnolia Street*, 301.

66. *Magnolia Street*, 302.

67. *Magnolia Street*, 311.

68. *Magnolia Street*, 312.

69. Paul Lerner, quote in Silverman, *Becoming Austrians*, 82.

70. Framed print, display in reconstructed photo studio, National Media Museum, Bradford, UK.

71. (Different) framed print, display in reconstructed photo studio, National Media Museum, Bradford, UK.

72. Conversation with Francis Hodgson, photography critic for the *Financial Times*.

73. Comments by Hal Erickson and Mark Deming from *Movie Guide* (undated): www.powell-pressburger.org/Reviews/60_PT/PT07.html (accessed May 2013).

74. Largely due to the efforts of film scholars Ian Christie and Laura Mulvey, and website host Steve Crook, there is an abundance of material on *Peeping Tom*. Most of this, unsurprisingly, centers around Michael Powell (1905–1990); see "The Powell & Pressburger Pages," at www.powell-pressburger.org/Members/Steve.html (accessed May 2013), and the gate to the website:

www.powell-pressburger.org/ (accessed May 2013). See Ian Christie, *Arrows of Desire: The Films of Michael Powell and Emeric Pressburger* (London: Faber and Faber, 1994), and Christie, ed., *Powell, Pressburger, and Others* (London: British Film Institute, 1978), esp. 53–62; "Pressbook" for "Martin Scorsese Presents Michael Powell's *Peeping Tom*" (undated, most likely 1995), www .rialtopictures.com/FTP/ZIP_britnoir/PeepingTomPressbook.pdf (accessed May 2013); David Ehrenstein, "Is the Filmgoer the Murderer? Michael Powell's Notorious Film Is More Gruesome Than Its Reputation, but More Ingratiating as Well," *New Times LA* (1999): www.powell-press burger.org/Reviews/60_PT/PT14.html (accessed May 2013). See also Laura Mulvey, "*Peeping Tom*," the Criterion Collection: www.criterion.com/current/posts/65-peeping-tom (accessed May 2013); Jeffrey M. Andreson, "*Peeping Tom*," www.combustiblecelluloid.com/peeping.shtml (accessed May 2013).

75. "*Peeping Tom* (1960)," *Monthly Film Bulletin* 27, no. 316 (May 1960): 65.

76. For the reception of *Peeping Tom* in the United States see Kevin Heffernan, *Ghouls, Gimmicks, and Gold: Horror Films and the American Movie Business, 1953–1968* (Durham: Duke University Press, 2004), 115, 126–132.

77. "Dilys Powell's Film of the Week," *Sunday Times*, June 1994: www.powell-pressburger .org/Reviews/60_PT/PT03.html (accessed May 2013).

78. See, for example, Ehrenstein, "Is the Filmgoer the Murderer?."

79. See the recent *Sight and Sound* and *Village Voice* polls; it has risen to as high as second or third on the list in some recent polls on the "Greatest British Film," behind *The Third Man.*

80. The best volume engaging *Peeping Tom* is *Michael Powell: Interviews*, ed. David Lazar (Jackson: University Press of Mississippi, 2003).

81. Some of the leading interpretations may be seen as complementary to this perspective; see Linda Williams, "When the Woman Looks," in *Essays in Feminist Film*, ed. Mary Ann Doane, Patricia Mellencamp, and Linda Williams (Frederick, MD: American Film Institute Monograph Series, 1983), 83–99; Elena del Rio, "The Body of Voyeurism: Mapping a Discourse of the Senses in Michael Powell's *Peeping Tom*," *Camera Obscura* 45 (15.3) (2000): 115–149; interviews in *Eye of the Beholder* (director Julie Cohen, 2005), a documentary featuring Ian Christie, Laura Mulvey, Martin Scorsese, and Thelma Schoonmaker, included in the DVD special edition reissue of *Peeping Tom* (Studio Canal, 2007).

82. Luke Jennings, "The Masterspy of Acton Town," Jan. 8, 1999, *This Is London*: www.powell -pressburger.org/Reviews/Leo/Leo.html (accessed May 2013).

83. French literary scholar Jann Matlock suggests that "the biggest story is in terms of anxieties about replicating the dark sides of Nazi research through any kind of recording— film, tapes, or photos. What do we think Marks knew about Nazi scientists given safe status in Britain or the US after the war? It's the father's place in that huge old house that gives me the creeps—more so than the son's photos (the murdering is the father's curse and legacy)," email to the author, March 29, 2013. See also Laurence A. Rickels, *Nazi Psychoanalysis, II: Crypto-Fetishism* (Minneapolis: University of Minnesota Press, 2002), 112–116. The most explicit articulation of a Jewish and Holocaust connection is in Mark Lazar's "Introduction," in *Michael Powell: Interviews*, x.

84. Paul Vitello, "Karlheniz Böhm, Actor-Turned-Humanitarian, Dies at 86," *New York Times*, June 4, 2014: www.nytimes.com/2014/06/05/arts/karlheinz-bohm-actor-who-led-ethiopian -charity-dies-at-86.html?_r=0 (accessed June 2014).

85. "An Interview with Michael Powell" (1968), Bertrand Tavernier, in *Michael Powell: Interviews*, 37, 63.

86. Entry for "Harvey, Laurence, 1928–1973," in David Thompson, *A Biographical Dictionary of Film* (London: Andre Deutsch, 1994), 319.

87. Paul Gardner, "The Screen's Perfect Cad," under the headline "Laurence Harvey, Screen Actor, Is Dead at 45," *New York Times*, Nov. 27, 1973: query.nytimes.com/mem/archive/pdf?res =F20C12FB3E5D127A93C5AB178AD95F478785F9 (accessed May 2013).

88. "An Interview with Michael Powell," 63.

89. Tony Sloman, "Obituary: Harrison Marks," Thursday, July 10, 1997, *The Independent*: www.independent.co.uk/news/people/obituary-harrison-marks-1249894.html (accessed Aug. 2013).

90. Helene Hanff, *84, Charing Cross Road* (New York: Grossman, 1970).

91. *84 Charing Cross Road*, directed by David Jones, 1987.

92. "Ninety per cent of the WT [Wireless Telegraphy] records handed over to C [Secret Intelligence Service] have been destroyed, and the code department's records scarcely exist" (*Between Silk and Cyanide*, 599).

93. *Between Silk and Cyanide*, 1.

94. Robert Capa, *Slightly Out of Focus* (New York: Henry Holt, 1947), 6.

95. *Between Silk and Cyanide*, 2.

96. *Between Silk and Cyanide*, 261–262.

97. "Introduction. Leo Marks Interviewed by Chris Rodley, 1998," in Leo Marks, *Peeping Tom* (London: Faber and Faber, 1998), xiv.

98. Simon Blumenfeld, *Phineas Kahn: Portrait of an Immigrant* (1937; London: Lawrence and Wishart, 1989), 204–205.

99. *Phineas Kahn*, 206–207.

100. Randy Kennedy, "Arsenic and Old Photos," *New York Times*, April 1, 2007: www.ny times.com/2007/04/01/arts/design/01kenn.html?pagewanted=all&_r=0 (accessed Dec. 2013).

101. Ad in *Popular Mechanics*, April 1911, advertising section, p. 144.

102. Ad in *Popular Mechanics*, Aug. 1912, p. 128.

103. Ad in *Popular Mechanics*, July 1911, advertising section, p. 144.

104. Salman Stemmer, transcript of interview, pp. 29–31, RfV.

105. John Strausbaugh, "Coin. Smile. Click!," *New York Times*, March 14, 2008: www.ny times.com/2008/03/14/arts/14expl.html?ref=arts (accessed Dec. 2013).

106. David Lodge, *Author, Author* (London: Secker and Warburg, 2004), 48.

107. Leonée Ormond, *George Du Maurier* (London: Routledge and Kegan Paul, 1969), 110; illustration, p. 111.

108. Roger Neill, "Barnett, Henry Walter (1862–1934)," *DNB*, Oct. 2006: www.oxforddnb .com/view/article/66742 (accessed Sept. 2009).

109. "Boris Bennett's Camera," Jewish Museum, London website: www.jewishmuseum.org .uk/jb-Boris-Bennett's-camera (accessed Aug. 2013).

110. Mell, *Myth of the Medieval Jewish Moneylender*, 49—quoting Wilhelm Roscher, as translated by Grayzel, "The Status of the Jews in the Middle Ages Considered from the Standpoint of Commercial Policy," *Historia Judaica* 6.1 (1944): 20.

111. For an excellent, fundamental account see *FHG*, 20–21.

112. Adi Gordon, "The Need for the 'West': Hans Kohn and the North Atlantic Community," *Journal of Contemporary History* 46 (2011): 33–57, see also Mell, *Myth of the Medieval Jewish Moneylender*, 94.

113. Silverman, *Becoming Austrians*, 175.

CHAPTER ONE

1. Peter Pollack, undated draft of "roof" article on Jews and photography for *Encyclopaedia Judaica*, located before letter of Lachman to Pollack, Oct. 29, 1968, file 1, box 6, Peter Pollack collection, GRI.

2. Uwe Westphal, *Berliner Konfektion und Mode: Die Zerstörung einer Tradition, 1836–1939* (Berlin: Hentrich, 1992); Irene Guenther, *Nazi Chic? Fashioning Women in the Third Reich* (Oxford: Berg, 2004).

3. See Neal Gabler, *An Empire of Their Own: How the Jews Invented Hollywood* (New York: Doubleday, 1988); Steven Carr, *Hollywood and Anti-Semitism: A Cultural History up to World War II* (Cambridge: Cambridge University Press, 2001).

4. Nigel Ostrer, *The Ostrers and Gaumont British* (published privately, 2010), 11–12.

5. See entry for "Mendelssohn, Albert," photoLondon website: www.photolondon.org.uk /pages/details.asp?pid=5272 (accessed Feb. 2011).

6. See entry for "Albert Mendelssohn," NPG London website: www.npg.org.uk/collections /search/portrait/mw114798/Helmuth-Karl-Bernhard-von-Moltke-Count-von-Moltke?LinkID= mp83167&search=sas&sText=Albert+Mendelssohn&role=art&rNo=0 (accessed Dec. 2013).

7. Robin and Carol Wichard, *Victorian Cartes-de-visite* (Princes Risborough: Shire, 1999), 37.

8. Cambridge University Library, RCS Photographers Index, entry for "Mendelssohn, Hayman Selig": www.lib.cam.ac.uk/rcs_photographers/entry.php?id=333 (accessed Feb. 2011).

9. "Nationality and Naturalisation: Mendelssohn, Hayman Seleg, from Russia. Resident in London." Certificate A4236, issued Jan. 27, 1885, HO 144/145/A37888, NA.

10. Ibid.

11. RCS Photographers Index entry.

12. A number of H. S. Mendelssohn's photographs are included in the "Guy Little Theatrical Photographs," mainly taken at Downey's: Ellen Terry, S.133:185-2007; Emma Eames (American opera star), S.144:5-2007; Violet Vanburgh, S.149:369-2007; Sarah Bernhardt, S.137:86-2007, V&A.

13. See, for example, Edna May, S.2894-2009, V&A.

14. See information on "Mendelssohn, Hayman Seleg" on the internal information portal of the NPG, which provides more data than the publicly accessible website.

15. "Nationality and Naturalisation: Mendelssohn, Hayman Seleg, from Russia. Resident in London." Certificate A4236, issued Jan. 27, 1885, HO 144/145/A37888, NA.

16. "Nationality and Naturalisation: Mendelssohn, Herman Eliaschor, from Russia. Resident in Newcastle-upon-Tyne." Certificate A4764, issued Aug. 13, 1886, HO 144/177/A44254, NA.

17. See entry for "Mendelssohn, Herman Eliaschov," photoLondon website: www.photolon don.org.uk/pages/details.asp?pid=5275 (accessed Feb. 2011).

18. Ibid.

19. The son of photographer and former boxer David Sharkey (b. 1927), Philip, informed me of this practice, which was part of the reason for his father's entry into the trade. David Sharkey's studio on Oxford Street is still known as a place where celebrities have their passport photos taken. See Michael Berkowitz and Ruti Ungar, eds., *Fighting Back? Jewish and Black Boxers in Britain* (London: University College London and the Jewish Museum London, 2007), xv.

20. Letter of G. Leigh Browne, Mayor, Newcastle upon Tyne, Aug. 5, 1886, in "Nationality and Naturalisation: Mendelssohn, Herman Eliaschor, from Russia. Resident in Newcastle-upon-Tyne"; certificate A4764, issued Aug. 13, 1886, HO 144/177/A44254, NA.

21. Tim Gidal, "Jews in Photography," *LBI Year Book* 32 (1987): 437–453.

22. Walter Benjamin, "The Work of Art in the Age of Mechanical Reproduction."

23. Undated fragment of letter to Leonard Lyons from Eliot Elisofon, 60.12, series VII, correspondence, 1930s–40s, HRC.

24. See the excellent website of the Metropolitan Postcard Club of New York City: www .metropostcard.com/metropcpublishers.html (accessed Feb. 2011).

25. Adrian Room, "Tuck, Raphael (1821–1900)," *DNB*: www.oxforddnb.com/view/article /39039 (accessed July 2011).

26. An exception to this rule is the extensive discussion by Margaret Bourke-White of her father's role in the development of the color rotary press. She does not comment, though, on his Jewish background. See Margaret Bourke-White, *Portrait of Myself* (New York: Simon and Schuster, 1963), 15–21.

27. *FHG*, 216–217.

28. "Barnett," *DNB*.

29. Ibid.

30. See the entry for "Benjamin J. Falk," on the website "Broadway Photographs: Art Photography & the American Stage 1900–1930": broadway.cas.sc.edu/index.php?action=showPhotogra pher&id=68 (accessed Feb. 2011); Sadakichi Hartmann, "B. J. Falk: An Exquisite Temperament," in *Valiant Knights of Daguerre: Selected Critical Essays on Photography and Profiles of Photographic Pioneers*, ed. Harry W. Lawton and George Knox (Berkeley: University of California Press, 1978), 227–233.

31. "B. J. Falk," in *British Journal of Photography Almanac*, "Annual Summary of Photographic Inventions and Events in Photographic History" (1926): notesonphotographs.org/index .php?title=British_Journal_of_Photography_Almanac_Annual_Summary_of_Photographic _Inventions_and_Events_in_Photographic_History/1926 (accessed Feb. 2011).

32. "Barnett," *DNB*.

33. Promotional material from the Falk Studios, 496 George Street, Sydney (hereafter cited as "Falk Promotion, Sydney"), in "Barnett, H. Walter," in "Cuttings, Catalogues, and Autograph letter Concerning the work of H. Walter Barnett (1862–1934), Pioneer of cinematography in Australia (1896), Portrait Photographer in London, Dieppe and Monte Carlo, Friend of Painters and collector of their works, Compiled by Miss Margaret Bentley, for 22 years assistant to Mr. Barnett, and presented by her to The Gernsheim Collection on 15. Oct. 1954" (hereafter cited as "Barnett cuttings"), fTR 140 B28 B368 HRC-P (964-0638:0001–0010?), B2613, HGC.

34. Falk Promotion, Sydney, Barnett cuttings, HGC.

35. Ibid.

36. Entry for "Benjamin J. Falk": broadway.cas.sc.edu/index.php?action=showPhotographer &id=68 (accessed Feb. 2011).

37. Falk Promotion, Sydney, Barnett cuttings, HGC.

38. Ibid.

39. Ibid.

40. Flukinger, *The Formative Decades*, 154.

41. "Photographic Section, Annual Report, 1895–1896: Brighton and Sussex National Historical and Philosophical Society": www.archive.org/stream/abstractsofpaper94brig_djvu.txt (accessed Feb. 2011).

42. Article from *The Stage* (London), June 9, 1898, Barnett cuttings, HGC.

43. "Barnett," *DNB.*

44. Ibid.

45. Ibid.

46. Miriam Hansen, *Babel and Babylon: Spectatorship in American Silent Film* (Cambridge, MA: Harvard University Press, 1991), 1.

47. *Melbourne Cup 1896*, Australian Screen website: aso.gov.au/titles/historical/melbourne -cup-1896/clip3/ (accessed April 2014).

48. "Barnett," *DNB.*

49. Alfred Stieglitz, "Four Happenings," in *Twice A Year: A Book of Literature, the Arts, and Civil Liberties* 8–9 (Spring–Summer 1942, Fall–Winter 1942): 105.

50. Chris Long/Luke McKernan (revised June 2009 and Feb. 2010), entry for "Henry Walter Barnett," Who's Who of Victorian Cinema website: www.victorian-cinema.net/barnett.htm (accessed Feb. 2011).

51. Gabriel Lippman, "Directions for Taking Photographs in Natural Colours," in *Optical Magic Lantern Journal*, vol. 10, no. 120 (May 1899): 67.

52. "Notice," by J. F. Fuerst, Jules Fuerst, and Albert Fuerst, *London Gazette*, Feb. 15, 1895, p. 923: www.london-gazette.co.uk/issues/26598/pages/923/page.pdf (accessed Aug. 2013).

53. Article from *Cinema*, Feb. 15, 1923, Barnett clippings, HGC.

54. "Barnett," *DNB.*

55. H. Walter Barnett, "A Protest against the Maladministration of the Beneficent Public Trust Known as the Felton Bequest" (Paris, 1933) (pamphlet) (hereafter cited as Barnett, Protest), Barnett clippings, HGC.

56. There are several photographs of Barnett's studio in the HGC collection: 964:0391:0067, 964:0391:0066, 964:0391:0123; 964:0391:0122.

57. Article from *The Stage*, June 9, 1898, Barnett clippings, HGC.

58. Ibid.

59. "Mr. Walter Barnett in America," *British Journal of Photography*, Jan. 12, 1906; "'English Photos All Look Alike' So Says London Photographer Who Had Made Success by Departing from Conventional—Pictures Now on Exhibition," *St. Louis* (Missouri) *Daily Globe*, June 6, 1911, Barnett clippings, HGC.

60. "Barnett," *DNB.*

61. "Henry Walter Barnett": www.victorian-cinema.net/barnett.htm (accessed Aug. 2013).

62. "Barnett," *DNB.*

63. Clipping from *Sydney Morning Herald*, "Personal" column, Monday, March 23, 1903, Barnett clippings, HGC.

64. "Barnett," *DNB.*

65. Ibid.

66. Unidentified newspaper article, probably from an English paper, Barnett clippings, HGC.

67. Article in *The Sketch* (London), Jan. 1914, Barnett clippings, HGC.

68. The idea that this practice was mainly for Hollywood studio stills is ahistorical. See the exhibition and accompanying publication, "Glamour of the Gods: Hollywood Portraits. Photographs from the John Kobal Foundation," July 7–Oct. 23, 2011, NPG.

69. Article in *The Sketch* (London), Jan. 1914, Barnett clippings, HGC.

70. Phyllis E. Wachter, "Ethel M. Arnold (1865–1930): New Woman Journalist," *Victorian Periodicals Review* 20.3 (Fall 1987): 107–111.

71. Article in *The Sketch* (London), Jan. 1914, Barnett clippings, HGC.

72. Sadakichi Hartmann, "Meredith Janvier: With a Rush," in *Valiant Knights of Daguerre*, 283–287.

73. "London Photographer of Royalty Visiting St. Louis," *St. Louis Post Dispatch*, Dec. 15, 1905, Barnett clippings, HGC; Hartmann, "J. C. Strauss: The Man behind the Gun," *Valiant Knights of Daguerre*, 234–238.

74. *Milwaukee Sunday Sentinel*, March 5, 1922, p. 1.

75. "Julius Caesar Strauss: A Sun of St. Louis," by Thomas G. Yanul: www.thomasyanul.com /strauss1index.html (accessed Aug. 2013).

76. Barnett clippings, HGC.

77. "Mr. Walter Barnett in America," *British Journal of Photography*, Jan. 12, 1906, Barnett clippings, HGC.

78. Ibid.

79. Article from the *Illustrated London News*, March 9, 1912, Barnett clippings, HGC.

80. "Barnett," *DNB*.

81. *Illustrated London News*, March 9, 1912, Barnett clippings, HGC.

82. "Barnett," *DNB*.

83. Flukinger, *The Formative Decades*, 145.

84. "Photographer of Kings. Mr. H. W. Barnett Home After 30 Years," unidentified Australian newspaper article, Feb. 9, 1924, Barnett clippings, HGC.

85. "Barnett," *DNB*.

86. Ibid.

87. Ibid.

88. Barnett Protest, Barnett clippings, HGC.

89. Barnett Protest, p. 3, Barnett clippings, HGC.

90. Barnett Protest, p. 10, Barnett clippings, HGC.

91. Jaynie Anderson, *Tiepolo's Cleopatra* (Melbourne: Macmillan, 2003), 189–191.

92. National Gallery of Australia website: artsearch.nga.gov.au/Detail.cfm?IRN=156188 (accessed Aug. 2011).

93. I appreciate Nathan Abrams's insight about Kubrick as a photographer.

94. Bucovich, *Photographs*.

95. Bucovich, *Photographs*.

96. Mario Bucovich, *Paris* (New York: Random House, 1930); *Manhattan Magic: A Collection of Eighty-Five Photographs* (self-published, printed in Philadelphia by the Beck Engraving Company, 1937); *Washington, DC: City Beautiful* (self-published, printed in Philadelphia by the Beck Engraving Company, 1936); *Berlin, 1928: Das Gesicht der Stadt* (Berlin: Nicolaische, 1992). According to Sabine Hake, "The reprint contains only 107 of the original 254 photographs included in the 1928 edition published by Albertus-Verlag" ("Visualising the Urban Masses: Modern Architecture and Architectural Photography in Weimar Berlin," *Journal of Architecture* 11.5 [2008]: 523–530).

97. Portrait of George Eastman by Nahum Luboschez, 964:0600:0011, HGC.

98. See Richard Tedlow, "The Manichean World of George Eastman," Division of Research Working Paper, Harvard Business School, 1996, copy in Rare Books, Rush Rhees Library, University of Rochester; Elizabeth Brayer, *George Eastman: A Biography* (Baltimore: Johns Hopkins University Press, 1966); Robert Taft, *Photography and the American Scene: A Social History, 1839–1889* (1938; New York: Dover, 1964).

99. Leopold Godowsky Jr., interview for the American Jewish Committee (AJC), Oral History Library, 1971, P Box 27, no. 2, pp. 63, 66, 106–109, New York Public Library.

100. Godowsky, AJC interview, pp. 105–107.

101. N. E. Luboschez, "Dr. C. E. Kenneth Mees," from the Exhibition of the Royal Photographic Society, published in *The Amateur Photographer & Photography*, Nov. 13, 1918.

102. Death certificate for Elea Lubschez (or Luboschey), Missouri State Board of Health, Bureau of Vital Statistics: www.sos.mo.gov/images/deatcerts/1924_00008879.PDF (accessed Feb. 2011).

103. Jacob Speakes, personal communication with the author, June 24, 2012.

104. "America's First Movie Show," in "Correspondence," *British Journal of Photography*, Aug. 26, 1921, p. 455; "A Kansas City Architect: Benjamin Lubschez," in *Historic Kansas City Foundation Gazette* (Sept. 1985): 6; Ben J. (Jehudah) Lubschez, *Manhattan, the Magical Island. One Hundred and Eight Pictures of Manhattan* (New York: Press of the American Institute of Architects, 1927).

105. Ben J. Lubschez, *The Story of the Motion Picture: 65 B.C. to 1920 A.D.* (New York: Reeland, 1920).

106. Email communication from photographic historian Martin Scott to the author, Aug. 16, 2010.

107. "N. E. Luboshey," *British Journal of Photography Almanac, 1926*, 156.

108. "Federal Officers Busy. Several Persons Arrested in West Charged with Anti-Draft Agitation," in *Geneva* [New York?] *Daily Times*, Friday, June 1, 1917; "Hit Draft Plots in Many States; Arrest Three College Students Here; Police Display Quiets Antis' Meeting Federal Agents Active. Seize Youthful Anti-Conscription Agitators Here on Conspiracy Charge. Barnard Girl Arrested. Two Columbia Men Held—Acted for an Anti-Militarism League. Judge Upholds the Law. Dismisses Kansas City Injunction Proceedings and Litigants Are Locked Up Later," *New York Times*, June 1, 1917.

109. Leavenworth County, Kansas, US Penitentiary, Leavenworth, 1895–1931, Inmate Case Files: genealogytrails.com/kan/leavenworth/prisonindexlulz.html (accessed Feb. 2011).

110. "N. E. Luboshey," *British Journal of Photography Almanac, 1926*, 156.

111. Prince Petr Alekseevich Kropotkin, ca. 1915, toned gelatin silver print, 1999:0445:0003, GEH.

112. Natasha Luboshez, ca. 1915, toned gelatin silver print, 1999:0445:0001, GEH.

113. "1892: Winter and Spring. In search of a financial base, Goldman moves to Massachusetts—first to Springfield to work in a photography studio with Modest Stein ("Fedya") [cousin of Alexander Berkman], and then to Worcester, where, with Alexander Berkman, Stein and Goldman open their own studio. When the photography business fails, they open an ice-cream parlor with the renewed aim of returning to Russia to respond to the political repression under Czar Alexander III" ("Emma Goldman: Chronology, 1869–1900" [Ema Goldman papers project, University of California, Berkeley: sunsite.berkeley.edu/goldman/Guide/chronology6900.html (accessed Aug. 2013)]); see also Paul Avrich and Karen Avrich, *Sasha and Emma: The Anarchist Odyssey of Alexander Berkman and Emma Goldman* (Boston: Belknap Press, 2012), 48–49.

114. "N. E. Luboshey," *British Journal of Photography Almanac, 1926*, 156.

115. Ibid.

116. Ibid.

117. Ibid.

118. Harriet McNanee, *Chinese Art from the Ferris Luboshez Collection: Exhibition Held at the University of Maryland Art Gallery, March 23–April 30, 1972.*

119. "Sergius N. Ferris Luboshez Photographs and Newspaper Clipping, 1945–1972 1945–1949," Archives, Manuscripts, Photographs Catalog, Smithsonian Institution Research Information System (SIRIS): siris-archives.si.edu/ipac20/ipac.jsp?uri=full=3100001~!282303!0 (accessed Aug. 2011).

120. "History of Cornmarket," Oxford History website: www.oxfordhistory.org.uk/cornmar ket/east/13_20_old/16_17/html (accessed Feb. 2011).

121. "Hills & Saunders," Early Cambridge Photographers website: www.earlyphotographers .org.uk/Cam%20H-L.html (accessed Feb. 2011).

122. Ibid.

123. "History of Cornmarket," Oxford History website.

124. "Hills & Saunders," Early Cambridge Photographers website.

125. Ibid.

126. Ibid.

127. Edin Photo website: www.edinphoto.org.uk/PP_I/pp_langfier_o.htm (accessed Feb. 2011).

128. "History of Cornmarket," Oxford History website.

129. Entry for "Hills & Saunders," photoLondon website (accessed Feb. 2011).

130. Beginning in 1932, the firm was merged with George Leslie's studio, which was located at number 49 Cornmarket; "History of Cornmarket," Oxford History website.

131. Dan Walter, "The Hills & Saunders Exhibition," in *The Harrow Observer*: www.oldphoto .freeuk.com/harrow/harrowtrust.htm (accessed Feb. 2011).

132. "Armed Services home," Gillman and Soame website: www.gillmanandsoame.co.uk /armed-services/ (accessed Feb. 2011).

133. "Our History," Gillman and Soame website: www.gillmanandsoame.co.uk/aboutUs /history/ (accessed Feb. 2011).

134. Transcript of interview with Salman Stemmer, no. 116, pp. 24, 29–31, 43, RfV.

135. Ibid., p. 30.

136. Ibid., pp. 30–31.

137. Ibid., p. 31.

138. Ibid.

139. Ibid.

140. Ibid.

141. Ibid., p. 43.

142. Ibid., p. 33.

143. Transcript of interview with Ernst Flesch, no. 137, p. 1, RfV.

144. Ibid., pp. 12–13.

145. Ibid., p. 17.

146. Michael Greisman, ed., *Vintage Glamour in London's East End* (London: Hoxton Mini Press, 2014); see also Michael Berkowitz, "How Great Grandma Looked," *Jewish Quarterly* [London] 61.3–4 (2014): 120–123.

147. Philip Walker, "Boris Bennett—Jewish East End Photographer to the Stars!!": www.jew isheastend.com/boris.html (accessed Feb. 2011).

148. "Michael Perkoff with His Grandchildren," Exploring Twentieth-Century London website: www.20thcenturylondon.org.uk/jml-1986-32-18 (accessed Feb. 2011); entry for "Perkoff, Isaac," photoLondon website: www.photolondon.org.uk/pages/details.asp?pid=6012 (accessed Feb. 2011).

149. Walker, "Boris Bennett."

150. Flesch, no. 137, p. 17, RfV.

151. Ibid., p. 18.

152. *Vienna's Shooting Girls*, 12, 208.

153. Flesch, no. 137, p. 40, RfV.

154. Ibid., p. 18.

155. Transcript of interview with Inge Ader, no. 18, pp. 1, 6–7, RfV.

156. Ibid., p. 9.

157. Wilfried Weinke, *Verdrängt, vertrieben, aber nicht vergessen: Die Fotografen Emil Bieber, Max Halberstadt, Erich Kastan, Kurt Schallenberg* (Weingarten: Weingarten, 2003), 177, 179–180, 221.

158. Weinke, *Verdrängt, vertrieben, aber nicht vergessen*, 177, 180.

159. Ader, no. 18, p. 23, RfV.

160. Ibid., pp. 9, 15.

161. Ibid., p. 23.

162. Ibid., pp. 16–17.

163. Ibid., pp. 17–18.

164. Ibid., p. 18.

165. Ibid., pp. 22–23.

166. "Dorothy Bohm on a Life Dedicated to Photography," *Sunday Times*, April 23, 2010: www.thetimes.co.uk/tto/arts/visualarts/photography/article2486202.ece (accessed Feb. 2011); Jane Richards, "Colourful Visions: Dorothy Bohm's Poetic Images Have Helped Her Come to Terms with an Unsettled Past," *The Independent*, Oct. 4, 1994.

167. Text of interview with Dorothy Bohm, Nov. 10, 2001, interviewer Bea Lewkowicz, no. 82, pp. 11–12, RfV.

168. Ibid., pp. 12–13.

169. Ibid., p. 13.

170. Ibid., p. 14.

171. Ibid., p. 14.

172. Ibid., pp. 23–24.

173. Ibid., p. 24.

174. Ibid., p. 27.

175. "Biography [time line]": www.dorothybohm.com/main.php?section=biography (accessed Feb. 2011).

176. Helmut Gernsheim, ed., *The Man behind the Camera* (London: Fountain, 1948), jacket blurb.

177. Duncan Forbes, "Politics, Photography, and Exile in the Life of Edith Tudor-Hart (1908–1973)," in *Arts in Exile*, 65.

CHAPTER TWO

1. Helmut Gernsheim, *Creative Photography: Aesthetic Trends, 1839–1960* (New York: Bonanza Books, 1963), 102.

2. R. Derek Wood, "The Daguerreotype in Liverpool in 1839: Ste. Croix, A. Abraham and J. B. Dancer": www.midley.co.uk/sourcetexts/liverpool_dag1839_wood.htm (accessed Feb. 2011).

3. "The First Photograph," HRC website: www.hrc.utexas.edu/exhibitions/permanent/wfp/ (accessed Feb. 2011).

4. Wood, "The Daguerreotype in Liverpool in 1839."

5. Gernsheim, *Creative Photography*, 102.

6. UCL Bloomsbury Project, Bloomsbury Streets, Squares, and Buildings: www.ucl.ac.uk /bloomsbury-project/streets/red_lion_square.htm (accessed Feb. 2011); *Chemical News and Journal of Industrial Science*, vol. 29–30, April 17, 1874, p. 178. They were an international concern, whose market included Australia; see *Sydney Morning Herald*, Tuesday, Sept. 28, 1869, p. 8.

7. Personal communication with Frank Dabba Smith, leading historian of Leica.

8. Gisèle Freund portrait, cage 678, box 1, folder 9, "The Searching Eyes," from Washington State University Archives, Pullman, WA. Despite a number of statements in her writings that are critical of retouching, this photograph is accompanied by specific instructions for how the picture was to be modified. This is not, however, an indication of vanity: her great concern was that the hands come out clearly.

9. Gisèle Freund, as told to Aime Lemoyne, in *Reader's Digest* (March 1986): 102.

10. In attempting to locate documentary material I encountered this term at the International Center for Photography in New York. I appreciate the opportunity to use the "business papers" of Robert Capa and Chim.

11. A similar point was made about photography generally in Robert Taft, *Photography and the American Scene: A Social History, 1839–1889* (1938; New York: Dover, 1964), vii.

12. C. Zoe Smith, "Émigré Contributions to *Life*: The German Influence in the Development of America's First Picture Magazine," paper presented at the 65th Annual Meeting of the Association for Education in Journalism (Athens, OH, July 25–28, 1982); C. Zoe Smith, "Germany's Kurt Korff: An Émigré's Influence on Early *Life*," in *Journalism Quarterly* 65.2–3 (Summer 1988): 412–424.

13. Irme Schaber, "Fotographie," in *Handbuch der deutschsprachigen Emigration, 1933–1945*, ed. Claus-Dieter Krohn, Patrik von zur Mühlen, Gerhard Paul, and Lutz Winckler (Darmstadt: Wissenschaftliche Buchgesellschaft, 1998), 970.

14. Gidal, "Jews in Photography," 447.

15. David Shneer, *Through Soviet Jewish Eyes: Photography, War, and the Holocaust* (Piscataway, NJ: Rutgers University Press, 2011).

16. Colin Ford, ed., *The Hungarian Connection: The Roots of Photojournalism* (Bradford: National Museum of Photography, Film, and Television, 1987); Peter Baki, Colin Ford, and George Szirtes, eds., *Eyewitness: Hungarian Photography in the Twentieth Century: Brassaï, Capa, Kertész, Moholy-Nagy, Munkácsi* (London: Royal Academy of Arts, 2011); the exhibition accompanying the latter was curated by Colin Ford and Peter Baki.

17. Tim Gidal, *Modern Photojournalism: Origin and Evolution, 1910–1933*, trans. Maureen Oberli-Turner (New York: Macmillan, 1973).

18. Annette Vonwinckel, "German (Jewish) Photojournalists in Exile: A Story of Networks and Success," *German History* 31.4 (2013): 473–496.

19. Felix Man to Beaumont Newhall, Jan. 27, 1979, Papers of Beaumont Newhall and Nancy Newhall (hereafter cited as BN-NN), GRI.

20. Gidal, "Jews in Photography," 432–453.

21. For an illuminating portrait of Lorant and *Picture Post* see Michael Hallett, *Stefan Lorant: Godfather of Journalism* (Lanham, MD: Scarecrow Press, 2006). I do, however, strongly depart from Hallett's understanding of the role of Lorant's "Jewishness" (10), his largely sympathetic portrayal of British government officials in the handling of Lorant's case for naturalization (85), and the characterization of the relationship between Lorant's work and *Life* magazine (52).

22. There are scores, if not hundreds, of interviews with Tom Hopkinson. Most relevant here, however, are his publications dealing explicitly with *Picture Post*, which went through several editions; see, for example, *Picture Post, 1938-1950*, ed. Tom Hopkinson (London: Chatto and Windus, 1984) and *Of This Our Time* (London: Hutchinson, 1982).

23. "1940 Chronology," p. 2, SLA. It seems that Lorant was meticulous in documenting his career.

24. Stefan Lorant interviews (SLT), tapes 5a and 6b. See also "Photojournalism in the 1920s. Seminar with Felix Man and Stephan (sic) Lorant, State University of New York Buffalo, Visual Studies Workshop [held in] Rochester, May 12, 1971," 32A, BN-NN, GRI. Interestingly, Lorant and Man appeared together in upstate New York.

25. Letters from Felix Man to Beaumont Newhall, March 8, 1977, and Jan. 27, 1979, box 72, folder 23; letter from Gidal to Newhall, Nov. 22, 1972, and June 26, 1984, box 54, file 5, BN-NN, GRI.

26. See, for example, Gernsheim, *Creative Photography*, 210.

27. Memo from Tom Hopkinson, June 18, 1940, INF 1/234, "Publicity by means of a Pictorial Publication 'Picture Post', Part B," May 1940–August 1941, NA.

28. "1940 Chronology," p. 3, SLA III.

29. "Back to the Middle Ages" and "These are some of the world-famous Jews for whom there is no room in Nazi Germany today," in *Picture Post*, Nov. 26, 1938, pp. 14–17.

30. Alan Brinkley, *The Publisher: Henry Luce and His American Century* (New York: Knopf, 2010).

31. Michael Hallett, "Lorant, Stefan (1901–1997)" (May 2007), *DNB*: www.oxforddnb.com /view/article/68434 (accessed Aug. 2011).

32. I owe this insight to Sander Gilman, who informed me of the crucial role played by Briton Hadden in the creation of *Time* magazine; see Isaiah Wilner, *The Man Time Forgot: A Tale of Genius, Betrayal, and the Creation of* Time *Magazine* (New York: Harper Perennial, 2007).

33. Helmut Gernsheim to Beaumont Newhall, April 14, 1950, box 53, file 9, BN-NN, GRI.

34. Jeffrey Finestone, *The Last Courts of Europe* (London: J. M. Dent and Sons, 1981), 35–64.

35. John Galsworthy, *The Forsyte Saga*, vol. 2, pt. 2, chap. 10 (London: Penguin, 2001), 446.

36. Galsworthy, *The Forsyte Saga*, 447.

37. Hannen Swaffer, "Foreword," in James Jarché, *People I Have Shot: Reminiscences of a Press Photographer* (London: Methuen and Co., 1934), unpaginated.

38. There is hardly any attention given to photojournalism in the seminal anthology *Classic Essays on Photography*, ed. Alan Trachtenberg (New Haven: Leete's Island Books, 1980); see Frederick S. Voss, *Reporting the War: The Journalistic Coverage of World War II* (Washington, DC: Smithsonian Institution Press for the National Portrait Gallery, 1994).

39. Roger Hargreaves, *Daily Encounters: Photographs from Fleet Street* (London: National Portrait Gallery, 2007), 18.

40. Jarché, *People I Have Shot*.

41. Swaffer, "Foreword," vii.

42. See, for example, Inge Ader, no. 25, pp. 17–19; Dorothy Bohm, no. 82, pp. 22–23; Ernst Flesch, no. 137, pp. 17–18, RfV.

43. Colin Osman, "Jarché, James (1890–1965)" (2004), *DNB*: www.oxforddnb.com/view/ar ticle/48447 (accessed Feb. 2011); "Jarché," *DNB*.

44. Entry for "Jarchy, Arnold Louis," photoLondon website: www.photolondon.org.uk/pages /details.asp?pid=4209. The entry also states, though, that he was "a Russian refugee."

45. BBC website: www.bbc.co.uk/whodoyouthinkyouare/past-stories/david-suchet.shtml (accessed Feb. 2011).

46. Jarché, *People I Have Shot*, 6.

47. "Our Heritage," Lafayette Photography: www.lafayettephotography.com/Main.aspx?Id=1. There are at least two versions of this potted history, with one acknowledging the name change. Most likely this is only part of the story.

48. The partially honest version of "How We Did It": www.bbc.co.uk/whodoyouthinkyouare /past-stories/david-how-we-did-it_1.shtml, and www.bbc.co.uk/whodoyouthinkyouare/past -stories/david-how-we-did-it_2.shtml (accessed Feb. 2011).

49. "Step 5: French Vital Records": www.bbc.co.uk/whodoyouthinkyouare/past-stories/david -how-we-did-it_2.shtml (accessed Feb. 2011).

50. Ibid.

51. "Eastern Europe": www.bbc.co.uk/whodoyouthinkyouare/past-stories/david-how-we -did-it_3.shtml (accessed Feb. 2011).

52. "Jarché," *DNB*.

53. See Daniel Pick, *Svengali's Web: The Alien Encounter in Modern Culture* (New Haven: Yale University Press, 2000).

54. Jarché, *People I Have Shot*, 6–7.

55. Pick, *Svengali's Web*, 93–111.

56. Jarché, *People I Have Shot*, 8.

57. Jarché, *People I Have Shot*, 8.

58. "Jarché," *DNB*.

59. Jarché, *People I Have Shot*, 10–11.

60. Jarché, *People I Have Shot*, 12.

61. "Jarché," *DNB*.

62. "Jarché," *DNB*.

63. "Jarché," *DNB*.

64. Jarché, *People I Have Shot*, 12.

65. Jarché, *People I Have Shot*, 15.

66. Jarché, *People I Have Shot*, 15–16.

67. Jarché, *People I Have Shot*, 16.

68. "Jarché," *DNB*.

69. Jarché, *People I Have Shot*, 17.

70. "Jarché," *DNB*.

71. Jarché, *People I Have Shot*, 20.

72. "Jarché," *DNB*; Jarché, *People I Have Shot*, 21.

73. Liz Wells, ed., *The Photography Reader* (London: Routledge, 2003), 272, n. 4.

74. Piece reference BT 31/12282/96772, company no. 96772; Press Photographic Agency Ltd., NA.

75. HO 45/23698, "WAR: Hans Max Albert Silver, owner of International Graphic Press Ltd.: internment, 1940–1941," NA.

76. Bert Garai, *The Man from Keystone: Behind the Scenes of a Great Picture Agency, by the Man Who Scooped the World* (London: Frederick Muller, 1965).

77. "Jarché," *DNB*.

78. "Lorant," *DNB*.

79. Colin Jacobson, "The Importance of Being There. James Jarche was a pioneer of modern news photography: a tireless hack with an uncanny way of being in the right place at the right time. Colin Jacobson considers his neglected legacy," *The Independent*, Sunday, Nov. 14, 1999; cf. Gernsheim, *Creative Photography*, 210; "Photojournalism in the 1920s."

80. "Jarché," *DNB*.

81. Jacobson, "The Importance."

82. Jacobson, "The Importance."

83. Jarché, *People I Have Shot*, 138–144.

84. "Jarché," *DNB*.

85. "Jarché," *DNB*.

86. "Jarché," *DNB*.

87. "Jarché," *DNB*.

88. "Jarché," *DNB*.

89. Andrew Matheson, *The Leica Way: The Leica Photographer's Companion*, 4th ed. (London: Focal Press, 1957), opp. p. 17.

90. Jacob Deschin, "Trickster with a Tripod," review of *Portrait of an Age: Erich Salomon*, *New York Times*, Aug. 13, 1967.

91. "Dr. Erich Salomon," draft of article for *Encyclopaedia Judaica*, Peter Pollack papers, box 6, file 5, GRI.

92. Helmut Gernsheim to Peter Hunter, Sept. 13, 1956, ms., Gernsheim H, TccL to Hunter, Peter, HGC.

93. Helmut Gernsheim, "Erich Salomon, 1886–1944," biographical essay, in *Photo Classics III: Erich Salomon, 1886–1944* (London: Photo-Graphic Editions Limited, 1971).

94. Pollack, "Dr. Erich Salomon."

95. Pollack, "Dr. Erich Salomon."

96. Helmut Gernsheim, "Erich Salomon, 1886–1944."

97. Helmut Gernsheim, "Erich Salomon, 1886–1944."

98. Hargreaves, *Daily Encounters*, 62–63.

99. Hargreaves, *Daily Encounters*, 66–67.

100. NPG, internal database (accessed Feb. 2011).

101. Photos by Hunter in *Erich Salomon, Emigrant in Holland, Peter Hunter, Emigrant in London. Erich Salomon, Fotos, 1933–1940, Peter Hunter, Fotos, 1935–1940* (Amsterdam: Focus, 1996), 152, 153, 155.

102. Weizmann is pictured next to President Warren Harding in *Palästina-Bilder-Korrespondenz* (May 1929): 3; this magazine encouraged the use of its photographs in other Jewish and Zionist periodicals.

103. "Lord Rothschild speaking during 'Palestine Week,' Friends Meeting House, London 1938," and Weizmann and Leopold Amery, 1938, in *Erich Salomon, Emigrant in Holland*, 152, 153.

104. Gidal, "Jews in Photography."

105. Deschin, "Trickster with a Tripod," 7.

106. Helmut Gernsheim, "Erich Salomon, 1886–1944."

107. Deschin, "Trickster with a Tripod," 7.

108. Quote in Gisèle Freund, *Photography and Society* (London: Gordon Fraser, 1980), 122.

109. Stefan Lorant, "Schööööön Akrobat: Wie die Rivels eine Brücke bauen," *Münchner Illustrierte Presse*, no. 42, 1932, pp. 1150–1151, SLA III: "Lorant in Germany, 1923–1932."

110. "Oscar Pulvermacher of the Daily Telegraph, London," 2000:0227:0078, GEH.

111. Roy Porter, *Health for Sale: Quackery in England, 1660–1850* (Manchester: Manchester University Press, 1989).

112. William Rubinstein, entry for "Oscar Pulvermacher," *Encyclopedia Judaica*, 2008 ed.: www.jewishvirtuallibrary.org/jsource/judaica/ejud_0002_0016_0_16190.html; see also wikipedia.org/wiki/Oscar_Pulvermacher, an appropriate source for the history of quackery (accessed Feb. 2011).

113. "The Italian Delegate Graf Aldrovandi (right, in his room in the Plaza Hotel) in conversation with the Italian ambassador to Brussels, Gabrielle Preziosi, on the occasion of the Nine-Power Conference, Brussels, November 16, 1937," 2000:0227:89, 92, 93, 94, GEH. Weizmann also is captured in motion.

114. Erich Auerbach, *An Eye for Music* (London: Rupert Hart-Davis, 1971), viii.

115. Matthew Butson, "A Life in Music," *black&white* 22, June 2003, 94: corporate.gettyimages.com/masters2/press/articles/BWP_Erich_Auerbach.pdf (accessed Feb. 2011).

116. Erich Auerbach, *An Eye for Music*, viii.

117. Butson, "A Life in Music," 94.

118. Butson, "A Life in Music," 94.

119. Lord Goodman, "Introduction," *An Eye for Music*, vii.

120. Butson, "A Life in Music," 95.

121. From an informal conversation with the author in the café of the Photographers' Gallery, London, Feb. 18, 2010.

122. SLT, tape 10, side a.

123. See the biography section of the major website devoted to Zoltán Glass, "based on a *Telegraph* article by John Reynolds, 2001." The article is "Sharp Shooter: John Reynolds Rediscovers the Life and Work of Automotive Photographer Zoltan Glass," *Telegraph*, Feb. 20, 2001. It is well informed and acknowledges Jewish connections to a greater degree than most similar presentations; see www.zoltanglass.com/zoltan.html (accessed Feb. 2011). There is further information on the National Media Museum website, "Photography: Biographical Notes on Zoltan Glass": www.nationalmediamuseum.org.uk/~/media/Files/NMeM/PDF/Collections/Photography/ZoltanGlass.ashx (accessed Feb. 2011).

124. Alfred Eisenstaedt, as told to Arthur Goldsmith, *Eye of Eisenstaedt* (New York: Viking, 1969), 12.

125. Reynolds, "Sharp Shooter."

126. "Juden—Motorsportsgruppen," folder 303, Deutsche Arbeitsfront (DAF), Reichssicherheitshauptamt (RSHA)-SD, Berlin (Ssobyi fond 500) (Main State Security of Germany-SD, Berlin [manuscript RG-11.001M.01], reel 4, United States Holocaust Memorial Museum archives, Washington, DC.

127. Papers of the J. Walter Thompson Company are held in the Duke University archives; see the finding aid at library.duke.edu/digitalcollections/rbmscl/jwttreasureroffice/inv/; "Advertising News and Notes," *New York Times*, June 4, 1948.

128. Reynolds, "Sharp Shooter."

129. Reynolds, "Sharp Shooter."

130. "Biographical Notes on Zoltan Glass."

131. Reynolds, "Sharp Shooter" and "Biographical Notes on Zoltan Glass."

132. *The Life of Stefan Lorant*, vol. 1.

133. "Biographical Notes on Zoltan Glass."

134. Marie-Jaqueline Lancaster, "Obituary: Arpad Elfer," *The Independent* (London), Aug. 18 1999: www.independent.co.uk/arts-entertainment/obituary-arpad-elfer-1113413.html (accessed Feb. 2011).

135. "Colman Prentis and Varley; CPV," website of "The History of Advertising Trust": www .hatads.org.uk/hat/newsitem.php?A=120&C=22 (accessed Feb. 2011).

136. "Biographical Notes on Zoltan Glass."

137. Reynolds, "Sharp Shooter."

138. Stefan Lorant (text and photos), "Haller: Hinter den Kulissen der Revue, II.," in *Das Magazin*, Dec. 1925, pp. 56, 57, SLA II: "Lorant in Germany, 1923–1932" section.

139. Reynolds, "Sharp Shooter."

140. *Lilliput*, vol. 1, no. 2 (July 1937): 44.

141. Reynolds, "Sharp Shooter."

142. Reynolds, "Sharp Shooter."

143. Nathan Abrams, "Triple-Exthnics," *Jewish Quarterly* 196 (Winter 2004): www.jewish quarterly.org/issuearchive/articled325.html?articleid=38 (accessed Feb. 2011).

144. Tony Sloman, "Obituary: Harrison Marks, Thursday, 10 July 1997," *The Independent*: www.independent.co.uk/news/people/obituary-harrison-marks-1249894.html (accessed Feb. 2011).

145. Wolf Suschitzky, informal interview with the author, Feb. 18, 2010.

146. [Identified as] Schall, Paris, "Dr. Goebbels in his house" [beneath a huge picture of Hitler], next to Bond, London, "Lemur Monkey with her young," *Lilliput*, vol. 2, no. 1 (Jan. 1938): 138–139.

147. "Gilland, London: HIPPOPOTAMUS AT MEAL," p. 10, juxtaposed with "Aigner, Paris: THE RUSSIAN SINGER CHALIAPIN," p. 11, *Lilliput*, vol. 1, no. 2 (July 1937); "The Humour of the Unexpected. A new form of humour, contrasting photographs, has been introduced into the illustrated journalism by *Lilliput*." In this article the contrasting photographs were "Hitler at a Motor-Car Show," possibly by Glass, and a still of Charlie Chaplin in *Modern Times*, *Picture Post*, June 10, 1939, p. 69.

148. "Photojournalism in the 1920s."

149. SLT, tape 12, side a, and tape 7, side b; "How Picture Post is Produced," *Picture Post*, Dec. 24, 1938, pp. 14–15.

150. SLT, tape 5, side a.

151. "Government Official in the Home Office, London," 1935, 2000:0227:0076, GEH.

152. "Dutch delegation views Erich Salomon's book *Famous Contemporaries in Unguarded Moments, the Hague*," ca. 1935, 2000:0227:0082, and "From the series about newspaper readers absorbed in looking at Erich Salomon's famous High Court Photo in the Sunday Dispatch, London," 1935, 2000/0227:0075, GEH.

153. Maxwell Raison to Brendan Bracken, June 4, 1940, INF 1/234, "Publicity by means of a Pictorial Publication 'Picture Post,' Part B, May 1940–August 1941," NA.

154. Information from the reference librarians at the National Archives, Kew, Aug. 3, 2011.

155. "Lorant," *DNB*.

156. "June 1940," "Chronology," SLA III.

157. Letter from Duff Cooper to Home Secretary, John Anderson, 16 September 1940, with a handwritten note from Clark at bottom, INF 1/234, "Publicity by means of a Pictorial Publication, 'Picture Post,'" Part B, May 1940–August 1941, NA.

158. "Places Where I Stayed in London as noted in my Certificate of Registration," in "Chronology in England, 1934–1940," SLA III.

159. Brendan Bracken to Lord Hood, handwritten note on stationery of 10 Downing Street, June 4, [1940,] INF 1/234, "Publicity by means of a Pictorial Publication, 'Picture Post,'" Part B, May 1940–August 1941, NA.

160. Wickam Steed, *Picture Post*, Feb. 25, 1939, pp. 16–23; retouched Churchill photo, p. 18, no. 1, "After his morning's work," top left.

161. "Chronology, May–June 1940," p. 3, SLA III.

162. "Lorant," *DNB*.

163. Thomas Willimowski, *Stefan Lorant: Eine Karriere im Exil* (Berlin: Wissenschaftlicher Verlag, 2005), 495.

164. SLT, tape 1, side a.

165. Around that time Leopold Godowsky, a composer and pianist, was offered a position as a court musician and conductor. His son recalls that his father, who did not practice Judaism at all, made a point of swearing his allegiance to the crown on a Hebrew bible, and wearing a yarmulke. That was the only time Godowsky saw his father wear a yarmulke. Leopold Godowsky Jr., AJC interview, pp. 8–9, 59.

166. SLT, tape 2, side a.

167. "Articles by Lorant," "Articles by Lorant in Hungary, 1917–1924," SLA III, no pagination, cover: *Das Interressante Blatt*, Vienna, Jan. 4, 1917.

168. SLT, tape 2, side a.

169. SLT, tape 2, sides a and b.

170. SLT, tape 3, side a.

171. "Lorant," *DNB*.

172. "Filmmaker" section, p. 2, SLA I; "Filmmaker" section, "Films on which Stefan Lorant worked between 1920 and 1924," no pagination. The company was Helios Film, which also produced the Mozart film; also "I Lived Six Lives" section, pp. 1–2, 9.

173. "Filmmaker" section, "Films on which Stefan Lorant worked between 1920 and 1924," no pagination; also "I Lived Six Lives" section, pp. 1–2.

174. "I Lived Six Lives," p. 10, SLA I.

175. "Filmmaker" section, p. 2, SLA I; "Filmmaker" section, "Films on which Stefan Lorant worked between 1920 and 1924," no pagination. The company was Sascha Film, and it also starred Max Neufeld; see also "I Lived Six Lives" section, pp. 1–2.

176. "Lorant," *DNB*.

177. SLT, tape 4, side a.

178. SLT, tape 3, side b.

179. SLT, tape 4, side a.

180. Lorant, "Unbekannte Talente haben hier Chance" [he slips into English: What Ernst Lubitsch experienced in America], *B.Z. am Mittag*, Dec. 16, 1924, SLA I, IV. Articles by Stefan Lorant in German, Austrian, and Hungarian newspapers and magazines.

181. "Die entfesselte Kamera" (Karl Freund), in *Ufa Magazin*, March 25, 1927; SLA I, IV.

182. SLT, tape 4, side b.

183. Wilner, *The Man Time Forgot*.

184. "Lorant," *DNB*.

185. "Germany. Editor of Magazines in Berlin and Munich," SLA III; "1927, January: Karl Grune, the firm director introduced me to Rudolf Schwartzkopf, the press chief of the *Ufa*. Schwartzkopf asked me to compile a special issue of the *Ufa* Magazin for Fritz Lang's "Metropolis." (The film had its premiere in the Ufa Palast am Zoo on January 10, 1927.) "After my work was praised by the critics, Schwartzkopf offered me the editorship of the *Ufa* magazine. I edited the magazine from its Number 3 in 1927, January 14 till its Number 27, July 7 of the same year." (Later the magazine was renamed "Film Magazin.")

186. Hallett, "Lorant," *DNB*. "Fritz Germann, publishing director of the Berliner Börsen Courier asked me to edit the newspaper's Sunday magazine, the Bilder Courier," "Lorant in Germany, 1923–1932," p. 2, SLA III.

187. "Fourth Life: Berlin—München—Germany," p. 11, SLA II. *Der Ton* was "a monthly magazine for the gramophone company Edition Accord," p. 25, "Editor of Pictorial Weeklies and Magazines in Germany and Hungary, 1926–1933," p. 25.

188. "Lorant," *DNB*.

189. SLT, tape 5, side a.

190. SLT, tape 5, sides a and b. High-ranking Nazis had been among the sitters for Lotte Jacobi and doubtless other Jewish photographers up through the war; see Lotte Jacobi interview with Sandra S. Phillips, in *Center Quarterly* 3.1 (1981), from the Catskill Center for Photography, in box 64, file 1, BN-NN, GRI. Some continued to do portraiture of German soldiers and officers in Nazi ghettos; see Bernard Gotfryd, *Anton the Dove Fancier and Other Tales of the Holocaust* (Baltimore: Johns Hopkins University Press, 2000).

191. Garai, *The Man from Keystone*, 89–90.

192. Garai, *The Man from Keystone*, 129.

193. SLT, tape 5, F3758, sides a and b.

194. "Lorant," *DNB*.

195. SLT, tape 6, side b, and tape 7, side a.

196. SLT, tape 5, side b.

197. "Chronology, 1934," "Chronology in England, 1934–1940," pp. 9–10, SLA III.

198. SLT, tape 3, side a; tape 7, side a.

199. "Lorant," *DNB*.

200. "Chronology, 1934," "Chronology in England, 1934–1940," p. 11, SLA III.

201. Cf. Hallett, *Stefan Lorant*, 52.

202. Quote from tape also in Hallett, *Stefan Lorant*, 52; see also C. Zoe Smith, "Émigré Contributions to *Life*" and "Germany's Kurt Korff"; SLT, tapes 6, 7, 11, 12.

203. SLT, tape 8, side b; "Chronology, 1938": "A very funny letter from Ervin Blumenfeld (photostatted) I printed in *Lilliput* for an article (see 1938)," SLA III.

204. SLA III, "Chronology, 1937": Feb. 1937: "Planning of a magazine, which became *Lilliput*. On my return to London, I rented Zoltan Glass's apartment at 76 Charlbert Court, Regents Park, where I started working on the dummy of *Lilliput*."

205. Erwin Blumenfeld, *Eye to I: The Autobiography of a Photographer*, trans. Mike Mitchell and Brian Murdoch (London: Thames and Hudson, 1999), 266.

206. Blumenfeld, *Eye to I*.

207. SLT, tape 11, side b.

208. "Lorant," *DNB*.

209. Pascal Ihle, "Ikonen des Grauens—die Hitler-Bilder von Erwin Blumenfeld," in *Neue Zürcher Zeitung*, no. 58, Nov. 3, 1997, p. 32; see *Eye to I*, 231.

210. "The Current Issue of *Lilliput*," *Picture Post*, May 6, 1939, p. 8.

211. "Lorant," *DNB*.

212. Letter of Helmut Gernsheim to Stefan Lorant, Dec. 6, 1954; HGC.

213. "Lorant," *DNB*.

214. Richard Whelan; Alex Kershaw, *Blood and Champagne: The Life and Times of Robert Capa* (London: Pan, 2002).

215. It should be either "André Friedman" or "Robert Capa."

216. Felix Man to Beaumont Newhall, Jan. 27, 1979, BN-NN, GRI.

217. Shneer, *Through Soviet Jewish Eyes*, 52.

218. Capa, *Slightly Out of Focus*, 4.

219. Capa, *Slightly Out of Focus*.

220. Capa, *Slightly Out of Focus*.

221. Capa, *Slightly Out of Focus*, 5.

222. Kershaw, *Blood and Champagne*, 11–16; Irme Schaber, "The Eye of Solidarity: The Photographer Gerda Taro and Her Work during the Spanish Civil War," in *Gerda Taro*, ed. Irme Schaber, Richard Whelan, and Kristen Lubben (Göttingen: ICP/Steidl, 2007), 12–19.

223. Capa, *Slightly Out of Focus*, 140–141.

224. Capa, *Slightly Out of Focus*, 148.

225. Capa, *Slightly Out of Focus*, 210.

226. Capa, *Slightly Out of Focus*, 235.

227. In the family correspondence references are often by first name only or nicknames, so it is difficult to ascertain identities and precise relationships to Capa; files by year date, ICP.

228. "Jarché," *DNB*.

229. Robert Capa, *Images of War* (London: Paul Hamlyn, 1964), 156.

230. Robert Capa and Irwin Shaw, *This Is Israel*; also in Capa, *Images of War*, 160; cf. Yaakov Benor-Kalter, "Joy in Work (Kvutzah Schiller)" and "The Levant Fair, Tel Aviv," in *Photographs of the New Working Palestine* (Haifa: S. Adler, no date), no pagination.

231. Capa, *Images of War*, 150.

232. "The Yiddisher Parliament Meets," *Picture Post*, Oct. 15, 1938, p. 24.

233. Charles Wintour, "Hopkinson, Sir (Henry) Thomas (1905–1990)," *DNB*: www.oxford dnb.com/view/article/40160 (accessed Aug. 2011).

234. Rebecca Hopkinson, "My Gran, Pioneer with a Camera," *JC*, March 26, 2010.

235. "Their First Day in England," in *Picture Post*, Dec. 17, 1938, pp. 56–57.

236. Ibid.

237. Christopher Breward and Claire Wilcox, eds., *The Ambassador Magazine: Promoting Post-War British Textiles and Fashion* (London: V&A Publishing, 2012).

238. Annamarie Stapleton, "Hans and Elsbeth Juda," in *The Ambassador Magazine*, 20.

239. "Opening Statement," *International Textiles*, July 15, 1933.

240. "German Fashions" and "Germany: Practical Vocational Training," *International Textiles*, Jan. 27, 1934, pp. 29–31.

241. "The Foreign Representative," *International Textiles*, Feb. 12, 1934, p. 28.

242. Ad for E. Meyer, *International Textiles*, no. 3, 1941, p. 10.

243. Corrected interview: An interview with Elsbeth Juda, re: *The Ambassador*, in autumn 1992 [Friday, Nov. 27, 1992], AAD/1987/1/207, Archive of Art and Design, Victoria and Albert Museum, Blythe House, London.

244. *Elsbeth Juda, 90 X Rembrandt.* Collages on the late self-portraits. From an exhibition Nov. 25–Dec. 17, 1994, England and Col, 14 Needham Road, p. 11, NK.94, 1234, NAL.

245. Corrected interview: An interview with Elsbeth Juda, re: *The Ambassador*, in autumn 1992 [Friday, Nov. 27, 1992].

246. Ad for Women's Wear Limited, 65 Margaret Street, London, *International Textiles*, no. 8, 1941, p. 5.

247. Corrected interview: An interview with Elsbeth Juda.

CHAPTER THREE

1. In chapter 5 Kenneth Clark's relationship to the history of photography will be examined in greater detail in the context of his complicated relationship with Helmut Gernsheim; Meryle Secrest, *Kenneth Clark: A Biography* (London: Weidenfeld and Nicolson, 1984).

2. For an outstanding history of the Warburg Institute, see Emily J. Levine, *Dreamland of Humanists: Warburg, Cassirer, Panofsky, and the Hamburg School* (Chicago: University of Chicago Press, 2013); see also Hans-Michael Schäfer, *Die Kulturwissenschaftliche Bibliothek Warburg: Geschichte und Persönlichkeiten der Bibliothek Warburg mit Berücksichtigung der Bibliothekslandschaft und der Stadtsituation der Freien und Hansestadt Hamburg zu Beginn des 20. Jahrhunderts* (Berlin: Logos, 2003); see also Tilmann von Stockhausen, *Die Kulturwissenschaftliche Bibliothek Warburg: Architektur, Einrichtung und Organisation* (Hamburg: Dölling und Galitz, 1992); for the earlier background see Mark A. Russell, *Between Tradition and Modernity: Aby Warburg and the Public Purposes of Art in Hamburg, 1896–1918* (New York: Berghahn Books, 2007).

3. See entry for "Lotte Meitner-Graf" in *Vienna's Shooting Girls*, 203.

4. "The Pictures of C. S. Forester by Lotte Meitner-Graf. Who was Lotte Meitner-Graf?": www.geni.com/people/Lotte-Charlotte-Meitner/6000000011515553802 (accessed Dec. 2014).

5. *Vienna's Shooting Girls*, 199.

6. See the much-cited Walter Benjamin, *A Short History of Photography*, originally published 1931: screen.oxfordjournals/org/cgi/reprint/13/1/5/pdf (accessed Feb. 2010); Gisèle Freund, *Photography and Society* (London: Gordon Fraser, 1980), 99–100; Elizabeth Anne McCauley, *Industrial Madness: Commercial Photography in Paris, 1848–1871* (New Haven: Yale University Press, 1994).

7. For a theoretical treatment, see Griselda Pollock, "Warburg and Mnemosyne: The Photograph as Aide-Mémoire or Optical Unconscious," evening lecture on the occasion of the conference "Photo Archives and the Photographic Memory of Art History, Part II," Kunsthistorisches Institut in Florence, Oct. 29, 2009.

8. The classic biography is E. H. Gombrich, *Aby Warburg: An Intellectual Biography* (Chicago: University of Chicago Press, 1986). Scholars since Gombrich have seen Warburg's Jewishness as more consequential than did Gombrich himself; see especially Aby M. Warburg, *Images from the Region of the Pueblo Indians of North America*, trans. Michael P. Steinberg (Ithaca: Cornell University Press, 1995), 59–114; Charlotte Schoell-Glass, *Aby Warburg and Anti-Semitism*, trans. Samuel Pakucs Willcocks (Detroit: Wayne State University Press, 2008); Thomas Schindler, *Zwischen Empfinden und Denken: Aspekte zur Kulturpsychologie von Aby Warburg* (Münster: Lit, 2000).

9. "SPSL Remarks" in internal document dated "4.11.39," stamp dated "8 Nov 1939," on the case of Fritz Saxl for naturalization, "SAXL, Professor Fritz (1890–1948)," file 1933–48, SPSL.

10. Warburg Institute website: warburg.sas.ac.uk/institute/institute_introduction.htm (accessed Feb. 2010).

11. "SPSL Remarks" in internal document dated "4.11.39," stamp dated "8 Nov 1939," on the case of Fritz Saxl for naturalisation, "SAXL, Professor Fritz (1890–1948)," file 1933–48, SPSL.

12. *Fritz Saxl (1890–1948): A Biographical Memoir by Gertrud Bing*. Reprinted in the fiftieth year of his death. The Warburg Institute, School of Advanced Study, University of London, London 1998. The front matter states, "This essay first appeared in *Fritz Saxl, 1890–1948. A Volume of Memorial Essays from his Friends in England*, edited by D. J. Gordon, London, etc. 1957. Minor factual corrections have been made to the text as here printed.," p. 1, BL.

13. See Michael Berkowitz, *Zionist Culture and West European Jewry before the First World War* (Cambridge: Cambridge University Press, 1993), 65–66, 90–91, 129–130, 132–134, 152.

14. Dorothea McEwan, "Exhibitions as Morale Boosters: The Exhibition Programme of the Warburg Institute, 1938–1945," in *Arts in Exile*, 273–274.

15. I am indebted to Dr. Grant Romer for this insight.

16. McEwan, "Exhibitions as Morale Boosters," 267–279.

17. Levine, *Dreamland of Humanists*, 116–117.

18. See Eric M. Warburg, "The Transfer to England," *The Warburg Institute Annual Report, 1952–1953*: warburg.sas.ac.uk/mnemosyne/history.htm (accessed Feb. 2010).

19. One of the exceptions was Otto Pächt (1902–1988), who had been born in Vienna and returned to Austria in 1963; see entry for "Pächt, Otto" in *Biographisches Handbuch deutschsprachiger Kunsthistoriker im Exil: Leben und Werk der unter dem Nationalsozialismus verfolgten und vertriebenen Wissenschaftler* [hereafter cited as *BH*], vol. 2: *L–Z*, ed. Ulrike Wendeland (Munich: K. G. Saur, 1999), 470–476.

20. I thank Christy Anderson for alerting me to this important qualification.

21. Ana Christine Nagel and Ulrich Sieg, eds., *Die Philipps-Universität Marburg im Nationalsozialismus: Dokumente zu ihrer Geschichte* (Stuttgart: F. Steiner, 2000), documents 226 and 227, 404, 414.

22. McEwan, "Exhibitions as Morale Boosters," 268–270.

23. HGVW, tapes 2 and 3.

24. Helmut Gernsheim does not figure in McEwan's survey.

25. Christy Anderson, "The Architectural Photography of Helmut Gernsheim (1913–1995)," in H. Gernsheim, *Messa a fuoco di architettura e scultura: Un modo originale di intendere la fotografia* (1951), Italian ed. (Turin: Allemandi, 2011); Anderson, in *The Birth of Photography: Highlights of the Gernsheim Collection/Die Geburtsstunde der Fotografie: Meilensteine der Gernsheim-Collection* (Heidelberg: Kehrer, 2012).

26. Personal correspondence with the author: Geoffrey Fischer, Feb. 4, 2010; Karin Kyburz, Feb. 3, 2010.

27. See Anthony Blunt, *The French Drawings in the Collection of His Majesty the King at Windsor Castle* (Oxford: Phaidon, 1945); Anthony Blunt, *The Drawings of G. B. Castiglione and Stefano della Bella in the Collection of Her Majesty the Queen at Windsor Castle* (London: Phaidon, 1954).

28. On Laib, see below, in relation to the Witt Collection.

29. This particularly relates to Gernsheim's plan for a national museum of photography in Britain, based on his own collection; see next chapter.

30. See Mark Haworth-Booth, "Helmut Gernsheim: An 'Unreasonable Man,'" in *FHG*, 327–330.

31. See James Renton, *The Zionist Masquerade: The Birth of the Anglo-Zionist Alliance, 1914–1918* (Basingstoke: Palgrave-Macmillan, 2007).

32. See Sander Gilman, *Fat: A Cultural History of Obesity* (London: Polity, 2008), 102–104.

33. Kenneth Clark, *Another Part of the Wood* (Hodder and Stoughton: Coronet, 1976), 168.

34. On Berenson, see Ernest Samuels, with the collaboration of Jayne Newcomer Samuels, *Bernard Berenson: The Making of a Legend* (Cambridge, MA: Belknap Press, 1987).

35. Clark, *Another Part*, 168–169.

36. Clark, *Another Part*, 169.

37. Clark, *Another Part*, 9.

38. Clark, *Another Part*, 172.

39. Clark, *Another Part*, 184.

40. *The Warburg Institute Annual Report, 1934–1935*, 10, BL. It was apparently written by Fritz Saxl.

41. "General Information Form," information supplied by Wittkower; in "WITTKOWER, Professor Rudolf (1901–1971)," file 1934–58, 194/8, SPSL.

42. Letters from Ernest Kahn to [Walter] Adams, April 26, 1934, and Fritz Saxl to Adams, May 7, 1934; in "WITTKOWER, Professor Rudolf (1901–1971)," file 1934–58, 194/8, SPSL.

43. Entry for "Wittkower, Rudolf," in *BH* 2:790.

44. Entry for "Wittkower, Rudolf," in *BH* 2:790.

45. Quoted in entry for "Wittkower, Rudolf," in *BH* 2:790.

46. The work of Christy Anderson is especially instructive in this area.

47. *The Warburg Institute Annual Report, 1934–1935*, 10–11.

48. *The Warburg Institute Annual Report, 1934–1935*, 11.

49. *The Warburg Institute Annual Report, 1934–1935*, 11.

50. *The Warburg Institute Annual Report, 1934–1935*, 11.

51. "Editorial. The Witt Library," in *Burlington Magazine*, vol. 94, no. 593 (Aug. 1952), p. 217.

52. See website of the De Laszlo Archive Trust: www.delaszloarchivetrust.com/index.php?cid=8&sid=12&PHPSESSID=0c15266ad82090ccc6a10ac6052fb165 (accessed Feb. 2010); see also PhotoLondon website: ww.photolondon.org.uk/pages/details.asp?pid=4536 (accessed Feb. 2010).

53. *The Warburg Institute Annual Report, 1934–1935*, 11.

54. See image of a vase at vads.ahds.ac.uk/large.php?uid=21993 (accessed Feb. 2010).

55. Alfred Carlebach portfolio, private collection of Susanne Mayer.

56. *The Warburg Institute Annual Report, 1934–1935*, 11.

57. *The Warburg Institute Annual Report, 1934–1935*, 11.

58. Entry for "Scharf, Alfred," in *BH* 2:601–604.

59. *The Warburg Institute Annual Report, 1934–1935*, 11.

60. McEwan, "Exhibitions as Morale Boosters."

61. A disproportionate number of Jews may have had such placements in the German and Austrian armies; another example is the artist E. M. Lilien; see Micha Bar-Am and Oma Bar-On, Nira Feldman, eds., *Painting with Light: The Photographic Aspect in the Work of E. M. Lilien*, trans. Ahuvia Kahane (Tel Aviv: Tel Aviv Museum of Art, Dvir, 1991), 18–20.

62. Michael P. Steinberg, in *Images from the Region*, 59–114; Charlotte Schoell-Glass, *Aby Warburg and Anti-Semitism*, 82–87.

63. *Fritz Saxl (1890–1948), A Biographical Memoir by Gertrud Bing*, p. 24, BL.

64. McEwan, "Exhibitions as Morale Boosters," 280.

65. *Fritz Saxl (1890–1948), A Biographical Memoir*, p. 24, BL.

66. The work of Christy Anderson on the collaboration between Gernsheim and Wittkower will fill this lacuna.

67. Warburg Institute Archive (WIA), 22.3, "THE VISUAL APPROACH TO THE CLASSICS. An Exhibition held at THE WARBURG INSTITUTE From January 9th to February 4th" [one-sheet printed announcement].

68. WIA, 22.1, "Exhibitions: I: 'The Visual Approach to the Classics.' Photographic Exhibition held at the Warburg Institute, Spring 1939" (catalogue with thirty-one photographs).

69. WIA, 22.1, "Classical Exhibition Notes" (undated, unpaginated).

70. WIA, 22.1, "Classical Exhibition Notes" [items] 104, 105.

71. WIA, 22.1, "Classical Exhibition Notes."

72. See George L. Mosse, *Toward the Final Solution: A History of European Racism* (New York: Harper Colophon, 1980), 10; Winckelmann's *Geschichte der Kunst des Altertums*, published originally in 1764, appeared in numerous forms and translations.

73. WIA, 22.3.

74. WIA, 22.5.1 [apparently address by Fritz Saxl to open the exhibition], six pages, typescript, p. 1.

75. WIA, 22.5.1, p. 1.

76. WIA, 22.5.1, pp. 2–4.

77. WIA, 22.5.1, pp. 2–4.

78. WIA, 22.5.1, pp. 4–5.

79. WIA, General Correspondence [GC], Helmut Gernsheim to Fritz Saxl, April 2, 1944; Saxl to Helmut Gernsheim, April 11, 1944; Gernsheim to Saxl, Dec. 10, 1944; Saxl to Gernsheim, Dec. 19, 1944.

80. WIA, 22.5.1, p. 5.

81. WIA, 22.5.1, p. 5.

82. WIA, 22.7, typed note.

83. WIA, 22.5.1, pp. 5–6.

84. Roger Hinks, item in *The Listener*, WIA.

85. Schäfer, *Die Kulturwissenschaftliche Bibliothek Warburg*, 313–314.

86. C. M. Kauffmann, obituary of Heidi Heimann, in *Burlington Magazine*, Oct. 1933, in bound folder of obituaries, WIA.

87. WIA, GC, A. [Adelheid] Heimann, Heimann to Saxl, Aug. 7, 1931.

88. Gertrude Bing to [Esther] Simpson, Feb. 20, 1942, in Bing file: "BING, Dr. Gertrud (1893–1964)," file 1938-64, 184/5, SPSL.

89. C. M. Kauffmann, obituary of Heidi Heimann.

90. "CLAIMS RESOLUTION TRIBUNAL. In re Holocaust Victim Assets Litigation. Case No. CV96–4849. Certified Award to Claimant Frank Ehrmann in re Account of Hans Max Heimann and Fritz Heimann. Claim Number: 217141/AH; 217142/AH": www.crt-ii.org/_awards/_apdfs /Heimann_Hans_Max_and_Fritz.pdf (accessed Feb. 2010). There is no evidence that Heidi Heimann sought to claim compensation from the German government, despite her family having had substantial wealth before the Nazi takeover; "Heimann, Adelheid (Heidi)," in BH 1 [vol. 1: A–K]:275–278.

91. The Warburg Institute Annual Report, 2006–2007: www.crt-ii.org/_awards/_apdfs/Hei mann_Hans_Max_and_Fritz.pdf (accessed Feb. 2010).

92. WIA, GC, Saxl to the German and Austrian Employment Exchange, Feb. 7, 1942.

93. Obituary from The Times Register, Saturday, May 20, 2006; in bound folder of obituaries, WIA.

94. Entry for "Ettlinger, Leopold David," in BH 1:139–142.

95. Unattributed typescript obituary of Leopold David Ettlinger (1913–1989), WIA.

96. WIA, 1.23.1, "LIST OF EXHIBITS."

97. "CURRICULUM VITAE" of Jenö Lanyi, in "LANYI, Dr. Jenö (1902–1940)," file 1939–40, 515/2, SPSL.

98. WIA, 1.23.1, "LIST OF EXHIBITS."

99. Entry for "Lanyi, Jenö," in BH 2:419.

100. Letter from Gertrud Bing to Miss (Esther) Simpson, Dec. 1, 1939, in "LANYI, Dr. Jenö (1902–1940)," file 1939–40, 515/2, SPSL.

101. Letter apparently from Fritz Saxl, Sept. 1940, in "LANYI, Dr. Jenö (1902–1940)," file 1939–40, 515/2, SPSL.

102. WIA, 1.23.2.1, [tear-sheet] Anthony Blunt, "ART: The Donatello Canon," The Spectator, April 7, 1939, p. 593.

103. Ibid.

104. WIA, 1.24.1 [unattributed description], "PHOTOGRAPHIC EXHIBITION OF IN-DIAN ART AT THE WARBURG INSTITUTE, 1940."

105. "Stella Kramrisch, Indian-Art Expert and Professor, 97," obituary, New York Times, Sept. 2, 1993.

106. Eliot Elisofon papers, 27.5, Series I, Photography files, "Exotic Bazaars" [Tehran and Orissa, India], set no. 62155, also Konarak and Bhubanebwar; letter from Stella Kramrisch, Feb. 26, 1961, HRC.

107. "Dr. Stella Kramrisch, May 29, 1898–August 31, 1991, Obituary," in Artibus Asiae 53.3–4 (1993): 499. Interestingly, in stressing her indebtedness to Professor Josef Strzygowski, this summary of her career does not acknowledge the extent to which her methods proceeded much more along the lines of Warburg, and her rejection of notions of race.

108. WIA, 1.24.7, file of reviews: Birmingham Gazette, Nov. 13, 1940.

109. WIA, 1.24.7, file of reviews: Daily Sketch (London), and South Wales Argus (Newport), Nov. 15, 1940.

110. WIA, 1.24.7, file of reviews: "Indian Art," cutting from the Irish Times (Dublin), Nov. 18, 1940.

111. WIA, 1.24.7, "Exhibition of Indian Art: Reviews"; Herbert Read, "Indian Art," cutting from *The Listener*, Nov. 21, 1940, 729–730.

112. Edward Said, *Orientalism* (New York: Vintage, 1979); see also John M. Efron, "Orientalism and the Jewish Historical Gaze," in *Orientalism and the Jews*, ed. Ivan Davidson Kalmar and Derek J. Penslar (Hanover, NH: Brandeis University Press, 2005), 80–93.

113. See entry for "KAHLE, Paul Ernst," by Frank Reiniger, *Biographisch-Bibliographischen KIRCHENLEXICON Lexicon* III (1992), Verlag Traugott Bautz, 943–945: www.bautz.de/bbkl/k /Kahle_p_e.shtml (accessed Feb. 2010).

114. Entry for "Demus, Otto," in *BH* 1:113–114; see entry for "Gray, Basil": www.dictionaryo farthistorians.org/grayb.htm (accessed Feb. 2010).

115. WIA, 1.24.7, "Exhibition of Indian Art: Reviews": "Moghul Art in India. Development under Persian Influence," cutting from *Great Britain and the East*, London, Dec. 19, 1940.

116. WIA, 1.24.4, "Lectures on Cultural Relations between East and West" [programme of lectures to accompany Indian Art Exhibition].

117. WIA, 1.24.7, "Exhibition of Indian Art: Reviews": "Indian Art Show," *The Daily Telegraph and Morning Post*, Nov. 13, 1940.

118. WIA, 1.24.7, "Exhibition of Indian Art: Reviews": "Photographs of Indian Art," cutting from *Birmingham Post*, Nov. 18, 1940.

119. For a similar argument about the role of Jewish intellectuals in Prague, see Scott Spector, *Prague Territories: National Conflict and Cultural Innovation in Franz Kafka's Fin de Siècle* (Berkeley: University of California Press, 2000).

120. WIA, 1.24.7, "Exhibition of Indian Art: Reviews": Jan Gordon, "India Comes to London," *The Observer*, Nov. 17, 1940.

121. WIA, 1.24.7, "Exhibition of Indian Art: Reviews": Herbert Read, "Indian Art," cutting from *The Listener*, Nov. 21, 1940, p. 730.

122. "WARBURG INSTITUTE REPORT, June 1940–August 1941," TGA.

123. Gertrude Bing to [Esther] Simpson, Feb. 20, 1942, in Bing file: "BING, Dr. Gertrud (1893–1964)," file 1938–64, 184/5, SPSL.

124. "WARBURG INSTITUTE REPORT, June 1940–August 1941," TGA.

125. F. Saxl and R. Wittkower, *British Art and the Mediterranean* (London: Oxford University Press, 1948).

126. WIA, 25.3, "Photographic Exhibition on English Art and the Mediterranean," cyclostyled leaflet.

127. Ibid.

128. Ibid.

129. Saxl and Wittkower, "Preface" (unpaginated), *British Art and the Mediterranean* (1948).

130. See Mosse, *History of European Racism*.

131. Saxl and Wittkower, *British Art and the Mediterranean*, section 62.

132. Saxl and Wittkower, *British Art and the Mediterranean*, section 60, I.

133. *Guide to the Photographic Exhibition of English Art and the Mediterranean Compiled by the Warburg Institute* [Imperial Institute Buildings, London S.W. 7] CEMA [Council for Encouragement of Music and the Arts, 9 Belgrave Square, London, S. W. 1], 1943, BL.

134. Ibid.

135. Ibid.

136. Ibid.

137. Ibid.

138. Saxl and Wittkower, "Preface" (unpaginated), *British Art and the Mediterranean.*

139. Entry for "Jacobsthal, Paul," in *Dictionary of Art Historians*: www.dictionaryofarthistori ans.org/jacobsthalp.htm (accessed Feb. 2010).

140. Saxl and Wittkower, "Preface" (unpaginated), *British Art and the Mediterranean.*

141. Ibid.

142. *FRITZ SAXL (1890–1948). A Biographical Memoir*, 24.

143. WIA, 25.6, "Courses in Connection with an Exhibition on English Art and the Mediterranean," 1941–1942, printed leaflet.

144. WIA, 25.7, "Exhibition Reviews: English Art and the Mediterranean": "Britain as Interpreter," *The Times*, Dec. 4, 1941.

145. WIA, 25.7, "Exhibition Reviews: English Art and the Mediterranean": Peter Naumberg, "Englishe Kunst und Mittelmeer. Ausstellung im Warburg Institute," cutting from *Die Zeitung*, Dec. 12, 1941.

146. WIA, 25.7, "Exhibition Reviews: English Art and the Mediterranean": "English Art and the Mediterranean," cutting from *The Architectural Review* (Jan. 1942).

147. WIA, 25.7, "Exhibition Reviews: English Art and the Mediterranean": Herbert Read, "English Art and the Mediterranean," *The Listener* [published every Thursday by the British Broadcasting Corporation] 26, no. 675, p. 819.

148. WIA, 25.7, "Exhibition Reviews: English Art and the Mediterranean": "Editorial: English Art and the Mediterranean," *The Burlington Magazine*, vol. 80, no. 466 (Jan. 1942), pp. 3–4.

149. WIA, 25.7, "Exhibition Reviews: English Art and the Mediterranean": "A York Postscript. Photographic Exhibition," cutting from *Yorkshire Evening Press*, Feb. 18, 1943.

150. WIA, 26.2, "'Portrait and Character . . .' Small printed exhibition guide with introductions to various sections," p. 1.

151. See next chapter.

152. WIA, 26.2, p. 1.

153. WIA, 26.2, "Acknowledgments."

154. WIA, 26.2, p. 1.

155. WIA, 26.5, undated statement regarding the purpose of the exhibition, cyclostyled tear-sheet.

156. Ibid.

157. WIA, 26.6, "Exhibition Reviews: Portrait and Character": "Art of Portraiture," cutting from *Newcastle Journal*, March 5, 1943.

158. WIA, 26.6, "Exhibition Reviews: Portrait and Character": Herbert Read, "The Art of the Portrait," *The Listener*, p. 299.

159. Ibid.

160. WIA, 26.6, "Exhibition Reviews: Portrait and Character": Eric Newton, "Specialism in Exhibitions," cutting from *The Sunday Times*, Sept. 5, 1943.

161. WIA, 26.6, "Exhibition Reviews: Portrait and Character": "Portraits and Character. Exhibition at Ipswich Art Gallery," cutting from *Evening Star*, Sept. 20, 1943.

162. *Fritz Saxl (1890–1948), A Biographical Memoir*, 24.

163. Ibid.

CHAPTER FOUR

1. Albert G. Hess, "The Cataloging of Music in the Visual Arts," in *Notes* [journal of the Music Library Association], 2nd ser., vol. 11, no. 4 (Sept. 1954): 531.

2. See "Afterword": Haworth-Booth, "Helmut Gernsheim: An 'Unreasonable Man,'" in *FHG*, 327–330.

3. Helen Barlow, "Gernsheim, Helmut Erich Robert (1913–1995)" (2004), *DNB*: www.oxford dnb.com/view/article/58543 (accessed Aug. 2011) (hereafter cited as "Gernsheim," *DNB*).

4. Haworth-Booth, "Helmut Gernsheim."

5. *FHG*, 17–18.

6. Klaus Wilczynski, *Das Gefangenenschiff: Mit der "Dunera" über vier Weltmeere* (Berlin: Verlag am Park, 2001), 5.

7. "The *Dunera* Boys—70 Years On after Notorious Voyage," BBC News, UK, July 10, 2010: www.bbc.co.uk/news/10409026?print=true (accessed Aug. 2011).

8. "Refugee Charges Heard. British Promise on Compensation to Passengers on the *Dunera*. Special Cable to the *New York Times*. London, February 25," *New York Times*, Feb. 26, 1941.

9. "1.10 Lt. Col. W.P. Scott, Commanding Officer, 'Q' Troops, *Dunera*, to Officer Commanding, Prisoners of War, Australian Armed Forces," in Paul R. Bartrop and Gabrielle Eisen, eds., *The Dunera Affair: A Documentary Resource Book* (Melbourne: Schwartz and Wilkenson and Jewish Museum of Australia, 1990), 53.

10. *The Dunera Boys*, directed by Ben Lewin, 1985.

11. Bartrop and Eisen, *The Dunera Affair*.

12. K. G. Loewald, "*Dunera* Internees at Hay, 1940–41," *Historical Studies* (Australia), vol. 17, issue 69 (1977): 512–21.

13. His name is misspelled in the list of prisoners provided in Bartrop and Eisen, *The Dunera Affair*, 401. Most of those highlighted, though, from this episode are those who chose to remain in Australia.

14. "The *Dunera* Boys—70 Years On."

15. This was shared by many, but not all who boarded the ship; account of Albert Karolyi, "3.9 Belief on *Dunera* that Internees are Heading for Canada," in Bartrop and Eisen, *The Dunera Affair*, 191–192.

16. HGVW, tape 4.

17. Letter from Professor J. B. Skemp to Paul Brind, Jan. 22, 1945, Walter Gernsheim file, SPSL.

18. Most of the information about Walter Gernsheim derives from his file in the Society for the Protection of Science and Learning, as he attempted to find an academic appointment when he came to Britain in 1934 or 1935. See "Gernsheim, Dr. Walter (1909–)," file 1934–35, ms. 490/4, SPSL.

19. "Gernsheim Photographic Corpus of Drawings," in ARTstor Digital Library: www.artstor .org/what-is-artstor/w-html/col-gernsheim.shtml (accessed Aug. 2011).

20. Walter Gernsheim, CV [first document in the file], SPSL.

21. There is no record of a book or even a dissertation, but there is a chance that his works were destroyed.

22. Claude W. Sui, "Chronology," in *HGPF*, 330, 332.

23. Helmut Gernsheim, "The Gernsheims of Worms," *LBI Year Book* 24 (1979): 249.

24. H. Gernsheim, "The Gernsheims of Worms," 250–255.

25. H. Gernsheim, "The Gernsheims of Worms," 249.

26. H. Gernsheim, "The Gernsheims of Worms," 254–255.

27. Alexander Ringer, "Friedrich Gernsheim (1839–1916) and the Lost Generation," *Music Judaica* 3.1 (1980): 1–13.

28. Barlow, "Gernsheim," *DNB*.

29. HGVW, tape 1.

30. Sui, "Chronology," 330, 332.

31. Sharman Kadish, "Landauer, Fritz Josef (1883–1968)" (2004), *DNB*: www.oxforddnb .com/view/article/75354 (accessed Aug. 2011).

32. HGVW, tape 1.

33. H. Gernsheim, "The Gernsheims of Worms."

34. Erich Karl Berneker, *Russische Grammatik* (Leipzig: G. J. Göschen, 1902) and *Slavisches etymologisches Wörterbuch* (Heidelberg: C. Winter, 1908–1913).

35. Ernst Buschor, *Vom Sinn der griechischen Standbilder* (Berlin: Mann, 1942).

36. "Buschor, Ernst," *Dictionary of Art Historians* website: dictionaryofarthistorians.org/bus chore.htm (accessed Aug. 2011).

37. Brian Harrison, "Pevsner, Sir Nikolaus Bernhard Leon (1902–1983)" (2004), *DNB*: www .oxforddnb.com/view/article/31543 (accessed Aug. 2011).

38. Wilhelm Pinder, *Die deutsche Kunst der Dürerzeit* (Leipzig: E. A. Seemann, 1940); it appeared in the series "Vom Wesen und Werden deutscher Formen" (The essence and evolution of German forms).

39. "Pinder, [Georg Maximilian] Wilhelm," *Dictionary of Art Historians* website: dictionary ofarthistorians.org/pinderw.htm (accessed Aug. 2011).

40. "Mayer, August Liebmann," *Dictionary of Art Historians* website: dictionaryofarthistori ans.org/mayera.htm (accessed Aug. 2011).

41. *Ausgewählte Handzeichnungen [von] Goya y Lucientes, Francisco* (Berlin: Propyläen, ca. 1943). Pinder's denunciation rang hollow for most art historians. In the next years Mayer published in Madrid, Paris, Buenos Aires, Barcelona, and London.

42. "Mayer, August Liebmann," *Dictionary of Art Historians* website.

43. Rudolf Kömstedt, *Vormittelalterliche Malerei: Die künstlerischen Probleme der Monumental- und Buchmalerei in der frühchristlichen und frühbyzantinischen Epoche* (Augsburg: Dr. B. Filser, 1929).

44. Walter Gernsheim CV, SPSL.

45. Ibid.

46. Ibid.

47. Letter from Walter Gernsheim to the Academic Assistance Council," dated "Nov. 5, 1934," stamped "7 Nov 1934," with a note from Saxl attached, SPSL.

48. Memo on pink paper, unsigned, most likely from Saxl concerning Walter Gernsheim, dated "14.12.34," Walter Gernsheim file, SPSL.

49. Ibid.

50. A note indicating the termination of a temporary research fellowship from Munich, covering the period from Nov. 1, 1934, to Jan. 31, 1935, undated note, Walter Gernsheim file, SPSL.

51. Unsigned memo on pink paper, apparently from Saxl, dated "17 July 1936," "Gernsheim" across the top, Walter Gernsheim file, SPSL.

52. *Erich Salomon/Peter Hunter: Photos, 1933–1940*, 155.

53. A. J. Sherman and Pamela Shatzkes, "Otto M. Schiff (1875–1952), Unsung Rescuer," *LBI Year Book* 54.1 (2009): 243–271.

54. Letter from Walter Gernsheim, Aug. 22, 1944, Walter Gernsheim file, SPSL. See Robert Lumley, *Marcello Levi: Portrait of a Collector. From Futurism to Arte povera* (London: Estorick Collection, 2005).

55. Card announcing exhibition, Walter Gernsheim file, SPSL.

56. See, for example, *Exhibition of Drawings of the Bolognese School: May 10th–June 19th, 1937* (London: W. Gernsheim, 1939), Warburg Institute Library.

57. Sui, "Chronology," 334; HGVW, tapes 1, 7, 22.

58. Many of these photographs appear in Helmut Gernsheim's first book, *New Photo Vision* (London: Fountain, 1942).

59. Item from the journal of Nancy Newhall on the relationship between Alfred Stieglitz and Julien Levy, Feb. 17, 1942, "Levy, Julien" file, BN-NN, GRI.

60. The name "Gertrud Landauer, MA 1934" appears in a spring 2004 newsletter of the Courtauld Institute, in relation to an effort to trace alumni with whom they have lost contact: www.courtauld.ac.uk/newsletter/spring_2004/cafs.shtml (accessed Aug. 2011).

61. Helmut Gernsheim, biographical statement, HRC.

62. This is one of the many strengths of Flukinger's approach; see "A Historiography: Helmut and Alison Gernsheim and The Gernsheim Collection," in *FHG*, 11–13, 19–23.

63. Letter from Walter Gernsheim, Aug. 22, 1944, Walter Gernsheim file, SPSL.

64. For background, see *FHG*, 20–21.

65. Letter from Walter Gernsheim, Aug. 22, 1944, Walter Gernsheim file, SPSL.

66. Fritz Saxl to Esther Simpson, Sept. 11 1944, file "Gernsheim, Dr. Walter (1909–)," file 1934–45, 490/4, SPSL.

67. Ibid.

68. Nagel and Sieg, eds., *Die Philipps-Universität Marburg im Nationalsozialismus*.

69. Fritz Saxl to Esther Simpson, Sept. 11, 1944, file "Gernsheim, Dr. Walter (1909–)," file 1934–45, 490/4, SPSL.

70. Ibid.

71. Undated memo, handwritten, from J. B. Skemp, "Dr. and Mrs. Gernsheim," Walter Gernsheim file, SPSL.

72. Fritz Saxl to Skemp, Nov. 28, 1944, Walter Gernsheim file, SPSL.

73. Letter from Skemp to Paul Brind, Jan. 16 or 19, 1945, Walter Gernsheim file, SPSL.

74. Letter from Esther Simpson to the under-secretary of state, Aliens Department, supporting the appeal of Fritz Saxl for the release of the Gernsheims and permission to resume their photographic work, Sept. 13, 1944, Walter Gernsheim file, SPSL.

75. Undated letter from Walter Gernsheim to Skemp, followed by a letter from Skemp to Gernsheim, June 4, 1945, with attached newspaper article from *The Times*, "Euripides at Radley. Boys Performance of the 'Bacchae,'" Walter Gernsheim file, SPSL.

76. Undated memo, handwritten, from J. B. Skemp, "Dr. and Mrs. Gernsheim," Walter Gernsheim file, SPSL.

77. Skemp to Walter Gernsheim, Jan. 18, 1945, Walter Gernsheim file, SPSL.

78. Gavin Townend, "Obituary: Professor J. B. Skemp," *The Independent*, Friday, Oct. 16, 1992: www.independent.co.uk/news/people/obituary-professor-j-b-skemp-1557704.html (accessed Aug. 2011).

79. David Daube to "Joe" Skemp, Jan. 19, 1945, Walter Gernsheim file, SPSL.

80. "Majorca Restaurant, Brewer Street, London: Corner with mural painting by Hans Aufseeser." "Born in Munich, Hans Aufseeser [1910–1997] moved to London in the early 1930s and later changed his name to Hans Tisdall," Royal Institute of British Architects website: www.rib apix.com/index.php?a=indexes&s=item&key=IYToxOntpOjA7czoxNDoiV2FsbCBwYWludGl uZ3MiO30=&pg=179 (accessed Dec. 2014).

81. "The Alchemist's Elements, Hans Tisdall, Farraday Building, UMIST Building, UMIST Campus, At Risk—Going, Going, Gone," Manchester Modernist Society website: www.manches termodernistsociety.org/atrisk.html (accessed Aug. 2011).

82. Skemp to David Daube, Jan. 22, 1945, Walter Gernsheim file, SPSL.

83. Alan Roger, "Obituary: Professor David Daube," *The Independent*, Friday, March 5, 1999: www.independent.co.uk/arts-entertainment/obituary-professor-david-daube-1078397.html (accessed Aug. 2011).

84. Roger, "Obituary: Professor David Daube."

85. Roger, "Obituary: Professor David Daube."

86. Eric Pace, "David Daube, an Authority on Talmudic and Roman Law," *New York Times*, March 8, 1999: www.law.berkeley.edu/library/daube/nytimes.html (accessed Aug. 2011).

87. Walter Gernsheim, "Corpus Photographicum of Drawings," in "Letters to the Editor," *College Art Journal* 8.2 (Winter 1948–1949): 136–137.

88. Letter from F. J. Landauer to Fritz Saxl, Aug. 31, 1944, Walter Gernsheim file, SPSL.

89. Walter Gernsheim, "Corpus Photographicum of Drawings."

90. Ibid.

91. Hess, "Cataloguing of Music in the Visual Arts," 531–533. Gernsheim here, however, is misidentified as "K. Gernsheim." Nevertheless this article serves as an excellent endorsement, even advertisement, for the Photographicum.

92. Walter Gernsheim, "Corpus Photographicum of Drawings."

93. Ibid.

94. Vera Grodzinski, "French Impressionism and German Jews: The Making of Modernist Art Collections in Imperial Germany, 1896–1914" (PhD diss., University College London, 2003).

95. I am very grateful to Elisabeth Beck-Gernsheim for providing me with information about her family. "Gertrud died in 1975. Some years later Walter married Jutta Lauke (née von Weegmann) in Florence. . . . Jutta (who holds a doctorate in art history) had been Walter's photographic partner since the 1950s" (personal communication to the author, Aug. 24, 2011).

96. "Corpus."

97. Hess, "Cataloguing of Music in the Visual Arts," 531.

98. Walter Gernsheim, "Corpus Photographicum of Drawings."

99. Undated letter from Walter Gernsheim to Skemp, followed by a letter from Skemp to Gernsheim, June 4, 1945, SPSL.

100. Undated note on pink sheet, apparently from Skemp, "W Gernsheim": "Mr Gernsheim called 27 September 1945[.] Dr Gernsheim wishes to return to art photography. He will consult his own Headmaster and then apply on his own responsibility to the Ministry of Labour."

101. Carol Vogel, "Michelangelo Drawing Is Headed to Auction Block," *New York Times*, Oct. 14, 2005.

102. Vogel, "Michelangelo Drawing."

103. Account of Karolyi, "3.9 Belief on *Dunera*," 191–192.

104. Sui, "Chronology," 336.

105. "Gernsheim," *DNB.*

106. HGVW, tapes 1–4.

107. Helmut Gernsheim biographical statement, HRC; HGVW, tapes 2 and 3; see *FHG,* 15–17.

108. Sui, "Chronology," 336.

109. Wilczynski, *Das Gefangenenschiff,* 199, 201.

110. HGVW, tape 3.

111. HGVW, tape 4.

112. "The Gernsheims of Worms," 249.

113. Gernsheim's work is inconsistent in the meticulousness of its references. He did not always see a need to give sources for what he regarded as factual information. In the beginning, his tendency was to be as scholarly as possible. But apparently the encounter with Newhall was critical in this way, as well. Gernsheim told Val Williams that Newhall claimed he did not give precise footnotes because he was afraid of people stealing from him for their own work, HGVW, tapes 9, 12.

114. Erich Stenger, *Die Photographie in Kultur und Technik: Ihre Geschichte während hundert Jahren* (Liepzig: E. A. Seemann, 1938); the translation, by Edward Epstean, is entitled *The History of Photography: Its Relation to Civilization and Practice* (Easton, PA: Mack Printing Co., 1939); Sui, "Chronology," 336.

115. Letter from Helmut Gernsheim to Beaumont Newhall, Nov. 20, 1945, "Gernsheim, H & A," box 53, file 9, BN-NN, GRI.

116. "Edward Epstean, A Photo-Engraver. Pioneer in the Field, Treasurer of Walker Corporation Dies Here at Age of 76," *New York Times,* Aug. 10, 1945.

117. "Biographical Note," Edward Epstean papers, 1923–1942, Columbia University: www .columbia.edu/cu/lweb/archival/collections/ldpd_4078738/ (accessed Aug. 2011).

118. (Item number) 167: "Louis Jacques Mandé Daguerre (1787–1851). Historique et description des procédés du daguerréotype et du diorama. Paris: Susse frères, 1839. RBML, Epstean Collection," Columbia University website "Jewels in Her Crown: Treasures of Columbia University Libraries": www.columbia.edu/cu/lweb/eresources/exhibitions/treasures/html/long_topic9 .html (accessed Aug. 2011).

119. "Engravers May Avoid Trial. Swann Tells Publishers He Hopes to Re-establish Competition," *New York Times,* Aug. 17, 1916.

120. See his forewords to translations.

121. "Schwarz, Heinrich," Dictionary of Art Historians website: dictionaryofarthistorians. org/schwarzh.htm (accessed Aug. 2011).

122. Beaumont Newhall to Walter Clark, Feb. 5, 1940, box 92, correspondence concerning the sale of the Cromer collection to Kodak and its subsequent history, GEH; also in "Guide to the Gabriel Cromer Manuscript Collection": www.geh.org/link/Sn/cromer-manuscript.html (accessed Aug. 2011).

123. Joshua N. Lambert, "Unclean Lips: Obscenity and Jews in American Literature" (PhD diss., University of Michigan, Ann Arbor, 2009), 8.

124. Sui, "Chronology," 336.

125. Sui, "Chronology," 336.

126. Sui, "Chronology," 336.

127. "3.30 The Camp School and University, Hay," in Bartrop and Eisen, *The Dunera Affair,* 263–264.

128. HGVW, tape 3.

129. Wilczynski, *Das Gefangenenschiff*, 219.

130. Bartrop and Eisen, *The Dunera Affair*, 387.

131. HGVW, tape 3.

132. Wilczynski, *Das Gefangenenschiff*, 227, 234–235.

133. Sui, "Chronology," 336.

134. HGVW, tape 3.

135. It is not clear if Gernsheim purchased or was given the scrapbook of H. W. Barnett. He did, however, acquire several of his photographs, so he most likely respected Barnett; see Gernsheim, *Creative Photography*, 147, 232.

136. Brian Harrison, "Pevsner, Sir Nikolaus Bernhard Leon (1902–1983)," *DNB*; the *DNB* entry does not mention Pevsner's tentmate, Gernsheim; HGVW, tape 3.

137. Helmut Gernsheim, "Draft Suggestion for the Foundation of a National Museum of Photography," May 24, 1951, first of three drafts with comments and editing by Pevsner, Gernsheim Collection, HRC.

138. Sui, "Chronology," 336.

139. Letter from Peter W. Johnson (formerly Wolfgang Josephs), Nov. 1, 1960, RE.

140. Letter from Eva Szmulewicz to Helmut Gernsheim, Aug. 7, 1960, Hillel House, RE.

141. Graham Saxby, *The Science of Imaging: An Introduction* (London: CRC, 2011), 101, 110–111; D. A. Spencer (Douglas Arthur), *Colour Photography in Practice* (London: Pitman and Sons, 1938).

142. HGVW, tape 3.

143. Gernsheim was apparently unaware of a similar effort by another refugee photographer from Munich, Josef Breitenbach (1896–1984).

144. Helmut Gernsheim to L. W. Sipley, Ms., Gernsheim, Letters, H, 11 TccL to the American Museum of Photography, 1953–1963, HRC.

145. HGVW, tapes 2, 3, 4.

146. HGVW, tape 4.

147. See Friedrich Kestel and Judith Supp, "Walter Hegge (1893–1955): 'Race Art Photographer' and/or 'Master of Photography'?," *Visual Resources: An International Journal of Documentation* 7.2–3 (1990): 185–207.

148. WIA, general correspondence, H. Gernsheim to F. Saxl, Dec. 30, 1941.

149. "Helmut Ruhemann CBE, 1891–3 May 1973," archival guide, Hamilton Kerr Institute, Fitzwilliam Museum, University of Cambridge: www.hki.fitzmuseum.cam.ac.uk/archives/helmutruhemann (accessed Aug. 2011).

150. "Georg Ehrlich, 1897–1966," Tate Online: www.tate.org.uk/servlet/ArtistWorks?cgroupid=999999961&artistid=1051&page=1&sole=y&collab=y&attr=y&sort=default&tabview=bio (accessed Aug. 2011).

151. Jo Bossanyi and Sarah Brown, eds., *Ervin Bossanyi: Vision, Art, and Exile* (Oxford: Oxbow, 2008).

152. Letter from A. C. Farr to Helmut Gernsheim, Oct. 6, 1944, HRC.

153. Helmut Gernsheim to Beaumont Newhall, Sept. 29, 1944, "Gernsheim, H & A," box 53, file 9, BN-NN, GRI.

154. Beaumont Newhall to Helmut Gernsheim, Nov. 20, 1944, "Gernsheim, H & A," box 53, file 9, BN-NN, GRI.

155. Beaumont Newhall to Walter Clark, Feb. 5, 1940, box 92, correspondence concerning the sale of the Cromer collection to Kodak and its subsequent history, GEH; also in "Guide to the Gabriel Cromer Manuscript Collection": www.geh.org/link/Sn/cromer-manuscript.html (accessed Aug. 2011).

156. This was, in fact, the very first item in the file; "Gernsheim, H & A," box 53, file 9, BN-NN, GRI.

157. There are drafts of sections of Beaumont Newhall's memoirs that remain unpublished. "Memoirs-III, 32," "Meeting Stieglitz," box 203, file 5, BN-NN, GRI.

158. Original transcript and drafts of published interview of Beaumont Newhall by Jan Castro, p. 7, "Misc. Letters," box 203, file 5, BN-NN, GRI.

159. Postcard showing Mount McKinley and Wonder Lake, Mount McKinley National Park, Alaska (1947, photo by Ansel Adams), from Ansel Adams to Helmut Gernsheim, June 2, 1980, RE. My thanks to Emma Hamilton for spotting this.

160. Letter of Helmut Gernsheim to Beaumont Newhall, Jan. 1, 1946, box 53, file 9, BN-NN, GRI.

161. Helmut Gernsheim, *Creative Photography*, 231–247, especially 247.

162. Letter of Helmut Gernsheim to Beaumont Newhall, April 14, 1950, "Gernsheim, H & A," box 53, file 9, BN-NN, GRI.

163. Excerpt of letter from Beaumont Newhall to Nancy Newhall, May 15, 1944, pages marked "Memoirs-VII-45–65," in "Eisenstaedt, Alfred," box 34, file 23, BN-NN, GRI.

164. Helmut Gernsheim to Yehoshua Nir, July 1, 1986, Gernsheim collection, RE.

165. Helmut Gernsheim to Beaumont Newhall, May 12, 1969; Beaumont Newhall to Helmut Gernsheim, April 17, 1969, box 53, file 9, BN-NN, GRI.

166. Beaumont Newhall to Helmut Gernsheim, April 17, 1969, box 53, file 9, BN-NN, GRI.

167. Deppner, ed., *Die verborgene Spur*.

168. Original transcript and drafts of published interview of Beaumont Newhall by Jan Castro, p. 7, "Misc. Letters," box 203, file 5, BN-NN, GRI; "Strand's Story" in "Confidential" file, box 250, file 18; "Strand, Paul—material misfiled," box 115, file 9, GRI.

CHAPTER FIVE

1. Colin Ford, "Helmut Gernsheim and Julia Margaret Cameron—A Personal Tribute," in *HGPF*, 80–81.

2. She is credited with producing one book of her own, although this too was a result of their joint research; see Alison Gernsheim, *Fashion and Reality* (London: Faber and Faber, 1963), republished in 1981 (London: Constable/New York: Dover).

3. "Helmut Gernsheim" (autobiography), in Helmut Gernsheim, ed., *The Man behind the Camera* (London: Fountain, 1948), 104.

4. "Obituary. Mrs. Alison Gernsheim, Photo-Historian and Biographer," *The Times*, Monday, April 7, 1969; tear-sheet in "Gernsheim, H & A," box 53, file 9, in BN-NN, GRI.

5. In the interview with Val Williams Gernsheim mentions that Alison's previous brief marriage ended abruptly—due to the fact that her husband had a mistress he wished to keep; HGVW, tape 2.

6. Letter from Beaumont Newhall to Peter Pollack, Dec. 23, 1957, Peter Pollack papers, box 5, file 27, GRI.

7. Berkowitz, "'Jews in Photography.'"

8. Geoffrey Cantor provided this insight in a presentation about "Anglo-Jewry and the Great Exhibition of 1851" at the Institute of Jewish Studies, University College London, Sept. 22, 2011.

9. HGVW, tape 9.

10. HGVW, tape 9; Esmond Cecil Harmsworth, 2nd Viscount Rothermere (1898–1978).

11. After her divorce from Harmsworth she married Ian Fleming, of "James Bond" fame.

12. HGVW, tape 9.

13. One of the matters of controversy that arose concerning the Gernsheim Collection at the University of Texas was that some of the material was in poor condition. This was, in fact, one of Gernsheim's chief motives in trying to establish a museum. In many instances he had purchased photographs and books that were not in good condition to begin with, and he had neither space nor climate control for long-term storage; see Michael Ennis, "Art: The Collector. In the Battle between Helmut Gernsheim and UT, No One Is Winning," *Texas Monthly* (July 1979): 164–166.

14. "Draft Suggestion for the Foundation of a National Museum of Photography," with comments by N. Pevsner, Gernsheim manuscript collection, HRC.

15. Ibid.

16. "Nelson's Column," Timeless-London-Attractions.com: www.timeless-london-attractions.com/nelsons-column.html (accessed Aug. 2011); "John Julius Angerstein," website of the National Gallery: www.nationalgallery.org.uk/paintings/history/collection-history/john-julius-angerstein (accessed Aug. 2011); Sarah Palmer, "Angerstein, John Julius (*c.* 1732–1823)" (Jan. 2008), *DNB*: www.oxforddnb.com/view/article/549 (accessed Sept. 2011).

17. Gernsheim recalled that the "director" of the film *The Red Shoes* had been with him on the *Dunera*, but he was thinking of Hein Heckroth, the film's production designer. Heckroth's wife was Jewish, which prompted his persecution by the Nazis; see Alastair Smart, "Out of Australia, at British Museum, *Seven* Magazine Review," *Telegraph*, June 5, 2011: www.telegraph.co.uk/culture/art/8554957/Out-of-Australia-at-British-Museum-Seven-magazine-review.html (accessed Sept. 2011).

18. Those at the forefront of photography who did not have independent means largely relied on donors. Alfred Stieglitz benefited greatly from the generosity of the Liebman family; Beaumont Newhall depended on David McAlpin (one of the few non-Jewish supporters of photography in the fine arts); and Cornell Capa, for the creation of the International Center for Photography, relied on Henry Margolis.

19. HGVW, tape 11.

20. Reid also put a pin in her lip.

21. Tom Woolfe, "Snob's Progress" (review of *Cecil Beaton: A Biography*, by Hugo Vickers), *New York Times*, June 15, 1986.

22. Entry for "Cecil Beaton," *Clothing and Fashion Encyclopedia* website: angelasancartier.net/cecil-beaton (accessed Sept. 2011).

23. Edna Woolman Chase to Baron Adolf De Mayer, Feb. 3, 1938, "Adolf De Meyer correspondence, 1935–1939," 850436, 3MS, folder 2, GRI.

24. "Magazine Artist out over Slur in Drawing. Beaton Leaves *Vogue* after an Apology for Comment Hidden in Lettering of Design," *New York Times*, Jan. 26, 1938.

25. Ibid.

26. Entry for "Cecil Beaton," *Clothing and Fashion Encyclopedia* website.

27. Letter from Kenneth Clark to the undersecretary of state for home affairs, Aug. 2, 1940; letter from F. J. Landauer, father-in-law of Walter Gernsheim, to Kenneth Clark, Aug. 2, 1940; Clark to Landauer, Aug. 14, 1940, 8812.1.4.182, Interned Refugees, Kenneth Clark collection, TGA.

28. See chapter 4.

29. Helmut Gernsheim to Kenneth Clark, April 14, 1950, TGA.

30. Kenneth Clark to Helmut Gernsheim, May 5, 1950, TGA.

31. Helmut Gernsheim to Kenneth Clark, May 6, 1950, TGA.

32. Obituary of Philip James, CBE, from *The Times*, May 1, 1974, on website of the Victoria and Albert Museum: www.vam.ac.uk/content/people-pages/obituary-philip-james/ (accessed Aug. 2011).

33. Helmut Gernsheim to Kenneth Clark, June 2, 1950, TGA.

34. Kenneth Clark to Helmut Gernsheim, June 5, 1950, TGA.

35. Letter from Helmut Gernsheim to Kenneth Clark, Nov. 14, 1950, TGA.

36. For an inner-institutional perspective see Mark Haworth-Booth, *Photography: An Independent Art. Photographs from the Victoria and Albert Museum, 1839–1996* (London: V&A Publications; Princeton: Princeton University Press, 1997), 131, 133, 135, and Haworth-Booth, "Helmut Gernsheim," in *FHG*, 328–330.

37. Obituary of Charles Harvard Gibbs-Smith, *The Times*, Dec. 7, 1981, on website of the Victoria and Albert Museum: www.vam.ac.uk/content/people-pages/obituary-charles-gibbs-smith/ (accessed Aug. 2011).

38. HGVW, tape 19.

39. Letter from Kenneth Clark to Helmut Gernsheim, Nov. 21, 1950, TGA.

40. Ibid.

41. Helmut Gernsheim to Kenneth Clark, Nov. 27, 1950, TGA.

42. Kenneth Clark to Helmut Gernsheim, June 21, 1951, TGA.

43. Kenneth Clark to Helmut Gernsheim, Oct. 8, 1951, TGA.

44. Haworth-Booth's retrospective view also fails to take this into consideration.

45. Kenneth Clark to Gibbs-Smith, May 30, 1950, TGA.

46. Kenneth Clark to Gibbs-Smith, Nov. 21, 1950, TGA.

47. Ibid.

48. "The History of William Morris Gallery": www.walthamforest.gov.uk/index/leisure/museums-galleries/william-morris/wmg-history.htm (accessed Sept. 2011).

49. "History of Lacock Abbey": www.nationaltrust.org.uk/main/w-vh/w-visits/w-findaplace/w-lacockabbeyvillage/w-lacockabbeyvillage-history.htm (accessed Sept. 2011).

50. "History" [of Osterley Park]: www.nationaltrust.org.uk/main/w-vh/w-visits/w-findaplace/w-osterleypark/w-osterley-history.htm (accessed Sept. 2011).

51. HGVW, tape 19.

52. Helmut Gernsheim to Lou and Alice Sipley, June 4, 1961 [to the American Museum of Photography, 1953–1963], HRC.

53. Heinrich Schwarz, *David Octavius Hill*, trans. Helene E. Fraenkel (London: G. G. Harrap, 1932).

54. Letter of Helmut Gernsheim to Arthur Farr, Feb. 25, 1945, HRC.

55. One of the copies of the book from the Gernsheim Collection is inscribed: "Given to N. M. for Christmas 1936." Gernsheim probably bought it in a secondhand shop. Throughout the book there are underlinings and notes in the margins by Gernsheim, HRC.

56. Author's presentation copy to Helmut Gernsheim, London, Sept. 12, 1957, HRC. Schwarz gave Gernsheim a Viking Press edition.

57. Julia Margaret Cameron, *Victorian Photographs of Famous Men & Fair Women. . . . with Introductions by Virginia Woolf and Roger Fry* (London: L and V Woolf, 1926).

58. Uwe Westphal, "German, Czech, and Austrian Jews in English Publishing," in *Second Chance: Two Centuries of German-Speaking Jews in the United Kingdom*, ed. Werner E. Mosse et al. (Tübingen: Mohr Siebeck, 1991), 195–208.

59. Marcel Natkin, *Photography and the Art of Seeing* (London: Fountain, 1935), *Photography by Artificial Light* (London: Fountain, 1937), *Photography of the Nude* (London: Fountain, 1937), and *Fascinating Fakes in Photography*, illustrations by Pierre Boucher (London: Fountain, 1939).

60. The others were Pierre Adam, Laure Albin Guillot, Pierre Boucher, Brassaï, Rémy Duval, Goursat, Keighley, Kollar, Krupy, Meerkamper, Person, Schall, Sougez, (Erno) Vada, and a work from the agency Photo-Wolff, which seems to be by Omar Oscar Marcus.

61. Natkin, *Photography and the Art of Seeing*, 3.

62. Natkin, *Photography of the Nude*.

63. Letter from Helmut Gernsheim to Beaumont Newhall, Sept. 7, 1947, box 53, file 9, BN-NN, GRI.

64. Letter from Beaumont Newhall to Paul Strand, May 15, 1947, box 115, file 9, BN-NN, GRI.

65. HGVW, tape 15.

66. "Gernsheim, Helmut, Correspondence relating to books published by the Fountain Press," Gernsheim, Misc., 1942–1956; letter of Arthur Farr to Helmut Gernsheim, Sept. 19, 1947, HRC.

67. HGVW, tape 15.

68. Letter of Arthur Farr to Helmut Gernsheim, Sept. 19, 1947, HRC.

69. T. Dalby to Helmut Gernsheim, July 24, 1951, HRC.

70. Walter Neurath to Helmut Gernsheim, Oct. 29, 1948 [Adprint Ltd., 1948 October 30, 1949 January 13], HRC.

71. Morton N. Cohen, "Dodgson, Charles Lutwidge [Lewis Carroll] (1832–1898)" (2004), *DNB*: www.oxforddnb.com/view/article/7749 (accessed Sept. 2011).

72. Cohen, "Dodgson, Charles Lutwidge [Lewis Carroll]."

73. Cohen, "Dodgson, Charles Lutwidge [Lewis Carroll]."

74. HGVW, tape 15.

75. Michael Hall, "Dolphins in the Swim," *Apollo*, May 29, 2009: www.apollo-magazine.com/reviews/books/3655033/dolphins-in-the-swim.thtml (accessed Aug. 2011).

76. HGVW, tape 15.

77. David Plante, "Obituary of Eva Neurath," *The Guardian*, Thursday, Jan. 6, 2000.

78. T. G. Rosenthal, "Neurath, Walter (1903–1967)" (Oct. 2009), *DNB*: www.oxforddnb.com/view/article/60042 (accessed Aug. 2011).

79. "The Press: Future with a Past," *Time*, Monday, May 24, 1948.

80. Lucia Moholy, *A Hundred Years of Photography, 1839–1939* (Hammondsworth: Penguin, 1939).

81. HGVW, tape 11.

82. Ibid.

83. Nick Russel, "Bookwatch. Book-Packaging—A Reply," *New Scientist*, Feb. 8, 1979, p. 387.

84. Helmut Gernsheim, *Masterpieces of Victorian Photography* (London: Phaidon, 1951).

85. Stanley Unwin, *The Truth about a Publisher: An Autobiographical Record* (London: George Allen and Unwin, 1960), 223–227.

86. Helmut Gernsheim, *Beautiful London* (London: Phaidon, 1950).

87. HGVW, tape 11.

88. See the books *Malerei, Photographie, Film* (Munich: Albert Langen, 1925), by Moholy-Nagy, and (apparently) *Foto-Auge*, ed. Franz Roh (text) assembled with Jan Tschichold (Stuttgart: Frank Wedekind, 1929); Helmut Gernsheim, "The Return to Realism," *Motif*, no. 2 (Feb. 1959): 34–48.

89. Peter Pollack to Helmut Gernsheim, July 31, 1956, HRC.

90. Helmut Gernsheim to Peter Pollack, June 9, 1957, HRC.

91. See Gernsheim, "The Return to Realism."

92. Lucia Moholy, *A Hundred Years of Photography, 1839–1939* (Hammondsworth: Penguin, 1939); HGVW, tape 6; see Robin Schuldenfrei, "Images in Exile: Lucia Moholy's Bauhaus Negatives and the Construction of the Bauhaus Legacy," *History of Photography* 37.2 (May 2013): 182–203.

93. HGVW, tape 7.

94. He probably meant Brunswick Square.

95. See Rolf Sachsse, *Lucia Moholy* (Düsseldorf: Marzona, 1985) and Rolf Sachsse, *Lucia Moholy: Bauhaus-Fotografin* (Berlin: Museumspädagogischer Dienst Berlin/Bauhaus Archiv Berlin, 1995).

96. Schuldenfrei, "Images in Exile."

97. HGVW, tape 7.

98. Helmut Gernsheim's list of Jewish photographers, HRC.

99. Sibyl Moholy-Nagy, *Moholy-Nagy: Experiment in Totality* (Cambridge, MA: MIT Press, 1969), 137.

100. Peter Pollack to Helmut Gernsheim, March 13, 1957, HRC.

101. For years Pollack supplied Gernsheim with a specific kind of pencil-cartridge.

102. Helmut Gernsheim to Peter Pollack, Dec. 6, 1959, box 5, file 17, Peter Pollack papers, GRI.

103. Peter Pollack to Helmut Gernsheim, March 29, 1957, HRC.

104. Peter Pollack to Helmut Gernsheim, March 13, 1957, HRC.

105. Pollack's archive in the Getty contains numerous slide trays and notes from lecture courses, many of which were repeatedly revised, GRI.

106. Peter Pollack to Paul Strand, March 2, 1967, box 5, file 38; correspondence with Gernsheim: box 5, file 17, Peter Pollack papers, GRI.

107. Peter Pollack correspondence with Gernsheim: box 5, file 17, Peter Pollack papers, GRI. Most important, apparently, is the letter from Gernsheim to Pollack of Dec. 6, 1959, in which he declines to "accept a check" from Pollack for use of photographs.

108. Helmut Gernsheim to Peter Pollack, Aug. 18, 1956, HRC.

109. Ibid.

110. Cornell Capa to Peter Pollack, Feb. 24, 1968, box 5, file 8, Peter Pollack papers, GRI.

111. Peter Pollack to Cornell Capa, Dec. 16, 1974, box 6, file 34, Peter Pollack papers, GRI.

112. Cornell Capa to Peter Pollack, Jan. 25, 1975, box 6, file 34, Peter Pollack papers, GRI.

113. Alfonso A. Narvaez, "H. M. Margolis, 80, Industrialist," *New York Times*, Nov. 3, 1989.

114. Jacob Deschin, "Museum, Archive, Gallery, Center," *New York Times*, Jan. 14, 1968.

115. *FHG*, 56–58.

116. Carol Vogel, "Lawrence A. Fleischman, 71, an Art Dealer," *New York Times*, Feb. 4, 1997.

117. Peter Pollack to Helmut Gernsheim, Dec. 7, 1962, HRC.

118. Peter Pollack to Lawrence Fleischmann, copied to Helmut Gernsheim, undated, HRC.

119. Helmut Gernsheim to Louis Walton Sipley, Aug. 31, 1963, HRC.

120. Peter Pollack to Paul Strand, March 2, 1967, box 5, file 38; correspondence with Gernsheim: box 5, file 17, Peter Pollack papers, GRI.

121. "The Sipley/3M Collection," in *Image: Journal of Photography and Motion Pictures of the International Museum of Photography at George Eastman House* 21.3 (Sept. 1978): 1. Sipley's work also includes *Frederic E. Ives, Photo-Graphic-Arts Inventor* (Philadelphia: American Museum of Photography, 1956); *Photography's Great Inventors* (Philadelphia: American Museum of Photography, 1965).

122. "Dr. Louis Sipley of Photo Museum. Head of Philadelphia Institution Is Dead," *New York Times*, Oct. 19, 1968.

123. Baum also established "the Judaica Museum of the Hebrew Home for the Aged in Riverdale," "Ralph Baum" (obituary), *New York Times*, April 20, 1984.

124. Jacob Deschin, "Museum for City on Way," *New York Times*, Feb. 16, 1969.

125. "The Sipley/3M Collection."

126. Ibid.

127. Helmut Gernsheim to Louis Sipley, March 21, 1960; Louis Sipley to Helmut Gernsheim, May 31, 1961; March 5, 1962, HRC.

128. Helmut Gernsheim to Grace Mayer, May 12, 1957; June 7, 1957; Gernsheim, 9 TccL to Mayer, Grace M., Gernsheim, Letters 1957–1963, box: letters:D–ski, folder Mae–Pha, HRC.

129. Michael Kimmelman, "Grace Mayer, Photography Curator, Dies at 95," *New York Times*, Dec. 24, 1996, section D, 17.

130. Ibid.

131. Helmut Gernsheim to Grace Mayer, May 9, 1963, HRC.

132. Claude Sui, "Chronology," in *HGPF*, 344. There is, however, no mention of Feldman.

133. "Lew D. Feldman, 70, Book Dealer, Dead," *New York Times*, Nov. 30, 1976.

134. Ibid.

135. Nicholas A. Basbanes, *A Gentle Madness: Bibliophiles, Bibliomanes, and the Eternal Passion for Books* (New York: Henry Holt, 1995), 106–107, 124, 230, 329–339, 424–425, 463. Interestingly, there is no mention of Gernsheim or the acquisition of the Gernsheim Collection in Basbanes's account.

136. Basbanes, *A Gentle Madness*, 339.

137. Robert McG. Thomas Jr., "Charles Hamilton Jr., 82, an Expert on Handwriting," *New York Times*, Dec. 13, 1996.

138. Basbanes, *A Gentle Madness*, 312–318, 328–329.

139. Lew Feldman to Harry Ransom, May 5, 1960, file "Feldman Lew 1960," Harry Ransom Files, HRC.

140. Ralph K. M. Haurwitz, "Alumnus: UT [University of Texas] Law Dean Helped End Discrimination against Jewish Graduates," *Statesman*, Sept. 13, 2010: www.statesman.com/news/news/local/alumnus-ut-law-dean-helped-end-discrimination-agai/nRxjZ/ (accessed Dec. 2013).

141. Lew Feldman to Harry Ransom, May 5, 1960, file "Feldman Lew 1960," Harry Ransom Files, HRC.

142. Sui, "Chronology," 344.

143. Ibid.

144. Lew Feldman to Harry Ransom, July 9, 1962, file "Feldman Lew 1962," Harry Ransom Files, HRC.

145. Harry Ransom to Lew Feldman, Aug. 20, 1962, file "Feldman Lew 1962," Harry Ransom Files, HRC.

146. Lew Feldman to Harry Ransom, Aug. 15, 1962, file "Feldman Lew 1962," Harry Ransom Files, HRC.

147. Harry Ransom to Lew Feldman, Aug. 20, 1962, file "Feldman Lew 1962," Harry Ransom Files, HRC.

148. Harry Ransom to Lew Feldman, Aug. 20, 1962, file "Feldman Lew 1962," Harry Ransom Files, HRC.

149. Frances Hudspeth, personal assistant to Harry Ransom, to Lew Feldman, Aug. 31, 1962, file "Feldman Lew 1962," Harry Ransom Files, HRC.

150. Ennis, "Art: The Collector," 164–166.

151. The terms were summarized in a letter requested by Gernsheim, in order to enable him to purchase property; Harry Ransom to Gernsheim, Jan. 21, 1964, "Gernsheim, Helmut (1960–1972)" file, Harry Ransom Collection, HRC.

152. Email from David Coleman, curator of photography, HRC, to the author, Sept. 7, 2011.

153. See Helmut Gernsheim, "The Return to Realism."

154. Helmut Gernsheim to Lew Feldman, Oct. 15, 1963, "Gernsheim, Helmut (1960–1972)" file, Harry Ransom Collection, HRC.

155. Helmut Gernsheim to Frances Hudspeth (now executive assistant to the chancellor), Oct. 6, 1964; Hudspeth to Gernsheim, Oct. 20, 1964, "Gernsheim, Helmut (1960–1972)" file, Harry Ransom Collection, HRC.

156. Helmut Gernsheim to Lew Feldman, April 1, 1965; Lew Feldman to Helmut Gernsheim, May 6, 1965, "Gernsheim, Helmut (1960–1972)" file, Harry Ransom Collection, HRC.

157. Harry Ransom to William J. Burke, July 15, 1964, "Gernsheim, Helmut (1960–1972)" file, Harry Ransom Collection, HRC.

158. Lew Feldman, "The Gernsheim Collection," p. 1, typescript attached to Harry Ransom to William J. Burke correspondence, July 15, 1964, "Gernsheim, Helmut (1960–1972)" file, Harry Ransom Collection, HRC.

159. Feldman, "The Gernsheim Collection," 4.

160. Harry Ransom to Helmut Gernsheim, Nov. 6, 1964, "Gernsheim, Helmut (1960–1972)" file, Harry Ransom Collection, HRC. On the "sweep" strategy see Feldman to Ransom, Nov. 16, 1961, "Feldman, Lew 1965" file (which includes the correspondence from 1961), HRC.

161. Irene Gernsheim, "The Fascination of Photography," in *HGPF*, 11; see also Claudio de Polo Saibanti, "Meeting Helmut Gernsheim," in *HGPF*, 15; Sui, "Helmut Gernsheim: Pioneer Collector and Historian of Photography," 19; Sui, "Chronology," 330–338.

162. HGVW, tape 11.

163. Gisèle Freund to Joan Daves, Dec. 18, 1986, folder 7, general correspondence, Gisèle Freund papers, Washington State University Special Collections, Pullman, WA.

164. HGVW, tape 11.

165. Ford, "Helmut Gernsheim and Julia Margaret Cameron," 77–81.

166. Mark Haworth Booth interviewed by Val Williams, Aug. 1992, Oral History of British Photography Collection, C459/24; F3062–F3066, part 7.

167. HGVW, tape 15.

CHAPTER SIX

1. See Berkowitz, "'Jews in Photography.'" By 1975 Gernsheim was definitely aware of the *Encyclopaedia Judaica*, which included an article about his renowned composer ancestor, Friedrich Gernsheim; Tim Gidal to Helmut Gernsheim, Nov. 15, 1975, and Dec. 21, 1975, RE.

2. Arnold Newman to Beaumont Newhall, Feb. 15, 1968, uncatalogued Arnold Newman material, Arnold Newman papers (in process) [hereafter cited as AN], box 33, HRC. It is important to recall that up to the 1970s a slide lecture about photography's history was not a simple proposition—few individuals except for Gernsheim and Newhall possessed comprehensive collections. Accessible library holdings, if they existed at all, were spotty.

3. Helmut Gernsheim to Franz (Ferenc) Berko, June 14, 1980, RE.

4. Helmut Gernsheim to Meir Meyer, June 21, 1990, RE.

5. HGVW, tape 15.

6. Eva Szmulewicz to Helmut Gernsheim, Aug. 7, 1960, RE.

7. Peter W. Johnson (formerly Wolfgang Josephs) to Helmut Gernsheim, 1/1/1 November 1960, RE.

8. This should probably be "Wilhelm" Gernsheim.

9. "Victorian Photography: The Gernsheim Collection," May 4, 1951, in *JC*, 5.

10. Ibid.

11. Helmut Gernsheim to Hugh Harris, *JC*, London, 6/1/1 May 1951, RE.

12. Ibid.

13. Hugh Harris to Helmut Gernsheim, May 8, 1951, RE.

14. Helmut Gernsheim to Hugh Harris, May 15, 1951, RE.

15. Ibid.

16. Kenneth Ambrose, "History in Pictures," *AJR Information*, vol. 2, no. 6 (June 1952): 4.

17. W. Rosenstock (Association of Jewish Refugees in Great Britain) to Helmut Gernsheim, 20/1/1 June 1952, RE.

18. A number of publications with similar names appeared around that time.

19. Helmut Gernsheim to J. Blumenfeld, July 1, 1962, RE.

20. "Jews Prominent in Photography," list compiled by Helmut Gernsheim, 1981, first version, RE.

21. Helmut Gernsheim to the editor, *New Statesman and Nation*, July 18, 1953, RE.

22. Ibid.

23. Ibid.

24. F. R. Bienenfeld, *The Religion of the Non-Religious Jews* (London: Museum Press, 1944).

25. HGVW, tapes 11 and 12.

26. "Photography. *The History of Photography*," *JC*, Nov. 18, 1955, p. 10.

27. Gernsheim, *Lewis Carroll, Photographer* (London: Max Parrish, 1949).

28. *FHG*, 33–35.

29. Arnold Paucker to Helmut Gernsheim, Oct. 21, 1975, RE.

30. Helmut Gernsheim to Arnold Paucker, Nov. 21, 1975, LBI Achives, Center for Jewish History, New York.

31. Ibid., p. 1.

32. Ibid., p. 3.

33. Ibid.

34. Ibid.

35. All that can be located, thus far, is one page of the poem, which has written at the bottom "pto"—"please turn over." It was apparently among stray material in the Reiss-Engelhorn Gernsheim archive. I am, however, extremely grateful to Claude Sui for bringing it to the attention of myself and those gathered at the Osnabrück symposium.

36. Nachum T. (Tim) Gidal, "Jews in Photography," *LBI Year Book* 32 (1987): 437–453.

37. Tim Gidal to Helmut Gernsheim, Feb. 2, 1976, RE.

38. Helmut Gernsheim to Tim Gidal, Jan. 2, 1976, RE.

39. Tim Gidal to Helmut Gernsheim, Feb. 2, 1976, RE.

40. See David N. Myers, *Re-Inventing the Jewish Past: European Jewish Intellectuals and the Zionist Return to History* (New York: Oxford University Press, 1995).

41. Helmut Gernsheim to Meir Meyer, June 21, 1990, RE.

42. This may have been *Germania Judaica*; see letter to Gernsheim, Feb. 14, 1980, RE. 43. Arnold Paucker to Helmut Gernsheim, Dec. 29, 1979, RE.

44. Helmut Gernsheim to Arnold Paucker, Nov. 21, 1975, p. 3, RE.

45. Gidal, "Jews in Photography." In his later publication Gidal reproduced the picture of Michael Gernsheim, the Jews' Bishop, but there is no reference to Helmut; see Nachum T. Gidal, *Jews in Germany from Roman Times to the Weimar Republic*, trans. Helen Atkins, Patricia Crampton, Iain Macmillian, Tony Wells (Cologne: Könemann, 1998), 106.

46. H. Gernsheim, "The Gernsheims of Worms," 250.

47. H. Gernsheim, "The Gernsheims of Worms," 247–257.

48. Ismar Schorsch, "The Myth of Sephardic Supremacy," *LBI Year Book* 34.1 (1989): 47–66.

49. H. Gernsheim, "The Gernsheims of Worms," 247.

50. Michael Berkowitz, "Beaumont Newhall and Helmut Gernsheim: Collaboration, Friendship, and Tension amidst the 'Jewishness' of Photography," *Perspectives* (Woolf Institute, Cambridge) (Spring 2010): 17–21.

51. Helmut Gernsheim's list of Jewish photographers, HRC. The same list appears in the archive of John Gutmann, where it is included in a request from the Beteler-Morgan Galleries in Houston, which wished to organize a show about émigré photographers. It is not known if the list originally came from Gernsheim or elsewhere, but the one at the HRC most likely has Gernsheim's handwritten annotations. For material related to the proposed exhibition see Petra Beteler to John Gutman (spelled incorrectly with one "n"), June 5, 1989, in AG 173: 6/23, Center for Creative Photography Archive, University of Arizona, Tucson.

52. Helmut Gernsheim to Tim Gidal, Feb. 25, 1976, RE.

53. Helmut Gernsheim to Y[ehoshua] Nir, July 1, 1986, RE.

54. "An Interview with Ferenc Berko," by Karl Steinroth, in *Ferenc Berko: 60 Years of Photography: "The Discovering Eye,"* ed. Karl Steinroth (Stuttgart: Stemmle, 1994), 8.

55. Steinroth, "Interview with Ferenc Berko."

56. Steinroth, "Interview with Ferenc Berko," 9.

57. Steinroth, "Interview with Ferenc Berko," 10–11.

58. Colin Ford, "Explorer in Black and White," in *Ferenc Berko: 60 Years of Photography.*

59. *Ferenc Berko: 60 Years of Photography*, 25, 26, 27.

60. Berkowitz, "'Jews in Photography.'"

61. Yehoshua Nir to Helmut Gernsheim, Nov. 23, 1986, RE.

62. Arnold Newman to Beaumont Newhall, Feb. 15, 1968, box 33, AN, HRC.

63. Arnold Newman to Han Laskin, Oct. 24, 1978, and lecture notes on Jews and photography, "Bezalel Jerusalem," file, box 33, AN, HRC.

64. Copy of letter from Augusta Newman (wife of Arnold) to Carol Smith, American photographer, Feb. 12, 1980, to support an ad about the photography department of the Israel Museum, "AFIM—/Israel Museum" file, AN, HRC.

65. Communications with the America–Israel Cultural Foundation, box 33, AN, HRC; Karl Katz to Arnold Newman, March 22, 1961, file marked "Am–Israel Foundation," AN, HRC.

66. Helmut Gernsheim to Yehoshua Nir, Dec. 12, 1986, RE.

67. Yehoshua Nir to Helmut Gernsheim, Feb. 2, 1987, RE.

68. Y. Nir to Helmut Gernsheim, March 29, 1988, RE.

69. The book by Nissan Perez, with the same title, appeared simultaneously: *Focus East: Early Photography in the Near East (1839–1885)* (New York and Jerusalem: Abrams and Domino Press and the Israel Museum, 1988).

70. "Focus East" and related material for Jerusalem trip, RE.

71. Helmut Gernsheim to Meir Meyer, June 21, 1990, RE.

72. Meir Meyer to Helmut Gernsheim, undated [1990], RE.

73. Helmut Gernsheim to Meir Meyer, June 21, 1990, RE.

74. Helmut Gernsheim to Tim Gidal, March 8, 1982, *RE.*

75. Yeshayahu Nir, "Camera Judaica," *Encyclopaedia Judaica Year Book* (1987): 139–145.

76. Postcard, showing Mount McKinley and Wonder Lake, Mount McKinley National Park, Alaska (1947, photo by Ansel Adams), from Ansel Adams to Helmut Gernsheim, June 2, 1980, RE.

77. According to Sander Gilman, there is no information about Diamond's background that would justify his identification as Jewish or not.

78. Helmut Gernsheim, *Photographien, 1935-1982* (Hamburg: Galerie F. C. Grundlach, 1983).

79. *Felix H. Man: Bildjournalist der ersten Stunde* (Berlin: Bildarchiv Preussischer Kulturbesitz, 1983).

80. Helmut Gernsheim to Tim Gidal, June 10, 1983, RE.

81. Helmut Gernsheim, "Felix H. Man," in *Felix H. Man.*

82. Ibid.

83. Helmut Gernsheim's list of Jewish photographers, 1994, RE.

84. Ibid.

85. "Il Diaframma Kodak Cultura Milan," in "Notes and Reviews" section, *History of Photography* 20.1 (Spring 1996): 93.

86. Ansel Adams to Helmut Gernsheim (postcard), June 2, 1980, RE.

87. George Gilbert, *The Illustrated Worldwide Who's Who of Jews in Photography: Photographers, Scientists, Israel, and Women* (New York: published by the author, 1996).

88. Personal communication with Frank Dabba Smith concerning Gilbert's publication "The Freedom Train"; copies of correspondence from Sept. 21, 2010, Nov. 29, 2013.

EPIGRAPH

1. "Museum History," [British] National Media Museum website: www.nationalmediamu seum.org.uk/AboutUs/MuseumHistory.aspx (accessed Feb. 2011).

2. I wish to thank Brian Liddy, Curator, Collections Access at the National Media Museum, for his assistance and insight.

3. Arnold Newman, *The Great British: Photographs by Arnold Newman* (London: Weidenfeld and Nicolson for the *Sunday Times* and the National Portrait Gallery, 1979).

4. Arnold Newman to Hanan Laskin, Oct. 24, 1978, "Bezalel" file, box 3, AN, HRC.

5. Galley for introduction by George Perry of *The Great British* with edits by Arnold Newman, "BBCre Great British & other" file, box 1, AN, HRC.

6. Undated press release, "BBCre Great British & other" file, box 1, AN, HRC.

7. "Arnold Newman Questions for Interview June 14 Serpentine Gallery Jonny Lucas/Peter Greenway, Director," in "BBCre Great British & other" file, box 1, AN, HRC.

8. Galleys for *The Great British*, in "BBCre Great British & other" file, box 1, AN, HRC.

9. "The Hughes Column: The Prince and the Photographer," *Amateur Photographer*, Dec. 6, 1978, p. 141.

10. "Arts, Briefly, Compiled by Lawrence Van Gelder: BBC Lens Captures Her Royal Coldness," *New York Times*, July 12, 2007.

11. Eric Pfanner, "Britain's Networks Come Clean to Lift a Cloud of Distrust," *New York Times*, Sept. 24, 2007.

12. "BBC Executive Resigns over Film of Queen," *New York Times*, Oct. 6, 2007.

13. Dorothy Wilding, *In Pursuit of Perfection* (London: Robert Hale, 1958), 18–19.

14. *Baron by Baron* [Baron Henry Sterling (Stirling) Nahum], foreword by Peter Ustinov (London: Frederick Muller, 1950), 26.

15. *Baron by Baron*, 169.

16. *Baron by Baron*, 27.

17. *Baron by Baron*, 31.

18. *Baron by Baron*, 32.

19. *Baron by Baron*, 54.

20. *Baron by Baron*, 126.

21. Helen Cathcart, *Lord Snowdon* (London: W. H. Allen, 1968).

22. *Snowdon: Personal View* (London: Weidenfeld and Nicolson in association with Condé Nast, 1980), 6.

23. *Snowdon: Personal View*, 12.

24. *Snowdon: Personal View*, 12.

25. I wish to again thank Cristy Anderson for this insight.

26. *Snowdon: Personal View*, 6.

27. Snowdon, *Israel: A First View* (London: Weidenfeld and Nicolson, 1986).

28. *Snowdon: Personal View*, 61–63.

29. "A Picture of Happiness—The Girl on the Merry-go-Round. Crises forgotten. War scares blown away. Private worries left at the top of the last incline. Only the rush of air. Only the shouts of friends. Only the sudden swooping movement of the caterpillar. Only the fun of the fair . . . ," *Picture Post*, Oct. 8, 1938, p. 77.

FURTHER READING

⟨≈⟩

THE WORKS LISTED here mainly inform the background of Jews and photography in Britain. They do not, on the whole, concern the problem of photographic representations of Jews. Neither the historical works of Helmut Gernsheim nor the catalogues of the individual photographers considered in this book are included in this select bibliography.

For books dealing with Jews, photography, and Britain see: Helmut Gernsheim, *Helmut Gernsheim: Pionier der Fotogeschichte/Pioneer of Photo History* (Ostfildren-Ruit: Hatje Catz, 2003); Roy Flukinger, *The Gernsheim Collection* (Austin: University of Texas Press, 2010); Roy Flukinger, *The Formative Decades: Photography in Great Britain, 1839–1920* (Austin: University of Texas Press, 1985); Michael Hallett, *Stefan Lorant: Godfather of Photojournalism* (Oxford: Scarecrow Press, 2006); Tim N. Gidal, *Modern Photojournalism: Origin and Evolution, 1910–1933*, trans. Maureen Oberli-Turner (New York: Collier, 1973); Shulamith Behr and Marian Malet, eds., *Arts and Exile in Britain, 1933–1945: Politics and Cultural Identity* (Amsterdam: Rodopi, 1994), especially Duncan Forbes, "Politics, Photography, and Exile in the Life of Edith Tudor-Hart (1908–1973)," 45–88, and Dorothea McEwan, "Exhibitions as Morale Boosters: The Exhibition Programme of the Warburg Institute, 1938–1945," 267–300; Marion Berghahn, *Continental Britons: German-Jewish Refugees from Nazi Germany*, rev. ed. (New York: Berghahn Books, 2007); Werner E. Mosse, ed., *Second Chance: Two Centuries of German-Speaking Jews in the United Kingdom* (Tübingen: J. C. B. Mohr [Paul Siebeck], 1991), especially Uwe Westphal, "German, Czech, and Austrian Jews in English Publishing," 195–208; Christopher Breward and Claire Wilcox, eds., *The Ambassador Magazine: Promoting Post-war British Textiles and Fashion* (London: V&A Publishing, 2012); *Erich Salomon: Emigrant in Holland/Peter Hunter: Emigrant in London* (Amsterdam: Focus, 1996); *Daily Encounters: Photographs from Fleet Street* (London: National Portrait Gallery, 2007).

Articles concerning Jews, photography, and Britain: Michael Berkowitz, "Jews and Photojournalism: Between Contempt, Intimacy, and Celebrity," in *Die PRESSA/The PRESSA: Internationale Pressausstellung Köln 1928 und der jüdische Beitrag zum modernen Journalismus/International Press Exhibition Cologne 1928 and the Jewish Contributions to Modern Journalism*, ed. Suzanne Marten-Finnis and Michael Nagel (Bremen: Lumière, 2012), 2:627–639; Berkowitz, "Beaumont Newhall and Helmut Gernsheim: Collaboration, Friendship, and Tension amidst the 'Jewishness' of Photography," in *Perspectives* (Woolf Institute, Cambridge) (Spring 2010): 17–21; Robin Schuldenfrei, "Images in Exile: Lucia Moholy's Bauhaus Negatives and the Construction of the Bauhaus Legacy," in *History of Photography* 37.2 (May 2013): 182–203; Annette Vonwinckel, "German (Jewish) Photojournalists in Exile: A Story of Networks and Success," *German History* 31.4 (2013): 453–472.

On Jews and photography generally: Lisa Silverman, "Reconsidering the Margins: Jewishness as an Analytical Framework," *Journal of Modern Jewish Studies* 8.1 (2009): 103–120; Michael Berkowitz, "Photography as a Jewish Business: From High Theory, to Studio, to Snapshot," *East European Jewish Affairs* 39.3 (Dec. 2009): 389–400; Nachum T. [Tim] Gidal, "Jews in Photography," *Leo Baeck Institute Year Book* 32 (1987): 437–453; David Shneer, *Through Soviet Jewish Eyes: Photography, War, and the Holocaust* (New Brunswick, NJ: Rutgers University Press, 2012); Martin Roman Deppner, ed., *Die verborgene Spur: Jüdische Wege durch Moderne/The Hidden Trace: Jewish Paths though Modernity* (Bramsche: Rasch, 2009); Roman Bezjak and Martin R. Deppner, eds., *Jüdisches: Fotografische Betrachungen der Gegenwart in Deutschland* (Bielefeld: Nicolai, 2006); Elizabeth Anne McCauley and Jason Francisco, *The Steerage and Alfred Stieglitz* (Berkeley: University of California Press, 2012); Max Kosloff, ed., *New York: Capital of Photography* (New York: Jewish Museum, under the auspices of the Jewish Theological Seminary; and New Haven: Yale University Press, 2002); George Gilbert, *The Illustrated Worldwide Who's Who of Jews in Photography* (Riverdale, NY: privately published, 1996). While useful as a reference, Gilbert's book should not be taken as authoritative.

Concerning areas outside of Britain which had the greatest impact on Jews and photography: *Vienna's Shooting Girls: Jüdische Fotografinnen aus Wien/Jewish Women Photographers from Vienna* (Vienna: Jüdisches Museums Wien and IPTS-Institute für Posttayloristische Studien, 2013); David Shneer, "Photography," in *YIVO Encyclopedia of Jews in Eastern Europe*, vol. 2, pp. 1350–1353; Anna Auer and Kunsthalle Wien, *Übersee: Flucht und Emigration österreichischer Fotografen 1920–1940/Exodus from Austria: Emigration of Austrian Photographers, 1920–1940* (Vienna: Kunsthalle, 1998); Rolf Sachsse, "'Dieses

Atelier ist sofort zu vermieten': Von der 'Entjudung' eines Berufsstandes," *"Arieserung" im Nationalsozialismus: Volksgemeinschaft, Raub und Gedächtnis: Jahrbuch 2000 zur Geschichte und Wirkung des Holocaust*, Fritz Bauer Institute (Hg.) von Irmtrud Wojak and Peter Hayes (Frankfurt/New York: Campus, 2000), 269–286; Daniel Magilow, *The Photography of Crisis: The Photo Essays of Weimar Germany* (State College, PA: Pennsylvania State University Press, 2012); Eugene Avrutin, Valeri Dymshits, Alexander Ivanov, Alexander Lvov, Harriet Murav, and Alla Sokolova, eds., *Photographing the Jewish Nation: Pictures from An-Sky's Ethnographic Expeditions* (Hanover, NH: Brandeis University Press, 2009); Lucjan Dobroszycki and Barbara Kirschenblatt-Gimlett, *Image before My Eyes: A Photographic History of Jewish Life in Poland before the Holocaust* (New York: Schocken Books, 1977); *Exilforschung. Ein internationales Jahrbuch. Band 21. Film und Fotographie* (2003); Matthew S. Witkovsky, *foto: Modernity in Central Europe* (Washington, DC: National Gallery of Art, 2007); Ute Eskildsen with Florian Ebner and Bettina Kaumnann, *Street & Studio: An Urban History of Photography* (London: Tate Publishing, 2008); Péter Baki, Colin Ford, and George Szirtes, *Eyewitness: Hungarian Photography in the Twentieth Century. Brassai, Capa, Kertész, Moholy-Nagy, Munkácsi* (London: Royal Academy of Arts, 2011); Emily J. Levine, *Dreamland of Humanists: Warburg, Cassirer, Panofsky, and the Hamburg School* (Chicago: University of Chicago Press, 2013); Howard Eiland and Michael W. Jennings, *Walter Benjamin: A Critical Life* (Cambridge, MA: Belknap Press of Harvard University Press, 2014); Manuela Fugenzi, curator, *They Fight with Cameras: Walter Rosenblum in World War II from D-Day to Dachau* (Rome: Postcart, 2014).

INDEX

Note: *Italic* page numbers refer to illustrations.

Fry, Roger, 215, 226
Fuerst, Jules, 39, 76
Fuerst Brothers, 39, 76

Galassi, Peter, 238
Galleria degli Uffizi, Florence, 195
Galsworthy, John, 81–82
Galvanic Pile Belt, 98
Games, Abram, 35, 74, 102
Gamse, Joseph, 35
Garai, Bert, 4–5, 87, 114
Gaspar, Bela, 200
George Allen and Unwin, 229
Germany: Jewish refugees from, 141; photo-
 journalism in, 77, 79, 90, 100–101, 113;
 as possible site for Helmut Gernsheim's
 collection of photographs, 225, 236, 237,
 244, 245. *See also* Nazism
Gernsheim, Alison Eames (wife of Helmut),
 81, 187, 201, 207–209, 210–211, 214–215,
 219, 222, 224, 322n2, 322n5; and Charles
 E. Fraser's *Helmut and Alison Gernsheim
 Examining a Print, 208*; and Charles E.
 Fraser's *Helmut and Alison Gernsheim in
 Their Attic, 213*. *See also* Gernsheim Col-
 lection (Helmut); Gernsheim collection
 (Helmut) of photographs
Gernsheim, Friedrich (musician), 181, 247,
 248, 259, 329n1, 329n8
Gernsheim, Gertrud Landauer (wife of
 Walter), 183, 185, 187, 318n60, 319n95;
 and Gernsheim Photographical Corpus
 of Drawings/Gernsheim Corpus (Walter),
 148, 149, 188, 190–193, 194, 207, 319n91;
 internment on Isle of Man, 179, 187–188,
 191, 196; as pacifist, 191
Gernsheim, Hans (brother), 181, 183, *184*
Gernsheim, Helmut: and Ansel Adams, 206,
 322n159; architectural photography of,
 27, 147, 194, 201–202, 247, 284; archi-
 val research of, 10; as art historian, 90,
 196, 199, 224, 260; in Australia, 28, 187,
 196–199, 200, 202, 247; and Beaumont
 Newhall, 81, 197–198, 201, 203–204,
 204, 207–209, 218, 227, 230, 235, 236,
 254, 260, 320n113, 322n156; on British

photography, 28, 199, 200; and Charles
E. Fraser's *Helmut and Alison Gernsheim
Examining a Print, 208*; and Charles E.
Fraser's *Helmut and Alison Gernsheim
in Their Attic, 213*; and Charles Harvard
Gibbs-Smith, 221; on cleaning statues and
buildings before photographing, 194; col-
laborative relationship with wife, Alison,
201, 207, 210–211, 214–215, 219, 222, 224,
322n2; and color photography, 27, 200,
263; as curator of photography exhibi-
tions, 201, 210, 211, 249, 254; as curator of
Victorian exhibition centenary, 211–212,
219, 222, 225, 229, 247, 248; on *Dunera*,
28, 178–179, 196, 199, 200, 201, 202, 206,
244, 247, 316n13, 316n15, 323n17; and
Encyclopaedia Judaica, 246, 329n1; in
"English Art and the Mediterranean" exhi-
bition, *163, 164*, 165, *168*, 169, 171–172;
and Erich Salomon, 200, 207; on Ermanox,
90; family history, 28, 181, 209, 251, 252,
259–261, 282; Felix Man's *Helmut Gern-
sheim with Camera, 27*; and Ferenc Berko,
201, 206, 261, 263; foreignness of, 178,
210, 225, 227, 229, 245, 247; and Fritz Saxl,
179, 202; in *Gernsheim Children, with
Their Mother, Dressed as German Soldiers
in the Great War, 183, 184*; and Hay camp,
196–199, 200; *Helmut Gernsheim as a
Baby, 185*; and Henry Walter Barnett's
photographs, 321n135; hiring photogra-
phers with background in art history, 155;
on history of photography, 8, 28, 79, 119,
121, 143, 171, 177, 198, 199, 201, 204, 210,
219, 220, 221, 224, 226, 234–235, 240–241,
245, 246, 247, 251, 252, 254, 257–258, 265,
266, 270–271, 329n2; on Holocaust, 28,
244, 251, 255–257, 260, 330n35; honorary
degree from University of Bradford, 273;
in Huyton camp, 199–200; inconsistency
in references given by, 320n113; influence
on photography in Britain, 11, 28, 143,
274; Jewishness of, 6–7, 11, 206, 209, 210,
236, 243–244, 245, 246–249, 251, 258, 260,
261, 269, 271, 279, 280; as Jewish refugee,
23, 28, 179, 181, 206, 210, 244, 247,